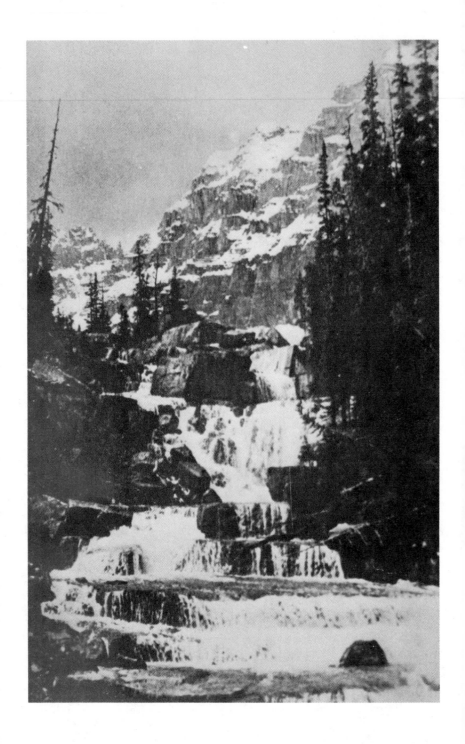

THE SEARCH FOR FORM

in Art and Architecture

Eliel Saarinen

Dover Publications, Inc., New York

TO YOUNG MINDS OF ALL AGES

Frontispiece (PLATE 1).
ART OF NATURE: THE "LANDSCAPE"
Giant Steps in Paradise Valley: a landscape
vibrant in both rhythm and movement.

This Dover edition, first published in 1985, is an un-
abridged republication of the work first published by the
Reinhold Publishing Corp., New York, in 1948 under the title
SEARCH FOR FORM: A Fundamental Approach to Art.

Manufactured in the United States of America
Dover Publications, Inc., 31 East 2nd Street, Mineola, N.Y
11501

Library of Congress Cataloging in Publication Data

Saarinen, Eliel, 1873–1950.
 The search for form in art and architecture.

 Reprint. Originally published: Search for form. New York :
Reinhold Pub. Corp., 1948 (1950 printing)
 1. Art—Philosophy. 2. Architecture—Philosophy.
I. Title.
N70.S27 1985 701'.8 85-10090
ISBN 0-486-24907-7 (pbk.)

FOREWORD

IN THE search for form—when sincere and honest—the action is twofold: to create form; and to diagnose the created form. Accordingly, as the artist proceeds with his creation, there simultaneously develops a rationalizing yet unwritten analysis of the work. This analysis is a personal meditation, characteristic of the individual and therefore independent of the thoughts of others. Nevertheless, the nearer the thoughts of the individual approach indispensable fundamentals, the closer will they contact the thoughts of others engaged in the same search.

During the many years of my work in the field of art in general and in architecture in particular, I have always tried to approach my problems in accordance with this two-fold procedure: through work, and then through an analytic criticism of this work. This analytic criticism has been a natural discipline springing from the work itself—**for myself only**—and not an intentional systematizing of thought for others to follow.

This dual procedure, I felt, was essential, particularly in my case, as conditions began to spin about myself and my efforts. For those years—from 1894 to 1897—during which I got my first dope [sic] in Classical architecture, coincided with those very years when it finally became evident that the Classical form after all is not the form to be used for contemporary purpose, but that our time must develop an architectural form of its own. So was the reasoning in forward-looking circles—and, for sure, forward-looking circles are the only criterion.

But since in those early days there was no architectural form of our own, the sincere student felt as if he were

brought onto deep waters with the assurance of a life-belt—only to find that the life-belt was old and useless. And there he was.

Perhaps this is the best way to learn to swim.

In art, it is the only way—so I learned soon. For, through such a procedure one is compelled to get along by one's own effort, and that's what forces one to do things.

That is to say, I had to learn to "swim."

Such was my first encounter with architecture.

But it was not my first encounter with art in general. For—to put it straight—I was not supposed to become an architect at all. That was not my dream. My dream was to become a painter and, indeed, this dream was from an earlier date. And it was far more intense.

Therefore—and particularly because this analysis is going to be **a personal viewing of things**—I might just as well tell my story from its very outset. By no means, however, is this story going to be an attempt at an autobiography, nor is it going to be a "confession" or any other effort to put myself into the limelight. It is going to be only the shortest record of events, intended to make those who care to read it familiar with the conditions under which my personal inclination to look upon things grew—and got its savor. This might better enable the reader to follow my reasoning.

No doubt, the circumstances about one's growth and the development of one's way of thinking go hand in hand and cannot be taken apart.

So then, here is my story.

In the year 1875, when I was two years of age, my parents moved from Finland and settled down in Ingermanlandia, in Russia—about thirty miles south of St. Petersburg, nowadays called Leningrad. Here my father was engaged as Lutheran minister among the Finnish speaking population. The population—liberated from serfdom some fifteen years previously—was religious, honest, generally intelligent, and eager to learn. It was entirely of peasant stock—small

farmers—each household having only a few acres to cultivate.

Among these fine people I spent my childhood. The landscape was gentle with fields, meadows, and forests. My entourage was limited—and to my liking. Besides family members and servants—and save occasional guests—my companions consisted of a few peasant children, of cows, pigs, chickens, and so on. In this rural milieu I ran around— very often with paper and pencil in my hands—for as far as my memory goes, down to my earliest childhood, I had a strong urge to draw and to paint and to look upon everything with a "painter's" eye. Of course, every child has that —more or less—but in my case it has proven lasting and of decisive effect. Whence this urge originated, I do not know, for no one of our acquaintances, mature or juvenile, had such leanings as might have offered example, advice, or encouragement. The only clue I could possibly follow is that the people on my mother's side were musical and keenly interested in music—whether or not this has anything to do with my case.

Anyhow, the urge was there. It could not be subdued. Rather, it grew in strength.

Well, in the course of time I began to attend high school in Wiipuri, in Finland. And while commuting at semester shiftings between home and school, I had to pass through the capital of Russia—St. Petersburg. By so traveling, I soon learned to know the Eremitage Museum of Art, one of the world's finest.

This was a great event in my life.

The "Eremitage" became my real "Mecca," and oftentimes when my parents went shopping they parked me in that museum. Probably they considered it the safest place to keep me out of mischief—which for sure was not a poor guess—and it worked wonderfully with regard to my disposition in those growing days. For hours I could wander from gallery to gallery—alone—silent—happy. Just think of it: a country boy used to cows, pigs, and hens—midst the most precious masterpieces of all time. Funny, isn't it!

Well I didn't think it funny. I was deadly earnest about

it. I grasped every chance to visit the museum. And so it happened that already in my middle "teens" or so I learned to know that extensive collection of paintings almost by heart.

I knew the paintings. I knew the names and the labels. But insofar as their place in history of art and the rest is concerned, my memory cannot record any such interest whatsoever. Probably I was satisfied with a direct and personal contact with these paintings. They spoke to me—so I probably felt. I understood their speech—so I probably thought. As for esthetic evaluation, I didn't have the slightest inkling of it—and, for that matter, I had my own "evaluation." I liked the paintings. Some of them I liked more. And probably I shifted my liking—just as one shifts his liking from meat to fish, and vice versa. How I shifted, I do not remember. The only thing I recollect distinctly is that for some length of time the topmost of my pet painters was Murillo—because of his many pretty and sweet Madonnas swaying in clouds and balancing on the tiniest of thin slices of the moon. Cute—what!

Such was my first acquaintance with Classical painting. It surely was exciting and, I assume, it did me much good.

As for contemporary painting, the prevailing trend in those times was imitative naturalism. I tried to follow this trend, and—no matter how clumsily—I painted flowers and all that I found worth while in nature, I painted landscape, and preferably I painted figure. I painted in oil and I painted in water-color. But in all this I had no desire to attend a regular art school—of whatever sort there were in those days. Perhaps I fancied my own free and autodidactic way of experimentation, or perhaps I wished to continue my high school education up to college grade so as to have enough background for another profession, should my attempt to become a painter fail—for, rather than to become a third-rate cobbler, I was willing to sacrifice my dream. As for this other "profession," I began to incline toward architecture, for—as I had learned—in architecture also there was a chance to use pencil and brush.

No deeper roots had my interest in architecture.

High school art-education—if any, and at best—consisted merely of that dull copying of ever the same plaster casts of classical ornament. This was killing—to say the least—and for that reason I carried on with my "art-work" outside of the school, using my vacation time as well as much of my school time: too much of my school time, I began to fear.

Nevertheless, in due course I sneaked through my college maturity examinations. And so I went to the university town, Helsinki, where I was enrolled in the Polytechnic Institute as a student of architecture and in the university art-school as a student of painting. The former was the result of cold reasoning. The latter was the choice of my heart.

For, as said, my dream was to become a painter.

Well, why should I become an architect?

Certainly, in those days architecture did not inspire one's fancy. Architecture was a dead art-form, and it had gradually become the mere crowding of obsolete and meaningless stylistic decoration on the building surface. And so long had this state of things already lasted that a break would have been considered almost as much of a sacrilege as the breaking of the most essential principles of religion. So was architecture understood. And the thought horrified me, to be condemned for the rest of my life to deal with obsolete ornamental stuff! I felt so, particularly, because I had experienced a sour pre-smack of it already on the high school bench while charcoaling plaster casts of classical decoration.

And then

And I repeat: "it finally became evident that the Classical form after all is not the form to be used for contemporary purpose, but that our time must develop an architectural form of its own."

So then, here it was—the alleged sacrilege!

To the young minds the change meant about this: architecture had gone astray; something had to be done about it; the road was free to go—and now was the time to do things.

Elated by such a challenge, many a young man plunged into the game eagerly striving for his very best. As for myself, it soon became clear to me that in architecture the field of action was broader and more significant than in that relatively confined field of painting.

From then on I had the ambition to become an architect.

This transition did not happen overnight, though. It was somewhat of a religious conflict within myself, the issue being whether or not to abandon my childhood gods of painting—always so gentle to me—and turn to new gods offering new and perhaps greater opportunities. However, my enthusiasm for architecture had already become strong enough to overcome such hesitations. I fixed the matter in accordance with my best judgment, and decided to become an architect.

Besides, I had much encouragement from without.

As for this encouragement from without, I had a more fortunate chance than ever before in all of my life.

In the closing years of the nineteenth century—and thenceforth—there was concentrated in Helsinki a numerous group of artists from every field. Generally speaking, these artists were by no means radical in an extreme sense of the word. Instead, they were—and this is more essential—sincerely forward-looking and imbued with high cultural aims. There were a number of painters and sculptors. There were many interested in handicraft—for in the Nordic countries handicraft has always played an important role. There were a number of men of letters of both Finnish and Swedish tongue. There were a number of composers; for example, young Jean Sibelius, just as sparkling of intellect and emotion as his music. And now the awakening of architecture brought a new note of vitality into the group.

Prior to my entering university life, I had scarcely met a single artist worth the name. Thus, although my thoughts already for years had been circulating about the intricate problems of art, I had no one to discuss the matter with, no one to put my questions to, and no one to get the

answers from. All questioning and answering had to take place within myself. And this fact, I think, planted the seed of meditation and analytic deliberation in my mind.

But from now on I had opportunity to be a close member of all the mentioned groups. And, as there were frequent gatherings and occasional discussions, and often heated arguments about this and that in art and in matters in general, this all brought to me a new experience—a contrast to my earlier isolated contemplation. Since then I have had the opportunity of ever broadened experience in many new circles and in many different countries. In fact, during the long run of almost half a century, my "social contacts"—if I may say so—have consisted primarily of art circles, creative or appreciative.

Although architecture now had become my profession, I cherished all the arts without any particular preference and my former interest in painting had by no means become lessened. I still tried to paint whenever I had the opportunity to do so, but soon it became evident that one cannot serve two masters. In spite of this, as said, I continued to cherish painting, at home or wherever I moved around. Thus it happened—incidentally—that one of the first and perhaps most important books, or parts of it, about Cézanne, was written at our country-home in Finland by our friend the late Julius Meier-Graefe. And as Meier-Graefe had written or was writing many a book about painters—as, for example, about El Greco, Van Gogh, and others—it is clear that at our home-corners there still was much painting in the air. The prevailing interest, however, was architecture.

Of course, all these contacts with different people of different means of expression, interests, and inclinations could not fail to find such a response in me as to enrich my understanding—appreciative or critical—of the complex problems of art. It is true enough that I had become growingly inclined to control my understanding of art-matters with an "architectural" eye—contrary to my earlier inclination to view things with a "pictorial" eye. But, on the other hand, my contact with men from all walks of art-life has broadened my eye—architectural or pictorial—and made me

see and understand things from a wider point of view. I
have learned to know that one cannot build up a compre-
hensive understanding of one art unless one learns to grasp
the whole field of art in a comprehensive sense. I have
learned to know that to understand art in all its compre-
hensiveness one must understand the comprehensive world
even beyond the problems of art—that is, one must learn to
understand life from which all art springs. And I have
learned to know that in order to understand both art and life
one must go down to the source of all things: to nature.

I have learned to know still more.

It happened quite often that a piece of art which I had
valued very highly quickly lost all its enchantment, whereas
another piece of art which I disfavored—yes, perhaps, even
denounced—became later on a pet piece of mine. In other
words, I had grown away from the former while I had grown
closer to the latter. And as this was not just an occasional
phenomenon but a regular course in the evolution of my
mind, I learned by and by—at least, I hope I learned—a
lesson which perhaps is the hardest lesson for an artist to
learn. I learned open-mindedly to respect the work of
others—when honest—even if it be in disagreement with
one's own concept, taste, or line of development. That is to
say, when an artist is honest, creative, endowed with sen-
sitiveness to form and color, and endeavors to do his sincerest
best, one must already for these reasons respect his endeavor
—just as one always must respect an honest man even if
opinions differ. And if one does not always understand the
artist's work, one should at least seek to understand it, rather
than to denounce it—and then later on, perhaps, regret this
denouncement. Particularly during a time of transition—
as our time has been and is to the highest degree—this kind
of open-mindedness helps one to keep pace with the progress
of things and with their countless ramifications.

All this—I hope—I have learned to know.

And I have learned to know still more.

I have learned to know that art, when fresh, vital, and
alive, is a sign of the artist's youthfulness of mind. And, be-
cause I have learned to know this already for a long time,

then, already long ago I decided that, no matter how old I might grow in years, I always will stick to the young. And so I have endeavored to do.

Regrettably, however, the young do not always constitute a solid youthful front. On one side there are those young who with youthful enthusiasm are ready to go at their work in a creatively alert way. On the other side there are those young who are ready to snatch the creative results of others and to boast as if they had helped to attain these results. These young may be young in years. But, as to mind, they are indolent and stagnant, and thus mentally senile. They are so because they are lacking in that indispensable spirit of creative search which keeps one's mind young.

All this I have learned to know.

And, finally, I have learned to know that all this is but the primary beginning of knowledge about essential fundamentals and that there still is much, much more to learn.

So, still I must go on.

Thus runs my story.

With this story as the background, the following analysis of the search for form must be understood. And as such it is bound to be a personal analysis, for—and I repeat—"no doubt, the circumstances of one's growth and the development of one's way of thinking go hand in hand and cannot be taken apart."

By no means do I pretend this to be a unique story. Surely, every sincere worker—and thus seeker—in the field of art would have a similar story to tell, provided he had cared to write it down. Yet such stories are but seldom written down. Neither would I have cared to write down my story nor, for that matter, would I have had the slightest intention to write down this long analysis of mine, had I not had a specific purpose for doing so.

And that's another story.

Due to the adventures of life—and altogether contrary to my indigenous bent—I have now not only to control my own work, but even the so much harder task of advising

others in the progress of their work. In such circumstances I have felt it my duty to disclose to these "others" my mode of thinking, and for this reason I have deemed it important to put down my thoughts in writing. This, however, does not mean that I am trying to impose my advice upon others as to how certain problems should be solved in certain circumstances. On the contrary, my writing is intended to be a treatise of fundamentals—as I **personally** understand these fundamentals. Since I am still a seeker myself, my chief advice is that everyone, individually, be a seeker also. **We cannot live physically on food digested by others. How then could we do it mentally!**

This is essential.

Really, I consider it essential in all education—and emphatically in education toward creative art—that education should be so directed as to imbue the student with the spirit of creation by means of his personal sensing, thinking, and experience. To that end I have been anxious to have the students understand that we all—instructors and students alike—are engaged in a creative search for forms to come, and that each one, individually, must—so to speak—digest his own food.

And as deeply as I am convinced of the positive qualities of this creative method of art-education, just as deeply am I convinced of the negative—and dangerous—qualities of the reverse method of art education, where the instructor has obtained all his facts from books and books again, and passes these facts, as such, to the student to be used, as such.

Through this kind of art-education, I am sure, the student is not given a fair chance. He is soothed into the sweet belief that he can get along with food digested by others, thus not to be bothered himself with that digestion. This is to foster **parasitic** minds—instead of **creative** minds—and as such this kind of art-education is baneful in the development of creative art.

Only through personal creative experience can one gain a truly genuine understanding of art.

Indeed, **one must have loved in order to know what love is.**

As the aforesaid discloses, the following analysis was originally intended to constitute a spiritual contact between the leader and those to be led—just as my previous book "The City" was originally intended to be. Having grown beyond its originally intended boundaries, it now appears that it may be of use also to others interested in the subject. Yet, even in its enlarged form, I have not approached the matter with exaggerated expectations as to its importance in the general development of form. I do hope, however, that this book will fulfill its mission by bringing enlightenment at least to some of the problems of form at the present high wave of transition.

ELIEL SAARINEN

CRANBROOK ACADEMY OF ART.
May, 1947

ILLUSTRATIONS

For Sources of Illustrations see pages 353-354.

CONTENTS

* * *

PART THREE

* * *

EPILOGUE

PREAMBLE

THE soul of the past is conveyed to posterity through the infallible language of art, the greatest treasure of human culture. When studying this language of art—rich and fecund —it is as if dwelling in a sacred grove of memories where the thoughts, feelings, and aims of our forebears speak to us their silent tongue, through form. And one gets a deep veneration for the work done. Indeed, what were the bygone times to us, unless their respective endeavors had become crystallized into corresponding forms of art.

Someday the future will look upon our form with discriminating eyes. With this in mind it is prudent to deliberate whether the present status of our form is favorable or, if not, to undertake the necessary steps of correction while the opportunity still is open. By surveying the situation—well, what does one discover! Life has run its normal course, but in many respects the employed forms breathe the alien spirit of a distant past. Our rooms, homes, buildings, towns, and cities have become the innocent victims of miscellaneous styles, accumulated from the abundant remnants of earlier epochs. Our art-experts and educators have been stressing the supremacy of these styles, and the sacredness of traditions. Our aims and ambitions have been lulled into servile acceptance of all this historic stuff, already obsolete for contemporary use long ago. And the most conspicuous trait of the prevailing form has been imitation: imitation of styles, imitation of materials, imitation of nature, imitation all the way along, whatever the media. And so, the spirit of imitation has permeated almost every field of visual art. In the face of all this, one must really wonder what the judgment of the future is going to be.

1

Well, what would our judgment of the Greek era be, if that era had bluntly adopted the Egyptian form for the mere **lack of ambition** to create one of its own? Wouldn't the Greek deeds have faded, long ago, like a hollow echo into boundless space?

Alas, just this **lack of ambition** has been significant in our case already for generations. And if things were to continue in this complacent manner, future generations certainly would have little reason for being proud of their forefathers.

Fortunately, however, there have been, and are, many signs that herald a new era, for an awakening to a more sincere understanding of form is already widespread. Our eyes have been opened to realize the long-persistent poverty of our form, and an intense search for forms to come is now under way. Many are engaged in this search, although viewpoints and methods vary. Some are surveying the whole field in an attempt to find the logical course between rational and emotional discretions. Some are reasoning on the firm ground of scientific experience. Some are utterly technical in trying to further form-mechanization. Some are passionately imposing home-made philosophies and arbitrary doctrines. Others are bold and impulsive in using radical and novel means. Others again are loud in trying novelties for the mere sake of novelties. Still others are searching sincerely in silence.

To approach the subject in such a manifold manner is sensible: since it were unwise for all to search along the same path. Yet all should work together toward a common goal, and all should endeavor for the truest expression of the best of life. For, indeed, **what good is there in the search for form, unless this search is sincere and honest.**

Beyond question, this search for form is of great cultural significance. Everyone engaged in this search, therefore, should accept this fact as his leading motto. Everyone should realize that he himself—if sincere and honest—is instrumental in moving the search for form in a positive direction. And everyone should realize that he himself—if insincere and dishonest—is instrumental in moving the

search for form in a negative direction. The truth of this must be much more strongly felt, particularly at the present time when all of humanity has just been involved in a serious agony of catastrophic dimensions and there is still much uncertainty in prospect. But whatever is in prospect, one thing is certain: there are bound to happen many adjustments before a social equilibrium can be secured on the basis of a new social order. During all these adjustments, life must progress—with its ups and downs. And parallel with this progress of life, form also must progress—with its ups and downs too, perhaps. It then would seem that in this oscillation of circumstances, it were difficult to maintain a clear understanding of form and of the direction of its course. We grant this. But, on the other hand, it is utterly important always to remember that whatever the circumstances and the course of form-development, **the fundamentals of form are just the same, all the time, unchangeable and firm.** And on the basis of these fundamentals, there must be much of straightforward thinking, much of straightforward sensing, and much of sincerity of mind.

So it must be.

So it always has been when form was strong. History testifies the truth of this. For, while in the course of thousands of years of man's civilization there has been many a war fought, won, or lost, nevertheless, during these struggles much that is strong has been created in the field of art. The moral then is, that the reasons for strength and weakness of form cannot be found in the turmoil of life, but in man himself.

That is:

Form is something which is in man, which grows when man grows, and which declines when man declines.

With this definition of form we have arrived at the core of all the problems of form. And our first question must be:

Which are the basic reasons for a strong or weak form?

This question, however—in its directness and simplicity —embraces a great number of equally vital questions. All

these questions must in the course of our analysis be satisfactorily answered, and to this end they all must be grouped into a logical and unified system in accordance with their respective natures and significances.

Exactly this has been our approach to the following "Search for Form." Having thus organized the problems involved, we have arrived at a three-partite division of the material of search. And, accordingly we are going to conduct the search, as follows:

The first part—PART ONE—is going to deal with a general analysis of form as to its origin, meaning, nature, import, and scope.

The second part—PART TWO—is going to deal with an inclusive analysis of those principles which are from time immemorial and which must constitute the basis for all form-development.

The third part—PART THREE—is going to deal with a series of separate analyses of some of those phases of form-development which are necessary to understand in order to understand the problems of form in general.

And finally, the EPILOGUE is going to deal with man's part in the development of form; as to how man has learned to understand the fundamental principles of form, how he has followed these principles in his work and, how he has educated others to understand and appreciate these principles.

The plant grows from its seed.

The characteristics of its form lie concealed in the potential power of the seed. The soil gives it strength to grow. And outer influences decide its shape in the environment.

Art is like the plant.

The quality of art lies concealed in the potential power of the people. The aim of the age is the soil that gives it vitality. And outer influences decide its fitness in its environment

To understand life, and to conceive form to express this life, is the great art of man.

PART ONE

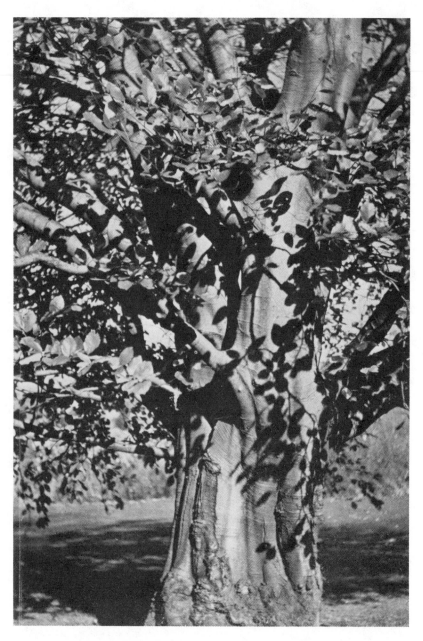

PLATE 2. ART OF NATURE: THE "TREE"

"The smooth silver gray bark of the American
beech looks finer with sun-projected leaf
shadows than with carved initials."

Rutherford Platt

PART ONE

THE first chapter of PART ONE—**Introductory Analysis**—deals with form in general as to its origin, meaning, nature, import, and scope. In order to proceed on a firm basis, there is first undertaken an analysis of nature's form-manifestations so as to obtain understanding of comparable form-manifestations in human art.

As for human art, three different stages of form-development are introduced, each one of them, respectively, with its own significative characteristics. These three stages are:

The Subconscious Stage,

The Conscious Stage, and

The Self-conscious Stage.

The closing point in this chapter deals with the scope within which human art must be understood.

* * *

The second chapter of PART ONE—**Retrospective Analysis**—is a historic survey of the development of visual art in all of its various fields, beginning from the time of the Renaissance, and ending with the present time. This survey is divided into two sub-chapters: "Pre-nineteen-hundred," and "Post-nineteen-hundred."

* * *

The closing chapter of PART ONE—**Prospective Analysis**—deals with the present world-situation—mechanized, and socio-political—so as to permit speculation about what the prospects of form-development are going to be. The answer is that, whatever may be in prospect, the only safe road to follow is the road of fundamental principles.

* * *

I. INTRODUCTORY ANALYSIS

BEFORE one is able to discuss a certain subject intelligently, its fundamental nature must be made clear. Accordingly, as we are now about to analyze "**Form**," we must first undertake an introductory examination of this subject, so that during the course of our analysis, as we view the various phases of form-manifestation, we have already, so to speak, built up a general platform from which to view these various phases.

Now then, what is form? Which are its primary characteristics? Is form an intelligible product of outer shape, apparent to the outer eye only? Or is there a deeper meaning infused into form from sources beyond man's apprehension?

Or, to put it thus: **is art soulless; or does it have a soul?** The answer is obvious.

However, because there exists an abundance of forms that are destitute of meaning and yet are regarded as forms of art—nay, in many circles as forms of art of the highest excellence—we might just as well at the very outset eliminate from our analysis those cases where form has its origin —soullessly and superficially—from other sources than those that can produce truly genuine art.

Such an elimination is highly important, we think. First, because it offers a clear field in which to work. And secondly, because it simplifies our task.

Considering the soulless and superficial form, there are particularly three phases where an attitude of too complacent an acceptance of form has been manifest. In these three cases form is either "superficially decorative," "realistically imitative," or "dryly practical." Let's then ransack these three phases, separately.

First: we have the superficially decorative form.

By "superficially decorative form" we mean exactly what we meant at the beginning of our Preamble when stating that "our rooms, homes, buildings, towns and cities have become the innocent victims of miscellaneous styles, accumulated from the abundant remnants of earlier epochs." This is a state of things which undoubtedly was a historic inevitability—for reasons to be explained later on. At this moment, however, we shall confine ourselves to mentioning the well-known fact that the Western World of the nineteenth century witnessed an orgy consisting of the most indiscriminate ornamental deluge of style "revivals," "rebirths," and other subtle-sounding appellations of form-adoption. On the whole, these adopted styles were derived from Classical Antiquity and from the Romanesque and Gothic form-orders of the Middle Ages. In their original concepts—when they were still indigenous—these form-orders, respectively, possessed an intrinsic creative essence of the same spiritual family that was intrinsically alive in those forms of civilization they represented. But after having been separated from their own genuine soils, and having been—millenniums and centuries later—arbitrarily and rootlessly transplanted into entirely strange life conditions, the intrinsic essences of these styles were bound to evaporate, leaving behind only an empty, vapid, and sterile encrustation of superficial decoration. This empty, vapid, and sterile ornament has since then been used and over-used, always and everywhere. And under the influence of this superficial decoration, generations after generations have been compelled to dwell and to breathe of its atmosphere.

And because this influence—from the point of view of genuine art—has been utterly depraving, naturally this superficially decorative form cannot be taken into consideration in a sincere search for form.

Second: we have the realistically imitative form.

By "realistically imitative form" we mean cases where clever reproduction by means of style, color, plastic media, or otherwise brings about an exact replica, image, or picture

of something already existing, without infusing creative quality—creative essence—into the product. Thus the use of media, as such, is often understood to be creation of art, regardless of whether or not one has something to impart by using these media. Surely, the mere using of media is not synonymous with creative accomplishment. For example, some are able to master several languages, yet they might have nothing to say; anyone can put rhythm and rhyme into stanzas, but this, as such, is not necessarily poetry; a good musical memory is not synonymous with musical creation; and the ability to draw, in itself, is as far from creation of art as is the ability to write from creation of literature. Thus, the use of media must not be confused with creation.

Yet, it often is. A skilful handling of brush and color, as such, is by many considered artistic talent; and when the faculty of spiritual creation does not follow this talent, the ability of slavish reproduction is raised to the rank of creation. The more skill, cleverness, and excellence one exhibits by reproducing with perfect correctness the outer appearance of a face or a landscape, the greater the artist he is supposed to be. It is not realized that perfect correctness is an easy thing to achieve and that this by itself is deceiving, inasmuch as the most perfect correctness is nothing more than the most realistic imitation. And, for sure, imitation kills the germ of creation. The practice of art by directly and intentionally copying nature, leads as much to imitative shallowness, as the direct and intentional copying of Greek architecture led to imitative shallowness—and, really, to a state of things which has been, and in many quarters still seems to be, pretty hard to overcome.

Why should art be directly imitative! The composer does not make a correct record of what he hears with his ears. The poet does not make a correct record of what he sees with his eyes. They both must observe with their inner senses. And with their inner instincts they must transpose their observations into form.

The same must hold good in any case, whatever the medium may be. Again, if this does not hold good, and the form produced is mere realistic imitation, naturally then,

the realistically imitative form cannot be taken into consideration in a sincere search for form.

Third: we have the dryly practical form.

By "dryly practical form" we mean cases where the matter-of-fact understanding of form is brought into the foreground. Form is considered a mere material thing for its practical purpose, where the commonly used slogan "form follows function" is understood to mean that form follows its *practical* functioning only. In other words: it is maintained that if form is functional, it is bound to be already beautiful for this sole reason. This is no valid statement, however. Take, for example, two pitchers both executed in the same material, both utterly simple and perfectly functional. Yet one of these might have no more art-value than to be thrown away at once, whereas the other might find its way to an exclusive museum as a precious object of art.

By no means does the above suggest that the functional quality of form is of no essential consequence. On the contrary, the functional quality of form is not only essential, but even indispensable. Yet, the quality of "function" must not mean *practical* function only. It must also mean *spiritual* function. Surely, a letter or a word in a stanza has not only its practical function of making the stanza understandable, but also its spiritual function of forming rhythm and rhyme into poetry. And surely a hammer or a knife, although shaped for hitting or cutting, must also be shaped in good form and proportion. And form and proportion constitute spiritual values. Consequently, when we speak about "form follows function," we are inclined to accept the slogan only in as broad a sense as above indicated; namely, that form must satisfy those functional requirements that originated its reason for being—both physical and spiritual. Only in such a sense can form be significative as an art-form.

If this is not the case, and the form is just "dryly practical," this kind of dryly practical form cannot be taken into consideration in a sincere search for form.

Generally speaking, these are the three phases of form-

14

appearance where the attitude of too complacent an acceptance of form has been manifest. In fact, none of these three phases has come into being through such a creative sensibility as could have infused that indispensable quality of creation into form. These three phases are the offspring of self-contentment and therefore they are lacking in that spirit of search which keeps form-development vital, and art strong. For this reason these three phases of form-appearance have no positive avail in the progress of culture. Rather, they constitute a dead-weight which must be dragged along, thus obstructing a constructive course of things.

In order to bring more validity into the aforesaid, let's try a synthesis of the matter in the light of history of art. History of art tells us—and so we were told at the beginning of our Preamble—that "the thoughts, feelings and aims of our forebears speak to us their silent tongue, **through form.**" This means that there must be a close relationship between a certain epoch of civilization and the mode in which this epoch of civilization comes into expression in form. Consequently then, this said epoch on the one hand, and its form-expression on the other, must reflect one another even in quality. Now, suppose that the quality of form-expression during a certain epoch of civilization were a mere decorative, imitative, or practical matter, lacking in any spiritual qualities whatsoever; naturally then, we might assume that the corresponding epoch of civilization would have been a decorative, imitative, or practical matter, lacking in any spiritual qualities whatsoever—which latter thought, by its very nature, is sheer absurdity. Of course, even the most inveterate champion of the "superficially decorative," the "realistically imitative," or the "dryly practical" must admit that form-expression of any epoch of civilization must have spiritual qualities of its own. But— says he, perhaps—this does not as yet mean that form-development throughout—even considering its most minute appearances—should be similarly qualified. Assuming now that such a point of view is granted: at what stage down the ladder are the spiritual qualities of form then supposed to cease? Isn't it to be supposed that every cell in a healthy

organism is vital. Surely. And if by chance there were sterile cells, unable to assist in the general growth of that organism, wouldn't they rather obstruct this growth? Undoubtedly. Now then, as to human cultural growth and its "cell-world" of forms, the same must be obvious—which makes it clear that any form-appearance lacking in spiritual qualities has no vitality insofar as human culture is concerned. Such form-appearance indicates cultural indifference and, therefore, it is apt rather to foster materialistic civilization. This again is beside our point, for we are not interested in that part of civilization which has coldly materialistic leanings. We are interested in that part of civilization which produces art and cultural values in general. In other words, in the search for form, our endeavor must be to analyze form-problems only as they appear in the progress of human culture.

Accordingly, in the whole course of the following analysis, any "cell" in the cultural "cell-pattern" is going to be considered from the viewpoint of its spiritual significance—that is, from the viewpoint of that meaning infused into form at its very inception.

Now, as for this meaning of form, how deep is one able to trace its existence? In other words, does one detect from the vein-pattern of an elm-leaf the elm's ambitions and aims —somewhat in the same sense as, for example, the fortune-teller is supposed to discern in one's palm when and how one is going to be married? Probably not. But from the formation of the human face one easily can read whether the mind behind this face is honestly modest or boastfully self-conscious. And things produced by human hand easily betray whether the work was done with modest sincerity and joy or only as a proud exhibition of cleverness. A musical composition is the truest proof of the composer's depth of thought and disposition of mind. The material treatment of the building reveals whether the architect is an artist at heart, or just a dry technician. The basket pattern of Western Indian make unveils the soul of the race. The Hungarian peasant's embroidery indicates the characteristics of

his nation. So does genuine folk-art in general. The same is true with regard to the great Civilizations: a few brush strokes of the Chinese artist signify Chinese mentality just as clearly as the delicate execution of the hieroglyphics reveals Egyptian aspiration.

In this manner one could go on, endlessly, disclosing the spiritual nature of material form.

Form, then, is not mute. Far from so, for form conveys its inner meaning with finer vibration and deeper expressiveness than can the spoken tongue. Even the practical form is not mute, as can be told by the practical chair itself. Surely, in the case of the chair, the expression "form follows function" has meaning, for here both form and function have much to do with the human body. Form must follow this human body, no matter whether the chair be found in the pompous palace of Roman Antiquity, or in the humble dwelling of the remote hamlet of today. It then would seem that the problem of the chair is pretty much limited to the practical requirements arising from the conveniences of the human body. And as the human body, relatively speaking, always is the same as to shape and size, then—so one would think—even the chair is bound to be always more or less the same as to shape and size. And yet, throughout its history the chair has had much significative meaning infused into its forms. Take at random one of these out of millions, and you can trace its origin—when genuine—as to time, race, and country. It can tell its story just as plainly and clearly as can the great temples and palaces. This is perfectly as it should be, for even minor objects should do it— and must—when form is genuine and true. Form must be born in closest contact with the intimacy of life. There the significative meaning of life is felt, there this meaning is transfused into form and, therefore, just there form can be most truly felt. If form—even the most minute, and just it—is not felt in the intimacy of life, form is bound to be superficial and lacking in meaning; it is bound to be independent of the characteristics of life; it is bound to be a strange form imposed upon life from without.

Certainly form must have meaning. **To abnegate this**

1 7

is just the same as to abnegate the meaning of life itself.

Meaning of form comes into expression differently in different instances. Sometimes this expression is strong. Sometimes, again, this expression is vague. This relativity of expression depends on the instinctive potencies of the creator of form.

From which sources these instinctive potencies originate is the sacred secret of life, of mankind, and of all creation. One might be able to penetrate to some extent into the mystery of this secret, but one cannot enter its deepest chambers—**just as one cannot enter the deepest chambers of that mystery of life, whether physical or spiritual.**

Yet, we must go as far as we possibly can. We must endeavor to analyze form from all its various phases: from those phases that are fundamental; from those phases that human intellect can understand; from those phases that can be explained through instinctive experiences; and to a certain degree even from those phases that are, and probably always will remain, closed to man. Along these various phases of possible disclosures we must steer our search for form.

However, before we can proceed in this search, we must first go to the origin of form—**to nature**—in order to gain advice which is from time immemorial. It is inconceivable that a truly complete understanding of form can be had unless one goes to those primeval sources where the concept of form was born.

1. NATURE, SOURCE OF FORM

Man is part of nature and therefore it is unquestionably obvious that the quintessence of those laws and underlying thoughts which are inherent in nature must constitute the quintessence even of those laws and underlying thoughts which are inherent in man. At the beginning of man's existence—when primitive—man was close to nature. Whatever he attempted to achieve was instinctively genuine and in full accord with the laws of nature. Such was continu-

ously the case even when man had gradually progressed to a higher level of development during the great Civilizations. Man still sensed intuitively the laws of nature, and his form was indigenous and expressive. Thus was the situation as long as man was **creative.** Later on, when man lost his spiritual communication with nature, he lost also much of that guidance nature could offer and, consequently, his instinctive sensitiveness lost much of its sharpness. In such a case man was compelled to lean on his reasoning, and he became self-conscious in believing that he could produce art with his intellect alone. And so, as time passed, he built for himself an ivory-tower of self-made doctrines, formulas, and esthetic theories. No wonder then that his form became doctrinal and lacking in vitality. Much of it was bound to become superficially decorative, realistically imitative, or dryly practical.

Having lost his spiritual communication with nature, man became gradually blind to nature's laws. Eventually he could not see them. He did not even recognize them. In some instances of shallow art-understanding, man became conceited enough to recognize these laws—say, the laws of beauty—nowhere else than in man's art. In order to defend this conceited opinion, he was eager to claim that "nature's beauty" is a point of view which never has been accepted in civilized circumstances, and never will. Thus, some of the nineteenth century esthetes maintained that Greek Antiquity, for example, was not conscious of "nature's beauty" and they furthermore maintained that in man's consciousness "nature's beauty" is a point of view which is relatively recent. This attitude of these nineteenth century esthetes, surely, testifies that they were blind, not only to nature's form-values but also in many other respects. If these esthetes had kept their eyes open, they might have discovered that the Greeks had a keen sense for nature's form-values, for when the Greeks designed their building layouts they carefully considered the surrounding landscape so as to create harmony between nature's forms and the forms of man. If these esthetes had kept their eyes open, they might have discovered that the mediaeval town-builder did much

the same in an excellent manner. Furthermore, they might have discovered that even their own time—save for those in the ivory-tower—was fully aware of all the form-treasures that nature bestows upon man. And, last but not least, they might have discovered that much of their own beloved art—that very "Art of Beauty"—had reached a status of sterile imitation, which in the last analysis is the antithesis of beauty.

Nay, nature's laws—the laws of "beauty," if you will—are fundamental, and cannot be shaken by mere esthetic conceitedness. These laws might not be always consciously apprehended, but sub-consciously one is always under their influence. Moreover, these laws as they appear in nature's form-world have been greatly amplified, insofar as man's consciousness of their existence is concerned. Because the microscope and the telescope have opened new vistas into both the microscopic and macroscopic realms, the seeing and sensing man of today has enriched his understanding of nature's laws—**the laws of "organic order"**—to a heretofore unforeseen degree. And **behind these laws, the sensing and seeing man discerns the pulsing rhythm of eternal life.**

Look at the flowers in your garden. For sure, they are not sterile paper-flowers, for in one way or another they have established their contacts with the outer world. They are the receiving-stations of enlivening messages from cosmic spaces and ethereal altitudes, from the sun and from many other places. In fact, even the tiniest of these blooms receives its inspiration from these celestial heights for its physical life—and, who knows, for its "spiritual" life as well. At the same time even the tiniest of these blooms is a broadcasting-station which transforms and sends enlivening messages—by emanating its "aura."

But, to what extent are these flowers in your garden conscious of their contacts with the outer world? Do they know, for example, that tender human hands take care of them? Are they after all conscious that man exists or, for that matter, are they conscious of one another's existence? In other words, is the flower next to another flower subcon-

sciously aware of its neighbors' existence—and if so, in what manner and to what extent? Moreover, do the various plants of the same species in the grove have herd-instinct in the same sense as do the insects and birds flying in flocks about the same grove—and if so, in what manner and to what extent? And—speaking now about nature's form-manifestations, collectively—does that spectacularly jubilant morning-glow of the rising sun inspire nature's floral audience—and faunal as well—in the same sense as the human audience is inspired when listening to the rhythms and harmonies of Haendel's "Messiah"?

Where is the answer to these questions?

Is science in a position to furnish the answer? Not conclusively, by any means. True enough, the scientist has penetrated pretty deeply into the organic construction of plants, and he has discovered many a method of breeding new and perhaps more striking varieties—and yet, how deep has he been able to go into the "spiritual" faculties of these plants? The botanist, having made an inclusive survey of his field, has had the broad form-world of plants to work with. So to speak, his work has been a comprehensive investigation pertaining to form; and through form he has arrived at his conclusions concerning plant life. Of course, his efforts have been concentrated primarily on a purely scientific research, although for our part we are inclined to suspect that in this research—in numerous cases, at least—a subconscious sensing of "plant-mentality," if we may say so, has been the inspiring yet perhaps unnoticed undercurrent. Linnaeus, foremost of the botanists, surely knew all the plants of the world—including the most glorious ones—yet he found his pet-plant hidden in the moss where the shadows of the Northern forest lie deep. It is that little "Linnea Borealis"—named after the great scientist himself—which modestly bows its tiny head, like a shy girl. Now, was Linnaeus so wholeheartedly attached to this little plant because of its modest charm?

He probably was.

Well, we are inclined to feel much the same—notwith-

standing the fact that plant life and human life do not vi-
brate on the same plane. Because of the difference of
planes, it is difficult to distinguish to what degree the seem-
ingly analogous appearances are comparable, and so, let's
ask: how is Linnaeus' impression of the Linnea's modesty
comparable with the flower's modest guise; and does this
modest guise after all indicate a feeling of modesty in the
flower?

One wonders!

Surely, there are quite a number of things to be won-
dered at. And herewith we leave the scientist to wonder, too.

Philosophical thinking has essayed much along this
same line. Already Plotinos in his time—and perhaps many
others prior to him—assumed some kind of subconsciousness
in floral existence. For example, he imagined that there
might exist a feeling of happiness in plant life—just as is
the case with both human and animal life—"for," said Plo-
tinos about plants, "they also live, their life also has a pur-
pose, by which they seek to fulfill their development."
Empiric and experimental philosophy tends somewhat
toward a similar line of thought—particularly since Darwin's
theory of evolution has become more generally recognized—
although wariness of becoming involved into too much
emotional speculation, we take it, has kept the thinkers from
drawing hasty conclusions without philosophically valid
foundation.

The poet is less cautious. And so we have Maeterlinck's
captivating essay—"L'Intelligence des Fleurs"—in which he
has undertaken an inclusive study of plant-ingenuity—
through which plants are able to adapt, change, and improve
their design methods so as to preserve and develop the spe-
cies in the constant fight for existence. Through this study,
Maeterlinck has arrived at the assumption that plants are
capable of "methodical thinking," so to speak.

However, in this keen research and speculation by dif-
ferent minds and different inclinations—whether scientists,
philosophers, poets, or other seekers—and whatever the
viewpoints—all these must agree that in the growth of

plants, of animals, and of everything that lives under this sun, there are certain forces in constant action—enigmatic ones, if you will. And all these scientists, philosophers, poets, and others must agree that these certain or similar forces were already in action millions of years before man came into existence, and that these same or similar forces will continue to be in action for more millions of years after man has destroyed himself by means of intrigues, politics, warfare, and that ever growing craving for money. It then is more than obvious that this globe was not created for the purpose of man only, with his faculties of thinking, of feeling, and all the rest. This globe was created for all that lives here, that has lived here for millions of years, and that will continue to live here for more millions of years to come.

And, surely, how could all this long-livedness have been and continue to be maintained, unless there has prevailed and always will prevail at least some kind of subconsciousness of this life, and unless there has prevailed and always will prevail at least some kind of reciprocal incentive so as to strengthen this life. To abnegate such a thought is to suggest perpetually soulless life—"dead life." Indeed, it is to suggest an absurd state of things.

Now, if such is the case, why try to find out what is what through analytic examination of minute matters— physical, chemical, biological, and what have we—or through philosophical acceptance of only such facts as man can support by the direct testimony of his limited instruments of apprehension! Why not, instead, approach the matter in synthetic spirit by drawing logical conclusions on a broad basis, covering even those fields where man's apprehension falls short? And doesn't a logical conclusion suggest that in the magnificent creation of the Great Designer—permeating all the spaces and directing all the lives—it is inconceivable that just this beloved globe of ours should have been so unkindly treated as to make life unfelt by this very life itself? Surely, such a thought is inconceivable. Such a thought would constitute—we feel—a distinct profanation, not only of that mysteriously sacred realm which we have

come to call "the secrets of life," but even of the "primus motor" of these secrets.

These secrets—insofar as man is concerned—will always belong to that realm of "the unknown." And so they must. For as long as they remain "secret," they will remain "sacred."

Also, when it comes to the final test as to How and Why, man's knowledge and thought then are, and always will remain, miniature manifestations of knowledge and thought.

And man must bow his head—humbly.

After all, whence do we get what knowledge and thought we are able to master?

In order to answer this question, one must always bear in mind the basic fact that man has his instruments of apprehension, both physical and mental. Through these instruments of apprehension, man is able to see, to hear, to taste, to smell, to feel, to know, to understand, to think, to sense—mentally, intuitively, instinctively, and imaginatively—and to be influenced by what he sees, hears, et cetera.

But behold: only through these.

Through these instruments of apprehension, man is able to do his work, both physical and spiritual, and by means of this work exert influence upon others.

But behold: only through these.

These instruments of apprehension are man's opportunities. But behold: they are also man's limitations. And these instruments of apprehension even effect the changes in man's opportunities and limitations. For the sharper man's intellectual reasoning becomes, the less sharp is his intuitive and instinctive sensitiveness bound to grow. That is: the more man reasons, the less chance have his senses to conduct his actions. This is a fact. And because of this fact, much of man's intuitive and instinctive sensitiveness has been lost during the long journey of his gradual development from a primitive man to a civilized one.

However, in all this discussion of man's apprehensive faculties of one kind or another, it is important to mention particularly those faculties which are most essential in the

search for form. First, there is the faculty of man's **intuition** to establish immediate contact with primary facts and truths. Second, there is the faculty of man's **instinct** to record vibrations of life and to transmute these vibrations into corresponding form. And third, there is the faculty of man's **imagination** to produce mental ideas and pictures that have no relationship to previous concept, knowledge, or experience. These three faculties of apprehension are the most precious gifts bestowed upon man. For indeed, without these gifts there could not exist human art, nor could there exist human culture.

Such are the instruments of apprehension through which man gets the knowledge and thought he is able to master. Through these—and only through these—man is able to penetrate into the mysteries of nature, and as time passes he probably will gain increasing knowledge about these mysteries.

Increasing **knowledge** about these mysteries, however, is not the essential thing in the search for form.

Increasing sensitiveness to these mysteries by means of intuition, instinct, and imagination, is the essential thing in the search for form. Again, to be able to increase our sensitiveness in this respect, we must, as said, go down to the source of all things so as to learn to feel the meaning of form. In other words, rather than to have merely scientific knowledge of all the facts, we must strengthen our instinctive communication with nature so as to learn **to feel her.**

Once we have learned this, we can see all of creation in a noble and fertile light. And the wealth of nature's beauty will belong to ourselves. This is true, no matter where we turn our eyes: to the microscope revealing the pattern of cell-structure or to the telescope bringing celestial worlds closer to man; to the tiniest plants in the shadow of the forest or to the loftiest trees rising toward the sky; to the stones washed by the waves on the beach or to the glittering movement of the waves themselves; to the birds flying high over our heads or to life in the oceanic depths. No matter where our eyes may dwell, they always meet the work of the

Great Designer with its ever pulsing freshness of form. They see the unlimited abundance of imagination—always new, always captivating, always full of life, rhythm, and beauty— and frequently cheery humor.

And upon examining the matter closely, an essential point will be clear: one soon will learn that nature's form-richness is established through a certain significative "order," different in each different case, and expressive of the meaning behind form.

Furthermore:

Let's stand on the hill and look at the landscape beneath our eyes. We see fields surrounded by woodlands and groves. We discern groups of trees and bushes bordering lakes and reflecting their verdant masses into the watery mirrors. Our eyes follow the rhythmic outline of hills and forests against the sky, the playful contours of the meadow, the plastic display of light and shadow. We observe flowers spreading color, animals and birds bringing in movement and life. We perceive the picture as a whole. We perceive the details of the picture, each in good correlation to the others and to the whole. We understand that the beauty of the landscape's details is not sufficient to make the landscape beautiful, unless there exists a proper correlation between these details so as to keep things together and to make of the whole an integrated picture of correlated order. We realize that just this **correlated order** makes the landscape so harmoniously appealing to the eye. And we realize still more: we realize the important fact that a lack of this correlated order would inevitably plunge the whole landscape into chaos.

Here we also have two distinct trends in nature's form-shaping. First, we have the trend toward **"expressive order."** And second, we have the trend toward **"correlative order."** Now, by further study of these two trends, we soon can learn that they both prevail always and everywhere, where order is maintained and nature is healthy. Moreover, we soon can learn that these two trends act always and everywhere, together and in mutual co-operation, in the maintaining of order and healthy conditions. In fact, these two

trends are twin-principles, and as such they are the daughter-principles of the universal principle of **organic order—the fundamental principle of architecture in all of creation.**

On this fundamental principle of architecture—of organic order—all nature's form-shaping is based. In cases where this principle is in command and organic order prevails, nature is healthy: it is "art of nature." Again, in cases where this principle is not in command and organic order consequently is bound to disintegrate, nature is unhealthy: it ceases to be "art of nature."

As we see, **in nature, art is synonymous with health and lack of art is synonymous with unhealth.**

Fundamentally, the same must hold even in man's affairs, and this we tried to emphasize when stating that "man is part of nature and therefore it is unquestionably obvious that the quintessence of those laws and underlying thoughts which are inherent in nature must constitute the quintessence even of those laws and underlying thoughts which are inherent in man."

"Art of nature" and "art of man" thus are closely interrelated.

Dürer gives the gist of this issue by stating that: **"art is inherent in nature; those who can get it therefrom, they have it."**

Therefore, in the course of the following analysis of the search for form in man's art, we are going—ever and anon—to return to Mother Nature for advice. This we are going to do particularly in those circumstances where we have become confused and cannot find our way out.

A parallel from nature, then, is enlightening.

2. ART OF MAN

Let's now shift our attention from nature's art to human art, and, to start with, let's try a survey—general but concise—of the development of human art, beginning from its most primitive cradle and continuing all along the line up to the very day of the present time. By doing so, we can discern in this development three distinctly different stages:

the "subconscious" stage; the "conscious" stage; and the "self-conscious" stage.

This three-partite concept of art development is by no means an orthodox one and therefore many a learned art-scholar might easily raise criticism as to the merit of our mode of reasoning. But as we are not learned art-scholars ourselves, but only ordinary workmen in the verdant vineyard of art, we feel free to go our own way and we are going to do it as follows:

The "Subconscious" stage represents that stage of art-development where primitive man, because of an inner drift, acted subconsciously in accordance with the laws of nature and produced unintentionally genuine art—because of an inherent gift.

The "Conscious" stage represents that stage of art-development where advanced man, consciously aware of the important place of art in human society and subconsciously sensing the fundamental laws of art, produced—and produces—indigenous art of such quality as is of constructive avail in the evolution of human culture.

The "Self-conscious" stage represents that stage of art-development where civilized man, because of esthetic speculation, dogmatic doctrines, or otherwise, has closed the instinctive channels of creation and has produced art that is "fine," but rootless.

In the course of history of art, generally speaking, these three stages have sprung in a logical sequence from one another, mirroring in each case its respective character, strength, and weakness. And they have produced, respectively, "primitive art," "cultural art," and "fine art."

These three stages have been decidedly momentous in the development of art and therefore we wish to delve at some length into each one of them.

a. The Subconscious Stage

In order to trace the roots of art in the realm of man, let's return for a short second to the realm of nature so as to get a clear comparison. By approaching the problem in this

comparative mode we can soon discover basic similarities between these realms. The first similarity that we can discover is the fact that precisely as nature uses media such as form, color, flavor, movement, and sound in order to stir up impression, so also man—considering now the primitive man—used these same media for the same purpose. And as these media are just the same as are used in human art in general, we then are able to discuss the problems of both "art of nature" and "art of man" on a common plane.

Now, we know that flowers—by means of form, color, and flavor—attract insects. We know also that the male bird is provided with a colorful make-up so as to impress the female and that he, for the same purpose of impression, performs his fervent love and war dances. The songbird on his part, uses his own medium of sound when calling for the far-away partner.

Thus, form, color, flavor, movement, and sound constitute the media—art media—which in nature are **"creatively in action"** in order to cause **"appreciative reaction."**

These actions and reactions in nature can at times be brought into highly dramatic performances. Those having attended the love and war dances of the northern cock-of-the-woods, for example, as the writer of this has attended—by chance, of course, and at a distance—can witness this.

While the female birds keep themselves hidden among trees and bushes, the males perform their fervent love and war dances in some open space, usually adjacent to water. While dancing, they sing a peculiar sounding song, which, when many join in, makes the surrounding atmosphere undulate with a monotonously melodious, soft, and sombre "tremolo." Into this soft and sombre tremolo, the northern nightingale, from the lofty darkness of the pine-wood, mingles its vibrant "coloratura." Midst the poetry-imbued silver-pale northern night, this chorus of the winged singers creates a penetrating feeling of something inexplicable and indefinable—say, a message from a long forgotten far-away dreamland or perhaps a low-lamenting elegy from the deepest depths of all things. Indeed, a strange sentiment of

melancholy overpowers one's whole being—and one understands what Lafcadio Hearn meant by declaring that such sentiments of melancholy are caused because man feels the loss of something essential in his existence—the loss of his originally so intimate contact with Mother Nature—"Paradise Lost."

Now, this dramatic performance of the winged singers is only one example of myriads of manifestations which permeate all of life—for all of life must constantly "act" and "react" so as to preserve life and make it fertile. This is a fact. And if man is not always able to follow all the performances of action and reaction that happen all the time and everywhere, nevertheless they are there. In the floral and faunal realms these actions and reactions are clearly evident, for, as said, they happen through form, color, flavor, movement, and sound—that is to say, through just the same "art-media" man is using himself.

However, nature's art is not intentionally "art." It is only an omnipresent undercurrent to the same effect.

Nor was the primitive man's art, intentionally "art."

As in the floral and faunal realms in nature "action" and "reaction" are essential to preserve life and make it fertile, so was the case even with the primtive man.

Clothed in fur, feathers, and colorful trinkets, the primitive child of nature performed his love and war dances and sang his love and war songs; by these means he tried to attract his females, and frighten his enemies; and by these means he created an atmosphere and a sentiment of his own. He "acted" so as to cause "reaction," and he did this by means of those oft-repeated art-media—form, color, flavor, movement, and sound. And by doing so he expressed himself **subconsciously** through a peculiar "rhythm and cadence" which had the fundamental characteristics of man, and of man only.

This was the advent of human art.

Meanwhile, the primitive man lived in constant fear. He felt much handicapped because nature had provided him with no adequate means of defense. By contrast, those

grim, bulky, and robust beasts which had their whereabouts all around his camps were provided with sharp claws, teeth, horns, and such like. Provided with such dreadful weapons, these beasts attacked the primitive man's camps, and they were steadily a threat to him and his breed. Living thus in constant fear, the primitive man had to be inventive: **he was compelled to develop his brain, hands, and fingers** to produce such weapons as could be helpful in that incessant fight for life. And his brain, hands, and fingers, really, produced these weapons.

In this manner the sharp edges of axes and knives were born.

Furthermore, the primitive man felt much handicapped because nature had provided him with no such swift limbs, legs and wings as she had supplied to those animals and birds that he had to pursue for his livelihood. Living thus in constant anxiety for his existence, the primitive man had to be inventive: **he was compelled to develop his brain, hands and fingers** to produce such implements as could move more swiftly than any of those animals and birds he had to catch for his food. And his brain, hands and fingers, really, produced these implements.

In this manner the slender forms of arrows and spears were born.

However, besides these strong and swift beasts and birds, the primitive man was surrounded by all kinds of spirits—invisible of course, but nevertheless present, he felt—which in one way or another were constantly harassing his peace of mind. These spirits were either malevolent or benevolent. In case they were malevolent, the primitive man had to try his utmost to satisfy them and, for the sake of his safety, maintain peace with them. Again, in case these spirits were benevolent, the primitive man had to try his utmost to make evident his gratitude so as to have these spirits continue with their benevolent attitude. Surely, in these trying times the primitive man had to be inventive: **he was compelled to develop his brain, hands, and fingers** to produce such things as were apt to impress all the spirits—good or evil—in a favorable way. In order to achieve this, the primitive man

had to keep himself busy forming stone and wood into symbolic images of these spirits; he had to erect altars on which to bring offerings to these spirits; he had to dance and sing his dances and songs of worship; he had to build drums and other musical instruments to beat cadence and rhythm to his dances and songs; and he had to do many other things to show his good will toward all the spirits—good or evil.

In this manner the images of gods, the tools of worship, the musical instruments, and a great number of various and varying things were born.

More than that:

In this manner the concept of "**work**" was born.

For while the primitive man was compelled to develop his brain, hands, and fingers so as to protect himself and his breed against the forces of nature—physical and spiritual— his brain, hands, and fingers, really grew in inventiveness and skill to originate and produce things. Elated at being able to originate and produce things, the primitive man became still more eager to originate and produce. He carved stone, he carved wood, he carved bone, he moulded clay into manifold forms for manifold purposes, he ground pigment for his color, he discovered metals, he learned to alloy metals and he learned to do many other things. During all these occupations of the primitive man, the concept of work was born—a concept which, as "Genesis" tells, was intended to be a grave condemnation but which instead, by virtue of its logic, has become the greatest blessing ever bestowed upon mankind.

And finally:

Once the primitive man learned to occupy himself with work, his art-form—due to a natural gift—derived subconsciously from this work. Subconsciously, we repeat, for as to its character and bias the primitive man's work was protective, religious, desirous, joyous, or whatever it might have been, but behold: **it was not intended to be artistic.** The oldest stone sculptures glorifying motherhood, the cave-paintings for bringing luck in hunting, the first attempts to produce rhythm in ornamental pattern, all these undertakings were not consciously intended to be artistic demonstrations. They

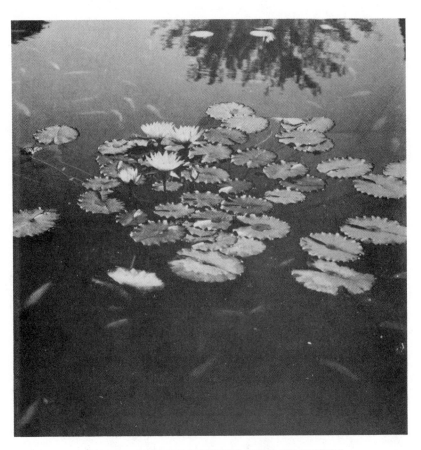

PLATE 3. ART OF NATURE: THE "FLOWER"
Waterlilies; with life both above and
below water.

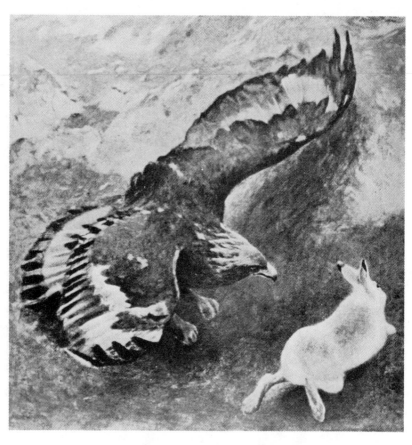

PLATE 4. ART OF NATURE: THE "BIRD"
Eagle hunting a rabbit: painting by
Bruno Liljefors

were **subconscious** drifts, expressing life, its desires, its hopes, its fears.

These drifts fostered **consciousness of work;** the spur to do things.

But **consciousness of art, thus far, was only in the making.**

Such, in general, was the subsconscious stage in the development of human art.

By the very nature of this development—as to its origin, as to the forces that brought it into being, and particularly as to its **subconsciousness,** it goes without saying that the primitive man's art was indigenous, direct, true, creative, and most expressive of the primitive man's life. In other words, the primitive man's art was founded on those principles which are and always must be the fundamental principles of true art. And because of this, the subconscious stage of human art-development has laid a strong foundation for all subsequent development in the field of art: for folk-art as well as for the art-forms of the great Civilizations.

b. The Conscious Stage

Someone—Ralph Waldo Emerson, we remember—once said something to the effect that the Greek creative vitality was not at its strongest when Greek art neared its perfection, but rather when the Greek soul emerged from its barbaric state—that is, from its "primitive" state—and **discovered the values of beauty.**

This is most significant.

For when—considering now things in general and not particularly the Greek case—the values of beauty—or, let's say, the values of art—became consciously felt, art then was indeed born as a **conscious manifestation:** to be sure, art was born as a **desire;** nay, as a **demand.** And eventually art became accepted as an imperative **necessity**—a necessity without which civilizations, in a cultural sense of the word, could not come into existence.

The primitive stage of art-development—the "Subconscious Stage"—was only a preparatory stage, where, as said, the fundamentals of art were instinctively sensed and where these fundamentals were laid down for all future art-development. The "Conscious Stage" of art-development, on the other hand, was marked by that intentionally creative force—consciously sensed, consciously desired, and consciously demanded—which brought art into growth.

Because of this growth, the field of art became broadened. The media of art-expression, consequently, became multiplied. And due to the fact that the faculty of employing these media was not evenly distributed among men, art became the profession of only a few. Hereby the caste of artists came into being. Although art activities thus became concentrated into certain hands, all phases of life were nevertheless represented, and art grew accordingly as an expression of this life. It grew from the essential characteristics of the people into a significative folk-art expressing these characteristics. It grew from the essential characteristics of folk-art, parallel with the development of a civilization, into a significative art-form—into a style-form representing the soul of that particular civilization. During these various steps of evolution, art was, and remained, true art; art was, and remained, the fertilizing impetus of the best in man; art was, and remained, the essence of man's noblest aspirations.

This phase of conscious art-development—the "Conscious Stage"—is overwhelmingly rich and comprehensive, and it embraces many different ages and races of man. Really, this conscious stage of art-development embraces all the gradual evolution of human civilization during the long course of many and momentous millenniums; it embraces all the various developments of folk-art at various times and at various places of the globe—of which developments a great number expired in their youth at the mere stage of folk-art, whereas others lived to become the foundations of great civilizations; it embraces, perhaps, many a great civilization which the ravages of time ages ago sank into non-existence, like another "Atlantis." Furthermore, this

conscious stage of art-development embraces many a civilization of which the explorer has dug out only a few remnants for posterity to wonder at; it embraces all those many and abundant civilizations which, like the kaleidoscopic performance, pass our eyes on the pages of that great book of history of human art; and finally, the conscious stage of art-development embraces all the sincere—note: **sincere**—endeavors of the present time in the development of an art-form of our own.

In this abundance of conscious art-development, one discerns many different ramifications of civilization. One discerns the Eastern branches, such as the Babylonian, Assyrian, Persian, Indian, and Chinese Civilizations. One discerns—in the Americas—the Pre-Columbian branches, such as the Civilizations of the Incas and the Mayas. And one discerns those branches which during a long course of development—and with great interruptions—have paved the way for what is generally understood as "Western Civilization." Within this long course of development we include, successively, the Egyptian Civilization, the Classical Antiquity, the Middle Ages, the Renaissances, et cetera.

It would be of little avail for our main purpose to go into a detailed study of all these ramifications of human civilization, for—no matter what might be their respective natures and characteristics, and however they might differ in these and many other respects—after all, their fundamentals are all alike. Therefore—and in order to make things simpler—we are going to confine ourselves to a short presentation of the characteristic traits of that long and often interrupted cultural development which ultimately, as indicated, brought about our "Western Civilization"; that is, the Egyptian Civilization, the Classical Antiquity, the Middle Ages, et cetera.

We have so much the more reason for being short and concise now, since during the course of our analysis we are often and again going to return to this same subject.

To proceed, then, first we have the Egyptian Civilization. Speaking about the Egyptian Civilization, it has been

said that "there does not exist 'development' or 'grades' of art—only a constant change of forms." This is to indicate that the Egyptian form was fully strong and mature at its beginnings and that, since those distant Egyptian days, art by no means grew stronger and more mature—"grade by grade," as one might think. Only the forms of expression changed so as to express the changing conditions of life. Therefore, when we speak about the Egyptian art-form as the earliest forerunner of our own art-form—as we really do in this analysis—we must speak about it with the same veneration with which one speaks about one's earliest ancestors, who, because of their bravery and recognized accomplishment, brought glory to one's lineage.

Through keen sensing of the characteristics of the age, the Egyptian art-form evolved into a consistent and expressive design-pattern of its own. It evolved into a refined and dignified style, and into a magnificent accomplishment in the history of mankind. The endeavor of the Egyptian was permanence and eternity, and really—entirely apart from the physical permanence of form as such—already the Egyptian form-development has lasted during a great number of millenniums—who actually knows how many?

Considering the fact that the earliest Egyptian form-achievements so far explored show a rather advanced ripeness of form, it can be stated with a great degree of certainty that there already must have been a considerably long form-evolution behind these achievements. With this in mind—and with hardly any need to stretch the imagination—we can surmise that perhaps the roots of the Egyptian form-evolution can be traced far back toward the paleolithic state of things when primitive man still tramped the Egyptian soil. Who knows? But, wherever lay the roots of the Egyptian form-evolution, life went on and things had to be done. And consequently, as this life became increasingly complex, the many things to be done grew increasingly manifold in both functional use and material treatment. During this time of ever-expanding activity, the fundamental characteristics of the Egyptian form were all along the line fully evident.

In this manner there developed a new and significant cultural cycle in the history of man.

Thus it was.

The Egyptian life—the very source of the Egyptian form—came into existence. In the progress of time this Egyptian life became transposed into a form-pattern of its own. And then, gradually, having fulfilled its long cycle in the history of man, the Egyptian life faded away. So faded away also the Egyptian form-pattern from the realm of living forms. It became history of art—never to be repeated again in the same pattern.

It was like the cumulus in the sky.

Cumuli appear. They become formed into characteristic form-patterns of their own. And then they fade—never again to appear in the same pattern.

In spite of this continual appearance and disappearance of living forms, the Egyptian form still stands strong and firm. It stands like a lighthouse on rocky ground. Already for thousands of years it has been history. But through these thousands of years of its history it has been a reliable beacon light for those subsequent civilizations which ultimately have resulted in the "Western Form."

After the Egyptian era, the next in succession was that of the Greeks. And with this latter there came into being a new epoch of cultural significance and, really, one of the truly great art-forms in all the annals of art.

The beginning of the Greek art-form was simple, just as was the beginning of that of the Egyptians—or, for that matter, as were those of primitive peoples in general. Along all walks of life there were things to be done. There was the making of utensils for everyday use. There was the making of armaments for warfare purposes. There was the making of clothing for bodily protection, and the erection of shelter against weather and wind. There was the production of objects of art to satisfy the growing demand for cultural achievement; and for the same reason there were to be produced pageantries, dances, poetry, plays, dramas, and many other things.

Indeed, there was generative strength in all phases of Greek life; and because the era had become consciously aware of the values of beauty, things were created with joy and elation. Moreover, because the era was sensitive to the fundamental laws of all art, then, from the depth of Greek life, there gradually emanated an expressive form-pattern of the Greek era—a form-pattern which as to its concept, spirit, and rhythm was entirely new and creative and which, in fact, became of decisive influence—of too decisive influence, we would say—in the evolution of the "Western Form."

The Greek art-form reached yet unsurpassed heights, if not in magnitude and imaginative richness, at least in the utmost grace of its concept. The acme of the era, we may say, was the Periclean Acropolis in Athens. But after the downfall of Athens the focus of the Classical cycle was moved to Rome, to the center of the Roman Empire.

Due to constant warfare and successful conquests, the pursuit of power and wealth became the leading aims of the Roman Empire. And as pursuit of power and wealth even in the Roman case—just as always, and not least in our time—caused the qualitative decline of cultural aspirations, the Roman brand of the Classical form was bound to become pompous and superficial—and these two properties are the surest signs of an inescapable form-degeneration.

So, gradually, the Classical Era came to an end.

Then, after a long night of cultural dullness, there began again to appear evidence of a new era with its own indigenous form-concept. Again, this new era and its form-concept emerged from the depths of the existing life—just as earlier there had emerged the eras of the Egyptians and of the Greeks. Again, all the phases of life with their manifold aims and shiftings were represented in the expressiveness of this new form-concept. Again, mankind was in the midst of abundant creation of a new and indigenous language of art: to the glory of man, of his art, and of his history. And again, there came into existence a new world-feeling, permeating life throughout all of its various walks—physical as well as spiritual.

This was the Mediaeval Civilization.

Thus, from the depth of the longings and aims of the time and people, a new era of human civilization was brought into existence. This gave birth to the great art-forms of the Middle Ages: the Romanesque and the Gothic. And because of the indigenously creative nature of these art-forms they must be ranged under the headline the "Conscious Stage."

But when the era of the Middle Ages had run its course, its form-expression, too, was ripe. It became history.

Then came the dawning of the Renaissances.

During the period of the Renaissances—and ever since —there has been and still is achieved much art of a quality which rightly belongs to the "Conscious Stage" of art-development. And, since this period of several centuries embraces the results of many ambitions and truly high records of man's cultural achievement, it would constitute an enlightening subject for our study. However, because we are going to discuss the same matter in the following chapter—"Retrospective Analysis"—we might just as well now shift our attention to the next objective on our program.

c. The Self-conscious Stage

As for the Self-conscious Stage, our short definition was put a moment ago as follows:

"The 'Self-conscious' stage represents that stage of art-development where civilized man, because of esthetic speculation, dogmatic doctrines, or otherwise, has closed the instinctive channels of creation and has produced art that is 'fine,' but rootless."

Where, when, how, and why it came to pass that the roots of creative art began gradually to wither will in proper time be examined in the chapter, "Retrospective Analysis," and it will be examined parallel with the continuance of the "conscious" case. But whatever the circumstances, the fact remains that when the roots of creative art began to wither esthetic speculation and dogmatic doctrines were called

upon as substitutes for the withering roots. Through this transition, art became a rootless manifestation in human society. It became self-sufficient for its own sake—"l'art pour l'art." Art was not any more an expression of life. It was considered something beyond life—and ultimately something "finer" than the profane everyday occupations of physical and material existence. Due to such an attitude, the field of art became limited to certain branches of activity, supposedly of highest order.

Thus, the "Fine Arts."

Obviously this was an awkward procedure through which art automatically became opinionated and speculative. Through such a procedure the contact between art and life lost its original meaning and eventually the procedure brought about many dire consequences. Thus its happened that the slogan "l'art pour l'art" easily became "l'art pour l'artiste," then "l'art pour l'exposition," and finally "l'art pour l'argent." Art became business. Big names were ballooned for the sake of high prices. Art-dealers sprang up like mushrooms beneath the moss. Art collectors were eager to collect products of art, often—let's admit it willingly— because of genuine desire, but often only for selfish pride, for speculative purposes, or for advantageous investment. Really, thousands upon thousands are expended merely for the vulgar sake of material possession, without the slightest genuine interest in art.

A philatelistic hobby!

This, however, has little to do with real possession of art, for the realm of spirit recognizes only spiritual values. The material part of art can be bought with money, that is true, but the spiritual part of it can be had only through mental appreciation. Only those taking a genuine delight in art can possess art, regardless of who owns the material side of it. What pleasure does it give one to own an excellent wine-cellar if ones health prohibits its use. One owns the bottles and their material content. The delight comes to someone else.

Besides this self-conscious trend in art development—caused by esthetic speculation and dogmatic doctrines—there is still another self-conscious trend where the artist tries to play with "secret strings."

The inmost problems of art will always belong to that realm of unknown: so we have learned and so they must, for—and we repeat—"as long as they remain 'secret,' they will remain 'sacred.'" Giotto, when painting his frescoes, and Beethoven, when composing his symphonies, knew perfectly well that their respective works were not achieved because of a thorough **knowledge** of the secrets of art. They knew perfectly well—provided they ever cared to consider the matter—that they had to communicate with the secrets of art by means of **subconscious intuition.** Indeed, in their cases there were no such things as self-conscious play with occultism, cabalism, hocus-pocus, and with any trickeries whatsoever.

And why should there have been?

Yet in some circles there seems to be a strange inclination to produce art by virtue of some sort of esoteric knowledge. Many see fit to recognize art—to be sure, art of the most "sublime order"—as something deeply mysterious, something enigmatically transcendental, understandable only by the selected few. Such an attitude of exaggerated self-consciousness—where the artist himself frequently plays the role of an innocent tool in the hands of purveyors of esthetic intricacy and commercial humbug—brings art easily into artificial depths and self-deceptive snobbishness. Those acting along such lines forget the essential thing—that only when art is direct, natural, and above all honest, can it be a living thing. For only in such cases does art get its nourishment through the real channels of life. And only when the artist himself is deep by nature can art become genuinely deep. Other "depths" do not count, for sure. When art is direct, natural, and honest it possesses those qualities that everyone can understand and appreciate. This, however, does not suggest that art should step down in quest of popular appeal by flattering "profanum vulgus." Nay, art must have

the influential power to elevate minds onto its own level. So always does strong art.

Giotto and Beethoven did not step down.

Nor does art of nature.

So much for the development of human art through its three stages: the "Subconscious," and "Conscious," and "Self-conscious."

The whole matter could be put into a nutshell.

Thus:

In one's childhood one is eager to draw, because of an inherent drift: this is the "Subconscious" stage.

When grown up, one devotes his life with enthusiasm to art, because of an inherent gift: this is the "Conscious" stage.

And then, sometimes—if one is too weak to resist temptation—one's enthusiasm might easily turn into conceit, and one might become too self-conscious to produce genuine art with the heart of a child: this is the "Self-conscious" stage.

In any walk of life the same is true.

In religion, for example:

Religious sentiment is from time immemorial inherent in man, no matter what the source of this sentiment—fear, anxiety, hope, or an undefinable longing.

Such is the "Subconscious" stage.

In the course of man's evolution, however, this subconsciously religious sentiment became consciously formed into religious groupings in accordance with the varying leanings of various times, peoples, and races. Thus, religions were born and denominations established.

Such is the "Conscious" stage.

When time passed—and the more traditional consideration began to guide emotional feeling—these religions and denominations became crystallized into routine church rituals and sterile service habits. And now, many, not being able to discriminate between inner religious sentiment and outer service habits, forget the former and accept the latter. And so frequently, some, no matter how eager churchgoers they may be, are mentally as far from the fundamental

meaning of religion as is untruth from truth. Yet they are very likely self-consciously proud of their secure position within the church.

Such is the "Self-conscious" stage.

Well, as for art and its fundamental meaning, everyone is free to draw his conclusions from the above. After all there is not much difference between religion and art, for the artist's state of mind at the moment of creation—when sincere, and at its best—is a religious state of mind.

Goethe says:

"He who has art, even religion has he;
He who has not art, let him religious be."

3. SCOPE OF FORM

This we have said:

"In the whole course of the following analysis, any 'cell' in the cultural 'cell-pattern' will be considered from the angle of its spiritual significance."

This means that man in all his actions should try his best to achieve quality of art. This thought—although attainable only in a very relative sense—must be the guiding thought in the realm of form. And in order to discover how and to what extent this leading thought has been understood and employed during the long course of man's cultural evolution, we undertook the foregoing three-partite analysis of the various stages of form-development.

Reviewing the said three-partite analysis from this viewpoint, we hope it has been made rather clear that in the two first cases—the "subconscious" and the "conscious"—form has evolved simultaneously and on an equal basis from all walks of life; whereas in the third case—the "self-conscious" —there has been a distinct inclination to establish certain limitations in form-development and to attempt to raise the level of art only within these limitations. At least, such has been the self-conscious intent. In many respects, however— so we have found—this intent has had an opposite result. For, when divisions of art become ranged according to supposed pre-eminence and inferiority, the result was bound to

be that the highly esteemed "Fine Arts" were taken care of, whereas the rest were neglected. Ultimately also—so we have found—the result has become unfavorable to the general form-proceeding. Thus, the self-conscious stage cannot successfully stand an examination on the basis of its understanding of the fundamental meaning of form.

It is obvious that in any examination of art-problems the fundamental meaning of form must be the guiding thought, and this means that all human activities pertaining to form must be subjected to this examination. Nature herself acts in this spirit, for she does not let only the big species become "fine" examples of her art, but even the most minute cell-pattern in the smallest and most obscure of her species, is made "fine." And that's what makes Nature's design honest and truthful, and not just showy display.

Man must act accordingly.

Accordingly must we, too, act in this analysis and therefore we must understand the field of form in its broadest scope. This does not necessarily complicate our task, for we are considering only fundamentals, and these are always the same no matter what the scope. And of these fundamentals we will for the moment accentuate only the fundamental principle of "organic order."

Now, it was said that the fundamental principle of "organic order" represents the principle of architecture in all of creation. That is, the structural and organic composition of the universe is architectural by nature, and so it is throughout all things, macrocosmic as well as microcosmic. Observe that the said principle is **an omnipresent architectural concept,** and not an art-form in itself. It is true, of course, that in nature's animal kingdom there is much building for protective and other purposes and that some might be inclined to consider these building activities specific art-form in themselves. We are not inclined to do so—at least, not in this connection—and therefore we mention the matter only in passing. Consequently, whenever we speak about "nature's architecture" **we mean merely that omnipresent architectural concept governed by the principle of "organic order."**

Even primitive man was engaged in building activities for protection or otherwise, but at the beginning he was scarcely able to do it better than did his animal comeptitors. It took a long time before he could do it as well as did the spider in planning and producing its web. And surely it took much more time before primitive man's building could surpass the skilful structural elegance of the beehive.

But primitive man was on his road of evolution: he strove ahead, he progressed, his demand for protection increased, his skill at producing man-made protection increased, too—and so, gradually, from the said omnipresent architectural concept, there began to emerge a distinct art-form of the primitive man's time.

Such was the genesis of the art of building.

Once the demand for man-made protection was there and man was able to satisfy this demand, the demand grew stronger and more protective shelter had to be built. And so, by and by, man grew in skill in the erection of shelter, in the handling of material for shelter erection, and in the making of stronger and more permanent shelter.

Meanwhile, the problems grew in variety. Protection was needed not only for man himself, but also for his gods, for his work and activities, and for everything having relation to man's existence. And when man began to organize society into communities, these too were in need of physical accommodation. Thus towns were developed, cities were planned, many other things were done in terms of building work, and so, in accelerated progression, the art of building became increasingly predominant among the arts. It became the indispensable art-form for all of the people. It became the protecting "mother" for everyone. It became the protecting "mother" for all of the arts as well. Really, in both spirit and service the art of building became the **"Mother of the Arts."**

Such was the high status that the art of building gradually gained during the long process of man's cultural evolution. And this status—as the "Mother of the Arts"—was thoroughly accepted by the great civilizations of the past.

Really, during all of the great civilizations of the past,

architecture was accepted in its broadest sense. Architecture did not mean the building only: it meant the whole world of forms for man's protection and accommodation; it meant the various objects of the room as well as the room itself; it meant the building as such as well as the interrelation of buildings into organic groupings; and it meant the correlation of all the structural features into the complex organism of the city. Within this broad world of architectural forms, man lived and worked. Under its motherly wings his days were spent, and he breathed of its architectural atmosphere.

In this spirit, architecture was both understood and appreciated—and accepted also in practice.

Indeed, it is easy to understand that much of the success of olden times in bringing about a truly genuine and coherent art-atmosphere can be traced to this attitude toward the "mother." Equally easy it is to understand why form-shaping later on has become so arbitrary and irrelevant: the "mother" has lost her co-ordinative influence.

Really, with time, the understanding of the art of building as the Mother of the Arts has become vague. When and how this happened is a question in itself, which in due time will be explained as things proceed. At this moment, only the cold fact is mentioned: to be sure, a cold fact with cold results—for because of it the various arts have been brought apart from one another, apart from one another they have become understood and appreciated, apart from one another they have become developed, and apart from one another they have caused misconception.

Thanks to this misconception, a unanimous answer to the question, "What is art?" scarcely could be had. Everyone looks upon things with his own medium of expression in the foreground. And, as things have gradually worked out, there is no doubt that the prevailing opinion today as to "what is art," would lean toward considering only the art of painting. At least, such has been the state of things for a long time. Accordingly, when art matters—art matters **in general**—are discussed today, in most cases this discussion turns out to be one about painting. And when a book about

"Art" appears in most cases it is not a book about art—**art in general**—but about painting; sculpture being of secondary importance, and architecture being given only a modest afterthought—if anything. Obviously this pushes the general understanding of art onto a side-track that leads into narrow fields. In fact, the commonly accepted opinion seems to be that one's standing in art matters—again, in art matters **in general**—is valued according to one's understanding of how the painter uses or should use his brush.

Narrow, isn't it!

Just as if one's standing in religion would be fully satisfactory if one should stick to one of the ten commandments and skip the rest.

Certainly, one must learn to look more broadly upon things.

And certainly, one must learn to know that the problems of the art of building cover much broader fields than do those of the art of painting. Whereas interest in painting is limited to certain circles and individuals, everyone everywhere in his everyday life has to deal with such activities as hang closely together with the art of building. Even the pioneer in the remote corner of the wilderness must do it— if not elaborately, at least fundamentally. And even those considering art only in pictorial terms are unable to hang a single picture unless they have a suitable architectural environment in which to hang it. Thus the proper setting of a picture is rather an architectural problem than a pictorial one, for consciously or subconsciously one must take into account a multitude of conditions belonging to the domain of architecture.

And this is said with all the high regard that the art of painting deserves.

Because the fundamental principle of organic order is the all-governing principle in the universe, naturally then, not only those forms that are for man's protection and accommodation—and thus directly architectural by nature— must follow the demand of this principle, but also the whole world of forms, whatever the objective or the means of expression. So, for example, a piece of musical composition

must be governed by this principle just as much as a piece of sculpture or painting. And a piece of poetry must have rhythm and order in its thought and flow just as much as these qualities must be present in the movements of a dancing girl, of a running deer, of a flying bird. Indeed, all things must follow the demand of the principle of organic order.

With the above analysis of the principle of organic order, we have now arrived at a logical conclusion, not only as to the scope which our search for form must embrace but also as to the co-ordinative nature of this scope. In other words, we have endeavored to bring the whole world of forms into a unified system under the guidance of the fundamental principle of organic order.

Consequently, this principle must constitute the co-ordinating nucleus of our investigation of the problems of form. As such—and in all its unpretentiousness—our investigation aims at rather broad fields of form-manifestation. Thus:

Our investigation aims to show that the designers of cities, towns, buildings, homes, and rooms **must first of all learn to understand the importance of such a form co-ordination as can make people happy to live and work in these cities, towns, buildings, homes, and rooms.**

Our investigation aims to show that the artist, whatever his medium, **must first of all learn to appreciate a proper form co-ordination before he is able to conceive the right relationship between his work and this form co-ordination.**

Our investigation aims to show that the layman interested in art **must first of all learn to know the significance of a proper form co-ordination before he can select and display his objects of art in this form co-ordination.**

In short, our investigation aims to show that whatever one is or whatever one does, one is and **does—when at his best—within a form co-ordination that breathes the atmosphere of art through the cohering influence of the principle of "organic order."**

* * *

II. RETROSPECTIVE ANALYSIS

IN A sense, this chapter is a continuance of the preceding chapter, "Introductory Analysis." For, when in that chapter we undertook our study of art-development, beginning from the earliest days of the primitive man and continuing up to the days of the Renaissances, suddenly we switched our attention to something else, for—as was then stated—this following chapter, "Retrospective Analysis," will take care of the post mediaeval problems.

The subject to be discussed now, therefore, is closely staked out. And so, having left the earlier eras behind, we must turn our attention to the problems of the Renaissances.

However, before we do so, let's first try a short synopsis of the gradual **mental transition** during the period now to be retrospectively discussed. It is important, we think, to know the psychological reasons behind this transition so as to gain a clearer understanding of the corresponding **form-transition** during the same period.

In this mental transition one discerns two distinctly opposite tendencies. On one side one discerns the rising and sinking tide of the Church, of rulers, and of nobility— each of these, respectively, pursuing power and magnitude. On the other side one discerns the gradually rising tide of the lower strata of the people—pursuing freedom from the narrow intolerance of the Church, from the chains of prevailing superstition, and from bondage to rulers as well as to nobility.

In this dual manner—and during a long period of time —a social ferment was going on in the Western World. By and by, its results began to come to light as the thin layer of the upper classes was perforated by the agitation from beneath. And, since the upper classes numbered a few thou-

sands only, whereas the lower classes numbered countless millions, a largely new breed of population came eventually to play an important role in the historic, social, and cultural events of the time.

However, there was still a third tendency in this transition.

In the province of science and philosophical thinking there took place a continuous progress which brought enlightenment into many important problems of life, and through which men's eyes were opened to look upon religious, political, and social matters from a completely different angle than before. Among increasing masses of people this enlightenment nurtured bitter criticism of existing conditions in almost every phase of life. Particularly in France—where much reason for dissatisfaction existed— there arose hatred toward the dictatorial measures of the royal regime, toward the intolerant disposition of the Church, and toward many other obsolete ideas and institutions. As in France, so—generally speaking—was the tendency in other countries. People began to lose confidence in traditional ideas and old ways of thinking. Instead, there arose interest in revolutionary new ideas and new ways of thinking. Thus things progressed continuously and consistently toward rational reasoning on the basis of scientific discoveries and philosophical speculation. And so, step by step, the Western World found itself in the midst of the so-called "Age of Reason."

But as in human nature there are two often co-operating and often conflicting tendencies—one rational, the other emotional—so we find even in the historic records of human achievement these two tendencies directing the course of things. Consequently, it might logically be foreseen that when the ideas of the Age of Reason became stretched far enough, sooner or later the pendulum was bound to swing the other way and then something new and of an opposite nature was likely to appear. It really appeared. And— again—man found himself in the midst of a new era with a new disposition of mind. This time it was an era of emotional disposition: "Neo-Romanticism."

But even Neo-Romanticism was inclined to stretch its ideas too far, and it so happened that, while the champions of romantic ideas lingered in their lofty clouds, down on this "prosaic" earth there was something new in the making where machines and money constituted the leading incentives. It was the beginning of the materialistic era—with its growing industrialism.

Well, the materialistic era still goes pretty strong. And —as we know—the ever growing trend to industrialization has penetrated rather deeply into the lives of all of us. But, on the other hand, present generations have had the opportunity to benefit by all the enlightenment the rapid progress of science has brought forth. All the more is this going to change man's mental disposition toward progressive thinking.

Now, this brief survey of a few centuries of man's struggle for freedom from obsolete ideas shows that he has already gained much of this freedom. And, since art is an expression of life, naturally form has undergone a corresponding struggle.

Actually, in the search for form during the period now in question—from the days of the Renaissances up to our time—the concept of current art has undergone—in many respects and at least in leading circles—a metamorphosis **from tradition-bound conservatism into pioneering progressivism.**

At just which time the decisive change from conservatism to progressivism took place is a matter of opinion—and, of course, this opinion depends much on which country or which art-form one takes into consideration. Considering the whole field in general, however, we have reason to fix the time of the change close to the dawning years of the twentieth century. With this in mind we are going to divide this analysis into two sub-chapters. In the first sub-chapter we will consider form-development prior to the change. In the second sub-chapter we will consider form-development after the change.

Ergo: "Pre-Nineteen-hundred," and "Post-Nineteen-hundred."

1. PRE-NINETEEN-HUNDRED

In those slow-moving times when mediaeval civilization became influenced by humanistic thought and the mediaeval form was gradually changed into the forms of the Renaissances, the movement began with a change in the mental attitude of the time. Instead of dry scholasticism, something refreshingly different entered into the mediaeval mode of thinking. Scholars began to read literature of ancient times. Artists began to study the art treasures of Classical Antiquity. And so, for two hundred years or more, the mediaeval ideal of God came into contact with the Greek ideal of man— through Humanism.

Mind was first changed before form was influenced. And when the basic characteristics of the new life became shaped into form, this new form on its part began to fertilize mind. It was a reciprocal procedure. And the Early Renaissance was the result.

The humanistic influence came through Classical philosophy, literature, and art. Intellect introduced and instinct transformed the Classical form to fit the spirit of the time and the characteristics of the changed mentality. However, this transformed form was bound to become too much of a reflection of its prototype, for the new era had to a great extent adopted the Classical way of thinking and of looking upon things. In other words, although form evolved toward something new, after all it had too much of a spirit of adoption.

Herein lay the danger.

The movement was sincere at the beginning, and it had many possibilities of becoming moulded into a new and logical art-form in accordance with the gradual shifting of life conditions and arising demands. Really, such was the case during the days of the Early Renaissance. And as such, that time was creative by nature. But in the long run the creative impetus was not strong enough to find its own ways. There was too much of precedent and too many opportunities to adopt direct. By and by, the temptation became too strong and the artists succumbed to direct copying. Such

was the fact during the Late Renaissance—as we prefer to call the matured stage of the Renaissance time, including the so called "High Renaissance" and the end. From then on, forms were taken more of less directly from the Classical Antiquity. Instead of using their creative imagination, the artists—the architects, to be more accurate—began to use their dividers and rulers for the exact measuring of pre-established dimensions and proportions. They began to use theories and formulas constituted in accordance with the long ago expired art-forms of the Greeks and Romans. For practical use they made a science of these theories and formulas. And they founded schools wherein to teach these theories and formulas. There was not much need of creative sensitiveness to accomplish results that were found satisfactory. Theories and formulas seemed to do the trick.

It is plain that there was a broad difference between the Early Renaissance and the Late Renaissance, as to the spirit of the time and, above all, as to the nature of form-development. The Early Renaissance was a many-sided awakening from the "dark" Middle Ages. It was a great discovery "of the world and of mankind." It was a time of intense search caused by this discovery. And, as such, it was a preparatory time for something to come. The Late Renaissance, on the other hand, was the abundant harvest of this preparatory time. Insofar as architecture particularly is concerned, the time was a grand festival where princes and noblemen played on the stage and where architects arranged the splendidly decorative stage-setting. This stage-setting was a magnificent achievement indeed—rich and colorful. And yet, sincerity of aim and genuineness of form-selection were not always regarded as important as was "perfect" design in terms of outer magnitude. The glorious architectural environment was the essential issue, and the former Roman splendor was the splendid example to follow—to "revive"! But due to the unambitious inclination to "revive"—and not to **"create"**—the bane of a momentuous propensity was planted in the Renaissance soil. Ultimately, thus, the Renaissance time became the "naissance" of imitation.

Surely, the Late Renaissance time was an illustrious

time: we do not deny this, not in the least. On the contrary, we are great admirers of the Late Renaissance achievements, particularly in sculpture and painting, and in architecture too—on its style-surface, of course. However, in analysis one must go deeper than the mere surface. And beneath this particular surface one can readily discern the gnawing worms of imitation which ultimately caused the roots of form to wither—when the time was ripe during the nineteenth century and particularly during the latter part of that century.

The great architectural masters of the Late Renaissance still leaned—at least partly—on their creative instinct, for they were nurtured in the previous spirit of creation and they erected masterpieces. But the habit of copying was spread through the schools of architecture, and the art of building began gradually to lose its mother-place among the arts. Because of this, the strongest art-minds of the time became sculptors and painters, with the result that sculpture and painting gained prominent positions, dominating the other arts—not least their former "mother." Sculptors and painters were proud of these gained positions, and they used them commandingly. Frequently the building was looked upon only as hardly more than a suitable background for sculptural and pictorial products and it often happened that sculptors and painters took advantage of the building for the expression of their artistic temperament. Michael Angelo himself, for example, an excellent anatomist and consequently a supreme champion of balanced function—and a master-architect too, for that matter—put the static forms of the Sistine Chapel into motion with his kinetic frescoes. Because of this, and especially because his followers continued to proceed in the same vein he had started, he became the forerunner of the Baroque—that mixture of Renaissance forms, of Gothic verticality, and of sculpturally dynamic movement.

So things went on.

Bernini made his buildings sculptural by letting sculptural forms overflow columns and cornices. Tiepolo painted theatrical effects of people, putti, clouds and what not, dis-

regarding the architectural space-formations constituted by walls and vaults. Bernini was the artist par excellence of the dramtic Baroque. Tiepolo already had in his veins the sparkling blood of the Rococo.

The development of architecture—as we can see—was a step by step procession toward decorative superficiality, lacking the guidance of structural logic. Things were bound to go that way, for the pursuit of ornamental opulence was the characteristic trait of the time. And one can trace the logical course of this trend toward augmenting illogicalities.

The Early Renaissance still had its imaginative faculty founded on logical creation. The Late Renaissance in its turn raised ancient doctrines to the rank of dictatorial dogma, thus making form perfect in design yet conventionally dry. The Baroque poured dynamic spirit into this conventionalized dryness with a brilliantly bubbling imagination, but without any responsibility as to fundamental architectural laws. Although the Baroque time can show many excellent examples of fine work and of elegant taste, its distinguishing achievements, from the standpoint of fundamental architectural laws, were "baroque" in the original meaning of the word—incongruous and fantastic. And in its further development it gave birth to that still more fantastic Rococo. Indeed, the whole form procession, as we have said, was a crescendo development toward histrionic forms, caused by the artificial disposition of Renaissance life. Thus, life and form declined parallel with one another, until the ultimate end was reached and the bubble was bound to burst.

It did burst, finally—as to both life and form—through the French Revolution.

After the emotional waves of the French Revolution had fallen calm, life became simpler and more genuine. The social structure was new. Views were new in the world of thought, literature, and art in general. Even the popular manner of dress—to get right down to the people in their everyday habits—were new and simple, expressing the prevailing tendency of the new era. And the time seemed to be animated by a strong creative awakening. But the gods of

architecture were dead. Imitation, introduced by the Late Renaissance, had already become an ingrown habit. The new style of architecture—"Neo-Classicism"—was a more or less direct "revival" of that (if we may say so) "Old-Classicism" of the Romans.

However much of a "revival" this neo-classical style might have been, it was after all a characteristic offshoot of the Age of Reason. Obviously the rationalizing age did not possess enough of creative stamina. Therefore its style—a product of comfortable unconcern—was destined to become a rationalization of the clear Classical form.

Hence, "Pseudo-Classicism."

And then came Neo-Romanticism.

MacPherson in Scotland sang the songs of Ossian, the songs of that bard from a dim past. With these songs of far-away romance, MacPherson conjured up the romantic movement, and a new spirit began to breathe through popular views and sentiments. The movement was spread through poetry and literature, and through the influence of these even the art of building became inspired to commit romantic escapades. The aim was to establish, by means of architecture, a romantic form-environment which might lift one's mind and soul up to higher spheres—far above the "prosaic and profane" trivialities of one's material existence. In order to achieve such an unreal environment, all the styles of the past were engaged in the work—and they were moulded and remoulded accordingly. Towers and turrets were erected in Romanesque style to imitate mediaeval "romance." The Gothic form was "romanticized" in order to fit the spirit of the era. For the same reason the Renaissance form was made exuberant and fantastic. Thus form-imagination was let loose—and certainly it had its free play. An overflow of form in all thinkable styles took place with an abundance of cheap decoration.

However, sooner or later the Romantic movement was found fallacious—just as its original animator was found fallacious. Ossian, Fingal's son, the bard, was not genuine, for the songs—as sung by MacPherson—were but the songs of a vivid MacPhersonian imagination. Largely for this

reason, and somewhat because an exaggerated emotional attitude of mind was not easy to maintain at length, the romantic era was bound to come to an end.

Yet its architectural style-confusion remained, bordering streets and plazas and the country-side as well. And someone had to inherit this style-confusion—but who?

Well, the materialistic era already was there.

This materialistic era—in which, as we have indicated, machines and money constituted the sharpest spurs—obviously had no serious ambition to bring forth an architectural expression of its own. It simply adopted the architectural remnants of the romantic episode, and continued in the same spirit—without any spirit!

And so, finally, we find ourselves at the threshold of the twentieth century.

We have attempted to illuminate the general form-transition during some odd centuries previous to the twentieth and to explain those forces which directed this transition. And—as we have found—the most significant point in this transition was a gradual change **from the formerly strong creative impetus to a non-creative acceptance of form.**

This was the fact insofar as the art of building is concerned.

Let us look into the records of sculptors and painters in order to learn what happened on their fronts.

If, to begin with, we would undertake, so to speak, a "birds-eye-preview" of the transition process in the fields of both sculpture and painting—considering the period from the days of Donatello and Giotto to the days of that illustrious Parisian "Grand Salon"—we would find that things in these two fields metamorphosed **from inner creative meaning into outer imitative elegance.** In other words, they took just the same downward course as architecture. This fact shows that, however eagerly sculptors and painters wished to emancipate themselves from the sovereignty of architecture, after all they had to follow their "mother"— even if this had to happen at a distance. We say "at a dis-

tance," meaning that the timing of these two art-developments—on one side architecture and on the other side sculpture and painting—was different insofar as the downward course is concerned.

Now, as to this difference in timing it must be understood that, during the so called "High Renaissance," Vignola in his book "Regole delli cinque ordine d'architettura" put down the exact measurements and proportions of architecture for every architect to follow. This, for sure, was a drastic dictation, but—believe it or not—it was accepted by the age and through this acceptance **all architectural design was pinned down to a standard where copying became almost imperative.** This means that the high sounding appellation "High Renaissance" could rather have been "Low Renaissance" insofar as architecture is concerned. For how could one's work be considered of **high** standard, when one **lowers** himself to the mere copying of the works of others!

But insofar as sculpture and painting are concerned, the epithet "high" was perfectly fitting for the era in question.

It really was.

And here we can record the difference in timing.

It is not necessary to mention all the names and achievements in sculpture and painting during the high tide of the Renaissance period. Surely, everyone has heard and read about—or actually seen—the works of the "Old Masters." Surely, everyone knows names such as Michael Angelo, Leonardo da Vinci, Raphael, Sandro Botticelli, Andrea del Verrochio, Piero della Francesca, Filippino Lippi, Titian, Tintoretto, et cetera, in Italy. And in other countries, everyone knows names such as Van Dyck, Rubens, Frans Hals, Jan van der Meer, not to forget that unforgettable Rembrandt, in Holland. And everyone knows names such as Albrecht Dürer, Lucas Cranach, and Hans Holbein, in Germany. Et cetera. Et cetera. All these and many others were more or less contemporaries of the high tide of the Renaissance era in the art-forms of sculpture and painting.

Indeed, a high tide—**even when considering human art at large.**

In the long range of transition from the Renaissances to Baroque, from Baroque to Rococo, from Rococo to Pseudo-Classicism, from Pseudo-Classicism to Neo-Romanticism, and then to materialistic industrialization, sculpture and painting—whether good or poor—mirrored the respective characteristics of these subsequent transitions.

As to these subsequent transitions, it is well to bear in mind that the respective timings of these transitions cannot be exactly estimated, since the processes were relatively slow and their results differently timed at different places. Yet the various trends were distinctly marked, and marked also were the achievements of the outstanding protagonists of these various trends. So, for example, Bernini—as already mentioned—was a distinct representative of the Baroque pattern. Tiepolo, on his part, was a typical Rococo painter. A typical Rococo painter, too, was Watteau. And so were Boucher and Fragonard, those two artists of sweetness and elegance during the regime of Madame de Pompadour. Of the pseudo-classical era we might mention typical sculptors such as Canova and Thorwaldsen, and typical painters such as David and Ingres. And, since we are now in the swing of mentioning names, we might as well add to the list, Delacroix as the colorful exponent of Neo-Romanticism. Then —after the romantic fervency had gradually dissipated— equally gradually the scenery was changed to a new act of the great drama of man, and the materialistic era of industrialization made its entrance, cold and calculating.

In terms of sculpture and painting, the materialistic era of industrialization—insofar as its appearance particularly at the end of the nineteenth century is concerned— signifies a distinct trend to an utterly imitative and naturalistic concept of form.

Thus, in sculpture, the human figure—male or female, naked or clothed—was moulded exactly as it existed in reality, yet very rarely with that superb and sure sculptural form-feeling of the Greeks. Indeed, in this utterly imitative concept of form there was produced—at the driest—an abundance of super-naturalistic images of the human figure, in bronze and in marble, having nothing more to boast of

than the clever execution of form and pose and, perhaps, the bombastic or bucolic appellative, such as "Victory," "Liberty," and "Freedom," or "Dream," "Awakening," and "Love," and heavens knows what, and what not. These and similar products of art were executed in great number. They filled the vast exhibition spaces of that exclusive "Grand Salon," or elsewhere. They were purchased for numberless museums or for other places. And before long they are probably doomed to vanish into less conspicuous quarters, and ultimately into the dim and spacious chambers of a dreadful oblivion.

As for the art of painting during this same period, even here the trend to imitative naturalism was significant. This period was the time of large scale oil-paint-illustrations, of realistic landscape paintings, or such like. It was the time of art-exhibitions at which to hang these large scale oil-paint-illustrations, realistic landscape paintings, or such like. On the whole, it was the time when the painter saw only with his outer eye, and painted exactly as he saw it. And he painted with utmost skill and elegance.

Now, concerning these art exhibitions, it must be understood that earlier times had other ways than art-exhibitions of bringing people into contact with products of art. Generally speaking, in earlier times there developed a demand for a certain piece of art before this piece of art was executed—and once executed it was properly fitted into its environment. In this logical manner, plazas, churches, public edifices, and countless other places were embellished with works of art in various media. And people—wherever they moved about their home quarters—had opportunity to enjoy these works of art. So to speak, they "lived" with them.

Art-exhibitions, as such, are of a later date. As a matter of fact, save for occasional displays during the seventeenth and eighteenth centuries, art-exhibitions—more or less regularly held—are the children of the nineteenth century.

The reasons for art-exhibitions might have been manifold, but the basic drift was this:

As years went by, there developed a tremendous art-production which to a great extent was a matter of, let us say, routine "picture making." Because this picture-making brought the normal relationship between demand and production out of balance, there arose a need for art-exhibitions through which to sound a possible market. And, since things continued to progress along such a speculative line, the ultimate result was that exhibition halls and art-markets became crowded with all kinds of painting—excellent, good, poor, and very poor. "Painting," we say, for that was the vogue.

To make matters still more confused, all the art-schools taught all the students to paint, to paint, and to paint. But few of these art-schools offered the advice that the artist's ultimate ambition should not be to have his products accepted at art-exhibitions and then happily sold. Rather, the artist's ultimate ambition should be to have his products find their ways into homes, buildings, and other places where human activities go on, so that they—in cooperation with other art-products—would help to create a genuine art-atmosphere in which to dwell and enjoy art.

Surely, this is in accord with the true meaning of art, and all the art-schools should have offered this advice.

On the other hand, such advice would have presupposed that the homes, buildings, and other places where human activities go on had been designed so as first to create a genuine demand for objects of art and secondly to create a proper setting for these objects of art.

This, however, was a problem which was architectural by nature, and—surely, it is unpleasant to admit—architecture had at the time now in question reached so low a level as to make all talk of creating "genuine desire," "proper setting," or anything in that spirit sound like a joke.

The problem of creating both genuine demand and proper setting for art—in homes, buildings, and other places —was accepted by earlier times as a perfectly natural matter. In fact, this problem had always been satisfactorily solved— till the days of the neo-romantic adventure. From then on,

however, thanks to the complex situation of styles, there was bound to be much bewilderment. The situation became still more bewildered in the materialistic era, as the remnants of the neo-romantic style-complex—inside and outside of the building—became pretty much jumbled up. This downbound trend became much surer and faster when industry was employed to reproduce—by the thousands and tens of thousands—all kinds of decorative stuff from bygone times.

This was the sure and fast downfall of taste.

Well, during this sure and fast downfall of taste, there arose a strong movement for the preservation of "good taste and esthetic excellence." This grand idea of good taste and esthetic excellence was the inheritance—so it was fancied—from the days of the Greeks and the Romans; and those doctrines which were valid in their early days, and had once already been adopted by the Late Renaissance, were now "revitalized" and called upon as the supporting pillars to prevent further decline. In other words, it was considered fully legitimate—and "good taste," for that matter—to base contemporary taste and esthetic excellence **on direct adoption of a form-world which represented entirely other times and entirely other life conditions.** At least, so reasoned the blunt adherents of École des Beaux-Arts thought and, consequently, in their eyes the pseudo-classical form was "the" form from which to expect "the" salvation. And everyone who might be eager to secure this salvation had to do it under the wings of this very Pseudo-Classicism. Thus, during the passing times of form-decline, there came into existence an "Ivory Tower of the Fine Arts"—that sacred citadel for the preservation of good taste and esthetic excellence in the art-forms of orthodox-pseudo-classical architecture and of conventional sculpture and painting.

The other art-forms: domestic design, furniture, objects of art of all kinds, et cetera—precisely those art-forms which really were the factors most essential for bringing about a proper form-atmosphere—were left outside to wither.

And they really did wither.

Thus, when the bells rang to herald the advent of the new century, the situation was about this:

On one side there was that climax of the self-conscious stage of art-development—the Ivory Tower of the École des Beaux-Arts and of other "Écoles" elsewhere, and of the "Grand Salong" and of other "Salongs" elsewhere.

On the other side there was the debased taste which had gradually reached such a low level as mankind never before had experienced and, we pray, never again will experience.

Yet, there was still a third side.

There was the growing dissatisfaction with existing art-conditions. And this dissatisfaction incited something new to come.

Just a few words more:

Hereabove we have endeavored to paint a generalized picture of art-conditions as they had developed toward the end of the nineteenth century. This does not, however, mean that things were altogether as bad as we have painted. It must be understood that there are no rules without exceptions, and that this held good even during the period just discussed. In fact, during this period there existed a great number of good artists, and some excellent ones, too. This was true, considering not only artists of that old vanishing school of thought, but particularly many young minds, trying to free themselves from the chains of that old vanishing school of thought.

Indeed, the pulse beat of a new era to come could already be felt.

2. POST-NINETEEN-HUNDRED

No doubt, when the future art-historian puts the events of the present day art-development into writing, he will mark the change from the nineteenth century into the twentieth century as the milestone between "tradition-bound conservatism" and "pioneering progressivism."

Naturally, this change has been and still is a slow and

gradual one, which has required and still requires a long period of time to become crystalized into its final characteristics. But, already now, we are so far advanced into the twentieth century as to fully justify the above statement. Another point to remember in this connection is the fact that the change, even in this case, was very differently timed as regards the various art-forms—and the various countries as well. So, for example, in France, while the impressionist painters protested against the dictatorial rules of the Grand Salon as early as a quarter of a century before the "milestone" was passed—with their own independent exhibitions held since the year 1874—the chains of the Beaux-Arts architectural style-concept were not broken until as late as a quarter of a century past the same "milestone"—through the Paris Fair of 1925.

That was a rather long interval of half a century. But, after all, the "milestone" is the significant pivot.

Considering, to begin with, the circumstances surrounding architecture, the writer was midst the pioneering for a new architectural form from its very start. For this reason it is natural to expect—and pardonable, we hope—that the following may have a subjective flavor—to some extent, at least.

However this may be, there must be made a few introductory remarks about this pioneering and, first of all, there must be made the fundamental remark that, generally speaking, this search for a new architectural form did not consider only the building as such: it considered equally the furnishing of the building as well as its relationship to the neighborhood and to the community as a whole. That is, from the very outset of the pioneering, architecture was understood—at least, in the leading circles—in the broad scope that has become increasingly recognized during the further course of this pioneering. Thus, Josef Hoffmann, that eminent pupil of Otto Wagner in Vienna—beside his activities in actual building design—founded that once so famous "Wiener Werkstaette," an establishment for the development of all kinds of objects for room interiors by

which to promote proper room atmosphere in the contem-
porary spirit. Simultaneously with this, the urban com-
munity, too, was taken into consideration; for the writings
of Camillo Sitte—also a Viennese architect—inspired a new
movement in town design following fundamental architec-
tural laws. These two examples show clearly—so one would
think—that something new and basic was in the making,
and that this new and basic something was by no means
exclusive in a self-conscious sense but covered the whole
field of architectural activities on an equal footing.

Yet Vienna was not an exception in this respect.

In Finland, for example—where the writer and his
colleagues were active in those pioneering days—the same
comprehensive understanding of architecture was present.
Beginning with minor objects of handicraft and continuing
all along the various phases of man's accommodation up to
inclusive urban organization, a search for contemporary
expression took place.

The same was more or less true in many other coun-
tries.

To stress this broad concept of architecture now—
after so many decades of constant search has brought such
a concept into maturity—might seem like undue stressing
of commonplace facts. On the other hand, the reason why
architecture has now become understood to require so broad
a concept, is precisely because this very pioneering—which
started half a century ago—laid the foundation for that
concept. And it did so in spite of the fact that several
centuries of stylistic predominance had been most instru-
mental in turning the general attitude toward the opposite
concept.

The said pioneering, therefore, deserves credit for such
foresight.

The pioneering was strongest in the German speaking
countries, in Holland and in Northern Europe. Austria
and Germany were the leaders, for particularly in these
countries there existed a strong desire to break free from
the prevailing conservative stalemate. In smaller countries,
as in Finland and later on in Sweden—in which two cases

conditions of life were relatively simple and a certain lean-
ing to handicraft was latent in the blood of the people—
the new form of architecture and the home form of handi-
craft met one another in mutual understanding. Other
countries had their reactions too, including England, Scot-
land, and the United States. These reactions, however—
in their earlier stages—were evident not so much as move-
ments but rather as individual efforts. In England, Baillie
Scott and Edgar Wood, to mention two, were active in
the search. Charles Rennie Mackintosh was the front-page
character in Scotland. As to the United States, Louis Sulli-
van and particularly Frank Lloyd Wright must be cited in
this connection.

With the exception of individual cases, conservative
stagnation was most persistent in the Latin countries. In
these countries the Late Renaissance doctrines had estab-
lished their deepest roots, and here the pseudo-classical
teaching tried longest to maintain style-traditions in the
general confusion; or to repeat, it tried to maintain "good
taste and esthetic excellence." Of course, it made a worth-
while contribution insofar as pseudo-good-taste and pseudo-
esthetic-excellence are concerned. But on the other hand it
is largely due to these detrimental pseudo-propensities that
the search for a genuine form was postponed for so long.

Of all the educational institutions, that already men-
tioned École des Beaux-Arts in Paris became the most in-
fluential. This famous École—founded in the middle of
the seventeenth century as the "École Academique"—held
for a long time a restraining disposition against the develop-
ment of a logical architectural form, not only in France but
in other countries—particularly those of Latin origin and
the United States. But as the new form gained ground
everywhere else and its influence became increasingly
strengthened, sooner or later even the old École's antiquated
educational system had to yield some of its strongholds in
the Beaux-Arts sacred citadel. To begin with, its orthodox-
pseudo-style-concept had to give way to a more liberal atti-
tude in architecture, and the Ecole was compelled to "mod-
ernize" its mode of expression. But its system of teaching

remained the same. And its system of teaching was the chief stumbling-block.

The reluctance of the Beaux-Arts architectural education to enter a more progressive road caused a curious form-inconsistency in France. For, while the art of building—that indispensable setting for painting—was delayed in its progress, the art of painting—which had already for a long time been searching for new fields—went progressively ahead. As for this art of painting, France, in fact, became the very center of several progressive movements. From here the new gospels of painting were spread to other countries, and it was widely believed almost mandatory to suck nourishment from ideas born in Paris, and only there. Famous artists arose—not seldom from the shadows of bohemian night-life. Their "fame" was carried to all corners of modern civilization—and more than many were found eager to have at least a glimpse of their products, if not to become the proud owners of some of them. Yet, take note, these products were most frequently extremely "radical."

Here was the said form-inconsistency.

On one side there was the stagnant architectural form which could produce only **"super-conservative setting"** for painting. On the other side there was the **"hyper-radical painting"** to be fitted into this super-conservative setting.

Indeed, an awkward situation!

But people—used to such inconsistencies—did not see the awkwardness of the situation as clearly as did Louis XIV when he removed that "rustic" Breughel from its "elegant" setting in Versailles.

It is true enough that at the very end of the past century there appeared in France a new movement in architecture, trying to bring freedom to that style-chained form. But this movement, rather vulgarly refined semi-rococo—"l'art nouveau"—passed away almost as rapidly as did the so called "Jugend Stil" in Germany. And the earlier academic dryness remained victorious on the battlefield.

However, the contribution of France to other countries insofar as painting is concerned was repaid in full value—as soon as France was ready to accept the repayment. The

influence of the new ideas in architecture came to France through Austria, Germany, and Holland. But, due to the persistent opposition from holders of the extremely conservative concept of form—which often had too much of feminine softness and elegance—this new form tended to go too far to the opposite extreme. It became—at least in the beginning—too dryly mechanized, straightlined, hard, uncomfortable, and often trickily overdone. On the other hand, one must take into consideration the fact that the French inclination, generally speaking, is and always has been toward a certain refinement of form, and therefore even this new form in its continuance has evolved toward such refinement. On the whole, then—and in spite of its delayed appearance—the new movement in France, as it stands now, bears witness of a promising progress.

France has always been regarded in the United States as the mother country of styles, fashions, and ideas. Everything should come from Paris, and such was accordingly the case with this new architectural form. Nobody is a prophet in his homeland; and so Louis Sullivan and Frank Lloyd Wright were not appraised at their full value in their own country. The efforts in Austria, Germany, and Holland, even after they had gone on for decades, were considered strange movements. But when Paris finally started, then . . .! At the Paris Fair of the year 1925, it became evident that France was ripe to change its architectural garments to something new and more fitting with contemporary life. This was a clear signal to New York. And it worked! In a surprisingly short time the French movement became superficially popular in the shopping centers of the United States—labelled "French modernistic." And in many quarters it was considered the very thing: a "fait accompli."

Yet it was an exotic cut flower: it had no roots.

However, the architectural soil of the United States had been fertilized. In fact, this soil was already pretty much disposed to nourish a new seed, for the oppression of the sterile Beaux-Arts world of thought had lasted too long. Thus, when the road was made free, contemporary ideas were discussed; they were tried, they were understood, and

they were accepted. And so the search for a new architectural form began.

Although the movement now already has two decades of experience, it still is young, yet promising—provided it can be kept simple and logical by the avoidance of bizarre extravagances. But so far it is more an aim toward something than it is of an accomplished style. There still is much to search for and much more to be sensed before the movement can settle upon those fundamental characteristics which can lead—really and ultimately—to an expressive style-concept of our age. World's-Fair buildings, moving-picture theatres, or like spectacular things do not truly express the best of life. Skyscrapers and other "big buildings," art publications and popular magazines, do help the movement—if form comes honestly into expression. But if form is only an arbitrary play with random shapes, seeking merely for striking effects in "modern" spirit, novelty for novelty's sake, advertisement for the architect, and business for the owner—as it much too often does—it may easily bring the movement into uncertainty and disrepute.

The movement still is largely on the surface and has not yet had time to penetrate deeply into the general consciousness—nor has it yet been widely accepted by rank and file. Things are bound to be so, for form must be felt in the home before it can be rooted into the soil of life. Surely, the greater proportion of our homes are still old-fashioned and over-ornate. Even the most inveterate clinger to democratic ideas dreams of that former splendor in Versailles, as he rests his ample body in the softness of a Louis XV imitation. The slender forms of the Chippendale tell their stories from Old England with a Grand Rapids accent. A great number of all kinds of pseudo-period-furniture—varying in style, varying in color, varying in character and spirit—bestow their perplexing potpourri-atmosphere upon rooms and homes. And, alas, someday somebody is going to inherit all this miscellaneous medley, and to use it—continuously for a long, long time to come.

Indeed, the road is long. But someday the goal will be near.

Thus we have told a short story of the search for a new architectural form, and of how this search appeared "on the surface" during those years of half a century of its development. The next step must be to go "beneath this surface" so as to learn about some of those inner conflicts that caused divergences and uncertainty during the search.

Speaking of these inner conflicts, it must first of all be borne in mind that, during its long course of full four centuries, architectural practice—almost entirely, we should say—has been some sort of a put-together-jig-saw-puzzle—so called "composition"—on the basis of those five classical orders as prescribed by Vignola. During this eternal jig-saw-puzzle-making, the conviction went increasingly deep into the blood of the times that architecture is, and must be, a style-bound art-form—subject to those doctrines and only to those doctrines that are dictated by style. With such an understanding of architecture, it seemed quite clear that there was no need of fundamental principles—and for this very reason the existence of such fundamental principles was totally overlooked. And—to make it plain—when we speak about fundamental principles we do not mean "man-made" ones, but those that are from the beginning of all time.

Thus, there were two points of conflict. In the first place there was **style-dictatorship**. And in the second place there was **the lack of fundamental principles.**

These two points of conflict constituted grave stumbling-blocks in the search for a contemporary architectural expression, when the time finally became seriously and decidedly conscious that the art of building had already been lingering for a dreadfully long time in a degraded parasite-existence. In increasingly wider circles this consciousness became utterly shocking. Most urgently, therefore, something had to be done to save the said art-form from its humiliating situation. In order to achieve this, naturally the first step was to undertake to free architecture from its style-grip and to let it develop in full freedom in accordance with its nature and the characteristics of the time. Of course, a step like this was easy to undertake. But, on the

other hand, it was entirely forgotten that there was nothing to substitute for style, nor were there any recognized principles to follow. Matters being so, the outcome was bound to be unfortunate. One needs only to cast a glance into the architectural magazines from the dawning years of the twentieth century—particularly into those of France and Germany—and one soon will find that things were heading toward an alarming form-chaos. Such a trend was so much the more easy to understand, for just at this very same period the debased taste—as said—had "gradually reached such a low level as mankind never before had experienced and, we pray, never again will experience."

Thus, in the search for form there was a fight in sight. And this fight had to be fought on two fronts. On one front there was the stylistic form which had to be stamped out because of its non-genuine character. On the other front there was the debased taste which was apt to paralyze any constructive effort toward better form-conception. Those who had been in the midst of this fight learned soon that the head and heart had to be kept clear in order to avoid digressions toward either that which was style-bound and restrained or that which was debased and undesired. And they learned furthermore that this was so much the more imperative inasmuch as frequently—even when the struggle was honest and sincere—things went astray through violation of the clearest primary principles, **just because these primary principles were not clearly apprehended.**

However, as the search progressed, in many instances there sprang into being some **leading thoughts** upon which to proceed. These leading thoughts were manifold in variety and born from different points of view. And as for the character of form-shaping, they were to a great extent decisive.

Here are a few of these leading thoughts:

First came the problem of **material.**

The writer and his colleagues in Finland were adherents of the thought that **the nature of material decides the nature of form.** This was by no means a new thought:

7 1

rather, it was a fundamental one. But because this fundamental thought had for so long been buried beneath all kind of accumulated stylistic nonsense, it was necessary to dig it out from its ornamental grave and to reinstate it into its former honesty. To do this, however, meant that one had to go backward in time to search for cases where employment of material still was honest. Such a step was thought essential in order to gain the needed knowledge.

Now, to go backward in time in order to search for something to come, seemed to many an awkward move. These "many" smelled here a distinct leaning toward romanticism—toward some sort of style with "old-time" romantic flavor. In certain instances this was correct, it is true. But—basically—the aim was toward sound honest material treatment in which the maxim, "form follows material," was considered essential. The aim was logical—it still is, we think. And yet the misleading word, "style," could not be escaped.

The same thought of material use was put into written form by Henry van der Velde, the Belgian. Van der Velde, however, was perhaps more of an intellectual reasoner than a creative artist. And besides, since he was unable to free himself from that impertinent style-confusion, his forms—in spite of his thoughts on material use—were designed to accord with an utterly determined style-concept: just the same throughout, no matter what the material. That is to say, his work was antithetic to his words. In disregard of this inconsistence, van der Velde's design—a kind of semi-rococo; in fact, "l'art nouveau"—soon became extremely popular almost all over the world. But for a short time only.

As we see then, the matter of style came to the fore after all. Thus it was: a perfectly sound and logical idea of material use was put forth; and yet, through the interference of style, this sound and logical idea was made unsound and illogical.

After this came the problem of **function**.

Of course, the problem of function is so fundamentally inherent in all things that there should not have been even

the slightest reason for taking the matter into consideration as an issue in itself. Yet, because the domination of style had so beclouded men's eyes as to keep them from seeing things as they really were, there was need for an awakening influence to bring the problem of function into a logical light. In the course of time this awakening influence really brought enlightenment. Thus, when Louis Sullivan issued his maxim "form follows function," the soil was already prepared for such a thought—and the maxim, therefore, was readily accepted.

It goes without saying that with the acceptance of the maxim of function the pseudo-classical style-form became automatically outdated among adherents of the functional idea. With the same acceptance, the art of building as a stylistic art-form lost ground and from then on the functional art-form was in broad circles considered an organic art-form. That is, architecture became **organically functional.**

So far, so good.

But then came the hampering matter of style again and reversed things. That momentous suffix, "-ism," was brought in—and architecture, instead of having become **functional**, became **"functionalistic."** It became a "functional style." And from then on, functionalistic style-forms were introduced into design, regardless of whether there was a corresponding function or not.

And so, again, the matter of style came to the fore after all. Thus it was, once more: a perfectly sound and logical idea of function was put forth and yet, through the interference of style, this sound and logical idea was made unsound and illogical.

After this came the problem of **movement.**

Well, we all know that the problem of movement has become extremely important insofar as design is concerned. Such things as motor-vehicles of all kinds, airplanes, trains, and other means of travel must in their mode of design satisfy the requirements of movement—or let's say, of speed. In other words, form must be "streamlined," as the term goes.

So far, so good.

But then came that harasser, style, again. The stream-
lined form—that form born from "movement"—was soon
made a style-form and used no matter whether there was
movement or not.

And so, again the matter of style came to the fore after
all. Again, the same old story about style-interference mak-
ing a perfectly sound and logical thought utterly unsound
and illogical. . . .

Et cetera

It is rather obvious that a transition process of the
above kind could not run along a steady orbit. Surely,
when a wholly new world of opportunities was laid open
for sincere enthusiasts who nevertheless often undertook
dubious experimentation, how then could it have been ex-
pected that the road was going to be straight and clear?
Surely, there were bound to be deviations of one sort or
another. Surely, there were bound to be exaggerations and
mistakes.

In such uncertain circumstances it was natural that
everyone engaged in the search—whether moderate or radi-
cal—should have made up his mind in order to be able to
discern the underlying reasons for what was going on. That
is to say that first of all it should have been an inner struggle:
a battle of fundamentals and inner certainty, without which
the outer change would not have been worth the battle.
In this respect it was often amusing—or rather discouraging
—to observe how the conflict went on. Many, not yet par-
ticularly convinced of what was what, were watching the
course of the fight so as to decide which side to join. So to
speak, they were keeping an eye on the wind in order to
know how to trim their sails. Thus it often happened—
and still happens—that an inveterate conservative turned
"modern" overnight, and then again the other way—if he
found it profitable. This, indeed, is sheer opportunism and
by no means sincere conviction. And we do not believe in
such behavior any more than we believe in the philosopher,
composer, or any other person of creative consequence who

suddenly changes his direction of thought for the mere sake of material profit.

However, it has by no means been a hopeless fight, for there is already enough evidence of positive harvest. In this respect it is well to bear in mind that we have passed and are passing through a process of transition which must be gradual and slow. It must be so in order to have form well-rooted and lasting. On the other hand, the grade of progress is not always easy to measure, for surface progress is not always a sure sign of inner progress—and inner progress is the thing that counts. Indeed, there still will be many ebbs and floods before the line of progress can attain a steady orbit.

To put it briefly—this is what happened in architecture.

Someone had an excellent idea. Then many laid hold of this excellent idea by using it timely and untimely, and promptly this very idea became a style-form—an "ism," to be sure—and so this excellent idea lost much of its excellence.

Exactly the same took place in the field of painting, for here also any striking approach along a new and heretofore untried course mustered many a follower, and promptly the "ism" was there. Therefore, as we now proceed to dig into the problems of painting—and what applies to painting applies to sculpture, too—we must pass through an abundant orchard of "isms," and we wonder how ever to come clear off.

In discussing painting a few pages back, it was mentioned that at the end of the nineteenth century there was a "distinct trend to an utterly imitative and naturalistic concept of form."

This trend continued for some time.

But when cleverness of technical execution in the course of time became the supreme virtue of painting, painting was doomed to decline into academic dryness and to lose ground. It was not, therefore, too long before that elegant

skilfulness displayed at the annual great events of the Grand Salon gave birth to reactions in many different quarters. Thus, the impressionist painters protested against the dictatorial rules of the Grand Salon, and instituted their own series of annual exhibitions, in Paris, from the year 1874 on.

Here, simply, is how things started.

A number of well-known painters made themselves free from prevailing academic rules. They went their own ways, and for that purpose their easels were moved outdoors to catch first-hand "impressions" of light and color values. The word "impression" was a good term to use. So thought art-commentators too, and therefore it was not long before that important suffix, "ism," was fastened to this term and—well—there it was: "Impressionism."

Simple, isn't it!

To be fair, however, it must be stressed that the impressionist painters themselves had no part in this play of "isms." Each one of these painters was an eminent and independent artist. The group consisted of such men as Monet, Manet, Renoir, Cézanne, Sisley, Pissarro, and others. They painted—respectively, sincerely, and honestly—in accordance with their best knowledge and they selected their own modes of expression freely and independently. Yet they had a common goal in abandoning the conventionally naturalistic school of painting and in raising the values of light, color, and atmospheric effects above the slavish correctness of the subject-matter. "Art must not copy nature, but should interpret the sensations aroused by her." Such was the leading—and sensible—motto.

Once impressionism had broken the dikes of conservatism, freedom of painting spread widely around, and the received impressions were "expressed" in various ways. And soon the word "expression" got its tail-end decorated with that indispensable "ism," and "Expressionism" was born.

Expressionism—in contrast to impressionism—strove away from nature with extreme simplification of strongly marked lines, masses, rhythm, and color display. Yet, as with impressionism, expressionism was not an intentional "ism," originated by the artists themselves. It was imposed

from without. One scarcely could expect any such intention from such sincere painters as Gauguin, van Gogh, and Matisse—well, we could mention many more; for example, that impressionist Cézanne himself—but so hazy was often the distinction between expressionist, impressionist, and what had they, that the painters themselves hardly knew what was what and whereto they belonged. And they did not even care to know.

This was perfectly as it should have been, for the issue of "isms" was wholly esthetic. Indeed, it had nothing to do with the creation of art.

As was expressionism an outgrowth of impressionism, so also was "Pointilism"—hence "Neo-impressionism." Pointilism was a highly theoretical mannerism of pure color-spot-treatment calculated to obtain a maximum of color-brilliancy. Obviously it was but a random adventure, but more of this later on.

The next in order of these "isms" came into being when Picasso abandoned his simple and almost classical concept of painting and began—accompanied by a horde of followers—a seemingly tricky play with all kinds of forms and lines and whatnots, where only the essentials were set forth, often in cubical terms: hence "Cubism."

Marinetti—an Italian poet—conjured up "Futurism": a predictive speculation as to what the future might have in store. With nihilistic pathos, futurism denounced all the cultural past of mankind as something obsolete and hence of no worth. Bombastically it proclaimed that form is not the thing to be bothered about, but movement and light or something else—heaven knows what. And so the genuine futurist—and cubist alike—unmercifully dissected their subject-matter, scattering the fragments all over the canvas in a way that seemed arbitrary indeed to those not familiar with the puzzling labyrinth of futuristic thinking—provided there was any.

So this great game of "isms" went on, and still goes. Any new idea—brilliant or otherwise—brought and brings forth a group of followers with their theoretical, metaphysical, and psychological interpretations, and—often, we are

afraid—pathological ejaculations. Thus: Dadaism, Naïvism, Purism, Primitivism, Surrealism, and who knows what else. To be frank, we cannot always follow the deep and dark paths of many of these "isms," perhaps because we still have faith in common sense, which—it often seems—is the least common of all the senses.

Now then, in the last analysis—what about these precious "isms"? And what significance have they in the development of the art of painting?

Well, take for example the impressionist and expressionist painters—in particular the leading minds of these groups—and it was just made clear that they had no part in this play of "isms." They were free men of their profession and, no matter whether impressionist or expressionists, they expressed their impressions just the same as anyone else in the creation of art has expressed and always will express his impressions. So it must have been and always must be in all instances—from the very first art-attempt of the primitive man to the very last art-action of a dying human race. For how could one express something unless one has at least some sort of an impression of something to express? Impression is an imperative antecedent of expression and, as for expression, it is a fundamental principle in all of creation. But when that annoying little suffix, "ism," was inflicted to interfere with the logical interrelation between impression and expression, the notion easily arose that the impressionist painters—and they only—had impressions, and that the expressionist painters—and they only—habitually expressed themselves.

To be sure, somehow, something had gone wrong!

Perhaps the right explanation of this wrong-going is that, after the long slumber in the indolence of imitative reproduction, the novelties of impression and expression were viewed as awakening heralds of dawning new eras and promptly these novelties were announced as promising trends—and arbitrarily disposed of. Perhaps this is the explanation. Perhaps not. But whatever the explanation, the fact remains that, looking upon things in a broader way,

impressionism and expressionism—as "isms"—were the esthetic children of a pretty narrow horizon.

Note: "esthetic"—**by no means artistic.**

Pretty narrow was the horizon also in the case of pointilism. In this case, however, the fault was with the artist, and not with the esthete.

Pointilism had rather limited possibilities, and had no such consequences as were perhaps expected by its originator. The originator—Seurat—aimed at an intense brilliance of color. To achieve this brilliance he employed a method of using unmixed color-spots next to one another so as to have each color carry its own full intensity. This attempt was below expectation, however, for instead of color-brilliance the color-spot method resulted often in a rather anemic palette.

The method was a new and untried approach to painting and, as such, it was fully justifiable in its place, for one never should hesitate to survey new fields and new methods. But Seurat was not left alone. Signac soon joined him, as did many others, and many esthetic treatises were written, printed, and read about this new approach to painting. And so the rather sincerely aimed new attempt became an "ism." In its further development, however, this color-spot-method had no other significance than its emphasis upon the importance of color.

As strongly as Seurat was a pursuer of color, equally strongly was Picasso inclined to explore form. Of course, even Picasso—in his earlier stage—was a painter of color, although in rather subdued terms. But believing that he already knew all about color he started a new adventure with his famous search for form. This was precisely as it should be, for, after all, Picasso was a searching soul—and a bold one, too. And if in this boldness he arrived at forms which sometimes in some sense reminded one of cubes, this was quite understandable. Equally understandable was the reaction of these cubical forms upon Matisse, when he—as the story goes—jokingly called Picasso's paintings "cubistic."

Why shouldn't Picasso go his own way? Haven't we already answered this question in our Preamble, where we maintained that in the search for form "it would be unwise

for all to go along the same path." Obviously Picasso sensed this, and so he plunged into his search with heart and soul. He played with his forms, freely and fiercely. And he originated new modes of expression, and new ways of looking upon art.

But cubism was not yet there just because of Picasso's ways and Matisse's joke.

Cubism—or should we say, "abstractionism"—as a group movement came into being first when many joined Picasso's ways and many a book was written about the matter.

How decisive an influence this adventure of Cubism— or whatever you choose to call it—is going to have on the general development of the art of painting, is too early to estimate. Probably the most manifest lesson of this adventure will be the increasing understanding of the vital fact that the painter, besides his outer eye, must have his inner eye too, through which to discern things that the outer eye cannot see. If such an understanding becomes increasingly widespread, cubism then has much to its credit—provided, of course, that the artists see to it that the inner eye is honest.

About futurism, this must be said:

Any alert mind looks toward the future in order to survey the course of things. Indeed, this must constitute the core in all search for form. Such forwardmindedness is both logical and sound and its need well-established. For heaven's sake, then, what real reason did Marinetti and his gang have to stage that hubbub about futurism! Well, that hubbub is over now, for futurism was too "futuristic" to have a future.

Dadaism and Naïvism, for their part, played on childhood strings. Here the initial thought—we assume—was that just as one must have a child's heart to enter the Kingdom of God, so must one approach art with the child's directness and joy in order to enter the Elysian Fields of true art. If this was the initial thought of both Dadism and Naïvism, it certainly was fundamentally sound—provided the thought was that of the heart, and not of theory.

The thought was by no means a new one. Rather, it was just as old as art itself, and it has been instinctively

sensed by artists of all times and in all places when and where art was strong.

But as an intentional "ism" the thought was still-born.

Fundamentally sound seemed the initial thought even in purism, as long as there was the lofty endeavor to achieve "pure" art—whatever that meant. As soon, however, as the inescapable "ism" changed this lofty endeavor into group speculation, that "pure" became turbid. The situation was the same with Primitivism, where that persistent "ism" brought self-consciousness into modest intentions, making the trend a good deal of an affected antithesis of itself. As to Surrealism, it should be fully clear that when one is enough of a creative artist, creative instinct infuses into one's art something "beyond" what seems "real": that is, something "sur-real"—if that word is your choice. Consequently, in the above sense—and in a good sense, too—**all creative art is sur-real-art.** As such it has its art value, as long as one does not burn his fingers with that misleading "ism."

.

Et cetera

We have briefly skimmed over some of the "isms," considered separately.

When **collectively considered,** there are a few additional remarks to be made.

First, this is to be said:

It might be true that these oft-mentioned "isms" constitute only a minor part in the general progress of painting, and that many of them were rather unimportant deviations from the logical line of constructive evolution. But on the other hand it must be admitted that, generally speaking, the influence of these "isms" has affected the whole structure of this evolution and has caused a widespread nervousness in the search for new objectives and new ways of expression in the field of painting.

Secondly, this is to be said:

No matter whether one approves or disapproves the respective "isms," as "isms" they all were inclined to **lay emphasis upon a particular phase** of painting. This was

deceptive. For, once one was inclined to emphasize one particular phase of painting—often a more or less unimportant one—one easily risked slighting those phases that are of fundamental nature. This deception, however, was not so much with the original inspirers of these "isms," for undoubtedly they acted according to genuine impulses. Their modes of expression, therefore—in spite of the emphasis—were indigenous and logical, **when honest.** The deception came with those many followers who adopted the emphasis, often rather arbitrarily—and not seldom for the sake of sheer speculation.

And thirdly, this is to be said:

In almost every one of these "ism" cases, there was a **sound initial thought** behind the movement. This—we gather—shows that those who had actually started the respective movements were engaged in a sincere search for new ways of expression following this sound initial thought. And as long as their followers were sincere too, and were inspired by the same initial thought, the art of painting progressed on a firm ground. So then, as we see—whatever the tendency or the "ism"—there was no menace as long as the painters professed their art imbued with the spirit of indigenous creation.

Such was not always the case, however.

Besides, as said, the matter of "ism" really did not originate with the painter. Rather, he was haunted by it.

The real originators—insofar as classification into "isms" is concerned—were those who did the writing about art, whatever their title: art-historians, art-critics, art-analysts, esthetes, or anything else. Of course, not only is it perfectly legitimate to write about art, but to do so plays an essential part in the development of art. For sure, such writing is indispensible, **particularly in the search for form.** And, in fact, at this writing moment we are doing the same ourselves.

But just as there are both good and poor artists, so are there both good and poor art-writers.

We are more than willing to pay our deepest respects to those art-writers **who have in their veins a truly genuine understanding of art** and are sincere in their efforts.

But we are concerned about those art-writers—sincere, or not sincere—**who have not in their veins a truly genuine understanding of art.** These, and just these, are the ones who—with their bottomless book-knowledge of facts, and with that only—are often ready to stipulate imperative rules for those endowed with the gift of genuine creation.

Indeed, through such misguidance many a promising mind has become entangled in the puzzling network of "isms."

In the latter part of this chapter—and in the major one—we have endeavored to paint an inclusive picture of the post-nineteen-hundred art-development. Under the heading of architecture we have considered in this picture the whole form-world of man's physical accommodation, embracing all the problems of design such as those of urban design, of building design, of interior design; in fact, of any design, including—at least in spirit—even the broad field of so-called "industrial design" which deals with the manifold demands of industrial mass-production. As for painting and sculpture, we have dealt quite lengthily with the former, whereas in the latter case it was mentioned, just briefly, that "what applies to painting, applies to sculpture, too." This method we have employed purposely, so as to become less involved in our task. In fact, painting and sculpture, in their varying trends, followed one another hand in hand. When painting abandoned the naturalistic concept of form, sculpture did likewise. Again, when painting played with "isms," abstractions, non-objective ideas, and such-like, sculpture did likewise. And when painting became involved in esotericism and other obscure ruminations, sculpture did likewise. And so on. Thus, even sculpture had to pass through the delights and agonies of those many and bewildering "isms" in which painting became involved from time to time.

Also—to repeat, and to be concise—we have endeavored to paint a picture covering all the post-nineteen-hundred art endeavors in every field of visual art—considering just as thoughtfully the most minute objects of intimate life as well

as the most comprehensive form-combinations of the urban community.

Now, in this all-embracing art-development of the post-nineteen-hundred period, we have found in almost every phase of search a persistent trend toward **collective action,** whether this happened in terms of architectural style or in terms of those many and often reiterated "isms." And because we have—again and again—interpreted this collective action as something apt to depreciate the quality of sincere form-search, one might easily get the impression that we are extremely worried because of the manner in which things have run away. We are not worried, however. We are not, because we are perfectly well aware that there cannot be any other procedure. Really, in any art-development one can discern two main leanings—both inescapable inasmuch as their causes can be traced deep into human nature. In the first place, one can discern the leaning to **individual search**—for surely the impetus of such search has been put into man's mind from time immemorial. In the second place, one can discern the leaning to **collective action**—for surely in all his actions man is led by herd-instinct for the sake of mutual protection, preservation, and inspiration. So things always have been. So they always must be. And because of this, human history can tell many a tale of various developments of civilization, of manifold cultural ramifications, of religious group-formations and denominations, of social and political group-ideologies, of all kind of groupings in the various walks of life and consequently even in the field of art. True enough, these groupings—looked upon with historical eyes—were and are highly inclusive as to both scope and duration. On the other hand, there should not be the slightest doubt that each one of these groupings—individually and during its formation-period—had to pass through many an "ism" before it became shaped into its final form. Because of the fact, however, that all-levelling time has softened the diverging edges of these "isms" and thus has conformed them into a unified pattern within the framework of one and the same grouping, these "isms" have become indiscernible to posterity.

In the same manner, no doubt, all-levelling time will also soften the diverging edges of those "styles" and "isms" that the post-nineteen-hundred search for form has brought about. And, once this has happened, the future art-historian will discern only the smoothly running search for form and will fail to see the randomly popped-up "styles" and "isms." That is, the future art-historian will discern the "form-forest" of our age—not the individual "trees" of the day.

Then why worry?

The only reason for worry, perhaps, is the impatient haste with which this commercial age of ours is eager to settle things in the ever growing competition for livelihood. Because of this competition, publicity has become an important issue, in that everyone is anxious to advertise his own goods. Thus, while the search for form goes on—in solitude and silence, at best—it oftentimes happens that a loud-speaker is employed to trumpet widely and effectively that the search really is going on—in "solitude and silence."

That's the reason for worry!

III. PROSPECTIVE ANALYSIS

IT MUST be understood that the post-nineteen-hundred form-development, as it has progressed up to this date—and as it has been analyzed in the preceding chapter—has by no means as yet reached its final state with an ultimate goal in sight. Rather, it has been only the beginning of a long and persistent fight for freedom from the tightly snared shackles of the pre-nineteen-hundred form-concept. As such, it has been somewhat of a preparatory orientation in the determination of how and where to shake free from these shackles. The often mentioned "styles" and "isms" have been those tentacles which, all along the broad front of form-search, have been stretched toward new aims and new ways to feel out all the possible routes along which to go. But in spite of its nature of preparatory orientation, the post-nineteen-hundred form-development—as it stands now—has resulted in a considerable achievement. In many respects it has cleared the way for further form-search: by the elimination of many mistakes, by the opening of new vistas, and above all by its bold and unbiased approach to heretofore untried solutions in architecture, in painting, in sculpture, and in all the other fields of art. Having done so, this form-development—to wit, this new "form-concept"—can already record decisive gains in the progress of form-search toward a style-form of our era.

On the other hand, as we stand now on the threshold of the future and review the gains made thus far, it must be freely admitted that this new form-concept has not yet been able to penetrate very deeply into the general consciousness of the time. It is not yet become that form-concept with which the majority of the people would like to live. Really, this new form-concept is widely regarded as a strange phenomenon. It has not grown from within; rather it has been

imposed from without—so it is said. For this reason it is looked upon with mistrust. It is considered something "modern"—"modern" architecture, "modern" painting, "modern" sculpture, "modern" this or that—where the epithet "modern" signifies something of an ephemeral vogue only, doomed soon to pass. And so, eventually—more-than-many seem to think—that old and well-worn "form of beauty," seasoned during centuries, will be reinstated into its former glory.

Well, if that old and well-worn "form of beauty" really —and eventually—were ever to be reinstated into its former glory, certainly this would mean lack of cultural vitality and ambition. It would mean cultural bankruptcy. That's what it would mean, at least as far as art is concerned. And indeed, **can there exist culture without art?**

So then—to settle matters—what do we have in prospect for the future of our art?

Let's just ask.

Of course, nobody can furnish an answer that is cocksure and crisp. But the issue is too serious to be left to the mercy of the four winds, so we must try our best.

Now—as we see it—there are particularly two factors of decisive importance in weighing the pros and cons insofar as the future of art is concerned. First, we have **"scientific discoveries,"** which in every phase of human activity have produced new possibilities and augmented opportunities, material as well as spiritual. Second, we have the present **"world-catastrophe"**—political, social, economic, and cultural —which, no doubt, is going to etch deep marks into each individual's life, and thus into the whole order of mankind.

As for the first factor—"scientific discoveries"—it is well-known that the contemporary life of the civilized community vibrates on an entirely different plane than it did not so long ago. Thanks to scientific knowledge and human inventiveness, there has been brought to the market a growing abundance of industrial products. All this—in one way or another—has altered man's life conditions in homes, in towns, in cities, and in the country at large. All this has brought men, countries, and continents into a lively inter-

communication on land, on water, and in the air. All this has altered much of that intimate spirit of the past when the making of all things by hand infused creative essence into the circumstances of each life. And all this has brought into our everyday life that impersonal feeling of machine production, concentrating creative activities into a few brains only, and affecting the rest with the non-creative monotony of mass-production. So things are now.

And so things will continue to be: acceleratingly.

For sure, there will be a constant increase of inventions, of inventions, and of more inventions. For sure, there will be a constant increase of production, of production, and of more production. Undoubtedly then, our age, as the veritable "Machine Age," will continue to be so—acceleratingly.

As for the second factor—the present "world-catastrophe"—this catastrophe is too enormous and widespread to enable one to grasp its consequences as to both duration and momentousness. Historically speaking, this catastrophe, in scope, in violence, and in barbarism, has surpassed any previous agony that mankind has gone through. If, nevertheless, we were to seek a parallel—somewhat similar in character, although less globe-embracing—undoubtedly that barbarian invasion which caused the downfall of the Roman Empire, would be the nearest one. Considering this barbarian invasion and its dire consequences, there is reason to ask: Is this agony that humanity is passing through in these grave times going to end in a long and dark night of cultural depression like that long and dark mediaeval night which followed Attila's devastating incursion? Or—to look upon things more hopefully—has mankind enough stamina to survive the present world-disaster and rise from it, healthier than before and purified in a "new and better order"? Could such a happy turn of things really be possible—perhaps in the same way that the human body gains in strength and vigor after having survived a violent typhoid fever?

Is there an answer?

Well, considering these two factors—"scientific discoveries" and the "world-catastrophe"—let's formulate our questions thus:

As regards the first factor, let's ask: **is the present "Machine Age" going to dominate future form-development to such an extent as to produce a form which is too much influenced by the cold and impersonal spirit of mechanization?**

Again, as regards the second factor, let's ask: **is the present world-catastrophe a sign that Western Civilization is doomed to disintegrate, and that mankind is heading toward a long and dark cultural depression?**

And if—thanks to some happy perception—we can find sufficient reason to answer the latter question with an encouraging denial, let's then ask, further: **does humanity, after the present crisis is over, have enough sincerity of heart and creative vitality to raise its form-development onto a level of truly cultural significance?**

It is important to have at least a likely answer to these questions. For, after all, the results of form-search are highly dependent on the quality of the soil from which form is to grow.

So then:

1. The Machine Age and its Consequences

In an age when almost every child can distinguish a combat-plane from a flying-fortress, and when scientific knowledge and technical cleverness can produce almost everything out of almost everything, it would be a pretty inadequate guess to conceive future form-development in other terms than those inspired by mechanization. This must be true, particularly insofar as that broad and growing field of forms for man's physical accommodation is concerned.

Machines and machine-made products are the dominant characteristics of the present era. Unquestionably it will be so during a long period to come. New inventions, new means, and the desire for ever new conveniences direct the course of things. And the more things advance in this same spirit, the more there will appear new demands to satisfy. Matters certainly develop in a constant crescendo with ac-

celerating possibilities on the horizon. One is often disposed to speculate about future conditions—about the hyper-mechanized lives of one's descendants and about countless new and often fantastic demands for conveniences such as the present generation scarcely is able to imagine. All of which is highly exciting.

This excitement is in perfect accord with human nature. For novel opportunities of increased enjoyment of life are always likely to be exciting.

So, for example, when a narrow minded individual suddenly comes into possession of a great deal of wealth, and is rated "nouveau riche," he acquires novel opportunities for increased enjoyment of life. His life conditions have suddenly changed and he begins to look upon all things through the spectacles of money. Money is his interest, his implement, and his might. And one can read from his face and his confident bearing that there is a lot of wealth about him.

Under those conditions, man is a slave of money.

After some generations, however—provided there still is wealth in the family—excitement about money has perhaps waned and cultural interests have been brought into the foreground.

If so—then man has become master of money.

Well, as for machines, we are now very much in the position of a "nouveau riche." We look upon things through the spectacles of the machine. The machine is an achievement of our era, and we are proud of this achievement. Machine making is so new, so stimulating, and so immensely exciting!

Novel opportunities, as we have said, are always exciting.

Man, during the course of history, has gone through many an excitement because of novel discoveries and inventions. Later, however, when the first intoxication has been overcome and things have become turned again into regular channels, the original causes of these excitements have become accepted as natural facilities contributing to man's daily convenience. There must, for example, have been much excitement when bronze was discovered and came into use. After the dullness of the stone-age, this new material

opened new opportunities of having new tools—new "machines," why not—to work with. This must have been exciting. After bronze, came iron with a new opportunity to produce tools and things. Then came steel. And so on. Excitement at the first moment. Then adjustment of this excitement into the regular course of things.

So man's conditions have gradually developed. And now man is using stone, bronze, iron, steel, and many other things. But he is using them without excitement and only insofar as they are serviceable for his purposes. Eventually even the machine may come to be ranged with these other things as a mere normal matter.

After the excitement has died down.

As for machines, we can be sure of one thing: due to the fact that man is able to invent machines, to produce them and use them for his manifold purposes, he will continue to do so and he will produce more and ever so much better machines. And so it must be, for this is a sure sign of technical progress. But—on the other hand—supposing that clear thinking would eventually bring man to his senses so that he would use machines reasonably; that is, only to such an extent and in such a spirit as is appropriate for human living with predominance given to spiritual issues. If such were the case, man would work his way out from the chains of the machine.

Eventually then, man would become master of the machine.

Indeed, why should man necessarily be governed by his enthusiasm for machines! Couldn't he just as well be moved by spiritual stimuli? Certainly he could—and should. Therefore, the character of man's development now and hereafter depends largely on which of these two tendencies—the mechanized or the human—is going to be the stronger. Just now the tendency to mechanization seems to inspire popular fancy. But when things become stretched to the breaking point—as may happen, someday—the logical continuity of machine enthusiasm might come to an end and there might enter a tendency to the opposite. Accordingly, supposing that the present enthusiasm for machines should

gradually subside, that there should enter a growing feeling of emptiness—of "horror vacui"—into the general attitude of mind, and that future generations should become discontent with the coldness of mechanization. Supposing that future generations do not feel any excitement in driving and flying around with the maximum of speed, but that they regard this as sheer foolishness and therefore arrange matters in accordance with their own placid inclination toward living. Supposing that future generations become tired of the exaggerated "rush," so characteristic of our age, and—by using their hearts and brains—come to realize that there is no need for hurry at all, and that there never existed any reason for it, and never will. And supposing, furthermore, that future generations, more than heretofore, begin to realize the necessity of deeper cultural endeavor, considering such an endeavor of more importance than all the physical conveniences—and inconveniences—that mechanized restlessness has brought into millions and more millions of lives. Supposing that all this should happen; undoubtedly then, form-evolution would turn into such channels as could bring cultured significance into man's art.

All this may sound like building air-castles, but in this speculation we are not the only ones. This kind of speculation has already gained much ground and no doubt in the future it will gain still more. A great deal has been written about the dangers of over-mechanization, through which man is apt to become largely reduced to a cog among the wheels of his machinery. In countless circles—those where the happiness of mankind is a sincere concern—this possibility has been recognized, again and again and already long ago.

But, what about it!

Once our age has accepted the broad avenue of mechanization, we must run its course to the end. For sure, **there is no escape.**

Writing about these matters, Walter Rathenau—the German industrialist, philosopher, and author—confronted the "mechanization of the human soul" with the "longing of the human soul" for escape from the imprisonment of this mechanization. Thus wrote Rathenau: **"There is no doubt**

that the present trend to mechanization is going to penetrate all of humanity so that even the most remote jungle-dweller of New Guinea will have his share of it, eventually. But at the same time"—Rathenau wrote—"there is already now, at the very crossroads of this mechanization, evident signs of longing to get away from its grip. And, no doubt,"—he continued—"the more the mechanization trend spreads, and the deeper it touches the most intimate human chords, the stronger the longing for freedom will grow."

So wrote Rathenau, already half a century ago.

Due, however, to many years of warfare, with an intense production of all kind of war-implements—and with the miraculously destructive success of these—much of this longing for freedom from mechanization is undoubtedly going to be postponed. That is: machine-enthusiasm seems to be still on the rise. This enthusiasm may, and probably will, last for some time to come. But the higher the altitude it reaches, the deeper the change will be. It is psychologically conceivable—and so testifies the history of man—that after the human mind has been saturated with overdoings in one direction it is likely to swing the other way.

This might or might not happen with machine-enthusiasm also.

After all, human evolution does not go in a straight and continuous line. It goes in cycles. One day Voltaire, d'Alembert, and Diderot preached the clearest reason, and the general attitude of mind went toward enlightenment and rational thinking. But, because of this over-emphasis on reason, a few decades later the neo-romantic movement laid its overemphasis on emotion. Today we are in the midst of the matter-of-fact era of mechanization. Tomorrow our emotions might take things into their hands. So it goes in cycles. Sometimes these cycles are of short duration only. Sometimes they are longer. How long is the present cycle of machine-enthusiasm going to be? That's the question.

The answer to this question has two phases. First, there are technical problems to be considered. Secondly, there are human problems to be considered.

As for the first phase—the technical—the answer depends

much on **how long scientific discoveries and technical inventions are going to be able to furnish production with continual novelties to keep the matter exciting.** At present there is a high tide in this respect and no impossibilities seem to exist. But by and by, no doubt, the tempo is bound to slow down. And what then. . . . ?

As for the second phase—the human—the answer depends much on those conditions **into which the present world-catastrophe is going to lead humanity.**

So then:

2. The World-catastrophe and its Consequences

In whatever manner power politics, social ideologies, nationalist ambitions, internationalist passions, or otherwise may try to swing the wheels of the present world-catastrophe into one direction or another, and however some of these might succeed—more or less temporarily, perhaps—in turning things in the direction of their own ideas of "social order," this catastrophe is too thoroughgoing and widespread to be controlled in its course. And, really, there scarcely exists a single living being on this earth, who is able to predict the ultimate outcome of the catastrophe. Consequently, as we set out upon the task of handling this subject ourselves, it goes without saying that we cannot make any conclusive statements as to what is going to happen, and what not. The only thing we can possibly do is to try a synthetic survey of the situation—and from this survey everyone is free to draw his own conclusion.

It was just mentioned that there are fluctuating cycles in the evolution of civilization and that these cycles are of varying wave-lengths. There are cycles of short wave-length which fluctuate within each single epoch of civilization. There are, on the other hand, cycles of longer wave-length that embrace entire epochs. And once the bottom of one of these long-range cyclic waves has been reached, that particular epoch of civilization is definitely at an end. There is no need here to cite historical examples: they are too

obvious and too familiar. Our main concern must be to make clear to ourselves what our own position in this long-range wave of Western Civilization is. That is, are we still going upward or are we on a temporarily high or low level of fluctuation or are we heading toward the inescapable finale?

Some observers report a definite downward trend. The most outstanding, perhaps, of these observers—Oswald Spengler—has made with German thoroughness an inclusive analysis of this matter in his voluminous and superbly written "Decline of the West." This opus—published in 1921— is so impregnated with facts, with knowledge, with parallels, with statistics, and with seemingly rather arbitrary conclusions, that—while Spengler may be right or wrong—there are plenty of loopholes through which to escape his reasoning! The quintessence of Spengler's studies and conclusions —put into a bitter pill—is something like this: the aged structure of Western Civilization is cracking; its order is speeding toward disintegration; soon there will be nothing but worthless refuse left in that once so abundant gold-mine; the work will be finished—and then someday new races in new places will start all over again.

Well, we are not experts in history. Nor is it our ambition to compete with those saturated with facts and immense knowledge. We are merely seekers in the field of art. And in and through art we may be able to sense the strengths and weaknessess of man's endeavors. For as art, good or poor, expresses truly the conditions from which it springs, then art is indeed a reliable recorder of the vibration of life.

Considering the latter part of the nineteenth century, our analysis has clearly shown that the prevailing art-form— no matter how highly it was esteemed in those non-creative days—has now to face a hopeless death-struggle till it is doomed gradually to lose the fight and ultimately—let's hope—be fittingly consigned to its columbarium as a mere historic art-form. The cause of this losing fight lies in the obvious fact that the soil of the time—with its changing and often conflicting viewpoints—has been and is unable to

germinate adequate nourishment for those obsolete and dwindling Classical-Mediaeval-Renaissance form-concepts that have been dragged along through centuries as traditional decors from bygone days. And since these obsolete and dwindling form-concepts have sunk deeper and deeper into a deplorable uncreative state—first in architecture, then in painting and sculpture and all the other arts—it is no surprise that this kind of reproductive art has become doomed to degenerate gradually into dogmatic sterility. And now the sterile features of this reproductive art are spread all over our living spaces, bringing bewilderment into the general art-understanding and affecting all minds with their sterility. Often these sterile features remind one of dried trees in forsaken swamps.

Now, what about all this sterile state of things?

Well, didn't we maintain a short second ago—as we have stressed many a time—that art, good or poor, expresses truly the conditions from which it springs. In other words, **quality of art is the infallible barometer of quality of culture.** Consequently then, if art has lost its creative vitality and has declined into doctrinal sterility, this only shows that the corresponding cultural epoch has become tired, indolent, and lacking in that stamina which is so essential for its existence. That is to say, frankly the epoch is close to its end. Things being so, we might as well accept Spengler's thought of the decline of Western Civilization—at least insofar as that nineteenth century brand of Classical-Mediaeval-Renaissance traditions is concerned.

Meanwhile, the indoctrinated inheritance of the Classical-Mediaeval-Renaissance traditions has been effective in other fields than art. It has had a broader significance, for actually its doctrinal bias has penetrated into the attitude of mind in almost every human activity. Really, if we were to delve deeper, we would find that the **ethical basis of all mankind**—that serene thought of the "Confucius-Christ-Marcus Aurelius" order, **the essence of which must be always with man as long as man is worth his name under this sun**—has often been distorted almost beyond recognition. That is to say, this very ethical basis of all mankind, so simple and so

true, has gradually become so overloaded with all kinds of traditional trimmings—dogmas, doctrines, rituals, prejudices, camouflaged iniquities, and many other things—that one is scarcely able to discern the fundamental meaning of the simple truth of this ethical basis of all mankind. And although the fundamental meaning of this simple truth has been stressed and stressed again through all the ages—in speech, in writing, in action, and otherwise—nevertheless its trimmings have taken the command into their hands. Indeed, this ethical idea of brotherhood—that best concept of man—has been widely forgotten, whereas all sorts of conflicting religious denominations, reciprocally hostile ideologies, racial prepossessions, national and international intrigues, pursuit of power for the sake of domination and aggression, injurious manipulation of "high finance," pernicious political gambling, and so on have caused and continue to cause all kinds of disturbances, suffering by millions and more millions, revolutions and revolutions again, wars and more wars—and finally that momentous atomic bomb. **And all this has been accomplished with the sweetest makebelieve that the aforementioned ethical basis of all mankind, so simple and so true, has been and is sincerely revered!**

So then, after observing all this unscrupulous maneuver with sacred issues, we might more than ever be inclined to accept Spengler's prediction of the early downfall of Western Civilization.

Well, before we do so, let's have a look at the reverse side of the medal.

And here we will find this:

Deep within the seeking soul of today, a new order of vibration already is felt. It is the undercurrent of a new "world-feeling," and indeed the seed of this new world-feeling is not from just yesteryear.

Long ago, when Copernicus suggested his heliocentric world-order, he planted in the human soil a seed, which subsequently has had a tremendous growth, thanks to man's untiring search. Thanks to his untiring search, man has uncovered an ever growing number of secrets of the universe and has opened ever new fields of thought and contemplation.

Man has been searching along two fronts—the microscopic, and the macroscopic—whereby to survey all possible provinces of science. With the aid of his microscope, man has gone far into the deepest depths of atomic existence and has found there a new world of sublime design. With the aid of his telescope, man has received far-away messages from boundless and ubiquitously vibrating space, and myriads of gigantic world-systems have been brought into the sphere of man's consciousness. In this manner there has been a continuous unveiling of the "Grand World of Order," a world of order that olden times could scarcely have dreamt about, and the depths of which man never will be able to comprehend.

Thus, thanks to his untiring search, man has created for himself a new world in which to live.

This new world is widely different from that old world of Aristotelian thought—a world of geocentric order where man sat throned on his earth while suns, planets, and stars had their celestial dances about him. This new world is widely different from that old world of Dante's petty "heaven-above-hell-below" bigotry where man lived in constant fear of cruel punishment. This new world is widely different from that old world of Classical-Mediaeval-Renaissance tradition with its stagnated laws and regulations from long dead eras of civilization. In fact, this new world is different from any previous world-concept, **for it is a world of boundless magnitude where our globe is but a particle of dust amid myriads of gigantic solar systems, and yet unlimitedly rich, deep, and noble in thought and design.**

But just as much as man—thanks to his untiring search—has created for himself this new world in which to live, equally much will this new world—thanks to its incomprehensible magnitude and divine thought—transform man into accord with it. Ultimately then—provided science is given enough time to ferment man's mind, heart, and soul—there will come into existence a new man of **heliocentric order,** so to speak. We do not mean by this a man who has all the knowledge of the heliocentric system of world-order. Rather, we mean a man **who is converted to his belief**

through the logical consequences of this knowledge so that he may bring "knowledge" and "belief" into true harmony.

Indeed, to bring knowledge and belief into true harmony is most essential for the balance of one's mind. For, if there is disagreement between scientific knowledge and religious belief, scientific knowledge will most likely get the upper hand and religious belief is bound to lose its authority. Again, if religious belief loses its authority, religion is degraded to a mere camouflage of irreligious bigotry and society is doomed to disintegration.

Certainly, this is no strange phenomenon these days.

On the other hand, **if scientific knowledge and religious belief are brought into true harmony, authority of religion then is restored, and society gains in spiritual strength.**

And certainly: **spiritual strength based on authority of religion, is indispensable for the preserving of civilization.**

Undoubtedly, already for a long period of time, increasing numbers of people have been eager to find—in science—answers to many a vital question in their spiritual life. Undoubtedly, from now on and more particularly in the future, this same eagerness will become increasingly true. As time passes, therefore, man might gradually free himself from many traditional convictions—such as in the course of time have become obsolete. On the other hand, man might accept gradually many new convictions—such as are in agreement with scientific knowledge and with the best understanding of the evolution of life.

Here, then, we might discern a dawning new "world-belief."

Now, this metamorphosis of man's mind in bringing scientific knowledge and religious belief into true harmony is undoubtedly going to require a long time of mental fermentation.

Therefore, may we ask:

Can the mind of the present age become ripe enough for a new "world-belief" before the sun of our epoch has sunk?

Assuming a negative answer, may we then ask this:

Where, on the surface of this earth, will that next epoch of civilization take place, which is going to inherit—in a cultural sense—the scientific gains of our age?

In order to bring an answer to this question, one must bear in mind that, in the past, any civilization was more or less a local manifestation, covering only a relatively limited section of the globe. And once some particular civilization had run out its course, perhaps another civilization in another place was already in the making. So, for example, when the Egyptian era was downward bound, the Greek era was already far in process. Now, the actual distance between the respective nuclei of these two eras was about the same distance as that between Rome and Copenhagen or New York and Chicago. Of course, such distances do not count any more, for Western Civilization has reached practically all corners of the explored earth. And if large areas of this territory have not as yet been influenced by Western thought, eventually they will be so, at least in two decisive instances. First, they will be influenced by Western thought because of the progress of science—which is of international appeal, and independent of racial or other inclinations. Second, they will be influenced by Western thought because of mechanization—which also is of international appeal, and which, to quote Rathenau again, will enventually reach "even the most remote jungle-dweller of New Guinea." These two instances—science and mechanization—are the two international languages which, ultimately, will cement all of humanity—independently of race, color, or creed—into one and the same epoch of civilization—**under one and the same roof,** so to speak.

Somewhere, **under this same roof,** therefore, the next epoch of civilization must be housed, whenever it is ripe to come.

Metaphorically speaking, the situation is this:

Under the same roof the father is aging, and by and by expecting the end, while his young son is growing up and already dreaming of his manhood days. Here we have two generations, unlike in their respective dispositions of mind toward the problems of life. The father is the old medi-

aevalist, living in his highly decorated dwelling of obsolete style. The son, on the other hand—forced for a time to dwell in that same atmosphere of obsolete decoration—is eagerly looking toward the future, dreaming of his future home, with its new design already in his mind.

Isn't this a characteristic parallel of conditions at present?

That is:

The old geocentric Classical-Mediaeval-Renaissance disposition of mind is doomed gradually to wane, while the youthful heliocentric disposition of mind is maturing. Here we also have—**under the same roof,** so to speak—two "eras," different in their respective dispositions toward the problems of life. The old backward-looking disposition of mind is surrounded by its own atmosphere of traditional doctrines from bygone historic times. The youthful forward-looking disposition of mind, on the other hand, is still compelled to dwell in the same atmosphere of traditional doctrines, although it is already far advanced in the search for its own thought.

Now, the question is: **are we the father; or are we the son?**

In other words, does the status of our civilization, at this moment, indicate that we belong to that Classical-Mediaeval-Renaissance concept of geocentric order; or does it indicate that we belong to that vital scientific era of heliocentric order? Or let's put it thus: do we belong to a decaying civilization where the present world-catastrophe is the deciding death-struggle announcing the end; or do we belong to an upward-going new civilization where the present world-agony is only a purging process toward better health, perhaps in the same sense—and we repeat—"as the human body gains in strength and vigor, after having survived a violent typhoid fever?"

Indeed, **the spirit of the answer is the answer.**

If the answer indicates that our matured civilization is heading toward its end, this only shows that we are tired, apathetic, and indolent; and if so, the end is surely ahead of us. On the other hand, if the answer indicates that our

young civilization has already for a long period of time fought for its freedom from the doctrinal shackles of the past and that we—boldly, eagerly and open-mindedly—are looking toward the future, then certainly we are going forward.

Consequently, in refusing to accept the attitude of a Spengler, we believe in the future of our civilization.

This is not a prophecy.

It is just a point of view. And as such it is a more optimistic point of view than are the ideas of those predicting the end. We insist on optimism. **For pessimism in itself indicates a downward road, whereas optimism is the bright road that inspires to new deeds.**

Also, now that we have arrived at a positive answer—what about the quality of the coming form? That is—and we repeat the next question on our program—**"after the present crisis is over, does humanity have enough sincerity of heart and creative vitality to raise its form-development onto a level of truly cultural significance?"**

So then:

3. The Cultural Significance of Form in the Making

As regards the cultural significance of our form, we can be short and concise; for if form is to have cultural significance it must first be creatively vital and honest. The rest follows automatically.

Considering the high standard of the Egyptian achievements, it must be admitted that art during the past five thousand years has not developed for the better—and this we have already mentioned. Development of standard, thus, is not a reality—at least, not historically speaking. The whole is only a dramatic change of form. In fact, if we get right down to the bottom of things, there is only one standard according to which the value of art can be measured, and that is **the truest expression of the best of life.** This is the ultimate distinction that art of man can attain.

Also, as we are speculating in terms of the future, we

should not soothe ourselves with the sanguine thought that things are going uphill insofar as opulence of form is concerned. They are not. Nor is this necessary. It may be that the Chinese Pagoda and the Gothic Cathedral, in comparison with our present and future form, are richer and more outstanding; and it may be that the epochs we have mentioned would have found our form poor, cool, and frugal. But we cannot help it. We have to make of our form the best we can, knowing that only in such a manner are we able to be truthful to ourselves and able to accomplish true art.

And—finally—to be able to accomplish true art, our actions must be based on those principles that are fundamental, and that are innate in all things.

These fundamental principles we are going to discuss in the following, PART TWO.

<p style="text-align:center">* * *</p>

PART TWO

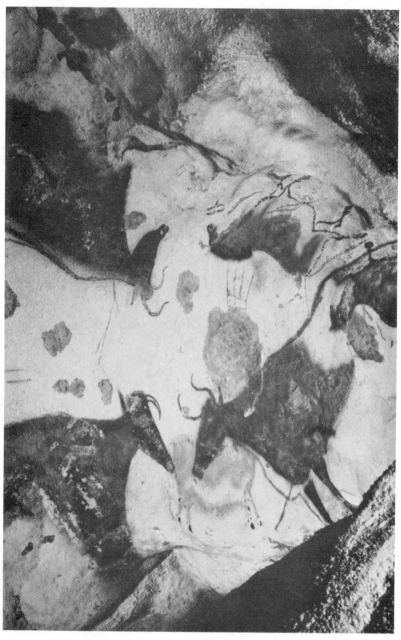

PLATE 5. THE PREHISTORIC FORM
Cave paintings from Montinac, France.
Time: 20,000 to 15,000 B.C.

PART TWO

THE first chapter of this PART TWO—**The Creative Instinct**—emphasizes the creative nature of art. Furthermore, it emphasizes the fact that this creative disposition is a matter of instinct: whereas intellect plays only a supporting role in the process of creation.

Moreover, this chapter tries to bring "scientific validity" into the above statements.

* * *

The second chapter of this PART TWO—**Organic Order**—emphasizes the fact that "organic order" is the principle of architecture in all of creation, and it elaborates on this fact by introducing two satellite principles—the daughter-principles of "expression" and "correlation."

These two satellite principles constitute the topic of the sub-chapters: **"Form and Expression,"** and **"Form and Correlation."**

* * *

The third chapter of this PART TWO—**Form and Vitality**—deals with the problems of vitality and decay, and with those of permanence and ephemerality.

* * *

The closing chapter of this PART TWO—**Form and Time**—brings the element of "time" into the discussion. Consequently, it elaborates on the theme of constant change in form-concept, as time moves on.

In this chapter there are four sub-chapters.

First, there is the sub-chapter **"The Fundamental Form,"** pertaining to a fundamental, and yet constantly changing form-concept.

Second, there is the sub-chapter **"Form and Evolution,"** pertaining to a specific evolutionary change of form-concept depending on potentialities from within.

Third, there is the sub-chapter **"Form and Migration,"** pertaining to a specific change of form-concept depending on influence from without.

And fourth, there is the sub-chapter **"Form and Style,"** pertaining to the final outcome of form-concept.

* * *

IV. THE CREATIVE INSTINCT

INTRODUCTORILY, this we have said:

"In all this discussion of man's apprehensive faculties of one kind or another, it is important to mention particularly those faculties which are most essential in the search for form. First, there is the faculty of man's 'intuition' to establish immediate contacts with primary facts and truths. Second, there is the faculty of man's 'instinct' to record vibrations of life and to transmute these vibrations into corresponding form. And third, there is the faculty of man's 'imagination' to produce mental ideas and pictures that have no relationship to previous concept, knowledge, or experience."

When it is said that **intuition** establishes direct contacts with primary facts and truths, this is fully plain, and there is nothing more to say. For, whoever tries to elaborate on the matter soon becomes involved into a network of arbitrary assumptions. Thus someone has said: "It is easy to know God, as long as one does not vex oneself to define Him."

As for **imagination,** this, too, is a pretty fluid case and, therefore, this matter is going to be the last one of our "intangibles."

With **instinct** the situation is different.

True enough, even here one frequently gets entangled in intangibilities, but at any rate, instinct is a matter which must be made clear before one is able to define art. In the course of our analysis we have ever so often referred to art as something "creative," where the "creative" quality is infused into art by means of instinct. Likewise we have said that art cannot come into being unless it is instinctively felt. Furthermore, we have said that this is a state of things which prevails in man's art just as much as in nature's art and that "instinctive creation" is a fundamental phenomenon.

It is a fundamental principle.

And, as our task now is to analyze fundamental principles, we are going to make the start with the principle of instinct.

Well:

How does the swallow travel from the north to the south and from the south to the north, always finding the same place to nest? There are no maps to go by. How does the cell find its proper location in the cell-web so as to achieve an expressive pattern of the species concerned? There are no textbooks to follow. How do plants, bushes, trees, and other growing things know that if they do not adjust their growths to the environment the coherence of the landscape could not come into existence? There are no ordinances to obey. And so, wherever one turns for information as to how things are conducted, one always is met by the hidden "how" that sets minds to wondering.

Obviously, in all this, the credit must be given to a transcendental **instinct**.

However, to undertake an inclusive analysis of instinct —in order to disclose its inmost nature as to origin, source of potency, mode of function, et cetera—would bring us into regions not yet and perhaps never to be explored. Consequently, we shall limit ourselves to a few characteristic traits, so far empirically experienced. Moreover, we shall eliminate from our discussion those instinctive manifestations which —atavistic or directly hereditary—constitute, so to speak, routine operations; such as, for example, the above indicated peregrination of birds along pre-established routes, generation after generation. Our object of search concerns primarily art—whether nature's or human—and because art is creative by nature, we must examine even the manifestations of instinct from fields where any action establishes new values by a constant creative process. In other words, we will consider chiefly the **"creative instinct."**

It is refreshing and instructive to walk in an early spring morning when nature is stirred from her wintry trance.

Wherever one looks, tiny buds are stretching out their heads as if trying to get a peep at weather, wind, and sun, so as to learn how the day's doings should be set. They all look youthfully healthy and energetic. And eagerly they seem to breathe the invigorating freshness of the morning dew. One feels as if walking among living beings, conscious of the existence of one another. One feels as if there were much looking around and wondering, and as if there were much whispering from bud to bud, from branch to branch. And one feels the echo of this whispering even in one's own veins: cell speaks to cell, "now is the time to do things." Really, one becomes imbued with energy, inspiration, and creative impetus.

Later on, in the autumn days, when one walks along the same path, the same buds have grown into verdant sprigs. Eagerly they wave recognition: "Look here, aren't we grand!" In fact, every branch has put forth new ones from a thickened limb. Every stem has gotten a new ring under the hardened bark. Every tree has grown in volume and size. Yet the material increase has added also spiritual values by conforming the new growth with the old into an enchanting whole—stronger—fuller—richer. Indeed, there has been positive action of gradual growth toward manifest design: expressive of the species, and fitting into environment. It has been the subconscious work of the creative instinct. It has been so all along the whole process of growth. And one feels as if walking in a wonderland of constant creation.

One feels much more so after having gone still deeper into things by observing the minutely pulsing life even in places where the naked eye cannot see. Here, in the concealed depths of organic life—even in areas where the sharpest instruments cannot penetrate—the thread is spun and the weft is laid for material to be made, and design is planned for forms to come. One is amazed to learn how the spirit of creation permeates every part of the organic fabric. And one is eager to learn still more.

Now then, let's experiment with this:

Let's follow the seed's gradual growth into a tree. And

let's assume that one could undertake the impossible task of examining the processes of cell-growth, of cell-movement, of cell-constellation, and of forming of cell-pattern, at every moment and in every part of the organism, and all this during the whole formation period of the species under study. One then could observe myriads of ever new designs, all derived from the same thought and all organized into functional pattern. It would be much like a kinetic performance of constantly novel features, sparkling with life and expressiveness—yet **never two alike.**

Moreover, supposing one were to put thousands of trees under a similar observation; for sure, then, all the more would nature disclose her trend to incessant creation. One would find all the thousands of trees—or millions of them during thousands of years, if you please—individually shaped. Yet **never two alike.**

Now, what would be the logical conclusion of all this?

Simply, that one would find every single cell—and every species as well—an artist, a true artist indeed, creating ever new values. Beyond doubt, therefore, there exists an all governing principle of creation: the "creative instinct."

Perhaps, to some, we might seem to have become involved in scientific digressions, rather than in the study of the problems of art. It all depends on what we are after. Generally speaking, **science means research on the basis of something existing, whereas art means the creation of something new.** Also, to study nature is science. But nature herself is incessantly creative. Therefore, in nature the truest principles of human art can be found—and one of these principles, as said, is the creative instinct.

Being an all governing principle, the creative instinct is in the blood of man just as much as it is in the sap of any healthy cell. That instinct, consequently, is manifested in every individual, more or less. Every individual senses the characteristics of his age and is able to express these characteristics in various ways: in movement, in speech, in thought, in sentiment. And whatever it may be, a certain creation always is achieved. Most of this kind of creation does not,

perhaps, affect the general course of things, but, at any rate, it is apt to indicate the direction of the course. And it offers—perhaps unseen—nourishment to more advanced creative sensing.

However, the various degrees of the creative instinct are marked, for sure. Therefore, when we speak of the creative instinct in terms of art—art in this connection being understood as the profession of artists—we shall take into consideration its artistically creative faculty only. In such an understanding **the creative instinct is the sensitive seismograph that records vibrations of life and transposes them into corresponding vibrations of art.**

Although there is but little chance to penetrate much deeper into the secrets of the creative instinct, nevertheless it is necessary to understand the relationship between the **"meaning to be expressed"** and the **"means of expression"**— between which two attributes the creative instinct functions as the mediator.

This subject, we think, is important and therefore our next endeavor must be to bring some light into it.

Volumes have been written about this matter, and yet the question is still open for ever new considerations. Perhaps the problem is insoluble in the minds of those who try to open up the secrets of art-creation by means of theoretical reasoning and esthetic speculation, where the thoughts have not been made fertile because of the lack of inherent creative instinct and personal creative experience. On the other hand, those who have the inherent gift for originating creative art, sense the solution already in the blood of their veins—yet even they, generally speaking, are unable to unveil the facts by proceeding along intellectual channels. Nor is it necessary insofar as actual creation is concerned.

However, being now tempted to find the keys, at least to come to the secret chambers of art, we must carry the task through as far as we possibly can. To do this, we must, to start with, step over the threshold of science in order to find some explanation of life-appearances in general, of which

art—as we understand it—is an integral necessity to the completeness of the whole.

Now, the scientist tells us that all of creation is a matter of energy, where an eternal and omnipresent movement of vibration takes place and where this vibration brings everything everywhere into existence. Consequently, this must be true even concerning light, color, sound, movement, form and all those media that together constitute the very media of art-expression. Accepting now this thought of vibration as an axiom, we must draw our conclusions accordingly. That is: fundamentally, art is a matter of "vibration."

Vibration, however, must be understood as a matter of "number." This again intimates that the world of number underlies all that exists and consequently that all things are explicable in terms of "mathematics." With this the mathematician is brought into our discussion. The mathematician can be of great theoretical help with his calculations, experiments, instruments, and perhaps with many other things. And yet, even he soon arrives at the conclusion that mathematics—when it approaches the abstruse—belongs to the world of that unknown which is beyond even the sharpest of intellects. Intellect, thus, has to admit its limitations and is compelled to cede further disclosures to instinct. This then means that even the most brilliant mathematical genius, in the solution of purely mathematical problems, must lean upon his instinct. Moreover, when Goethe maintains that "the mathematician is only complete insofar as he feels within himself the beauty of the true," the poet reveals the close relationship between mathematical instinct and artistic instinct. Here we meet the mathematician and the artist on a common plane, both wondering what it is all about. And no matter how they may try to explain number and vibration in the creation of art, all the same they must leave the final word to the creative instinct to decide how mathematical formulas must be established in each individual case, to infuse expressiveness into art.

Really, what is impossible in this respect to the mathematical intellect is utterly easy to the mathematical instinct. So, for example, when the peasant girl of the country-side

is in love, she expresses her joys and sorrows by singing. The more musical she is and the deeper her sentiments go, the more she fills the air with vibrations that are adjusted to the choicest mathematical concept of numbers—beyond even the most advanced intellectual expert. And yet she might not know more about mathematics than to be able to add a few things together with the aid of her finger tips. This surely must seem uncanny to the ambitious intellect. It must seem much more so when considering the fact that the lark in the sky, through its trill, surrounds itself with vibrations of the most perfect infinitesimal calculus.

Uncanny, perhaps, to intellect—**but the most natural thing to instinct.**

When it is said that all of creation is based on mathematics, this does not mean just a simple matter of arithmetic. It means mathematics of the highest order. And of this highest order there are myriads of ramifications, each ramification represented by a "number" of its own.

Take, for example, that love-sick girl and her mathematical adventures. Whether she sings of happiness or sorrow, her number is significant of her individuality and of all that pertains to this individuality. Let's put it thus: she moves, breathes, feels, reasons, and sings in accordance with a number all of her own. Self-evidently, therefore, her number is altogether of another nature than that of the lark. The lark, again, might trill because of summer and sunshine; in any case its number has much to do with the lark itself, with its significance as a songbird, and with many other things pertaining to lark-characteristics. Thus we have two totally unlike number-concepts, each of which, respectively, constitutes the fundamental import of its respective form-expressions.

Drawing our conclusions as to matters in general, it is evident that there are as many "numbers" as there are form-expressions. Accordingly, the number of man in general is different from that of animals in general. The number of a cow is different from that of a swallow; of a pheasant from that of a salmon; of a palm tree from that of a birch; and so

on and so forth in unlimited variations and ramifications.

Again, speaking about variations and ramifications in human conditions as contrasted with one another, we might as well return to our singing girl. It makes all the difference, whether she—say she's a Nordic blonde—sings her melodious elegies in the pale northern summer night, longing for her blue-eyed and far-away friend, or whether she is that dark, fiery, and swift castanet-clicker from the Spanish village, burning and sparkling for the stirring and silver-glittering toreador. Naturally, the numbers would be differently set and used in both of these unlike instances. Similarly, the numbers of South American tangos are unlike the numbers of those songs born on the vast steppes of Russia. And the harmonies of Bach have other number-constellations than have all previous compositions and those of later date.

This last remark brings the element of "time" into our discussion. By this we mean that "number"—in the sense now being considered—is not a static thing. And how could it be. Due to the fact that life conditions and their form-expressions are subject to constant change, naturally then, corresponding numbers also are subject to constant change.

Thus, "conditions of life," "form-expression," and corresponding "number," have been—all along and all together—subject to an evolutionary process. Down the ages these three together have formed various characteristic groups, corresponding to the characteristics of their respective civilizations. Spengler—among others—writes about this same matter in his "Decline of the West" as follows: "There is not, and cannot be, a number as such. There are several number-worlds, as there are several Civilizations. We find an Indian, an Arabian, a Classical, a Western type of mathematical thought, and corresponding with each, a type of number—each type fundamentally peculiar and unique, an expression of a specific world-feeling, reflecting the central essence of one and only one soul, viz., the soul of that particular Civilization."

Now, number is the basic attribute through which "rhythm" is constituted. That is to say, grouping of num-

ber with emphasis on "repetition," "interval," and "accent," brings forth rhythm-manifestation. So is the situation in all of creation. And in this respect there is no difference whether rhythm-manifestation takes place through microscopic variation producing life, light, color, sound, and a great multitude of all kinds of things; whether it causes materialization of line, form, and design-pattern, in dimensions understandable to the human mind; or whether it causes constellation of macrocosmic order in dimension beyond the human mind. After all, rhythm is a universal phenomenon.

And now, with this emphasis laid on "rhythm," we have entered the province of art, for rhythm of a "certain" order is fundamental in art. "Certain," we say, and by this we wish to accent the fact that rhythm in art is not just rhythm as such, but a significative language. It is a "language of number" which the creative instinct—and only the creative instinct—is able to employ by infusing meaning into rhythm, thus making rhythm-manifestation the "means" of art-expression.

The main endeavor of our mathematical excursion was to make evident just this point—the interrelationship between "means" and "meaning." For, as was said at the outset of this excursion: "it is necessary to understand the relationship between the **"meaning to be expressed"** and the **"means of expression"**—between which two attributes the creative instinct functions as the mediator."

As such, the thought of the said relationship is rather logical and clear—we do realize this fact, of course. But our prime aim has been to bring into this thought **"scientific validity,"** so to speak. This "scientific validity" we consider important, indeed. It must be borne in mind that esthetic rationalization—and much actual work in the field of art—do not always pay enough attention to the significance of the above thought.

For example:

According to our mathematical investigation—now we are "scientifically" speaking—the characteristics of Greek

life became transmuted into Greek art. Obviously, then, there existed an intimate relationship—in mathematical terms—between Greek life and Greek art. And by virtue of this intimate relationship—and by virtue of this only— Greek art was "creative and true art." Consequently, if another time were indiscriminate enough to adopt Greek art for its own purpose, indeed then a true relationship— again in mathematical terms—between life and art could not exist. And the adopted, formerly "creative and true art" would cease to be "creative"; it would cease to be "true"; and it would cease to be "art." It were just imitation. Sheer fallacy!

This example is one of many, although perhaps more conspicuous than others, and precisely because of its conspicuousness we will frequently have much reason to refer to it. And because this same criticism that we have found true in this Greek case must hold true in any similar case, it is important to stress the distinction between "creation" and "imitation," even from a **mathematical point of view.**

It is an easy task to establish mathematical records of the rhythmic characteristics of an alien art-form, and to apply these records to our conditions of life. Such a procedure is purely technical and can have nothing in common with the creation of art. It is a reproductive procedure which results in imitation, and as such it must be denounced. Again, as to our own conditions of life, it is an impossible task to produce an art-form of our own by mere intellectual reasoning or by purely technical means. Indeed, it would not result in art in a true sense of the word. Intellect cannot measure the rhythmic characteristic of our psychological disposition toward the problems of life and put them into corresponding form. These rhythmic characteristics must be instinctively felt; they must be felt by the creative instinct; and only by the creative instinct can they be transmuted into expressive form—into form which is "creative," which is "true," which is "art," and which represents the very art-form of our time.

Surely, this is a mystery that intellect cannot solve.
The greatest mystery, however, is the fact that rhythm,

by producing a certain form, makes this form harmonious to the human mind; whereas another form is apt to affect the human mind disharmoniously. Intellect may be of some help in explaining why a certain order of vibrations—often mathematically identified—causes harmonious effects; while another order, or especially disorder, causes cacophonous effects. Furthermore, intellect is able to confirm the fact that harmonious and cacophonous effects, respectively, are constructive and destructive by their respective natures. The validity of this statement can be exhibited by scientific methods: a healthy organism, through an orderly set of vibrations, always has a rhythmic configuration of cell-pattern; whereas an unhealthy organism, through its disorderly set of vibrations, shows a distinct leaning to disintegration. All these points—the harmonious and constructive quality of order, and the discordant and destructive quality of another order, or of disorder—are essential discoveries on which the whole problem of form-world values is based. Through this the positive cultural value of healthy art is scientifically demonstrated.

However, the discoveries of intellect are only statements built upon outer experiences, and by no means disclosures of **inherent potencies.** Therefore, the question still remains unanswered: why do the vibrations of just these certain orders—and only under certain circumstances—have harmonious and constructive effects? The creative instinct, **too,** is unable to furnish the answer. **It is able only to sense the means.**

If we are willing to gain knowledge of the creative instinct and to construct our further analysis of art on this knowledge, we must emphasize particularly two points that we have learned through the above investigation—the validity of which, as said, can be proven by scientific methods.

In the first place, we have learned that **art cannot come into being without the creative instinct.**

In the second place, we have learned that **alien forms, formulas, and doctrines must not be employed to conduct the development of present day art.**

The first point emphasizes creative ambition in all art development. The second point denounces reproductive—and thus imitative—lethargy in all art development.

As the closing point, may we remind of the fact that the human creative instinct is a precious instrument of apprehension, and that everyone sincerely engaged in art must see to it that the sensitive seismographic needle of one's creative instinct be kept clean and sharp.

* * *

V. ORGANIC ORDER*

THE principle of "organic order" has often been referred to. It has been referred to particularly because of its close relation to the structural consistence of the universe. And in view of this fact, we designated the principle as the fundamental principle of architecture.

Furthermore, we said that this principle functions along two distinctly different and **decisive** trends.

These two trends—we said—are twin-principles: the principles of "expression" and "correlation," respectively; and as such they act always and everywhere together and in mutual cooperation. In fact, these two trends are the daughter-principles of the universal principle of organic order.

So then, in analyzing the universal principle of organic order, we will do it best—we believe—by analyzing these two daughter-principles separately.

Accordingly, first we will discuss the principle of "expression."

1. FORM AND EXPRESSION

The matter of "expression" came first into our consideration when studying nature's form-manifestations, and we discovered "that nature's form-richness is established through a certain significative 'order,' different in each case, and expressive of the meaning behind form."

Since then, this matter of "expression" has often come up in our discussions and we have learned to consider

* This matter of "Organic Order"—including its satellites, "Expression" and "Correlation"—I have previously analyzed in "The City." I repeat the analysis here for those who have not read "The City." And I do it now in extended form. E.S.

nature's form-expression a specific language in itself. It is a language by means of which nature communicates with those able to feel and to understand. Thus, the more we study nature's form-world, the more clearly it becomes evident how rich in inventiveness, nuances, and shiftings nature's form-language is. And the more deeply we learn to realize that, in nature's realm, **expressiveness is "basic."**

As for the realm of man, the same is true.

The mere body of man—already as such—is a telling example. For man, as he moves, as he acts, or whatever he does with his body, is a mirror of his inner mood. The muscular changes of his face express corresponding changes of his mind. The sparkle in his eye, the lift of his brow, the wrinkle of his chin, the shrug of his shoulder, and the swing of his hip—all these are expressions of joy, of sorrow, of temperament of one kind or another. And they all convey these expressions to other men.

But, as man—already himself—is an expressive language in the intercommunication between man and man, so much the more does the spoken language serve the same purpose.

The same holds with regard to man's relation to his art.

Indeed, the expressive language of man's art is just as significative a means of intercommunication between man and man as is the spoken language. The nature of this intercommunication, therefore, must be our next problem to tackle.

Now, in this intercommunication there are three factors to deal with. First we have the **artist** who expresses himself through art. Second we have **art** which radiates this expression. And third we have the **public** to which this expression is conveyed.

In order to bring light into the proper relationship between these three factors, we must first of all investigate the origin of this relationship: **man himself.**

a. Aura of Man

From whatever angle one tries to penetrate into the secrets of human art in order to arrive at correct conclusions, one

thing is sure: **the answer to all the problems of human art must be found in man himself:** man is the stage-manager.

Already subconsciously one senses that the achievements of the past mirror the inmost characteristics of the respective minds and peoples who directed the play behind the stage. Art of the great civilizations, really, is like an open book with its unmistakably clear language. It conveys the emotions and thoughts of the historic ages in much surer terms than historians have done, or possibly could do.

What in this respect is true concerning the past is equally true concerning the present. And what holds good in general terms must hold good even in individual cases. In his work, the author opens his soul. So does the philosopher. So does the composer. The more direct and honest the work, the deeper does one feel the inner drift that brought this work forth. And so, when we ask: "What is art?" the answer, as said, must be found in man himself.

But, let's ask first: **"What is man?"**

Well, the answer to this depends much on from which point of view one looks upon man. But as we are now dealing with the problems of form, we might then—to be consistent—look even upon man as a matter of "form." That is to say, let's consider man a living organism which radiates its influence—just as does form.

Now, the spiritual essence that radiates from an individual is called "aura." Originally, aura meant breeze. It meant "gentle breeze," often personified in Greek art and literature. In such an understanding, aura symbolizes something ethereal radiating from one's personality and having a distinct influence on one's surrounding.

Everyone radiates a certain aura.

Supposing that you are sitting alone in your study, working, reading, or just meditating. Supposing furthermore, that you are at the moment in an open mood so that impressions from the outside are not apt to disturb you. Then suddenly, someone enters your study, someone you know nothing about, nor whence he comes nor for what purpose he has come to see you. You look at him. And you

find that you are confronted with an appearance consisting of proportions, masses, rhythm, color, and movement. From the first moment, this appearance conveys to you a distinct impression—perhaps sympathetic, perhaps unsympathetic. And instantly you feel that a strange atmosphere, corresponding to that very appearance of the entered person, has permeated your study.

It is his aura.

Also, while a moment ago your personality alone dominated the room, now the human atmosphere in this room has become a combination of two sets of waves which either blend harmoniously or cause discord. If these two sets of waves, yours and his, establish an accord of vibration, you feel mutual sympathy. In a reverse case, the contrary would happen. Sympathy or antipathy are apt to impress both of you equally strongly, in case both personalities are of equal strength. But supposing you are the stronger. You then will impose your personality upon the other, and he becomes influenced by you. And the positive or negative quality of this influence depends on the character of your personality.

In most cases, the aura of an individual has only a momentary power of influence, and this influence disappears as soon as the individual himself disappears. Sometimes, though, such an influence is lasting, depending on strength and quality. Sometimes, again, when two persons meet one another for the first time, their mutual influences might establish a lifelong contact. In general, the first influence can be corrected, strengthened, or weakened by closer contact. Such closer contact is apt to bring to light some mental characteristics, not before observed. Hence the changes. In fact—and so must aura be understood—the influence of aura radiates primarily from the mental characteristics of a person. His physical characteristics—naturally being congruent with the mental—strengthen the influence.

During the course of his life, an individual goes through a continuous metamorphosis in the making of his shape. The different stages of his physical development are expressed and the development of his mental ego is reflected in his appearance, in the carriage of his body, and in the bearing of

his head. In other words, his aura is under a continuous evolutionary change. This means that every person begins from childhood to build up his individuality. A baby does not have much individuality to begin with. But the possibilities of development lie hidden in his birth and in the experiences he is going to have during his growth. Every moment brings something mentally new to the aspiring individual. Every new mental experience sets its traces in the bodily aspect. And so every person, during the growth of his mentality, goes through a corresponding bodily transformation. In this manner his outer aspect develops into an integrality of characteristics which reflect his inner characteristics. And the combination of outer and inner characteristics constitutes his personality—his aura.

It really is amazing to observe how everyone—no matter whom one considers—is a millionfold constellation of one and the same key of order, characteristic of that person only. Everyone has his characteristic rhythm of movement, when walking, gesticulating, speaking, laughing, et cetera. In this peculiar rhythm of movement his personality comes into appearance. And whatever movements—physical or mental —one examines, there always is an evident congruity with his other movements. All these combinedly, constitute a distinct formula of "individuality"—if we may say so—which does not exist elsewhere, which never existed before, and which never will appear again. Whence this "individuality" has its origin and where it is heading, no one knows—and to know this is not our concern just now. But, were we to delve into the problems of congruous actions, we could not escape the thought that a person, during the whole orbit of his development, whether he creates, understands, or appreciates art—to mention those faculties we are now interested in—is subconsciously bound to do it in accordance with that "individuality" he represents. In fact, these faculties—and their consequences—grow just from this very "individuality." And were it possible to discover all the mysteries of mathematics, one really could reconstruct a mathematical formula—a module, if you will—according to which an individual exists, acts, and works, in all his comprehen-

siveness, no matter how personal or impersonal. Certainly, he is a "microscomos," as Paracelsus, the philosopher, once put it.

b. Aura of Form

Now—as just said—an individual, in creating art, **"is subconsciously bound to do it in accordance with that 'individuality' he represents."** In other words, an individual transposes his "aura of man" into his "aura of form."

So then, while Rembrandt walked and worked on this earth, and while he might have influenced his surroundings with the vibrations of his aura, first of all he transposed these vibrations into the enchanting pigment, light, and shadow of his canvases. That is, he transposed his "aura of man" into the "aura of form" of his art. Yet, while Rembrandt and his aura have been gone for a long period of time, nevertheless that vital aura of his art still remains undiminished, exerting its influence upon humanity, century after century. And so deeply has this aura of Rembrandt's art grown into the general consciousness, that when we speak today about Rembrandt we do not mean him in person, but rather that vital expressiveness which radiates from his superb treatment of pigment, light, and shadow.

The situation in Rembrandt's case, therefore, is this:

Rembrandt translated the aims and sentiments of his time into the expressive language of his art. Rembrandt himself soon was gone. But the expressive language of his art still conveys to posterity the aims and sentiments of his time.

Speaking in general terms, the situation is the same:

By their various means, the artists translate the aims and sentiments of their times into the expressive language of their art. And while the artists themselves soon are gone, the expressive language of their art conveys to posterity the aims and sentiments of the passed times.

Such has always been and such will always be the course of things. It is a continuous play in two parts. In the first part of this play, the leading theme is "man influences form."

In the second part of this play, the leading theme is "form influences man."

Thus far, the first part of this play has been performed: **"Influence of Man."**

Now is the time for the second part: **"Influence of Form."**

The spiritual quality of any form rests within its expressive proportion and rhythm. Because of this, it makes no difference which form we select as the object of our examination. We might, however, arrive closest to the roots of the problem, if we select the most generally used form; namely, that form which not only meets a general demand, but constitutes even an indispensable everyday necessity for everyone. It is the space of protection that everyone is compelled to establish about himself.

It is the **"room."**

Really, the "room" is the most indispensable form-problem in civilized human life. It is so, for most of life takes place within the four walls of the room. In the room, the various phases of life are blended into a colorful complexity of joy and sorrow, of aim and passion; into a "Humana Commedia"—the most intimate of all the performances of man. In the room the new-born opens his eyes for the first time. There he grows up. There he spends most of his life. There his work is done. And there his eyes someday will close forever. Therefore, the room is the sanctuary of man's life and work. And the essence of the room—aura of the room—is that environment, constituted by means of proportion and rhythm, which bestows upon man its spiritual atmosphere.

It must be understood, however, that when we speak about the "room" in the above sense, we do not mean a space-formation of just four bare walls. We mean a space-formation of organic integrity, including all the features that make of the room an adequate place for proper human existence.

As such, the room radiates its influence.

When a person enters a room, in one way or another he

is influenced by the room. Either he feels comfortable, or he feels uncomfortable. But, if sensitive enough, he seldom feels indifferent. In case he is conscious of the spiritual atmosphere of his environment, the room can satisfy him only insofar as the room-atmosphere is in accord with his personality. If such is not the case, and he is forced in spite of this to dwell in the room, he might be able to undertake such rearrangements as could suit his well-being, physical and spiritual. By so doing, he might strengthen the kinship between the room and himself.

We may feel at home in a room by just rearranging a few odd things. Or perhaps there is need of major changes. Or perhaps all our efforts are in vain, and we are forced to move out because the room is fundamentally in disagreement with our ego. On the other hand, if our ego does not agree with the spirit of the room, and we are able in spite of this gradually to feel content with the room—without making any changes—our ego then is moulded to correspond to the spirit of the room. In such a case the influence of the room is stronger than our character. And our character is improved or depraved, depending on whether the room is esthetically—or why not say "ethically"—on a higher or lower level than we are ourselves.

A person sensitive to proportion and rhythm feels distinctly these qualities in the room. He is "musical" with regard to space. He is like the person able to enjoy music because of his sensitiveness to cadence, rhythm, and color in music. But as nearly everyone is able to whistle a melody, so is nearly everyone more or less sensitive to the "music" of the room.

I have taken a fancy to study this.

When a group of people is invited to inspect a building and one observes how the various members of this group behave themselves, one can easily see which ones are sensitive to the "music" of the room. After the general "looking around" is over, the members of the party wish to rest, and refreshments are brought around. Now, if there is a room which really is well-shaped and unspoiled by irrelevant decoration, one can be sure that those sensitive to proportion

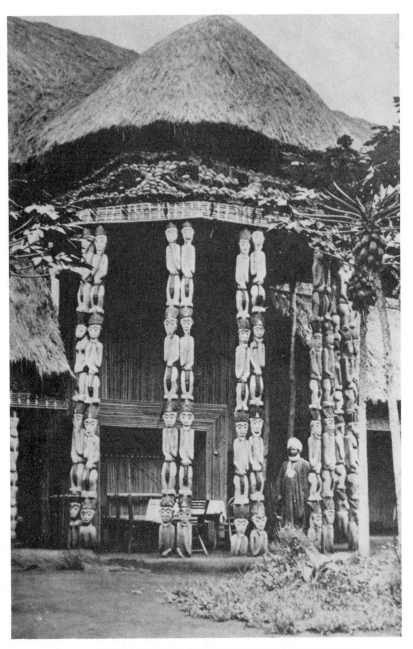

PLATE 6. THE PRIMITIVE AFRICAN NEGRO FORM
Courtyard of King's Palace in Fumban,
French Kamerun Mandate

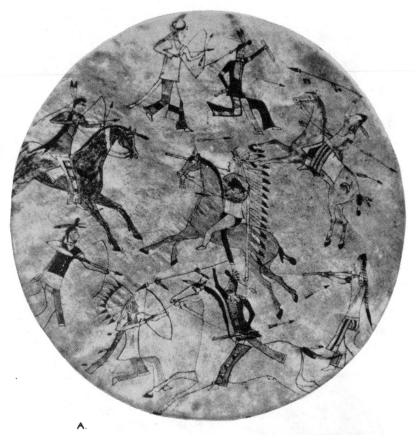

A.

B.

PLATE 7. THE PRIMITIVE NORTH AMERICAN INDIAN FORM
A. Painted Shield Cover
B. Man with Feather Headdress

and rhythm have found their place of rest precisely in this room. Perhaps they have expressed their admiration for the various decorations of the place, believing such admiration to be the purpose of the invitation. But their selected room speaks its silent tongue, and they listen to its speech. Perhaps they are not conscious of this fact. Subconsciously they feel it.

I was once invited for dinner at a club. After the dinner, my host took me to the smoking room. Arrived there, I was astonished because of its truly excellent proportions and restful use of color. When we were seated, my host pointed at a painting and said, "Look at this picture. I always select this seat so as to be able to see the picture; for hours I can sit here and enjoy it: isn't it charming!" Well, the painting was just a dry academic landscape, so I replied, "You are mistaken my dear friend. You do not sit here because of the painting; you do so because of the room itself; and you select just this seat because it is the best place from which to grasp the whole charm of the room. Certainly you have a good sense for proportion—perhaps without knowing it."

Many have it, we are sure. And many more would have it—even consciously—if the value of proportion were not so insistently hidden behind abundant decoration.

Supposing there is an extremely well-proportioned music hall where the public is subconsciously tuned into harmonious mood. Undoubtedly the influence of this music hall enables the public so much the more to respond to the music. Undoubtedly, therefore, everyone feels that the orchestra is playing unusually well. It really is, for the well-proportioned music-hall speaks also to the conductor and the musicians. Even they are tuned into harmonious mood and transfer this mood into their music. And so the music, the conductor, and the musicians meet the public in the all-embracing atmosphere of the music hall.

Such is the spiritual power of the room.

The room-concept has existed as long as man has needed shelter. Basically, the room is formed by means of its four walls. By means of these four walls there has been, there is,

and there always will be the possibility of forming rooms with an unlimited richness of variety.

The room is like a violin.

A violin has four strings. He who knows these four strings and weaves his life and being into their use, can make the violin sing the most varying music, ever new and enchanting. All of music that has been and that will be created during the progress of time, however it may change and however the scope of its contents may be, can make the violin sound with full tone through its four strings.

To regard the room as a practical necessity only, and to disregard the spiritual influence constituted by means of its four walls, is much the same as to disregard the influence of the vibrations of the four strings of the violin. To do so, and to be consistent in looking upon things in such a matter-of-fact way, would lead to nihilism.

We selected the room-problem as the object of our examination for the following reasons:

First, and mainly:

Because the "room"—as said—not only meets a general demand, but constitutes even an indispensable everyday necessity for everyone.

Secondly:

Because the "room"—notwithstanding its indispensability—has been much neglected as a feature, and likewise because it has been greatly disregarded as of little consequence in the realm of art. Even in the highest circles of esthetic knowledge, the room, insofar as its atmosphere—its aura—is concerned, has frequently been slighted almost as a matter-of-course. Thus, for example, it is not a rare thing to find that the most exquisite products of creative art have been nonchalantly accumulated into a room of valuless imitative decoration. By reason of this valuless imitative decoration, the room is lacking in that resonance of congenial vibration, so essential in the case of creative art. In such a room, how could art—even the best of it—radiate its message with clear tone? One might just as well stretch the strings of the violin on any old piece of ornamented wood.

To be sure, things have become confused.

And just because of this confusion, we have thought it necessary to stress the importance of proper atmosphere in as commonly used—and as commonly ignored—a feature in human art as is the room.

And thirdly:

We selected the room-problem as the subject of our examination, with the essential assumption that the "room" must not be considered a space-formation of just four bare walls, but—and we repeat—one of "organic integrity, including all the features that make of the room an adequate place for proper human existence."

This means that things such as furniture, textiles, painting, sculpture, and objects of all kind—all together, and each individually—must be reckoned with if we are to attain the desired atmosphere of the room.

So must the room-concept be.

Now, with this kind of room-concept, **any piece of art becomes automatically included in our discussion.**

It is so because any piece of art is bound to have its location in some embracing space where human life goes on in one form or another. And in this respect it makes no difference whether the "embracing space" is a room in a home, a hall in a public building, a nave in a church, a street or plaza enclosure in a city, a space-formation in a garden or a park, or—for that matter—just space in nature's architecture. In any circumstance, any piece of art must be disposed so as to make of it an integral part of its space-environment: as such, any piece of art must be in harmony with this space-environment as well as with the various features within its sphere of influence: as such, any piece of art must be expressive of its meaning in the ensemble of all the features in the "embracing space": as such, any piece of art must serve its function in the said ensemble—just as much as any word must serve its function in the sentence.

Consequently, in case the piece of art has no function to serve in its "embracing space," it could just as well be left out from this space—**just as any word having no function to serve must be left out of the sentence.**

To compare a piece of art in its space-environment with a word in a sentence is not just a random thought. In the language of art, this thought has its fundamental significance and therefore we must dig deeper into it.

Well, thus to compare a piece of art with a mere spoken word might easily raise the thought that the expressiveness of the piece of art is pretty much circumscribed within the narrow boundaries of a single word.

It is not so, however, for rather generally the single word has no narrow boundaries.

Take, for example, that short word "man."

Indeed, that short word "man" is not just a sound-container of its three plain letters. In the spoken language, that short word "man" compasses all of man and mankind, and all of man's origin, history, knowledge, reasoning, sensing and imagination about man himself and his species. Again, in the language of art, that short word "man" compasses—besides the whole concept of "art of man," as such—all of what man has accomplished in art, pertaining to man or to anything else.

We might select randomly such words as, say, "light," "color," "shadow," "earth," "water," "atmosphere," or whatever your choice, and each one of these words, respectively, constitutes the nucleus of an almost unlimited aureola of expressiveness pertaining to its nature, appearance, and significance. And this holds true just as much concerning the language of art as the spoken tongue.

Surely, an unlimited number of words could be referred to in this same way.

In this manner, and during the whole course of man's existence, there has developed the spoken language—which, in richness and expressiveness, covers all of man's world of thought, feeling, and wish. And simultaneously with this there has developed the language of art, with an equally broad scope of richness and expressiveness.

Thus, there have come into being two distinctly different means of spiritual intercommunication between man and man: the spoken language, and the language of art.

The former—the spoken language—communicates di-

rectly with man's intellect, and through intellect with his inner sensitiveness.

The latter—the language of art—communicates directly with man's inner sensitiveness. It is that silent tongue, which —at best and when honest—brings to all mankind its "expressive" message of the deepest and most precious achievements of man. This expressive message has sounded, sounds, and will continue to sound as an inspiring simulus—through centuries, millenniums, and ages.

And during these same centuries, millenniums, and ages, **every single piece of art—at best and when honest—has had, has, and will have its part in this expressive message.**

Just as every single word in the spoken tongue has its expressive function.

2. FORM AND CORRELATION

As came "expression," so came also "correlation" into our consideration, while we were studying form-manifestations in nature. Our subject of study was the landscape, and we learned that in the landscape there must exist a trend to correlation "so as to keep things together and to make of the whole an integrality of correlated order."

Furthermore, while studying the gradual growth of the seed into a tree, we could discern myriads of ever new designs, all organized into functional pattern. It is obvious that the principle of expression directed the growth insofar as expressiveness is concerned. But, due to the fact that the two mentioned daughter-principles of "organic order" act together, always and everywhere, the principle of correlation was instrumental in directing the said growth toward correlated order. Through this, the ever growing number of cells became correlated into cell-pattern—and, eventually, into the shape of the tree itself.

However, the shape of the tree—as such—is not yet enough to achieve correlated order in the landscape. During its growth the tree must adjust itself also in accordance with the correlative demands of its environment and of the landscape as a whole as well. In this manner the tree is shaped

for its own particular place. There the tree belongs. And nowhere else.

Supposing now that the tree must be moved into another location. It then, no doubt—having been shaped for its own particular place—would look strange in its new environment. But from the very first moment of its removal the principle of correlation would be on duty. The reshaping of the tree would begin, and a few years hence the tree would be "naturalized" as a congenial member of its new neighborhood.

Shaping and reshaping is a continuous process in nature, since in nature an insistent trend to correlation is always present. Therefore it is too much to say that the human hand can perfect a garden. The gardener can scheme, direct, and plant, of course—but without nature's help a unified effect could not be had. For sure, without this help, the garden would look like a plant-show of irrelevant specimens. Only when nature's trend to correlation has had the chance to direct the growth toward unified effect, can one speak about the harmonious garden. True enough, as the growth proceeds, much trimming and clipping will be of need. It is so because man's planting and nature's planting are different, as to both action and aim. The former is artificial, forced, and for decorative purposes; the latter is genuine, where the "trimming and clipping" is the result of natural selection as to strength and fitness.

As nature is helpful in the garden, so does she conduct matters also in other respects. Almost everywhere this comes into evidence. For example, when walking in the countryside, frequently one's eyes are attracted by an idyllic picture: a group consisting of an old barn and a few trees and bushes, with perhaps a stone wall, a fence, a brook, and a bridge. There is always something fascinating about the composition. There are good masses, good proportions, good grouping and rhythm. Hundreds of similar compositions could be selected, and nearly always they would create a certain poetry. And the colors would melt smoothly together with the surrounding field, the hillside slope, the passing brook—no matter whether it be Winter, Spring, Summer, or Autumn.

The barn was built by man. Even though the trees may have been planted by human hand, it would not matter. For if nature has had time to blend things together, to shape the trees, and to soften the colors, the result would be a good correlation of interwoven features. Thus, even man's work is reshaped by nature in her striving for correlated order.

"Correlation" has not always been considered of significant importance—the less a fundamental principle. In spite of this fact, many instinctively follow its command. Those interested in gardening, for example, are eager to achieve a satisfactory color grouping of flowers, and to that end they select their plants accordingly. And when they select flowers for room-decoration, they arrange them into choice bouquets, and into a good co-ordination with the room and with all of its features.

Perhaps this example was selected from a field where man still is sensitive. Perhaps dealing with flowers and gardens has kept man close to nature so that his atavistic ego has been subconsciously absorbing nature's fundamentals. Whereas, on the other hand, man's innate sensitiveness has become less alert when he deals with man-made things only. In this latter respect it is often amazing to observe how things are carried out. How often are pictures hung on walls where they do not belong! How often are sculptures located so as to destroy their actual art-values! How often are the most miscellaneous things jumbled and bungled together in one's room so as to make the room anything but healthy for spiritual living! And last but not least, how often are buildings designed without discrimination as to environment! Surely, this sad fact has caused much jest that is anything but flattering to the architect.

Thus, sensitiveness to correlation seems to be vague. One forgets that everything must be both "relative" and "correlative."

Is there a beautiful form, as such? Indeed, as such, there is no like thing. Any form must be imagined in connection with its reason for being, with its means of expression, and with contiguous forms. The beautiful form of a

head—a lady's, we should say—is beautiful, perhaps, because of its expressiveness of inner life, because of its sympathetic complexion, and because of its proper relation to the whole body. The same head put on the shoulders of a robust truck driver would be funny rather than beautiful.

Is there a beautiful movement, as such? Indeed, as such, there is no like thing. Any movement must be considered from the point of its objective, from the nature of the object in movement, and from the surrounding spatial characteristics. The gracious flight of the bird in the air, or the gliding course of the fish in the water, would be unfit for rhythm in human movement.

Is there a beautiful color, as such? Indeed, as such, there is no like thing. The color that you might consider beautiful is always discerned in correlation with contiguous colors, or you picture a certain amount of this color to be employed with other colors for some particular purpose. You might have a personal liking for a certain color and you might be inclined to use it wherever there opens a chance to do so. But remember this: you must use it in proper correlation and proportion. Otherwise your pet color might soon become ugly even in your own eyes. Surely the beauty of color can be measured only according to its correlation with other colors as to scale, shade, and proportion. The most seductive color of the flower might prove horrifying if used for covering the broad surface of a big building. And the most ugly color might produce a striking effect in a proper color-ensemble.

Thus, any manifestation of form is dependent on a multitude of circumstances and must be adequately adjusted toward these circumstances. Otherwise the manifestation of form not only loses its quality, but its effects might even become reversed as well. Generally, indeed, it is so. Every individual, no matter how eminent, must adjust himself to the assembly of other individuals. Or if he is enough of a captivating personality, the assembly might adjust itself in accordance with his influence. Whether the adjustment happens the one way or the other, a proper adjustment must take place in order to prevent discordant effects.

In any field of art the situation is the same.

A musical accord is a correlative interblending of sounds. It must tune at the right moment and in the right tonal-ensemble. It cannot, therefore, be mingled independently into the composition without causing discord. The composition itself must be in agreement with the characteristics of its age. And, when performed, the composition must bring the audience and the surrounding space into correlated vibrations.

The author's mission is to bring the reader's mind into accord with the world of thought of his own era. The author's own world of thought, therefore, cannot be independent of the pulse-beat of his time. Ibsen might have had the notion that a strong mind goes his own way, independently and autonomously. And yet, even in Ibsen's own case, his strength—and success—was due to his close relationship to the current social trends of his time.

Any piece of sculpture must be so located as to bring it into agreement with its environment. This is pointedly true in the case of open-air sculpture, where the piece of scuplture has a static position, yet is exposed to changing atmospheric conditions. For in such a case, the sculptural forms are a playground for light, shadow, reflection, and effects of many kinds, all of which must be taken into consideration in the shaping of the piece of sculpture.

The painter's problem is to correlate form and color, light and shadow, into the pattern of his painting. The function of the frame is not only to set the border line between the painting's content and the surrounding wall, but even more to bring the whole ensemble into correlated unison.

And finally, architecture is the art-form of correlation par excellence. It is the mother of the arts under whose correlating wings all the other arts must be interrelated.

As for architecture, this we have said:
"During all the Great Civilizations of the past, architecture was conceived in its broadest sense. Architecture did not mean the building only: it meant the whole world of forms for man's protection and accommodation; it meant the

various objects of the room as well as the room itself; it meant the building, as such, as well as the interrelation of buildings into organic groupings; and it meant the correlation of all the structural features into the complex organism of the city. Within this broad world of architectural forms, man lived and worked."

Because the broad world of architectural forms is built by man for his protection and accommodation, it then must be expressive of man's mode of living. Indeed, **this human equation must be the core of all architectural problems.**

Also, again: man is the stage-manager. His status, therefore, must again be put under examination.

And as in the case of "expression" we examined man from the point of view of an individual, so must we now in this case of "correlation" examine man from the point of view of individuals organized into families, into societies, and into nations.

This we must do in a logical succession, beginning from the smallest correlated unit: the family.

Because human beings—due to aura—are inclined to influence one another, the logical consequence is that persons of close spiritual kinship are apt to form lasting alliances. This leads directly to the subject: "man and wife." The subject "man and wife," indeed, is full of variations, but frequently one does meet a married couple who seem to form an "individual duality," if we may say so. When the children—who, because of inherited tendencies and parental influence naturally belong to the same group—are included in the ensemble, the family is instituted.

For the sake of self-preservation, the family came into being. And once the family was instituted, society was a natural consequence in accord with this same thought of self-preservation. Thus, through a continuous process, in which mutual influences established relationships between individuals, families, and kindred people of one kind or another, there came into existence a variety of social groupings. And as this process continued, ultimately the human material became disposed along the surface of the earth,

forming a great diversity of human concentration. In this manner—considering now particularly the present mode of habitation—we have individual family life in the country-side; contacts with country-side neighbor families; social groupings in greatly varying scope, such as in hamlets, villages, townships, and towns. Furthermore, we have social formations in cities of varying sizes and of varying natures; and then the tremendous accumulations of greatly miscellaneous strata of humanity in the ever growing metropolitan concentrations. And, finally—as an easily explainable escape from these ever growing metropolitan concentrations—we have varied group formations in suburban areas, in satellite towns, et cetera.

Now, the quality of the social structure in all these varying groupings of humanity, depends: first, on **the quality of the respective individuals** belonging to these groupings, and secondly, on **the quality of the social pattern** in these groupings.

If the quality in both of these instances is satisfactory, one then can speak about **"social order."**

Let's now return to our form-problems so as to see how—and in what spirit—"social order" and "form order" must be interrelated to one another. And let's do it in the same sequence as above; that is, beginning from the family and its accommodation.

The first step must be to examine the interrelation between the family and its space of living: **the home.**

As regards family matters, surely the most important thing is that the members of the family form a harmonious unity: this goes to make the very foundation of good home-atmosphere. Moreover, the mission of the home is to provide a moral and ethical ground from which the growing generation may further grow. Honesty of thought and sincerity in work are the inheritances with which the home can and should endow the youth. To that end, all the means must co-operate, and in this respect the form-treatment of the home—**if honestly conceived and sincerely executed**—is a vital, although perhaps subconscious factor. As such,

the form-treatment of the home is a significant phase in the development of honest form. For an honest form may help to build, from early childhood days, a firm sense of moral and ethical values of life and of art as well.

We say this to stress the fact that there must exist a spiritual interrelationship between the family and the form-treatment of the home. In other words, it must be understood that the form-treatment of the home should not be just an impersonal and coldly technical combination of various rooms for various purposes, but rather a treatment of form which is capable of bestowing a proper resonance to the human atmosphere in the home. The form-treatment of the home, consequently, is comparable to the body of the violin, which has not only its practical function of supporting the strings, but even more so its musical function of giving the strings their singing tone.

This same quality—that of resonance—must be maintained throughout all the problems of man's physical accommodation, whatever their nature or scope. This means that hamlets, villages, towns, and cities must be designed with the same honest conception and sincere execution as must the home.

Thus, as people settle down and their living places develop into architectural environments of various natures and of various dimensions, simultaneously there will—or rather, there **should**—develop a corresponding spiritual form-atmosphere in which to live. And this spiritual form-atmosphere will—or rather, **should**—constitute a proper resonance for all who live in these architectural environments of various natures and of various dimensions. As we see then, there will—or rather, there **should**—exist a spiritual interrelationship between the population of the community and the form-treatment of the community.

There **should**, we say—**if art after all has its place in the spiritual life of the community.**

Looking at town development with historical eyes, it is a generally accepted fact—at least in enlightened circles

—that the towns of olden times—those of the Classical Antiquity and the Middle Ages, for example—were erected in accordance with genuine form-conception based on fundamental principles. For this reason, these towns really did bestow upon their respective populations a spiritual atmosphere having the qualifications of creative art.

This is true, no matter whether one examines these towns as such, or some of their specific parts such as street formations and plazas. There always prevailed the quality of subconscious or conscious sensing of those fundamentals without which art cannot be creative art.

However, the town-builders of those olden times did not consider only man-made architectural forms. They considered equally the characteristics of surrounding nature, so as to achieve a satisfactory interrelationship between forms of man and forms of nature. Because of this appreciation of nature's beauty, the towns of olden times breathed the same beauty as breathed the surrounding landscape. Naturally, this added much to the spiritual atmosphere about these towns.

There is no doubt that even our age is appreciative of nature's beauty. And the better the various features of the landscape are correlated into a rhythmic display of mountains, valleys, woodlands, meadows, and lakes, the more the beauty of the landscape is appreciated. In this appreciation there might not be the slightest consciousness of the principle of correlation, nevertheless its existence is subconsciously felt. And if this principle of correlation, for one reason or another, should cease to function—as is the case in those parts of the landscape where an obvious decay is prevailing —then, for sure, the absence of our principle is distinctly and deeply felt.

Man considers it a natural thing that nature is beautiful—nay, he considers it even an obligation of hers. Man is in need of this beauty and he must have it. He must have it just as much as he must have sunshine and rain when he needs them. But at the same time man seems to be quick to forget that this same obligation—of having order about his

own abodes and living places, towns, and cities—concerns himself as well. And what is still worse, nature is often indeed counteracted by man in her laudable endeavor.

Please, look at what happens in this respect.

Well, looking around in our urban communities, almost everywhere we find disorder, decay, and lack of planning; almost everywhere we find all sorts of imported decorations, indiscriminately jumbled together. Only seldom we find something that has grown from the soil of the place and that is properly correlated to achieve a humanly livable form-atmosphere.

For sure, the art-form of the community must not be artificially made by imposing upon the defenseless population an imitative atmosphere of borrowed forms indiscriminately jumbled together. Such an imitative and indiscriminate procedure results only in deceitful theatrical effects, which because of their hollowness reflect the indifference of the population. And because the population is doomed to dwell in this atmosphere of imitative and indiscriminate hollowness, the population grows so much the stronger in its disposition to indifference.

This is by no means a rare thing.

There is no need to go to slum areas, to decayed parts of the town, to "suburban-builders" regions, or to other low-rate places. One needs to go only to the top centers of such places as New York, Chicago, or other cities where the skyscraper has had an uncontrolled growth and where the finger-marks of many a top figure in the field of architecture can be easily read. And one is completely discouraged insofar as correlation is concerned.

Hence:

Unless the sense for correlation grows keen again, the search for form is of but little help in the development of a proper form-atmosphere in which to live.

Indeed, this is equally true in art in general.

And, **herein lies the generally valid significance of the principle of correlation.**

At the outset of this chapter it was said that the prin-

ciples of "expression" and "correlation" constitute the decisive characteristics of the principle of "organic" order. For this reason we deemed it best to explain the principle of organic order by analyzing separately the expressive and correlative tendencies of this principle.

This we have done.

And so, a few more words—of repetition:

The fundamental principle of organic order—the principle of architecture—prevails in all of creation. In accordance with this principle everything in the universe comes into manifestation. This is the situation—everywhere and unceasingly—as long as the expressive and correlative energies **are vital enough** to maintain organic order. But so ceases to be the situation as soon as the expressive and correlative energies **are not vital enough** to prevent disintegration of organic order.

So here we discern a distinct conditional state—a "sine qua non"—in the course of things.

That is: "vitality," or "lack of vitality."

This we shall discuss in the chapter to follow.

* * *

VI. FORM AND VITALITY

EVER so often we have referred to nature by emphasizing her sublime "order." This emphasis, to some, might seem a rather unbalanced idealistic disposition—a one-sided judgment of things. It might—or it might not—it all depends on one's attitude of mind. But those inclined to this kind of criticism often are looking upon things one-sidedly themselves. Because of the ceaseless fight between life and death in organic existence, many see fit to accuse nature of cruelty. They are blind to her constructive aims because of her supposedly destructive tendencies and therefore they minimize the former by using magnifying glasses to amplify the latter. Consequently, in their opinion, the talk about universal principles of "order" and like things is just quixotic self-deception.

It is understandable that controversial opinions might arise because of the seemingly contradictory situation in nature. Yet, one should learn to see things in a logical light. One should learn to realize that there cannot be life without death. No manifestation in organic life can run along a perpetually even orbit. Any manifestation in organic life must have its conception, its birth, its growth, its climax, its decline, and its end. Ever continuing life, with no end, could not have vitality but would be doomed to constant lingering in a state of sterile existence. And if such were the rule-bound procedure in the universe, life never could have been born. But it is not so. Life is there. And it is a continuous struggle between life and death. It is a continuous metamorphosis which keeps organic order vital, and which, through constant evolution—birth and rebirth —instills ever new sets of waves in the steadily shifting vibration of life.

We know perfectly well that the situation is the same—

and must be so—in the life of peoples and their cultural endeavors. We know that this has been the course of things as long as man has been able to follow the events of humanity. We know that civilizations have been born and have died, and new ones have come and gone again. And we know that even our own endeavors, no matter how honest, sincere, and vital at the moment, are doomed someday to go. But we must know just as well that this very struggle of ours is a distinct cultural struggle: it is our duty; it is the purpose of our life; it is the spur of our emotions; it is the goal of our ambitions; and it is the elixir of our satisfaction as well.

And, indeed, in this very struggle, nature does her best in supporting our endeavors. She has furnished us with a glorious environment in which to live. She has displayed her products of highest order and placed them at our disposal: to be used, to be enjoyed, and to be learned from. She has provided us with the faculties of sensing and understanding. And she has put us into an excellent position— with a sublime prerogative, for sure—to build up our own culture by following her advice based on that "grand order of all things."

The only thing we ourselves have to furnish is **good will.**

However, to furnish good will does not necessarily mean that we must look upon matters with idealizing spectacles. It rather means that we must have a genuine ambition to discover those positive and negative forces which manage the perpetual battle of "to be or not to be," and to unveil those principles which support the positive forces.

This we have tried to do.

And so far we have discovered a few principles according to which—as we understand them—vitality is infused into life manifestation.

In its simplest terms it happens as follows:

The characteristics of an organism must be already inherent in its cells, for, due to the principle of expression, any cell is expressive of the organism concerned. Yet so far the cells are but hopeless beings unless, due to the prin-

ciple of correlation, they are properly located into the organism. This is the general design, no matter in which scope "cell" is understood.

However—insofar as organic life is concerned—the situation is not yet complete unless there exists a life-pre-serving energy which keeps "order" young and fertile. This happens, thanks to incessant birth—incessant "creation"—through which the animating spirit of constant competition is instilled into life: to serve, and to preserve.

Herein we discern the underlying idea of **"Vitality"** in nature.

Well, we do not intend to maintain—idealistically—that things are always running smoothly according to the above recipe. They could not possibly do so, because life —for the sake of vitality—means a perpetual fight between two opposite poles: constructive and destructive. But we do maintain that matters must be founded on constructive principles on the constructive side of the fighting front. For the fight—throughout—is the fight between **order** and **disorder,** between **accord** and **discord.** Such is consistently the dual situation in all of life, wherever one turns his eyes —and from this there is no chance of getting away.

Thus, when we say that the microscope discloses rhyth-mic pattern in the cell-weft, it is not always so. Occasionally we hit upon a cell-pattern that has lost its rhythmic char-acteristics. And we understand that the organism is sick. Again, when we say that the tree, as to its general shape, is a rhythmic feature of stems, limbs, and branches, it is not always so. For occasionally we find some strange marks of dissonance that have nothing in common with the character-istics of the tree. And we know that the cell-structure of that particular location has been affected by some disturb-ance from within or without, and that disease has crept into the tree-organism. Occasionally, again, we find but dry remainders of something that once was a tree, full of life. And we realize that the tree has lost the battle for its life: it is dead.

Concisely put, this is what happens:

While the individual cells decline and the cell-pattern

begins to disintegrate, some inside or outside influence over-
powers the weakened organism.

So it happens in all places and circumstances, whatever
the nature or scope: in the body of the mosquito or the
mouse; in the body of this globe or in the immeasurable
spaces. So it happened with the downfall of the Roman
Empire. First: due to weakened morals there was a general
decline of the individual members of society. Secondly:
due to a weakened common spirit there was the decline of
social order. And then the overpowering barbarian inva-
sion caused the long night of mediaeval darkness—from
which the mediaeval cultural form eventually evolved when
fundamental principles became gradually reinstated in the
general course of things.

Thus: birth and death, and then birth again. So goes
the ever running wheel of history.

So do things happen even in the field of art.

**The creative quality of art loses its keenness and, be-
cause of this, imitation is accepted as a lifeless substitute.
Then, because of the weakened sense of the cohering cor-
relation, this imitative form is used without discrimination
as to how and where.**

Thus, again: either principles—or no principles.

1. CREATIVE VITALITY

However, to found art on principles does not as yet secure
vitality, unless the creative instinct is vitally concentrated
at the very moment of creation. If such is the case, the con-
centrated vitality then is transposed into form, and through
form it speaks its convincing language with lasting vibration.
Thus, generally indeed, art produced thousands of years
ago still maintains the same vitality as it did in the days of
its inception.

Mother earth is a good example in this respect.

Ages and ages ago, when our worthy globe was much of
a boiling-pot and material was melted into material, our
oldest rocks got their petrified consistence. Notwithstand-
ing the great length of time lying between, we still can

read today about the monstrous movement of glowing masses which created the design-pattern of rhythm and color in all the granite rocks. There must have been vitality, indeed. Yet, in this tremendous formation of our globe, the creation of design pattern—truly expressive of the movement of melted material—never was neglected. Even the smallest particles of the huge masses were not forgotten— as we so convincingly can still read today.

This same is true throughout the whole world of mineralogy.

Finding ourselves now in the world of mineralogy, we might spend weeks and months and years of astonishment, excitement, and enjoyment in the study of all the patterns of form and color and the combinations of these into unlimited varieties. And these—all of these, for sure—could tell the stories of their origins—where vitality at the moment of creation brought about a state of vibration, which—as to expressiveness and rhythmic order—is just as vital today as it was at the time of its origin.

And when the crystallization of human art—human "mineralogy"—enters into our kaleidoscope, both the procedure and the results are analogous to the above. The subconscious sensitiveness that produced the cave paintings tens of thousands of years ago, when man lay in the cradle of his development, still unveils today an undiminished vitality of conception, line, and color. The Mycenean, Egyptian, and Assyrian products of art confirm the same. Really, wherever one turns his attention to find support in this respect, the support is there. The vitally crystallized form, regardless of time distance, will always maintain the quality that brought it forth. And one must accept the fact that the value of art lies in the artist's creative vitality at the moment of creation.

Looking at "Hendrickje Stoffels" in the Louvre, one finds it a work of great art. Not necessarily because it is a "Rembrandt," but because Rembrandt happened to be in good spirits while painting it. There is no doubt that even Rembrandt produced many a thing of minor value—al-

148

though, we assume, he was wise enough to keep them out of sight. From the point of view of art-historians, esthetes, art-collectors, and art-dealers it might be true that the name, as such, makes the master. But from the standpoint of art —and of its vitality—the name is not the deciding factor. Surely, the most vital period in the artist's production means more than just his name. And most significant of all is the strength of the artist's creative vitality at the very moment of creation. Obviously, an artist even of the highest distinction—just as Rembrandt—might do and actually does things of little value when he is mentally tired. If he be artistically honest, however, he is conscientious enough to separate grain from chaff. Or, if he does not do so himself, the critic of time will do it, thus purging his name. Through such a selection, the most vital part of the artist's production is left to posterity for appreciation to establish the artist's historic fame. Generally speaking, also, the difference between historic and contemporary fame is that the first is based on selection of the best of the artist's work, thus making work and name equivalent, whereas in the latter instance the name might often be misleading as to the quality of work behind the name. And this is so much the more misleading, the more careless the artist is about his methods and means for obtaining fame.

With reference to this—to discuss an actual case— Sibelius once said, shortly and pointedly. "Reputation is Obligation."

That is, an important part of the artist's vitality lies in his self-criticism, in his regard for himself as an artist, and in his stamina against yielding to temptation when offered material opportunities affecting honest creation. As for this remark, we are not mentioning apocryphal ideas when we suggest that the sky of art is not entirely free from such clouds. And although it is not our pleasure to put our fingers too deep into the pie, we must, in the name of art-evaluation based on creative vitality, make the comment that when art becomes primarily a matter of material speculation; when it is advertised by means of names supposed to signify more than they are actually worth; when such a

system of advertisement puts the meaning of art out of balance in the minds of artists, dealers, and the public; and when even sincere critics—because of the puzzling situation—become purblind to see who is who and what is what: it is then more than obvious that art, in such cases, has been living on a "magic" pseudo-vitality which sooner or later is bound to lose its enchantment.

Surely, a lover, no matter how convincingly he tries to elucidate, cannot in the long run convince the girl of his love—unless he really loves her.

"In the long run"—well, there we have it!

And so, when the penetrating critic of time begins to ransack hearts and kidneys, then, no doubt, it becomes evident which one had the inspiring sparkle of love to his work, and which one was the mere actor. Then, no doubt, many names that have been artificially ballooned into fame will drop flat like an empty sack, while others, modestly obscure, will be discovered and brought into light. And the future has much reason for being perplexed because of the frequent short-sightedness shown by many in discriminating between real and fictitious values. In fact, we are often perplexed ourselves.

On the other hand, we must realize that the present time is a time of transition—perhaps one of the most thorough-going in all history of human art. In this transition we are confronted with ever novel experimentation. No wonder, then, that esthetic reasoning—in spite of putting on a good face—is nervously uncertain along the meandering road of search. So it goes; yesterday we became squeamish because of the perfect reproduction of naturalistic forms; today—because of logical reaction—we go to just the opposite extreme in one way or another. Yesterday we were overfed by an ornamental deluge; today we are purging our forms into the most extreme nakedness. The pendulum goes from one extreme to the other, and we are unable to seize its swing at the right moment.

That is our trouble.

Undoubtedly, the future will have its troubles, too. In the progress of things, every age—particularly during times

of transition—has exhibited miscellaneous and perplexing forms, in all of which the contemporary mind was too close to sound the true values of creative vitality.

Now, what are the true values of creative vitality?

It is still rather an easy task to let one's imagination loose and to do things differently than they have been done before. But when one's creative instinct gives birth to forms that are expressive of "the best" of today, only then can there develop a firm foundation on which to build. But to build on the firm foundation of expressiveness of today is not yet constructive progress, unless expressiveness of today is at the same time indicative of expressiveness along the general course of progress in order to achieve continuous form-development toward the ultimate goal: toward the style-form of the age.

Indeed, to achieve continuous form-development toward the style-form of the age requires continuous and consistent creative vitality.

And it calls for a "permanent" quality of form.

2. PERMANENCE OF FORM

Frequently a piece of art is judged according to the amount of work put into it and to the delicate minuteness of its execution. The piece of art is admired just for this reason. It is believed that the more the artist is concerned with the exact finishing of his work, the more perfect the work and the more permanent its value. This, however, is a misconception in the evaluation of art. One should never forget that the highest artistic quality is not achieved by mere refinement of surface but by expressiveness of form. A fresh sketch, of momentary inspiration, often has more permanent qualities than is possessed by its further elaboration, intended to make of it a supposedly "permanent" piece of art. Through such an elaboration the freshness of the sketch may decline to mere skilful labor and academic dryness. Rubens—to take an illustrious example—owes his reputation, chiefly perhaps, to his many large and magnificently

executed canvasses. And yet the strength of his creative vitality lies in his "unfinished" sketches.

Please do not misunderstand. Our argument is not *pro* momentary achievement or *con* sincere study of the problem. Our aim is to emphasize the material fact that the moment of direct creative conception is the vital moment, and that as long as the artist is able to keep his conception on a creative level—while working on it—so long is he infusing positive strength into his art. And as long as such a relationship prevails, one must have respect for the work, no matter how elaborate. But once the creative climax is reached, any further attempt is a mere overdoing with weakening result. As a matter of fact, one of the most important things for the artist to know is **when to stop.** All cannot be as fortunate in this respect as was Beethoven with his Ninth Symphony when he—as has been said—bestowed the more freshness upon this opus the more he worked on it. Those who have followed Carl Milles' work have found in him the same gift.

Yet this gift is nothing more than a continuous and consistent vitality of the creative instinct controlling the work. Vitality of the creative instinct, however—no matter how continuous and consistent—cannot be weighed by quantity of work and length of time, but only by **quality.** Thus it frequently happens that a work of art, produced through years and years of hard labor, once completed, may be found artistically worthless and be soon doomed to oblivion; whereas a brief action of intense vitality may produce lasting qualities that can bring inspiration and joy to millions during centuries. As to this brief action of intense vitality, it might be well—as an illustration—to remember Whistler's remark to the attorney general when questioned whether it was for two days work that he asked such a high price. "No," Whistler retorted, "I ask it for the knowledge of a lifetime." Goethe, in a momentary inspiration, might have scratched on paper a few of the finest stanzas ever written: "Über allen Gipfeln ist Ruh—," but he must have lived with the content of these stanzas during the days and nights of a long preparation of suffering and joy.

Ultimately, any piece of art will find its proper place on the long line of graduation between "worthless" and "exquisite." This decides the nature of ephemerality or permanence of the piece of art, insofar as art-evaluation is concerned. The more and the broader the appreciation of the leaning toward permanence, the clearer is the indication that the time is creatively strong. And the more the spirit of permanence permeates form in general—including even the seemingly less significant objects—the more deeply the understanding of art permeates everyday life.

This latter thought—"including even the seemingly less significant objects"—must be particularly emphasized. Because, when the tendency to permanence becomes strong concerning these "less significant" form-manifestations, it then testifies to the fact that form—that is, form-atmosphere in which to live—is a genuine desire, and not a mere superficial vogue.

In this respect there are illuminating parallels between physical food and spiritual food.

While the dishes we enjoy at home and elsewhere vary in quality and richness, bread-and-butter constitutes the permanent nourishment that we need every day and never seem to tire of. Analogically, while we surround ourselves with objects of art and enjoy art even outside of our possession, the necessary accommodations, such as furniture and furnishings, constitute the permanent environment in which we live. Constantly we imbibe the spirit of this permanent environment of furniture and furnishings, and therefore they constitute our everyday spiritual bread and butter.

Now, the quality of this everyday spiritual bread and butter decides whether the permanent nourishment we imbibe at home is spiritually healthful or not. It is healthful in case the nourishment is of positive form-value. It is not healthful in case the nourishment is just that same imitative trash that has become the commonplace thing almost everywhere. Consequently, it is up to us—everyone individually and all together—to learn to appreciate art of such vital quality as can constitute healthful spiritual bread and butter in our homes, and we must learn to appreciate it as some-

thing that can bestow upon our home life a healthful spiritual resonance. If so, it then might happen—and it should —that a chair, a table, an ashtray, or what have we, becomes an intimate friend of ours with whom we are happy permanently to live.

It is well to bear in mind that if all the various things brought together within the four walls of our living place are our friends, we then live amidst our friends in the friendly atmosphere of a **home**. Again, if all the various things brought together within the four walls of our living place are only for practical use, without spiritual considerations whatsoever, we then cannot have a home. We have parked ourselves among strangers in a strange **house**.

It is essential to obtain permanence between man and form, for such a relationship shows that form is strong and that man is conscious of its strength.

In olden times, man lived with his things in lasting satisfaction. Every piece was made by hand—with labor, pride, and joy—and it remained in the family's possession, generation after generation. It was a member of the family.

The present time is very different. Hand-production has been pushed aside and the machine is making the things. These have less of the human touch. They are cooler in spirit. And they lack individuality. Yet we predict—and we are now already far toward such a goal—that the day will soon dawn when excellence of design and humanization of the machine touch will bring man and the machine-made into close contact, so that man will learn to love his things, so that he will learn to live with them, thus strengthening the relationship of permanence between himself and his machine-made form.

In many respects, this is already the case.

But, between this and the day when real handiwork ceased to exist, lies a long period of non-creative decadence during which form was copied, recopied, and copied again in millions of modifications. Thus, by constantly repeating the same stuff, the time degenerated into accumulated lethargy in these matters, going from father to son and from

154

son to grandson, depraving the previous good taste all along the way.

And what is the result!

I once visited a museum with a man whose home is a good example of what we may call contemporary design. As we stood in a gallery of Western Indian products, I asked him to select an object **he would not like** to have in his home. He could find none. Arrived at a section of machine-made-craft-products of the nineteenth century brand, I repeated my question, now asking him to select something **he would like** to embody into his home. "There are none of that sort," was the short but convincing answer.

Isn't it strange!

We make our homes simple and sensible—"contemporary," if you will. We could embody there objects from as remote an age as the Egyptian, and they would be fitting and congenial in spirit. We could embody there things from as alien a civilization as the Chinese, and they would blend harmoniously with the whole. We could combine objects as foreign to one another as the Western Indian and the newest machine-made, and they would vibrate in correlated keys. We could mingle African negro sculpture, Eskimo art, and what not, and they all—if organized with good taste—would be in accord with the room and with its varied elements. But, if you please, try to mingle into this environment a single object of those machine-made-craft-products of the nineteenth century brand—and you will be surprised.

Now, why is that so?

Well, we scarcely could give any other explanation than that sincerity can linger in sincere accord with sincerity, but showy emptiness belongs somewhere else.

On the whole, this explanation can just as well serve to differentiate between **"creative vitality"** and **"imitative indolence,"** in which differentiation creative vitality represents sincere endeavor to produce sincere art, whereas imitative indolence represents showy exhibition of meaningless surface.

These two forces—creative vitality and imitative indo-

lence—are two opposite forces which, by their action and counteraction, are effective in the evolution of form.

Creative vitality is that constructive force which in the course of time brings art onto a high wave of evolution, and which, because of its continuance and consistence, keeps it there. Imitative indolence, on the other hand, is that destructive force, which in the course of time brings art down to a low wave of devolution, and which, because of its continuance and consistence, keeps it there.

In this manner—during the long course of historic times—art of man has had its high floods, and it has had its low ebbs, and floods and ebbs again.

And in this fluctuation, the "time" element has had its distinct influence.

"Time," therefore, must be our next topic.

* * *

VII. FORM AND TIME

TIME is that endless something which surrounds us. It moves forward, seemingly. Behind is the **past**, gone forever. The **present** is a ceaseless passing of the future into the past. Ahead is that unknown **future**.

During his long journey of evolution, man has passed through all the stages of the past. He is kindred with them, physically and spiritually. The forms of the past, therefore, are to man like an atavistic echo once experienced—and he understands them. But in the long course of time the divergences of the details wane, and so much the more distinct appear the contours of the whole. Man discerns the fundamental form of the past.

Today man is in the midst of his activities in shaping life into form. It is the detail of the day he is concerned with; the detail he feels; the detail he does; and the detail he discerns about himself. Thus, form appears multiphased, while its general characteristics lie hidden beneath. Therefore, the fundamental form of the present can be sensed only by the creative instinct—as it directs the work of today on the basis of that fundamental form.

The fundamental form of the future is obscure to man. Life that is going to give birth to that form has not as yet been lived, and as long as the life still is non-existent, the form is but a shapeless nebula. Even the fundamental vibrations of forms to come are not as yet in action as far as man can conceive. They are only seeking their way ahead as time passes. Perhaps the vibrations of the immediate future can be felt, yet only by the most sensitive among men. And so, cultural pioneers—being ahead of their time —can show the road onward.

Thus, time is divided into three main phases insofar as understanding of form is concerned: **past, present,** and **future.** And as in the course of time there has gone and goes on a continuous change from the past through the present into the unknown future, so has there gone and goes on a continuous change of the fundamental form.

This continuous change of the fundamental form, man must follow.

No man is timeless.

First: Everyone is born at a certain time; he is a child of that time: and so he must be. This is a categorical imperative from which there is no escape.

Secondly: Everyone has his individual inherency of distinct potentialities which, in the course of time, are determinative in his development toward character. This is a categorical imperative from which there is no escape.

Thirdly: Everyone is predestined to exist in a sphere of outside influence which, in the course of time, is decisive in his development in accordance with this influence. Even this is a categorical imperative from which there is no escape.

And so: Everyone, in the course of time, is building up his personality in accordance with the said three categorical imperatives: "place in time," "inherent potentialities," and "outside influences."

Such is man's destiny—in time.

As is no man, so is no Civilization timeless.

First: Any Civilization comes into existence at a certain time; it is a product of that time: and so it must be.

This is a categorical imperative.

Secondly: Any Civilization has its inherent potentialities which, in the course of time, are determinative in the evolution of that particular Civilization toward character.

This is a categorical imperative.

Thirdly: Any Civilization is predestined to exist in a certain sphere of outside influence which, in the course of

time, is decisive in the development of that particular Civilization in accordance with this influence.

Even this is a categorical imperative.

And so: Any Civilization, in the course of time, is building up its "personality"—its "style"—in accordance with the said three categorical imperatives: "place in time," "inherent potentialities," and "outside influences."

With the above as the leading thought, we are now going to follow the adventures of man and his form in the course of historic times. And we are going to follow them in accordance with the said three categorical imperatives.

Thus:

First—in the sub-chapter, **"The Fundamental Form"**— we are going to analyze form from the point of view of fundamental significances as related to time.

Secondly—in the sub-chapter, **"Form and Evolution"**— we are going to analyze form from the point of view of inherent potentialities as related to time.

Thirdly—in the sub-chapter, **"Form and Migration"**— we are going to analyze form from the point of view of outside influences as related to time.

And then, we have the sub-chapter, **"Form and Style"**— the accumulated result of form-development in the course of time.

1. THE FUNDAMENTAL FORM

Let's say to begin with—as was said a moment ago—that insofar as form-understanding is concerned, time is divided into three main phases: past, present, and future—and that past and present are understood, not future.

A melody from our days is apprehensible to the mind of today, grown as it is from our own way of life. A melody from Ancient Greece likewise is apprehensible to the mind of today, expressive as it is of a way of life which we have learned to understand through Greek achievement. But Ancient Greece scarcely could have apprehended a fugue by Bach. And we can be sure that our time could not

enjoy music of some distant future. Undoubtedly, such an experience would be a strange sensation. As the simple singing melody of olden times has evolved through the ages a richness of counterpoint that probably would have been a puzzling disorder to the mind of the past, so the counterpoint of today will someday evolve into harmonies unintelligible to the present mind.

Music is no exception in these respects. Rather, it explains things in general.

In every field of life, man is searching for ways toward unknown and unfelt spaces. Whether the search concerns forms of art or of life does not matter, for this very search itself is both art and life. And hereby man is gaining his knowledge of the past, he is enriching his understanding of the present, and he is trying to penetrate into coming things —into things which really cannot be understood before they have been experienced.

So far, this concerns merely the **understanding** of form and, as was found in this respect, past and present are understood, not future.

Again, as to the **creation** of form, the creative action is limited to the very moment of that action and to the sensing of its fundamental form.

Thus, Beethoven's symphonies, for example, as to their concept, were distinctly limited to Beethoven's time and to the sensing of the fundamentals of his time. No present day composer—or one of any other period—could base his music on the same concept as did Beethoven. Such music would not grow from the depths of its own life, nor would it tune in accord with the fundamental form of its time.

It might be said—perhaps as a matter of argument— that Beethoven was great enough to create his own fundamental form and to impose this form upon his time. For sure, Beethoven was great. But he was great just because he sensed the fundamental characteristics of his time and was able to give them the truest musical interpretation. Indeed, herein lay his real greatness.

On this thought—on sensing the fundamental char-

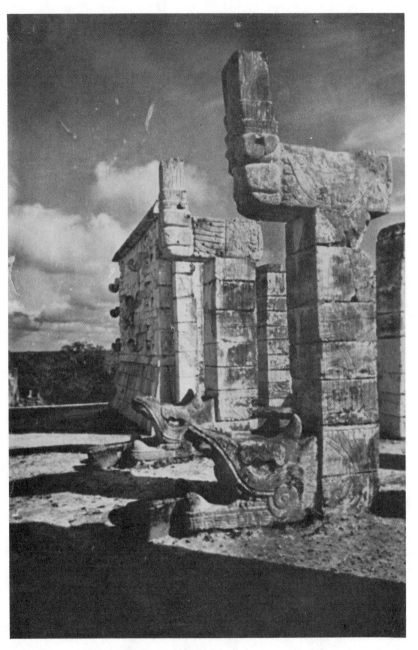

PLATE 8. THE MAYAN FORM
Temple of Warriors, Entrance, Chichen-Itza,
Yucatan

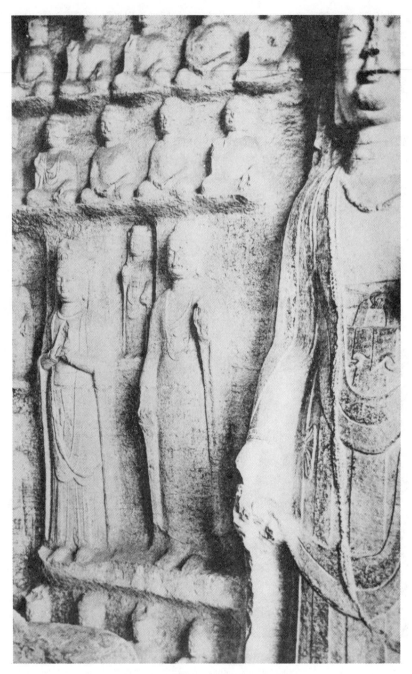

PLATE 9. THE CHINESE FORM
Chinese rock-sculptures

acteristics of the time and of giving these characteristics the truest interpretation—hinges the greatness of any really great man. Any really great man has his roots in the soil of his time, and his greatness is measured according to his sensibility to suck the true characteristics of his time through these roots. Any great reformer of mankind has been brought into greatness when the time was ripe to make that reformation—which he had sensed—a success. Thus the roots of greatness are secreted in time and in the sensing of its characteristics.

Just as was the case with Beethoven.

In the evolution of music from the Middle Ages up to the sixteenth century, Palestrina was substantially a milestone between the old school of music and something new to come. As such, he was the true interpreter of the sixteenth century concept of music. And when listening to his music today, one's mind is readily brought back to his time.

Similarly, only a few chords of Bach's harmonies—and one feels the spirit of his era.

Only a few cadences of Mozart's serene rhythm—and promptly one is transferred to that sphere.

And, surely, only a short strophe of Beethoven—and one is fully with Beethoven and his age.

Thus, the mind of today can discern the gradual shifting of the fundamental form along the Palestrina-Bach-Mozart-Beethoven line. It is a logical evolutionary line, and in this respect, we take it, a rather general agreement can be had.

But, what next?

Well, as we have now arrived fairly close to our time, our perception has therefore become pretty hazy insofar as the discernment of the fundamental form is concerned. For this reason, if Brahms, for example, were suggested as the next composer on the evolutionary line, some others might be considered more typical. And then, coming still closer to our time, the situation has become so much the more uncertain—and **subjective**. Thus, if the name of Sibelius, for example, were suggested as the next name on the line, there

already might be a much longer waiting list for that promi-
nence. And no wonder! Because of the uncertainty in the
sensing of the contemporary fundamental form, the tentacles
are spread in all directions to catch the prevailing vibrations
of the time.

But now, precisely today, how do we stand?

What about jazz?

Speaking about jazz, someone has said that jazz might
exert some influence upon future music, but that there has
not as yet been born a composer able enough to turn it
into "art." Well, we do not know if and when such a com-
poser will be born, and are not supposed to know; but on
the other hand, when we speak about music in connection
with the fundamental form, we mean music such as origi-
nates from the sincerest depths of the best of life, not from
the shallow "depths" of dinner-entertainment.

So then, jazz might exert its influence upon future
music—or it might prove to be just a disturbing interlude
—we do not know. But if jazz is out—as we hope—it is
then anyone's guess in which direction the development of
music is going to go, and how the evolutionary line of the
fundamental form stands at present.

It is not the future's guess, however.

For, certainly, the more distant the future, the clearer
will become the discernment of the characteristics of the
fundamental form of our age. So again time is the supreme
adviser. For—and we cite from the foregoing—"when the
penetrating critic of time begins to ransack hearts and kid-
neys, then, no doubt, it becomes evident which one had the
inspiring sparkle of love to his work, and which one was the
mere actor." In this manner the musical harvest of our age
is going to pass the selective purgatory of time, and all
random compositions—which have no real roots—are
doomed gradually to vanish. Thus the contours of the
fundamental characteristics of our age become gradually
clear. That is, the future will discern the fundamental
form of our age—insofar as music is concerned.

So much about creation of music as related to time.

These examples from the realm of music are explana-

tory as to matters in general. So—we found—was the case
with the **understanding** of art. So must be the case even
with the **creation** of art. The whole form-world follows
the same maxim. In accordance with this maxim we learn
that the creation of art—when true—must be limited to
the characteristics of its own time, no matter how broad
the understanding of this creation might be.

And in this creation the fundamental form of the time
issues the leading theme.

The fundamental form is not an intentional achieve-
ment of man. It grows determinatively from the soul of
the age. It is the agency which directs man's work during
that age. And because of its fundamentally decisive nature,
it is the categorical imperative which has conducted and
conducts form-shaping during the times. Yet time—as we
understand it—is never stable. Ceaselessly it passes along
its course and every new movement brings ever new thoughts,
sentiments, and features into life. And when life is thus
altered, the fundamental form—the leaven of form-expres-
sion—is altered accordingly. However, life, in its course of
evolution, never repeats itself, and consequently even form
becomes constantly new, whereas the old vanishes from the
stage of living forms—**never to appear again.**

During the long orbit of thousands of years, man has
sensed this. He has transposed the fundamental character-
istics of his time into his art. He has brought forth new
values of form, always expressive of the very time of crea-
tion. He has felt that the work of today must have its own
flavor, different from that of yesterday. And he has acted
in accordance with this feeling. He has been sure that his
descendants also, in their turn, would do their work with
the same zeal as did he—by constant creation of forms of
their own. And, really, they have done so.

In this creative spirit, form has been kept expressive
during the various civilizations that man has brought into
existence in the long course of historic times. Form has
been kept expressive thanks to one of the most precious gifts
bestowed upon man—the sensing of the fundamental char-

acteristics of the time and the faculty of building up a cultural form expressing these fundamental characteristics. However, this sensing has not followed fixed concepts of reality, but it has functioned by creating new realities. It has been a constant, sequent, and forward-moving achievement of the creative instinct which—as to its inmost nature —was, is, and always will be just the same as Henry Bergson calls *"l'évolution créatrice."*

Now, if we were to mirror this creative evolution— *"l'évolution créatrice"*—in the light of the facts that history of art can offer, scarcely anyone then, not even the most coldly calculating mind, could deny the existence of a certain creative sensitiveness which transformed the vibrations of the various times into corresponding languages of form. The Egyptian form—born through its fundamental form— was to such an extent a reflection of the life of the Egyptian people that these two—form and life—could not be separated from one another. The Greek fundamental form had its specific rhythm which during a long period of evolution became the very foundation of that exquisite Greek art. By comparing Assyrian, Indian, Chinese, Romanesque, and Gothic forms, one can discern how each one of these epochs had a significant tone of its own. Each one had a keen sense for its fundamental form and enough of instinctive sensitiveness to develop its form-language on the basis of this fundamental form. So it has been always when creative evolution had its clear and genuine course.

All this is plain. In fact, one's consciousness in this respect—at least, insofar as the great Civilizations of the past are concerned—is strong enough not to accept deviations from this as honest and sincere art. Surely, one would be surprised—if such things really could have taken place— at a Greek artisan who had used Egyptian decorations for his vases; at a Chinese painter who had directly copied Assyrian motifs for his panels; at a Romanesque sculptor who had ornamented his churches with Chinese dragons; or at a Gothic builder who had erected Greek temples. Why, for sure, everyone would regard such things as rude deviations from the spirit of the time, the race, and the

cultural form in the making. And one would stamp such things as signs of imitative degeneration—say, *"la dégénération imitatrice."*

This fact, then, must be accepted as the leading canon. And yet, consider what has happened in spite of this leading canon—so simply understandable and so fully acceptable. Really, form has fooled life by appearing in the garments of alien and ancient ages. We meet such phenomena—and this we have already discussed many a time—when examining form-development in the art of building. And we wonder by what right this art-form has taken the privilege of freeing itself, not only from the logical course of things, but even—and so much the worse—from the fundamental laws of all time.

The practice of plagiarism—as we know—was an invention of a few of the latest centuries. Earlier times, not having had any experience in such adventures, would have been astounded had they been told how matters came to pass. The builder of the Gothic cathedral—always truly sincere in his work—would have been shocked to know that new peoples a few centuries later had adopted his forms which long since had ceased to exist as living forms. And Iktinos, no doubt, would have felt dizzy in his head if told that more than two thousand years later his very form of support was hung like a Christmas tree decoration on the face of the steel-skeleton of a skyscraper.

It is important to understand the full significance of this adventure of plagiarism in the art of building. Although the art of building—and for a good reason, too—had lost its position as the "Mother of the Arts," all the same it continued to be the "mother" on which the other arts were dependent—no matter how step-motherly treated; all the same it continued to be the space-formation about the other arts—no matter how deeply involved in its imitative adventure; all the same it continued to constitute the spiritual atmosphere of the other arts—no matter how spiritless.

In the face of all this, how could the other arts be pro-

tected from being contaminated by the bane of imitation!

And, besides, how could it be avoided that one's sensitiveness to the fundamental form was doomed to be lost in all this bungle of imitation. Indeed, it could not be avoided. For, since there began those days of imitation, the fundamental form has not been spoken of, nor has it been thought of—and much less has it been sensed.

Things could scarcely be otherwise! Look at our homes, buildings, streets, and plazas, and there you can find an overwhelming abundance of "fundamental forms," borrowed from the Greeks, from the Romans, from the Middle Ages, or from other places. But scarcely one of our own. And, really, in this alien form-noise how could one be able to hear the silent pulse beat of one's own time, and of its fundamental form.

So much for the pre-nineteen-hundred situation.

Again, as for the post-nineteen-hundred situation, in many respects we are now already far advanced toward a form-language of our own.

On the other hand, there still remains the question to be answered; whether this form-language of our own grows from the fundamental form of our time, or whether it is arbitrarily developed as a product of theoretical reasoning.

This latter question is a serious one. It is so, in view of the fact that there is an abundance of esthetic literature offering all kinds of theoretical solutions in the production of art. Some of this esthetic literature tries to impose theoretical solutions based on such formulas as are derived from classical form-feeling—also based on the fundamental form of a distant past. Some again—and really a great deal of it—has come into existence through mere generalized theoretical speculation.

For sure, here lurks the danger.

2. FORM AND EVOLUTION

The growth of a seed into a tree is a miniature picture of evolution. In this growth, the seed, no matter how minute,

is the source of those latent potentialities which become active during the growth and which decide the character of this growth.

Without the seed the tree could not come into being.

Similarly, no form-world could come into being, unless it evolves from and through its prime germ. Such has always been the course of things no matter what the scope or significance of form-evolution.

The first attempts from which the Egyptian era had its origin are concealed in the clouds of a dim past. Undoubtedly, at the outset these attempts were just as modest as were the attempts of many a minor development which has vanished into early non-existence. For the size of the seed does not determine the extent of the species. The extent of the species is determined by the potential nature of the seed, and by the circumstances of soil and space, from and within which the growth takes place.

Obviously, in the Egyptian case there were potential vigor and favorable conditions to offer good opportunities of free development. And obviously, moreover, there was creative vitality to originate a truly strong form-expression. "Obviously," we repeat, for one thing is sure: from its very inception, the Egyptian form had the true zest of Egyptian mentality. For, once the Egyptians became conscious of the values of beauty, indeed the budding new form was most manifestly "Egyptian"—and only Egyptian. To prove this, if you please, select at random any object of art from the earliest days of Egyptian history—any object of art, no matter how inconspicuous—and you will find it thoroughly imbued with that same form-essence which during the long cycle of several thousand years became the very form-essence of that great art-form of the Egyptians. Now, how could it happen—someone might ask—that the earliest Egyptian artist could have so clear a conception of things to come that he could already predict, thousands of years previously, what the Egyptian style ultimately was going to be? Well, how can it happen—one might ask with the same amount of naïve candor—that the seed of the oak can have so clear

a conception of things to come, that it can already—say, one hundred or more years previously, before the tree has become shaped into that robust pattern of a matured oak—direct the growth of the oak toward that very pattern? Why certainly, the seed of the oak is not only a seed as such: it is a seed **with the soul of an oak.** Similarly, the budding Egyptian form was not only a form as such: it was a form **with an Egyptian soul.**

In accord with the fundamental characteristics of the Egyptian soul, the art-form of the Egyptians evolved during a long period of creative process. It evolved slowly, and ultimately it became crystallized into a rigid style—into a style where the individual was lost, and where time and race came into expression. At least, so it seems to us. Because of the long time-distance and the many intervening civilizations, one is bound to miss much of the personal touch of the Egyptian art. Perhaps, though, by looking deeply enough, one might be able to distinguish even the handwriting of individual humans in the execution of their art. No doubt, the Egyptians themselves—being close to the artists and their work—distinguished such individuality.

Because of a strong disposition toward human existence —both here and beyond—Egyptian art sought to bridge the gulf between temporal life and immortality. The art-form of the Egyptians, therefore, was made strong, massive, and substantial in construction to withstand the ravages of time. Their decorative pattern, likewise, was executed accordingly with permanence and posterity in mind: a pattern consisting of gracefully designed reliefs and hieroglyphics, cut in stone with calm dignity.

Such was the Egyptian form-evolution. It originated from its little seed, and it ended with that great art of the Egyptians expressing their cultural ego. It was—as has been said—a cumulus on the sky of human cultural evolution. It came. It went—And then came the Greeks.

The Egyptian Civilization was already on a downhill trend when the Greek form began to climb its way up. Along the mainlands and archipelagoes of the Aegean sea,

and in many places about the Mediterranean shores, there began to grow increasing signs that the time was ripe for new peoples to act. There was much of traveling and trading, of seafare and warfare, of exploring excursions and romantic adventures, all of which heralded a new era to come. And as many a song was sung about these events, the Homeric era was thus conjured into existence with its hexametric tales of glorious deeds. Simultaneously with and subsequently to this Homeric era, a new philosophy of life was in the making, and so was in the making also a new ethical and moral attitude of mind and a new religious world-feeling.

Fundamentally, the Greek form-evolution was the same as that of the Egyptian. Again, as to its form-flavor, it was as different from that of the Egyptian as the Greek mentality was different from the Egyptian mentality. The ideal of the Greek was man himself, and because of such an attitude of mind the Greek endowed his gods, not only with human forms, but even with human virtues and vices. Thus, his gods fought as fought the Greeks themselves. And on Olympus they had their family troubles just as had Socrates and Xantippe. Contrary to the Egyptian, with his mind toward eternal things, the Greek was a child of the moment and lived his temporal life in beauty. From this pursuit of beauty, the Greek form evolved. It evolved from utmost simplicity toward ripening richness, though remaining always well-balanced. Undoubtedly the Greek form, to some extent at least, was inspired by the Egyptian form-concept—in spite of the difference in attitudes toward the problems of life. Why not? Cannot the songbird be impressed by the depth of the forest and still trill joyously! Was it not possible that the grave Egyptian temperament could resound in a brighter tune through the Greek disposition of mind?

Here we discern the creative vitality of the Greeks. The Greeks knew that they had a cultural mission to fulfil, and they approached their work with pride and discrimination. The Greeks did not regard the Egyptian form as something which could be used by others. They regarded it as a part of Egyptian life, just as religion, language,

manners, dresses, and habits in general. The Greeks knew that alien art, just as alien customs, could not be directly adopted without making art false and lacking in meaning. It is true that the basic mode of construction—the bipartite mode with column and beam—was brought over from Egypt. But the Egyptians and the Greeks used this mode of construction differently according to their different mental dispositions: the Egyptians like one who already from childhood was grave, carrying this gravity through life with unwavering equanimity and calm; the Greeks, on the other hand, with sharply marked periods of age—the Doric and Ionic orders, and then the Corinthian one which with its richness of decoration fixed the boundary of further development: old age had been reached and the Greek culture was about to finish its orbit.

Yet the Greek temple still remains, noble and serene, as the eloquent testimony of work done and aims accomplished. The Greek temple was not the beginning of the Greek form-evolution. It was the illustrious end.

There was much of interblending before the Greek form could be moulded into its final key in accordance with the fundamental significance of the Greek life. In comparison with this, the Mediaeval time was the very melting-pot of peoples and races and of the consequences they brought into the dramatic pattern of the changing conditions of life. The remainders of passed civilizations formed the enlightening background of the long performance to come. But the problems were new, practically and spiritually. The practical theme was dictated by the uncertainty of conditions calling for protection. Christianity, on the other hand, furnished the spiritual issues. And those creative faculties which had to put this new life into significative design were often of strange and transplanted breed. The numerous barbarians from the East moved in, settled down, and mixed themselves with the original population. The Vikings crossed the seas, attacked the shores, and thus established intercommunication of both material and spiritual significance. So did the Moors. In this manner things went on;

and so, gradually, the Mediaeval form-concept emerged from these new circumstances of life. It emerged with its two main ramifications, the Romanesque and the Gothic style-orders—of which the Gothic style-order, no doubt, was the leading one.

The art-historian might be able to tell when the Gothic style-order came into existence. He might be able to do so because of certain events of conspicuous nature. And he might be able to do it just as easily as the historian can tell when Lincoln became president. But just as Lincoln needed a long time of preparation to become fitted for his high office, so the Gothic style-order needed a considerable period of evolution before it could be consolidated into the elaborate organism of the cathedral. Great things cannot be achieved overnight. Surely, the roots of the cathedral must be traced far back into the darkness of the "dark age." There, form had its intimate contact with the intimate pursuits of life. There, its fundamental characteristics were settled. And from there it evolved toward the big problems to be solved. Thus, as time passed, the Gothic style-order became increasingly complex; and the more complex it became, the more ornate became the stone organism of the cathedral. And ultimately, as this course toward increased ornamentation continued, the creative wells of further evolution began to run dry. That was the decisive finale of the creative Gothic period.

Thus, again, a great era of form-evolution came to an end.

Since then there has been created no Gothic art in Gothic spirit; only **spiritless echoes**—and plenty of them—of that once so abundant art of the Goths.

These three great Civilizations—the Egyptian, the Greek, and the Mediaeval—were the three truly creative epochs in the evolution of the Western Civilization. In considering each one of these epochs one can speak about genuine form-evolution, originated from its primary germ and carried on the basis of the fundamental forms of the respective times. And in each one of these epochs, evolu-

tion took place simultaneously in all the fields of form-manifestation.

After the Mediaeval era, there were the Renaissances, the Baroque and the Rococo. These we have discussed previously and from these discussions we can easily gather that in their respective cases no particular form-evolution took place—at least, not in the sense in which the process has been presented here. This was so much the more true during the times of reason and romanticism, with their "revivals" and "rebirths." And emphatically indeed, this was true when the age of materialism took the conduct of things into its hands. From then on, one could not speak of evolution—but rather of devolution.

Say, "*la dévolution imitatrice.*"

Again, as for the post-nineteen-hundred era, the time so far has been much too short to speak about evolution. Rather, in many respects the time has been a matter of stretching out one's antennae in order to sound the correct course. For—as we know—the natural evolutionary line had been broken and therefore an intense search for its logical continuance has become imperative.

We are still very much in the process of this search.

Form-evolution—as described—is a broad process spanning entire epochs of civilization. It originates with its prime germ. It ends with its style. And by its nature it is "categorical," it is "fundamental," and it is "creative."

Such is form-evolution—as a general process.

Yet form-evolution has also another aspect:

Going down to the peoples themselves with their feelings and thoughts, and to the artists who are to translate these feelings and thoughts, it must be understood that—basically—form-evolution is the work of an individual, multiplied. It is the individual's sensing of the call of the fundamental form which makes the process **categorical**. It is the individual's sensing of the basic laws which makes the process **fundamental**. And it is the individual's creative instinct which makes the process **creative**.

In this manner—and within the general process of form-

evolution—there takes place in the artist's mind and through his work an individual form-evolution which, multiplied, constitutes the substance of the general one.

Form-evolution, thus, is dual by nature: general and individual.

Speaking in metaphors, the process is twofold, as is the movement of the ocean when it is stirred up by the wind and the waves go high. The waves themselves proceed in the direction of the wind. The water-molecules, on the other hand, oscillate up and down as if surveying the vertical significance of the movement. In analogy with this, the general form-evolution proceeds along the course of the fundamental form; the individual search, on the other hand, surveys the cross-section of the movement by solving the individual problems.

This dual process is essential:

First, because it brings into the process the significance of time and race. And secondly, because it enlivens the process by the flavor of individual creation.

3. FORM AND MIGRATION

A few pages back—this was said: "Everyone is predestined to exist in a sphere of outside influence which, in the course of time, is decisive in his development in accordance with this influence." This, for sure, holds in any circumstance, for even the most secluded hermit cannot escape his fate of meeting at least some people.

The same concerns nations and races—it was said.

Consequently, when we speak about form-evolution as a genuine expression of the characteristics of nations and races, we must take into consideration also the sphere of outside influences. That is, **the genuine current of form-evolution is met by side-streams of alien influences which affect the course and character of this evolution.**

Self-evidently, these alien influences differ much as to both strength and character. It is a well-known fact that in early days the various tribes lived in isolated circumstances and shaped their respective forms more or less independently.

In spite of this isolation, however, one can find much similarity of form between things created at the same stage of development, although far apart from one another. Because of the similarity, many are inclined to attempt to prove the existence of direct connection and mutual influence between tribe and tribe, nation and nation. Perhaps there was a connection. Perhaps not. However that may be, one should not disregard entirely the fundamental human characteristics. Rather, one should understand—more than is commonly understood—that the fundamental human characteristics are the driving incentives of many a subconscious action. For example, do not young children of equal age draw figures in the same childlike expressive manner, no matter how far apart they live on this globe? And—to draw parallels in general—do not dogs bark just the same no matter whether in the North or in the South? And how about the taste and flavor of strawberries, and—for that matter—how about anything else that grows and lives on this earth!

On the other hand, it is fully clear that, through direct contact, similarity of form becomes more obvious. And the more frequent the contact, the closer the characteristics of form. During earlier times of civilization, intercommunication was limited to certain peoples and therefore the "side-streams" of alien influence were of rather local nature. In the course of time, though, intercommunication has steadily gained in both intensity and scope. Now it has become much of an international routine.

When we view form-evolution in the above light—with consideration of the growing influence from without—it is obvious that many a form-feature has become nomadic in both character and effect. This manifestation we may call "form-migration."

By form-migration—or why not "form-immigration" or "form-intermigration"—we mean form-influence between various ramifications of human civilization.

This, we should say, is a simple matter.

However, before we go further into this simple matter,

we must first pause to deliberate upon what the implication of the word **influence** really is. Does it mean creative inspiration derived from contacts with alien forms or is it to be understood as a direct adoption of these alien forms—meaning that the commandment forbidding us to take things belonging to others can be violated? It is essential to find the right answer to this question—even in the case of form-migration—as we have been ever so often confronted with the drift to direct copying.

Previously, when the relationship between **man and his genuine form** was our topic, we went to the roots of the problem by studying the situation where this relationship was most general and intimate: in the "room." As the topic now is the relationship between **man and the alien form,** we must do the same.

So again we find ourselves in the "room."

Now, supposing that you are the occupant of this room. Supposing that you have designed the room yourself, that you have selected every piece in the room, that you have organized all these pieces in accordance with your desires, inclination, and taste. Having done all this, you have expressed your personality through the room-atmosphere thus created. Then, naturally, in the aura of the room your own aura has become reflected. And every object brought into the room-ensemble tells its own story about one phase or another of your character and disposition of mind. However, in this room-ensemble there may be many features which originally came into being in quite alien circumstances, so that seemingly they have no connection with your personality, nor with that ramification of civilization you belong to. Yet there they are. They have been selected by you. And in one way or another they must then be expressive of your personality.

Now, there might be a piece of Chinese sculpture. Obviously this indicates that you have broadened your horizon to be receptive even to Chinese thought. And because just this particular piece of sculpture has touched the "Chinese strings of your soul"—if we dare to put it thus

175

sweetly—it is expressive of your personal leaning in this very way. It then belongs to you spiritually also: it represents your Chinese inclinations in the room, and it has migrated from that far-away China to serve its new master—and friend—and to enlighten him.

But this is not form-migration.

So far, it is a mere matter of import of physical objects, and not the transfering of spiritual form-values from one form-world to another. For, remember this: Chinese art is and always will remain Chinese art.

But, supposing that you are a sculptor. Someday then you might produce a piece of sculpture of your own, which, because of your intimate contact with the said Chinese sculpture, might get something of Chinese form-feeling. In other words: your piece of sculpture **expresses** Western mentality, while at the same time it **reflects** that of the Chinese. In this creative manner, Chinese mentality has been infused into Western art. And the latter has become enriched accordingly.

So functions form-migration.

In this example there are two points for you to observe. First: you have **selected** the piece of sculpture according to your Chinese inclination. And secondly: you have **created** something of your own, in which process your Chinese inclination has become translated into Western thought. So must be the procedure. And this means that alien forms cannot be accepted into form-evolution at random: **they must pass through instinctive selection as to adaptability before they can be embodied into form-evolution through a creative process.**

The purpose of the above example was to make these two points clear: the **selective,** and the **creative.** It is of importance—we think—to stress these points, for in innumerable cases things do not happen that way. On the contrary, alien forms of miscellaneous kinds are imported and directly copied without any scruples whatsoever. To prove this, one might refer to countless examples which show obvious lack of both selective and creative consideration.

Here is one—and a conspicuous one, too:

Almost generally the floors of Western rooms are covered with oriental rugs. Now, one could bet ninety-nine to one that in the selection of these rugs there is no question of "touching the oriental strings of one's soul" whatsoever. Most probably these rugs—or mostly, super-commercialized imitations of these rugs—are bought quite handily without much deliberation as to what they are and wherefrom they originate. And now these "oriental" rugs lie around on the Western floors as some sort of exotic misfits. They have already been lying there for generations, imposing their strange atmosphere, and having no spiritual alliance with the rest of the environment—unless the rest of the environment is made "orientally" false. And only a few seem to whisper: "why the oriental rug."

But, no doubt, this whisper is bound soon to grow louder, for that seems to be the current trend. At least, that's our hope: not because we are eager to disparage the oriental rug—when genuine—but because it is humiliating to our sense of dignity to have its bastards lying around in our innocent homes.

Indeed, in the Western case of the oriental rug, the "selective" and "creative" points have been conspicuously absent. And therefore the case is not a matter of form-migration in a creative sense. Rather, it is—let's say—a grand-scale-imitative-vulgarization.

Form-migration of the great Civilizations exhibited both "selective" and "creative" strength.

The creative strength we have already discussed, and, as for the selective strength, this might be said:

When we maintained that the Greek bipartite mode of construction—beam and column—had its origin from Egypt, by no means did this insinuate an intrusion into a field which did not belong to the Greeks. Obviously the Egyptian bipartite mode of construction would not have been accepted by the Greeks unless the Greek selective instinct had sensed its fitness in the Greek form-evolution. It is not necessary to delve deeply into the matter to be convinced of the validity

of this thought, for both the function and spirit of the Greek temple, for example, show this clearly enough. In fact, the bipartite mode of construction was to such an extent a fundamental essence of the Greek form-concept that one really wonders whether its employment was a matter of form-migration, or of genuine form-evolution.

The Gothic master-builder did not select the pointed arch—of supposedly oriental origin—because he thought it a mighty good idea. He did so because the Gothic selective instinct identified the inherent spirit of Gothicism in the pointed arch. As a matter of fact, the pointed arch was so thoroughly in accord with the whole Gothic form-feeling, that obviously the Goths, sooner or later, would have arrived at the same pointed solution—without the trouble of crossing broad waters. Or perhaps the pointed solution after all was an original concept of the Goths themselves—in spite of art-historic thinking! Who knows. And who cares.

Again, as for the Renaissances, undoubtedly there was much subconscious and conscious selection before the Gothic and Classical form-worlds could become interblended into the Early Renaissance. But however this selection was made—subconsciously or consciously—form was never directly applied. It had to undergo a creative transformation process so as to be fitted into the spirit of the new form-expression. Thus, in the Early Renaissance case, both "selection" and "creation" were alert.

The Late Renaissance, on the other hand, limited itself to mere dogmatic adoption of the Classical form, thus ignoring the creative part of the problem. This, surely, had little in common with form-migration.

What happened after the Late Renaissance time, we are already familiar with. Likewise we are familiar with the nineteenth century adventure of imitation. And we know that this adventure of imitation was a random procedure of arbitrary "revivals," "rebirths," and the like. So that is outside our subject.

Considering finally the present era, we are facing an entirely novel situation insofar as form-migration is con-

cerned. The "side-streams" are active from every direction. And the mind of today is increasingly moulded toward internationalism.

It is fully logical that the mind of today, since it dwells in the midst of world events of international consequence, must become internationally adjusted. Form-migration—or rather now, "form-intermigration"—must show corresponding adjustments; for the search for form gets its impulses from the East and the West, from the North and the South, and consequently the earlier narrow concept of form is apt to undergo a change toward a broader one of international significance.

These points are at stake:

When actions were localized and problems few—as they were in olden times—concentration of work was easy. And due to the fact that mind was close to the pulse-beat of life, quality of form was true and expressive. But the impressions were few; the means of expression limited; and the confined mode of living tended to keep mind in narrow circles.

On the other hand, when actions are widespread and problems manifold—as they are today—concentration of work is trying. And because one dwells amidst the internationally pulsing cross-roads of life, form-expression tends toward complexity. The impressions, therefore, are many; the means of expression multiplied; and the diversified mode of living tends to mould mind shallow.

Thus, comparing the localized conditions of olden times with the broadened contacts of today, both cases have their advantages and disadvantages. But as it is our fate to follow the categorical course of things toward **international consequence,** there is no choice, and we must make the best of the situation.

Now—sounding the surface—international consequence means increased knowledge and broadened views about a great number of things. And these, too, may have their consequences.

Often it is maintained that knowledge dulls the sharpness of instinct. Many are inclined to believe that the

broader the views that history, geography, sciences, and other branches of knowledge can offer, the greater becomes the endangering factor to the creative mind. The creative mind might become more reflective and less sensitive. And, if so, culture is in danger of becoming rational rather than deep.

So it is feared.

There may be reason for such a fear, and surely there are many examples that confirm this. But on the other hand one should not mingle the two things: **knowledge,** and **receptiveness of mind.** Knowledge in itself is not culture. Culture depends entirely on receptiveness of mind, and by no means on the amount of knowledge the brain is able to absorb.

Someone has put it thus:

"Culture is the result of what remains in one's mind after the facts of knowledge are forgotten."

From this we can draw conclusions as to two different types of mind. One type absorbs facts, digests them, and makes them creatively fertile. The other type absorts facts, sterilizes them, and uses them as such. The former is the **creative** mind. The latter is the **parasitic** mind—"parasitic," for after all it lives on food digested by others.

It is worth while to note this distinction, for, on the road toward internationalization of mind, this distinction is highly indicative of the difference between creative vigilance and non-creative shallowness.

Now as to shallowness, a shallow mind might or might not become shallower through internationalism. It really does not matter, for we are not interested in shallowness. The receptive mind, on the other hand, cannot be harmed by the breadth of his knowledge. On the contrary: does the philosopher become shallow if, from the bigotry of narrowness, he broadens his system of thought into universality; or is the composer less deep, if his music expresses the soul of the universe, instead of interpreting local tunes of folk-song?

Accordingly, internationalism is not an obstacle in the progress of culture, provided man is wise enough to adjust himself to meet the situation.

Rather, it is **an opportunity.**

The present age is eager to spread ideas about. When a novel form appears—and is found strong and expressive—in a short time it is published, described, analyzed, criticized, exhibited, and advertised everywhere and in every way. Almost immediately this novel form is made internationally known. Its idea is applied, the form itself adapted—and, for sure, often directly adopted. This fact becomes a levelling agent by diminishing the differences of form between nations and countries. It becomes a dangerous agent in case forms are employed without discrimination as to fitness, and only because of their novelty. On the other hand, if forms are properly used—in accordance with both selective and creative considerations—then the positive value of form-publicity is obvious.

There is little doubt that our form-in-the-making is bound to become of international significance. Yet it can become so in respect to its fundamental nature only. It really must become so, if the fundamental form of the time—which moves toward an international concept of form—comes into expression as it really should. But from this fundamental basis, individuality of form must become modulated to fit local conditions of life and climate. The native from Canton or Tokio—as to his mentality—cannot be cast in the same mould as the man from London or Paris. Nor can this be done with his habits of life or with the forms he likes to live with. And the climate of Finland, with short summers and dark wintry days, has other form-requirements than hot and sunny Pernambuco.

The more slowly form develops toward international expression, the safer the development.

Alas, there seems not to be much patience in this respect. In certain circles much is already spoken and written about "international style." Obviously this is premature, for the so called "international style," thus far, is neither international nor style. Even though a scant number of smokers were scattered all around the world, this would not of itself make smoking an international habit. Much deeper rooted must the habit of smoking be—as it probably is—if

it is to be considered international. Now, the contemporary form-expression is thus far pretty thinly scattered around the world. And insofar as its style is concerned, the new way of doing things is still far from style.

Style is not accomplished by merely eliminating the old ornamental stuff and by letting materials and construction appear in their ultimate nakedness and ascetic simplicity. This may be the fashion of today, but as for style, it is only the very beginning on which to build its slow and gradual evolution. Form does not speak through material and construction. Form speaks through proportion and rhythm infused into material and construction. When proportion and rhythm are tuned in accord with the characteristics of the time, form of the time first comes into being—and from this form of the time, style grows very gradually. Therefore, "international style" still has a long way to go before it will become crystallized into style.

Certainly, there is no hurry. Style cannot be forced into existence. Much less should it become intentionally international. If style after all is going to be international—and, ultimately, this is very much a matter of categorical imperative—it can become so only by virtue of its inner merits and because of the strength of its foundation.

Did Bach try to compose international music?

Because of his marked individuality, Bach's music became individually typical. Because Bach was true to the inherent potentialities of his blood, his music expresses the characteristics of his nationality. Because Bach sensed the fundamental characteristics of his time, his music has the bearing of international significance. But Bach himself did not try to be either individual, national, or international.

Bach simply did his best—for his own inner satisfaction.

4. FORM AND STYLE

May we first make it plain that when we speak in this analysis about "style," we do not mean a specific architectural order of one kind of another, nor do we mean some typical phase of local form-development. By "style" we mean a "form-

language," which, during the long span of a certain civilization, evolves into expression of all the phases of that particular civilization.

Style, in this sense, is no problem in itself.

Style, so understood, is the categorical result of the search for form of any civilization.

This then must be true even in our case.

And as in the search for our own form we have decidedly —at least, let's hope so—turned away from the copying of obsolete styles, and are heading toward new fields without any style-concept of our own whatsoever, we are in precisely the same situation as were the Greeks and Goths at the beginning of their respective eras. Surely, to start with, the Greeks and Goths had no style-concept of their own. They simply had to get along with their own creative stamina. And so they started the long journey of search for their forms along the whole front of current problems. Gradually, in this manner, the characteristics of their respective styles became apparent. So things went on for a long period of time; and the more time advanced, the more the freedom of form tightened into the rigidity of style, till ultimately there was nothing else left over for the creative instinct than to repeat and repeat again the rigidly fixed style demands. That was the end. Yet the end in both of these cases was an illustrious one. It was so, because the Greeks and the Goths were not initially bound by any preconceived style-ideas, but had and grasped the supreme opportunity to create their own form by themselves.

Our age has now a similar journey to undertake—and a similar opportunity, for sure. And during this journey we will do wisely if we approach our problems in the same sincere and creative spirit as did the Greeks, the Goths—or any other of the great Civilizations.

Previously, now and then, in this analysis, form has been considered from the angle of style—just as, for example, a moment ago it was considered from the angle of "international style." But so far the real nature of "style" has not been made clear enough. And, although we now think it

183

necessary to take the matter of "style" separately under discussion, our concern even now—as has been the case during this whole analysis—is the search for form, and decidedly not the search for style. This point must be stressed explicitly indeed, because there is a substantial difference between these two modes of procedure. The former—the search for form—is a natural pursuit in form-evolution. The pursuit may be intentional or unintentional, it does not matter; for automatically—and categorically—it becomes an unintentional progress toward style. The latter—again, the search for style—when intentional, is caused by a deceptive ambition which is bound to lead any normal form-development into a deadlock. It misses the point that style cannot be attained by a quick action, but only by a slow evolution of form. And it takes a short cut to an easy goal. It brings forth the "fashion" of the day and proclaims it the very style of the age.

In the annals of the art of building there have been many incidents of style short-cuts. So, for example, when the Late Renaissance made Vitruvius' "de architectura" its canon, it could not accomplish any style of its own—due to the quick and easy action. It was as sudden a movement as was the change of architectural clothes during and after the Columbian Fair of the year 1893 in Chicago. Both of these incidents had their fashions tailored by previous times. The same was true of all those so called "revivals," "rebirths," and whatnots, which from time to time have popped up on the architectural horizon. All these were just plain and capricious adoptions of forms belonging to other times and other peoples.

The present age—we hope—does not agree any more with such a handy procedure. The present age—and again, we hope—begins to understand the necessity of indigenous creation in the process of form-evolution toward style. And there seems to be much eagerness to sense the way ahead. In spite of this, however, the search for form has frequently strayed into the search for style. And, as said, it has brought about many "fashions."

To illustrate the situation, we might take a peep behind the screen to see what's going on.

In some circles the operation is this: In solving his problems, someone may have struck a new note, expressive as to both function and time. A new and honest form for its specific purpose thus has been born. Because of its expressiveness—and particularly because of its "novelty," we guess —this new form is advertised. Soon, many cling to it and use it timely and untimely and in every which way. It becomes popular, and it is considered just the very thing: "modern style," to be sure. Such an attitude, however, brings additional perplexity into the style-situation, for the idea— fundamentally speaking—is not to be "modern," but merely to be "true" by trying to sense the true characteristics of the problem, surely not the whims of publicity. By virtue of being true, form becomes modern in the best sense of the word—without the command of the modern "stylist." The nature of the problem is the deciding factor, the epithet "modern" is but a vainglorious nick-name which the sincere seeker tries to avoid—because of its smack of reciprocal imitation.

The "modern" has many faces—some of which we have already mentioned. So we repeat, quite freely:

One day form is softly curved, characterizing material, no matter what the material—for just the softly curved form is the essential thing: it means "style." The next day form is straight-lined, characterizing function, no matter what the function—for just the straight-lined form is the essential thing: it means "style," Then, again, form is streamlined, characterizing movement, no matter whether movement or not—for just the streamlined form is the essential thing: it means "style." And so, whatever form represents, everyone —to be "modern"—is compelled to use the right style-shape at the right style-time, no matter whether he uses it rightly or wrongly as to both shape and time.

Of course, all this is not a sincere search for form which develops along an even orbit toward a certain goal, but a pseudo-ambitious search for style which zigzags from one extreme to another, thus making the situation puzzling to

both the general public and the searchers themselves. The originators of the various new forms and their followers are not to be blamed for the puzzling situation: they deserve much recognition for their accomplishments. The blame belongs to the swarm of indiscriminate imitators who are making "style" out of the sincere forms of others.

Man still seems to be much of a monkey.

Style does not develop that way. Deeper import must be put into form than casual achievements and their indiscriminate repetition. Style means a sequential process of spontaneous yet conducive actions that spring from the physical and spiritual characteristics of the time and people. Style is a matter of gradual growth and of instinctive selection of the best of this growth. Growth of style is much the same as is growth of folk-songs—in a collective sense. Of all songs that are sung, those which do not reflect the inmost aims and emotions of the people are soon forgotten; whereas those which interpret the downright properties of folk-soul, remain folk-songs. Thus, just as in the singing of songs there is no deliberate effort to create folk-songs, so must there be in the search for form no deliberate effort to create forms that make style.

Conscious conduct is of no avail in style process. As much as the fundamental form develops in a certain direction without the efforts of human decision, just so much does style move—on the basis of the fundamental form—in a direction that nobody is able rationally to control but that everyone is compelled instinctively to follow. Man's efforts do not create style. Style created itself through man. In the last analysis, therefore, **the essence of style must be found within man.** And we fully agree with Buffon—the French scientist of the eighteenth century—when he says: "Le style c'est l'homme même." That is: "Style is man himself."

In form-evolution toward style, the spoken language can furnish many illuminating parallels. For, as in form-evolution there takes place a continuous process toward ripening style-expression, so does there take place, in the evolution

of the spoken language an analogously continuous process toward ripening language-expression. Because of this analogy, it is frequently believed that the spoken language is comparable to style. The comparison is not correct, however. In the spoken language, the individual words are the material which, combined into proper order, constitute communicative sentences—just as in the realm of art, where substance, color, sound, movement, et cetera, are the material which, combined into proper order, constitute communicative form-expressions. Yet this is still far from style. Not until words are combined into sentences and these sentences into logical sequence, is thought put into the spoken language; and not until the spoken language is raised into a certain level beyond colloquial use—into speech, literature, poetry—is the spoken language developed into style.

It might be of value to venture further comparison between these two languages, the spoken language and the language of form. In certain respects such a comparison might prove enlightening.

The spoken language was created through a gradual **instinctive process** characteristic of the people having originated it. The linguist studies this language and puts it into a scientific system. He learns that the language has a logical construction which follows its own grammar-laws, and he learns that this logical construction and its grammar-laws have evolved subconsciously during the evolutionary process of the language itself. Furthermore, the linguist learns that certain seemingly fortuitous exceptions to the rule have crept into the language construction, as though to free it from rigid stiffness and thus to enchant the color of speech. For our part, we see the kinship between the spoken language and the language of art. This kinship lies in their common origins within man, and in their employment of basic principles. And as the principles that hold good for one must hold good also for the other, we must then rightly infer the logical conclusions.

Every word of the spoken language must express its share of meaning in the sentence. If it does not, it is doomed to vanish of its own accord.

The same applies to the language of art.

Every sentence in the spoken language must be formed so as to convey its thought. If that is not the case, the sentence is meaningless.

The same applies to the language of art.

Every sentence of the spoken language must be humanly expressive, and in accord with the spirit of the situation.

The same applies to the language of art.

The spoken language—developed into style—moves with suppleness and litheness close to human life in all its shiftings. It builds folklore, tales, literature, and poetry.

The same flexibility and richness must be the characteristic even of the language of art. The language of art, therefore, must not be permitted to stiffen into academic style-formulas and it must not be made dry and stereotyped. That is, the language of art must remain dynamic—for only as long as form is free in this sense, can it remain vital.

Considering exactly this dynamic quality of the language of art, the spoken language can offer instructive parallels.

The spoken language can be of particularly good advice to the inveterate champion of historic style-forms, always so ready to chain style by his obsolete doctrines. Because of the seemingly analogous situation between the spoken language and the language of art, many of those ensnared in historic styles have been eager to defend their position by referring to the "elements" of style as a parallel to the "vocabulary" of the spoken language. In their eagerness to defend their position they have gone thousands of years back in time in order to import the "elements" of architecture—believing them to have become petrified into static features as soon as they were released into the market by the Greeks. But they were not petrified into static features. They were subject to change just as is the "vocabulary" of the spoken language—which latter fact the inveterate champion of styles apparently has overlooked.

Indeed, the vocabulary of the spoken language must be subject to changes, as time passes. It must be just as much subject to both form-evolution and form-migration as is any other form. Day after day, the vocabulary of the spoken

language adopts new meanings, new thoughts, and new nuances. Every new meaning, thought, or nuance added into the changing conditions of life puts its stamp on the language in use. Every new contact with new peoples and their languages influences the vocabulary accordingly. Particularly at the present time, when novelties are constantly coming in and connections with new countries are increasingly established, the spoken language is bound to be enriched, broadened and altered, and alien words are bound to be brought into it. In this manner the spoken language is maintained on the precise level of the changing demands of life. For sure, one does not use the language of Chaucer, asking in old-time mode for water for the mule, when going to the filling station to have one's car supplied with gasoline. One settles the errand in plain, direct, and current terms. One uses the vocabulary as it has been developed up-to-date as to its form, sound, and nuance. Even the simplest and most commonly used words are apt to change character and meaning from their use in earlier days. And one wonders what Francis Bacon might have thought if by some curious chance he had been told that someone "roaring through the red light had a blow-out in front of a speak-easy."

Speaking about Francis Bacon, it is rather amusing—and instructive—to learn how insistent he was to have his writings translated into Latin, thereby to preserve them for posterity. He thought the English language—that veritable conglomeration of various and different tongues—did not possess the quality of longevity; whereas Latin, that old and proven language which had successfully struggled through the turmoils of many ages, was a firm ground on which to build lasting recognition.

History testifies that Francis Bacon's forethought was of little avail, and so testifies common sense too; for indeed, the more rigid the language, the less does it possess the flexibility of moulding itself to the changing conditions of life. Bacon was not conscious of this fact. Because of this, he misjudged the respective possibilities of these two languages—Latin and English—in keeping themselves pliantly up to date, in the long run. The Latin language had already

been developed into a final and perfect construction long before Bacon's time, and therefore it was lacking in flexibility and sooner or later doomed to be withdrawn into libraries for the use of but few. The English language, on the other hand—just by virtue of its complex origin—became related to the many tongues from which its vocabulary had been gradually supplied. Its vocabulary, thus, has become many-sided and elastic, broadly adaptable and useful in the complexity of changing conditions of life. It has become "functional." And in the course of time it has been put increasingly into function. Thanks to its broad international qualification, the English language has all the possibilities of becoming an international language. Undoubtedly—by the way—the English language will be able to outdistance and outlast those many artificially constructed languages which from time to time have been imposed upon humanity, such as Ido, Volapuk, Esperanto, and—what next!

We have stayed for quite a long time with the problems of the spoken language, because, as was said, from the viewpoints of form and style these problems are in many respects illuminating. Really if we were to delve into the life-labyrinths of the past in an attempt to trace the genealogy of every word of all the languages and every element of expression in all the genuine form-evolutions, we would unroll a truly dramatic picture of the melting-pot of life—with all the thoughts and ideas born, with all the migrations of these thoughts and ideas, and all the reciprocal fertilization of these migrations. We would realize how all the language-styles as well as all the form-styles had a similar conception, a similar birth, and a similarly gradual growth . . . And —leaving now the spoken language and considering the general art-form only—we would learn to understand how styles have been born at the depths of the souls of the times, and how they have grown up breathing the spirit of the peoples and races that fostered them. And **we would have a deep esteem for the genuine and sincere approach in the formation of these styles:** styles which—whether significant within a limited period only, or covering millenniums—**fertilized the general cultural development of mankind.**

190

PART THREE

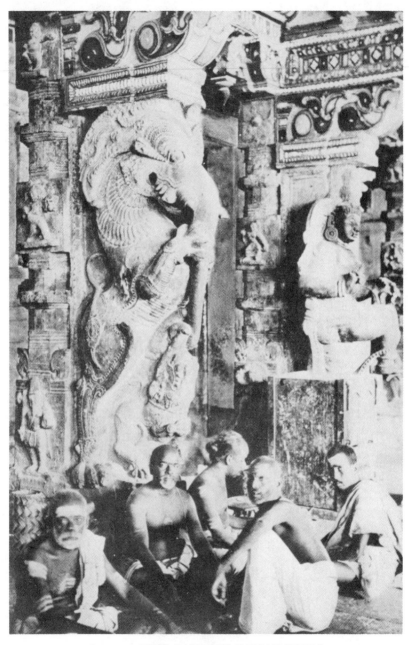

PLATE 10. THE EASTERN INDIAN FORM
The Great Temple at Madura, India

PART THREE

IN BOTH PART ONE and PART TWO of this book, we have dealt with those provinces of form-search which are of a general nature—whether historical or fundamental—and which, therefore, apply to form-development as a whole.

In contrast, PART THREE considers those special provinces of form-search which cannot be generally discussed, but which call for individual consideration in each individual case and consequently must be catalogued in accordance with their specific natures. We are, of course, aware that things cannot always be readily catalogued without becoming involved in inconsistencies. In spite of this we have thought it appropriate to divide the discussion of the said special provinces of form-search into two main groups. In the first group we have included the problems which can be understood mainly by reasoning. In the second group we have included the problems which are mainly a matter of instinctive sensing.

a. **Province of Reasoning:** Tangible problems.
 Form and Truth.
 Form and Logic.
 Form and Function.
 Form and Color.
 Form and Decoration.
 Form and Space.
 Form and Theory.
 Form and Tradition.

b. **Province of Instinctive Sensing:** Intangible.
 Form and Beauty.
 Form and Taste.
 Form and Imagination.

VIII. FORM AND TRUTH

RATHER frequently the quality of "true art" has been mentioned in our discussions, and although the meaning of the word "true" has not so far been clearly defined, we have assumed it to be understood that this word—in connection with art—means much the same as "indigenously creative." So, for example, when speaking about the primitive man and his subconscious stage of art-development, it was said that "the primitive man's art was indigenous, direct, **true,** creative, and most expressive of the primitive man's life"—which actually means the same as "indigenously creative."

This definition, however, does not as yet clear up the whole implication of the concept "true," "truth"—or what else.

No doubt, in the primitive man's case, "true" and "truth" were synonymous—for surely, there was much "truth" infused into the primitive man's "true" art. But there might be found an abundance of other linguistic interpretations of these words. Take, for example, the case of a wood-carver who may have spent months and years of hard labor—sincerely and diligently—in carving some seasoned oak-trunk into a prettily ornamented church-madonna. While doing so, he might have poured plentifully of the most intense "truth" into his work, and yet the result might be utterly poor. And if utterly poor, how then could one call it "true art"?

Well, the expression "true art" has a double implication. First, it implies the **moral quality** of "true." And secondly, it implies the **creative quality** of "art." Such must be the understanding in any circumstance with true art. Such has been our understanding even with the primitive man's art—namely, that his work had attained the quality of art.

However, between "true art" and "untrue art," there are bound to be many gradations.

Take, for example, a youthful group engaged in arranging the décor for a festival. Now, what could be the result of this kind of a job, insofar as the implications of "true" and "truth" are concerned?

The result could be "true art"—provided the work was done with true expressiveness of the character of the occasion and with sensitiveness to the fundamentals of creative art. The result could be "truthful art"—provided that at least the endeavor was truly to express the character of the occasion, and that the work was done with enough taste to warrant the label "art." The result could be "untrue art"—provided the work was done without any connection with the character of the occasion, and yet with enough taste to have the label, "art," at least superficially, accepted. And finally, the result could be "no art," provided the work was done without any connection with the character of the occasion, and entirely without taste.

As we see, then, **"true expressiveness of meaning," and "creative quality of form," are the categorical prerequisites in the appraisal of true art.**

Let's now try a historic parallel in order to learn how earlier times looked upon these matters. Such a parallel may provide a broader platform from which to look upon things. Moreover, such a parallel is essential, particularly in view of the fact that during the long course of passing centuries the understanding of truth in art has undergone a rather radical change—and a thoroughgoing one, too. This is to intimate that the original Greek and Gothic understanding of truth in art was not necessarily the same as was the later understanding of truth in the adoption of the Greek and Gothic styles. Undoubtedly, the genuine styles were developed through a painstaking search for truth. A later adoption of these styles, on the other hand, did not seem to consider this truth very seriously, and the operation probably was rather easygoing. Of course! For there is no need for the mother of an adopted child to have pains.

However, this said adoption has caused a ticklish situation insofar as truth in art is concerned. Many explanatory theories have been written about the matter, but on the whole these writings have more of a smack of self-defense than of a sincere aim for truth.

Some critics with "sharp appraising eyes" have discovered that none of the styles, old or new, are truthful—neither in their means of expression, nor in their methods of construction. No matter what style-period the critics study, they are always able to find fallacies of one kind or another. Consoles do not support cornices as their shapes indicate, but are hung as mere decorations from the cornices themselves. The real construction is often concealed behind fake forms, indicating another construction. The façade is often only a decorative mask having little in common with inner space-organization and mode of construction. The critics discover all this and many other kinds of untruth throughout the various styles. And as their "sharp appraising eyes" are eager to trace this trend to untruth even in the genuine styles, they then arrive at the conclusion that truth and form do not have much to do with one another. Things being so, they say, criticism has to be based on other virtues than truthfulness and honesty in the treatment of form. According to their opinion, therefore, ethics is not essential in art, whereas the decorative side is of prime importance. Style is the deciding factor. And that style is pre-eminent which has the ability to bring the most delight to man.

This indeed—it seems to us—is a flat declaration of moral bankruptcy. If art expresses life, it must be judged according to the same standards as must be used to judge life itself. Surely, **mind,** and **action of mind,** are related to one another. Consequently, if action of mind is not based on ethical criteria, then undoubtedly the mind behind this action is correspondingly wanting. And if one should be satisfied with "delight" versus "ethics" in the realm of art, then by the same token one should be satisfied with a person —no matter how unethical—as long as he is a delightful entertainer, say a harlequin.

That is the logical conclusion of the superficial attitude of the aforesaid critics.

We cherish a different opinion—really, **we do!** For the above evaluation of things cannot be satisfactory from the viewpoint of sincere consideration of human values—whether one is considering man himself or his actions.

The great epochs did not approach their work in as easygoing a manner as that. Without doubt the Greek bipartite structural concept is honest. Without doubt the Romanesque and Gothic vaults are truthful in both concept and execution. Such is the case, especially with regard to the basic construction of the whole structural organism. But such is the case also insofar as applied decoration is concerned. The applied decoration sprang directly from construction methods, from practical requirements, from religious and cultural considerations, and not least from the psychology of the people and the spirit of the time. All this was a logical and sequential procedure in the birth and growth of style.

In this birth and growth of style, however, there are structural and functional features which, as time passed, became changed from their former practical assignments to decorative ones, remaining thereafter as mere stylistic features in the building organism. Such are the triglyphs and metopes of the Doric order—let it so be, remainders of earlier structural forms in wood. Such are the archers' galleries and battlements of the Romanesque and Gothic styles, which originally served defensive purposes, but which, after their usefulness as such had ceased, remained as decorative members in the service of style. One can discern the logical existence of such remainders, just as well as one can discern correspondingly logical phenomena in organic evolution in nature. And the gradual metamorphosis of their character from functional to decorative must be accepted as a truthfully consistent evolution. At the same time it was to be expected that these decorative members were doomed eventually to disappear, if the style-process had remained creatively vital—which however was not the case.

Thus, following the evolution of the great styles, it is

easy to read the trend to truth in their forms. That was the situation as long as the creative instinct was vital. Later on, when the respective periods came toward their ends, the inclination to the decorative became predominant. This was the normal course of things. Indeed, insofar as truth is concerned, it is significant that the trend to truth is a sign of youthfulness in the creation of art and this is true in all fields of art, and in all times. Accordingly, at the beginning of form-evolution—when the search for form is youthful—the trend to truth is strong. Whereas in the course of time—when the search for form loses much of its youthfulness—the trend to truth weakens in the same ratio as the inclination toward the decorative gains in strength.

This, as said, is the normal course of things. And in this respect there have been no exceptions in the birth and growth of styles in general. Nor could any style escape eventually its inevitable decorative destiny, no matter how keenly it may have longed for truth at the beginning.

So much for genuine styles.

But when these genuine styles were directly transplanted into strange conditions, this action in itself was already contrary to truth. It was to impose a genuine form upon circumstances where it did not belong, and through this the relationship between form and life was made false—no matter how true both form and life were in themselves. Thus the formerly true form became automatically untrue. And when dogmatic rules were established to act as the supreme guardians of this untruth, then style-independence of ethical considerations became so deeply rooted in the general consciousness of the time that even earnest critics have seen fit to cast aside moral qualities in art. With such an understanding of things in mind, we can appreciate that it is only a natural downhill development when the hanging of Greek columns and Gothic vaults on steel skeletons is accepted by the Fine Arts patrons as truly corrective procedures. And so, when the aforementioned critics maintain that none of the styles—genuine or adopted—are truthful in their modes of construction, they thereby show a lack of discrimination between **creation** and **imitation,** and one has

reason to suspect that they have examined the creative status with the spectacles of imitation. As for the falsity of imitation, their criticism is fully correct. We accept this with acclamation.

The fallacies, thus, are the faults of those who adopted the truthfully conceived styles, and not of those who conceived them. There is no reason, consequently, to throw overboard ethical and moral values of art, merely because things have drifted astray and minds have become so dull as to deem them right. Why, after all, use styles? Why not, instead, go to the wells of all things whence true art springs? Truth is found there in its simplest simplicity and truest truth, and there one can learn that art must be founded on truth.

How could it be otherwise!

Man must have the ambition to be truthful. His art must reflect this.

On the opposite side—on the "functional"—the situation is different. Meaningless stylistic ideas have been discarded, and the functional nature of form has been accepted under the auspices of truth. Thus, truth has been reinstated into its former authority. As such, this approach —being exactly the same as in any genuinely creative case— is a positive step toward the much neglected truth. Surely, a positive step. For, only through the cement of truth can form have a firm foundation on which to build.

Yet, there are still dangers lurking around. And these dangers can be found in the fact that truth is too rigidly understood.

So it often happens.

It is said—for example—that the reinforced concrete column, to be truthful in construction, must be dimensioned according to the load to be carried. This, of course, is a perfectly logical thought, and as such it must be highly recommended. On the other hand, if this perfectly logical and highly recommendable thought is brought to its extreme consequence, so that we are led to consider **any form** untrue where more material has been used than utmost economy

requires, there soon are controversies in sight. According to this, for example, the exquisite Doric column must be considered false in construction, since there is more material used than is needed for the load it has to carry.

Well, if this point holds, then there is much untruth in nature's form-shaping, too. Such would be the case with the dimensioning of the human body, for example. Please compare the human legs with the legs of a flamingo, and you have a good starting point for an argument. The legs of a flamingo are slender indeed, yet they seem to carry the body quite satisfactorily. In comparison, the human legs—even if we take the thinnest of all thin men or women—consist of too much material, if the functional theory of material use holds good.

We know, of course, that in her material use nature is thoroughly true—just as she is thoroughly true in her whole organic structure. We know that any cell in a living organism has its specific assignment to perform and that to that end there is no material waste. We know that the cellular construction of the beehive is perfect engineering from the point of view of efficient use of material. And so, no matter how deeply one might delve into nature's structural form-shaping in order to find evidence of untruth, all the more would one be convinced of the lack of such evidence. Therefore, in nature we must search for truth. In nature we can find it, and not in short-sighted theories—which might hold good in certain circumstances, but mislead in others.

In every problem—and so even in the problems of truth —many different requirements are interblended, and all of these must be taken into consideration in order to arrive at correct answers. A brief second of functional service requires other use of material than does the lasting quality of form. Thus is the spider-web differently dimensioned than the old matured oak. Thus is the cumulus in the sky different in its material consistence than is the aged rock below. The summer-camp has different requirements as to material use than has a church expected to survive centuries. And what about the pyramid? Should the tomb of the Pharoah have been only the practical protection of the

rather insignificant subterranean chamber or were there other considerations connected with the problem, considerations which made of the pyramid the most tremendous heap of stone that the human hand has ever brought together? Indeed, there were. And when these considerations are taken into account, the Egyptian pyramid with its colossal material use must be regarded as just as truthful a construction as is the aeroplane. And, thanks to the supposedly "untruthful" material use, many of the greatest and truest monuments of human culture have been preserved for posterity.

Why should the truthful form necessarily be ascetic and gaunt? Is only that man honest who in his speech uses nothing more than the absolutely necessary words to make his thought clear, and who in his manner is dry to the utmost? Isn't he dreadful rather than honest? And is that man dishonest who has delightful manners and is pleasing for his wit? Surely, there exists a great variety of situations where the quality of truth in speech and manners depends on the spirit of the situation rather than on preconceived stipulations. Truth from the pulpit is clothed in different words than truth expressed amid the glamour of a gay gathering of people. Take, for example, an old skipper who has crossed the seven seas and visited hundreds of harbors: he can fill you with skipper-stories hour after hour, and even though you know that all these stories are sheer imagination, you may confidently feel that basically, in his heart and being, he is just as honest and trustworthy as anyone can be.

Thus, truth does not depend on the speech one uses, nor does it depend on one's manners. These might reflect it, but they do not decide. Certainly truth must be **the fundamental quality of one's being.**

What is truth, then?

When absolute truth is searched for, the search is in vain. The absolute is perfection—and when perfection is there, there is no further step to take. It means stagnation, death—absolute death! Truth must be relatively under-

stood, for relativity opens the way for movement, for change, for life. Accordingly, truth in connection with life must be part of life. When truth is made unfruitful by formulas or other means of sterilization, its individual nature is endangered; it is made rigid, a lifeless institution, a prejudice —and often indeed, "untruth."

The living quality of truth must be preserved by encouraging its individual freedom. For what is truth for one is not necessarily truth for another. It would be foolish for us to worship wooden images; and yet the primitive man worshipping them, sincerely, was closer to truth than we are with our higher understanding of truth, if we be not sincere. Thus, truth is not so readily catalogued as many seem to think. Truth is a mental disposition in which each one individually must ransack his heart and kidneys in order to know where he stands.

And soon one will learn that **truth is not truth, unless there is a sincere desire for truth.**

There is no difference in this respect whether truth concerns man himself, or his art. Concerning art, the more a sincere desire for truth permeates the artist, the more he transfers this quality into his work and the more honest his form is apt to be. On the other hand, when the artist's mind strays away from the aim for truth, his work is then not based on premises that can lead to honest art.

Accordingly, **truth in art is a matter of attitude of mind, and not of established rules to follow.**

* * *

IX. FORM AND LOGIC

AS FORM must be true, so must it also be logical. However, if we try to conduct form-development along strictly logical channels, form easily becomes a rational product of reasoning. On the other hand, form—as we understand it— is an expression of human life. As such, it must have its emotional leanings, too. For human life is largely conducted by emotions which do not follow logical reasoning. Here we are facing a rather serious conflict between the strictly rational and the humanly emotional form. And if both of these conflicting qualities must exist in form, how then can form be logical!

Nevertheless, we insist on regarding logic as an essential foundation of every phase of human life and of its products as well. And because art is a product of human life, and particularly because we are concerned with art of true quality, it is of vital importance to clear up this matter of logic by investigating its status as it appears—or should appear—in human art.

This status of logic can scarcely be understood, unless it is examined in a broad perspective. And so—again—we must go to the well of all things—to nature. However, in studying nature we soon seem to arrive at the same contradictory experience as we met in the study of art. For nature's logical order seems not always to be logically schemed. Many conflicting signs give the impression that nature is not after all as logical as has perhaps been expected. Exceptional happenings of all kinds seem to intrude, constantly deranging the course of things.

Now, considering the construction of the universe, there is reason to assume—insofar as our knowledge goes—that this construction is fully logical. We lead ourselves into error by suspecting the contrary. Perhaps we do not grasp

all the problems of logic, particularly when things become complicated beyond our wit and experience.

Common sense and experience tell us that even the smallest of tools—to be workable—must have logical thought behind its form-shaping and mode of functioning. So much the more must this be true when things become complex. Therefore, as comprehensive a mechanism as the universe could not possibly function unless it were governed by a thoroughly logical thought, of a sort to keep things in congruous form and action and to penetrate the whole universal system, giving substance and movement to even the smallest microcosmic units of the cosmic structure. Certainly, logical thought is necessary to organize and control so gigantic a system.

Now, it would seem that the more perfect this logical thought, the more should it be able to eliminate illogical deviations from the functioning of the universe. It would also seem that by virtue of its logic the machinery of the universe should be able to approach close to an absolute state of perfection as to both its construction and the regularity of its action. The result, consequently, would be a state of mathematical accuracy permeating the whole system, now and eternally.

However, if this were the case, the consequences would be disastrous. The universe would function eternally like clock-work—perfectly, of course, but sterilely. The cosmic structure would be incessantly the same, but formless. Form presupposes rhythm. But the vibrations put into function by the "primus motor" would constantly go on as a gigantic and all-embracing "perpetuum mobile," with always the same sets of waves. Because of such regularity, deviations could not occur through the introduction of characteristic rhythm-groupings and rhythm-divisions, and the resultant production of characteristic form-groupings and form-divisions. Because of such regularity, no typical manifestations of celestial constellations, solar systems, substances, species, thoughts, and sentiments whatsoever, could come into existence. Action would exist. But life would not come

into being. The universe would bear the marks of death on its ever monotonous aspect and on its continuously similar movements and formlessness. Interest and individuality would be unknown things. And evolution would be out of the question, for evolution means change. The whole universe, in spite of its gigantic mechanism in full swing, would be the source of a tremendous "horror vacui"—provided there existed senses to feel it. But such sensibility could not exist.

So much the better that the universe is not built that way! Its sense for organization is logical enough to prevent such disastrous results. It purposely introduces exceptions to disturb the mechanical accuracy of its machinery. And just these "exceptions" make the construction of the universe seem illogical.

Let's now examine matters from the opposite viewpoint: from the viewpoint of "exceptions."

Suppose that there might exist two human beings exactly alike; that is, that an individual could be duplicated, physically and mentally. Insofar as human beings are concerned, certainly, this would be the first step toward standardization in the universe. And certainly it would seem utterly uncanny. Just think of it: **two human beings, exactly alike!** Such a thought, carried further—to a general likeness of all human beings, of animals, of plants, of all things—would turn the whole world crazy, in our understanding. So strongly rooted in our minds is the idea of **"dissimilarity"** in the universe.

Now, as far as man is able to penetrate, there are no two things exactly alike—at least, not in the so called "organic" structure of the universe. Previously—somewhere in this analysis—it was mentioned that even the smallest cells, their groupings and growths, are ever new, ever different, ever individual, and so are even their products in further development. This we found to be a rule-bound phenomenon in organic life.

But when we get down to inorganic matter—to molecules, atoms, and other minute particles—their actions and

reactions are known to advanced science. But, **how about their "inner mechanisms" that give them the potency to act and react as they do?**

Yet where are the ultimate boundaries between the "organic" and the "inorganic" structure of the universe?—or do these boundaries exist only for the simple reason that man's knowledge is limited?

Isn't science just at the beginning of its long journey? and may not many surprising discoveries happen along the road? Supposing, then, that someday it should become evident that the inorganic particles of inorganic substance are nothing but organic individuals of organic life, and that the terrestrial scientists of this globe should learn to look upon these "inorganic" particles with eyes similar to those with which the giant celestial scientist of the Milky-way-order would incline to look upon that little "inorganic pill" we call our globe—if and when he should discover the rich life that we are living on this pill.

Such a discovery, surely, would establish the unbroken continuity of a single system in the construction of the universe. It would simplify matters considerably. And, above all, it would seem logical. According to such a discovery, even the most fundamental manifestations so far known to science—such as the activities of the most minute particles of the atomic "solar system"—must have come about through the process of evolution. And, for sure, the results of evolution always have the tendency to diverge and to produce dissimilarities—say, **"exceptions."**

Indeed, in the long run science is not inclined to reject such a thought. As a matter of fact, science is already far advanced toward its acceptance.

Philosophical reasoning is eager to find that universal principles apply in this respect. Considering the fact that all things so far comprehended have been found to be based on the principle of dissimilarity, philosophical reasoning cannot accept the thought that the rest—not yet comprehended—should necessarily be established otherwise. Philosophical reasoning, therefore, is inclined to be open-minded about further discoveries. In the meantime it prefers the

logical thought to the illogical one, and it concludes that exceptions occur always and everywhere—**without exception.** Consequently—so philosophical reasoning maintains —exceptions are not exceptions at all, but differently constituted and accentuated combinations of circumstances for reasons which are not only fully logical, but even indispensable in the logical functioning of the universe. Therefore, philosophical reasoning establishes **the thought of dissimilarity as a fundamental principle in all of creation.** And because this principle is based on a logical thought—profound indeed insofar as the existence of life is concerned— it must be regarded as belonging to the realm of logic.

The principle of dissimilarity is strictly logical, since, due to its influence, the universe is not a mere mechanism —constantly the same and eternally stereotyped—but thoroughly a living organism. In the principle of dissimilarity, also, we discover a logical thought of its own order. It is different from that which keeps the machinery of the universe in mechanical function. It is seemingly acting against this latter. Nevertheless it is always and everywhere in an inseparable co-operation with it.

Fundamentally, also, **the logical thought of the universe is dual.** In the first place it is logically intellectual, directing the regularly functioning universe. In the second place it is, we might say, intellectual too—because of the logical thought behind it—but emotionally directing the manifestations of the universe toward life. In the first place—we might say—it is masculine. In the second place, it is feminine. And together and in inseparable co-operation they both constitute the **duality of logic.** Because always, when life is born, it is born in the co-operation of this duality and because of this duality. At the very birth of life, inclinations to both the logically intellectual and the logically emotional are bestowed upon life. In this dual manner life is made possible. And in this dual manner—that is, in the co-operation of both intellectual and emotional logic—the process of life is to be found. Indeed, only the **process of** life—not its **meaning.**

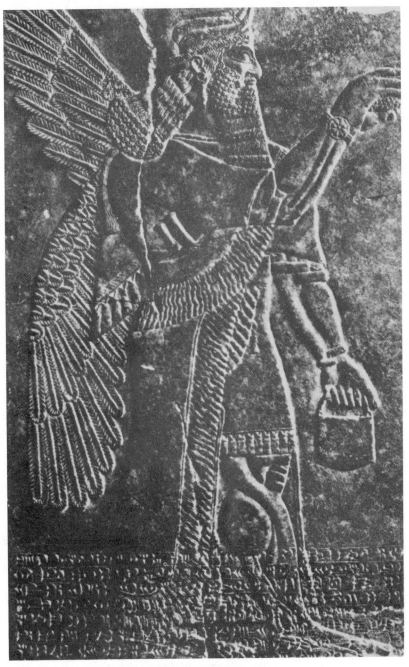

PLATE 11. THE ASSYRIAN FORM
"Protective Genius," Alabaster Relief, 885-860 B.C.

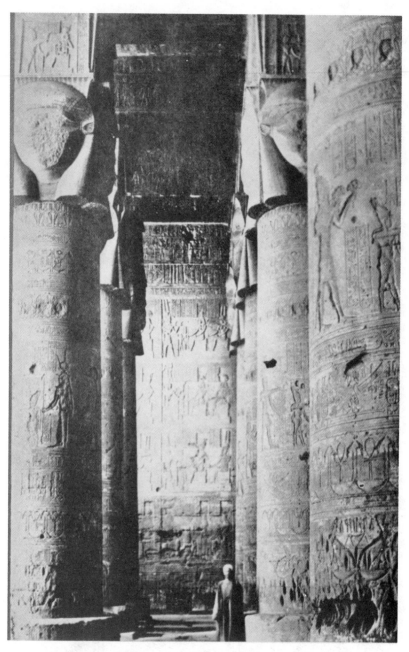

PLATE 12. THE EGYPTIAN FORM
Temple of Hathor at Denderah, Egypt

By virtue of duality of logic—and because of the seemingly "exceptional" but in reality "logically coherent" processes—life is directed toward variety, richness, and profoundness.

For example:

The cells of a birch, as they multiply themselves, find their respective locations in the cell-pattern seemingly accidentally, because their reciprocal interrelations, without exception, deviate from regular scheming. If the cells of the birch could reflect skeptically—as we so often do—they surely would regard all that occurs in the trunk and in the branches as capricious happenings which had no relation to one another whatsoever. They would assume their skeptical attitude because of their limited sphere of observation. But we human beings have a broader perspective as we follow the growth of the birch; and in doing so, even we are able to realize the consistently accidental character of this growth. Yet, at the same time we observe how the birch —just because of its "accidental" growth—grows in to a birch, and not accidentally into something else. We observe corresponding phenomena in the growth of a spruce. Moreover, we observe how the "accidents" of the birch have a different character than have the "accidents" of a spruce. And we draw our conclusions as to the logical thought behind these two growths, respectively, into the shape of a birch, and into the shape of a spruce.

In this manner, thousands and millions of different species have their own characteristic "accident-worlds" which direct their designs according to their respective individualities. And in every single case—if the organism is healthy—the result is not only rhythmic, but even individually and expressively rhythmic. It is so, just because of billions and more billions of "independent accidents."

Of course, we can follow these incidents in microscopic growth because we are observers from without. But in the midst of the turmoil of our own life we are just "accidental" occurrences ourselves, with difficulties in grasping the meaning—or meaninglessness—of constant caprices. Nevertheless, we may feel the logical coherence behind these caprices.

And we may even be able to sense the correlation between healthy and unhealthy processes—between life and death—as a logical necessity in the functioning of the whole.

If, in spite of this, we insist on regarding at least some of the "accidental" happenings as purely accidental, then where should the boundary be drawn between "purely accidental" and "logically coherent" happenings? Does not philosophical reasoning even in this respect incline toward a unified mode of looking upon things. And in so doing, philosophical reasoning must accept the "logical coherent" thought, and certainly not the "purely accidental." Because, in the latter case, if consequences were followed to their ultimate conclusion—as philosophical reasoning requires—it would lead to nothingness. And if the universe in its functioning should act according to this—surely, there would be no universe.

However, the universe has not constituted its dual logic with accidental happenings for the sake of self-destruction, but merely for self-preservation. Therefore—disregarding other points of view—from this viewpoint of self-preservation alone, the "logically coherent" accidents seem logical.

Logic—just as truth—cannot be conceived of in terms of the "absolute." The "absolute" is ultimate perfection, where logical thought has no further space to move, and where the reason for logic, therefore, ceases to exist.

Consequently, logic considers only relativities in which the mission of logic is the striving for valid inference—or, let's say, for **"logical equilibrium."** Now, logical equilibrium presupposes opposite conditions balanced against one another. This means that any condition—being relative—becomes a matter of comparison with other conditions related to but tending to conflict with it. So, for example, when we speak about "harmony," its relative status cannot be measured unless its quality is balanced against the conflicting quality of "discord." In other words, harmony—when logically adjusted—is not a generally signicative quality, but rather a relative value of this quality in the gradation between harmony and discord. In analogy to this, light is

a relative value in the gradation between light and darkness; warmth between warmth and coolness; joy between joy and sorrow; intellect between intellect and stupidity; and so on.

Furthermore, when harmony is confronted with discord, the influence is reciprocal. Therefore, discord—notwithstanding the fact that it is generally considered a negative value—becomes a logical necessity, often of positive quality when logically balanced against harmony. In the musical composition for example, discord, when in right relation to harmony, brings the latter into emphasis; and, vice versa, harmony, when in right relation to discord, makes the latter sound harmonious in the tonal ensemble.

This conflicting influence is a general phenomenon.

For example:

Joy, when logically balanced against sorrow, has an undertone of an enigmatic leaning to sorrow, and becomes thus ennobled. Beauty, when logically balanced against ugliness, becomes elevated by accents which are in themselves ugly. Humor, when logically balanced against seriousness, becomes deepened by the latter. And seriousness, when logically balanced against humor, becomes brightened through the sense of humor.

All these manifestations of different nuances of life are a mere matter of striving toward logical equilibrium—where the "striving," as such, is the essential factor and dynamic impetus—not necessarily the obtained balance.

When all these conflicting conditions become logically balanced against one another—differently in different situations in accordance with the intellectual and emotional duality of logic—life itself becomes logically balanced. It becomes "art of living." On the other hand, when a logical equilibrium between the conflicting conditions of life does not exist, life itself becomes illogically out of balance. Thus, when life is a constant pursuit of pleasure and merriment, it is lacking in that ennobling influence of sorrow and becomes superficially illogical. When life is full of sorrow without the brightening glimpses of joy, it is not the logical life that life is supposed to be, for it is one-sidedly out of

poise. When seriousness is detached from humor, humor becomes a meaningless—and tiresome—exhibition of moods and gesticulations. And when humor does not fertilize seriousness, seriousness becomes horrifying indeed.

Thus—as indicated—life is full of "logical conflicts."

Often we see people arguing "logically"—and perhaps fanatically—to defend some emotional point of wishful thinking. And by so doing they are soon entangled in the complexity of all sorts of illogicalities, because of the clear fact that "wishful thinking" just does not always coincide with logical reasoning. In other words, very rarely is there such a thing as "straight thinking," for more or less emotional sensing creeps in as the deciding regulator. Man may consider himself strictly logical in whatever he thinks and does; nevertheless, in his thoughts and actions he is led by his emotions as to what and how he wishes to think and to do. Because of this he is seemingly illogical, although really, perhaps, so much the more logically adjusted to his thought and actions—and to his individuality. There are scarcely any exceptions to this dual course of thinking and acting. And just for this reason there are as many lives as there are hearts, brains, and minds; there are as many philosophies as there are philosophers; and there are as many ways of creating art as there are artists. Thus it is: **duality of logic always establishes the parentage of individuality.**

The tendency toward logical equilibrium is essential in any condition of life. So, for example, when life for one reason or another has deviated from its logical course, the tendency toward logical equilibrium enters in with its discipline. However, in case this discipline is not logically carried out, it may easily effect a reverse deviation. Exactly this is the case with revolutionary events. Let these revolutionary events be of political, social, or economic nature—in either case the situation is the same; that is, more often than not the discipline is overdone because it is not logically balanced. Thus, when an economic "boom" spreads about the country and everyone lingers on the lap of "prosperity."

life gradually deviates from its logically balanced economic course. The more this goes on, the more the weakness of the foundation becomes generally sensed—due to logical instinct. And then a single incident, no matter how insignificant, may bring about a catastrophe—and everyone runs away like a dog stung below the tail-line. It is simply a national nervous breakdown, where logic has had no opportunity to lay hold of the situation at the very moment of the critical happening. By and by, though, when logic enters in with its balancing trend, the necessary equilibrium is attained. Whether this happens through a constructive and convincing idea or whether it is accomplished by strong personal influence, does not matter. In any case, the directing force is the "authority of logic." Or the "principle of authority," as George Brandes puts it.

There are no essential differences between the logical disposition of man and the logical characteristics he infuses into his art. And because man's disposition in this respect —as said—must be both intellectually and emotionally balanced, man's art, consequently, must exhibit a tendency to a corresponding balance. Otherwise the art is not logical. Thus, the significant point brought to light by the above investigation is the inseparability of reasoning and sensing in all of man's actions, no matter whether it concerns his living in general, his disposition of mind in his undertakings, or his art.

Accordingly we must draw our conclusions.

Thus: rationalization of old styles for contemporary use never can be logical. Such a procedure is the result of illogical transplantation, and cannot, therefore, represent our way of life and our emotional digressions. Any direct form-adoption cannot be logical for the same reason. And random decoration, without meaning, has no more logical reason for its existence than has a loud chuckle, when out of place.

An important part of art-creation lies in the artist's sensitiveness to logical equilibrium. Much "art" has failed in this respect. For example:

213

Harmony without the support of discord makes music sweet—and frequently unbearable. It is like the unbearable "perfect gentleman" who has no individualizing defects. Lack of comical moments in the tragedy makes the tragedy sad and gloomy. And lack of tragical points in the comedy makes the comedy foolish, but not funny.

Furthermore, if form is conceived too one-sidedly, there may be a surprise the other way. Thus, rational over-emphasis may easily result in emotional over-emphasis.

So it goes. By straining things too much into one direction, the balance easily shifts to the reverse. It is like the child's excessive laughter which readily turns into tears.

In analogy to revolutionary upturns and their effects, form-development is subject to corresponding fluctuations. When radical changes, promoted by stagnation in the logical course of form-development, force new forms into existence, these new forms easily and usually become radically over-done. This fact, in turn, causes much hesitation about accepting these new forms, and so—consequently—the pendulum swings toward the old—yet, again too far. In this manner it goes the one way and the other way till the pendulum reaches its logical position along the natural line of form-evolution—and the logical equilibrium is there.

This very swinging of the pendulum is acute today. Form-transition goes on with violence, both intellectual and emotional. It oscillates between sterile conservatism and juvenile progressivism. Conservatism, *ipso facto*, is illogical because it tries to maintain static conditions in a dynamic process. Progressivism, on the other hand, must learn to understand that a dynamic process must have a logical succession, otherwise it cannot be successful.

We do not mean by this that a new and radical form is necessarily out of logical balance. Our point is rather that sudden and radical changes are apt to have such results. In fact, they often have. On the other hand, those who, because of instinct and vision, because of sincerity and self-control, go their own way—independently of stagnation and revolution—are able to escape the Scylla and Charybdis of

dry reasoning and emotional extravagances. Perhaps their forms are considered extreme today, but tomorrow these forms will be understood and accepted, because they are logically adjusted along the natural course of form-evolution. So to speak, they are **logically visionary.**

The above is not supposed to be a philosophical essay on logic. Nor is it supposed to be based on orthodox thinking—for, indeed, such is not our intention. And least of all is it an attempt to establish a new school of thought along a logical line. It simply is one of the many phases of our series of analyses, undertaken so as to learn to understand form in the search for it.

In this analysis of logic, we have first endeavored to build up our conception of **logic in nature;** from logic in nature we have endeavored to build up our conception of **logic in man;** and from logic in man we have endeavored to build up our conception of **logic in form.** This is exactly the same sequence—nature, man, and form—that we have followed during the whole course of our discussions. This approach—we venture to maintain—is fully logical.

*　*　*

X. FORM AND FUNCTION

ONE of the very first matters brought into this analysis concerned the problems of function. Thus, rather early in our introduction it was said that "the functional quality of form is not only essential, but even indispensable." And furthermore it was said that "form must satisfy those functional requirements that originated its reason for being—both physical and spiritual,"—and that "only in such a sense can form be significative as an art-form."

Later on, in another connection, the same subject was further elaborated by stressing the fact that the problem of function is so fundamentally inherent in all things that there should not be even the slightest thought of taking the matter into consideration as an issue in itself. Yet, because the influence of style—even as regards this problem of function—has beclouded things as they really are, there is need of an awakening influence to bring the problems of function into logical light.

Although these remarks seem fully self-explanatory, there may be reason to elucidate still more about this problem of function. For this problem—just as any other problem—has various angles from which it may be regarded. Therefore it may be worth-while to take some of these angles under examination. However, before we do so, here is a short story about the "hammer."

Once upon a time there was a hammer. This hammer was used for manifold purposes. It was used for beating silver, copper, iron, and other metals. It was used for driving nails into wood by hammering the heads of the nails. It was used for hammering the heads of chisels when carving marble and other stones. And it was used in many other ways. Surely, this hammer was functional for manifold

purposes—but it never occurred to anyone **to speak about this function.**

Then, one day, the hammer was lost—and it was believed, it was lost for good. . . .

However, centuries later some art-hunters came across this very hammer. They examined it—or rather, they examined its choice decoration—and discovered that this decoration was expressive of **the human soul.** So they took the hammer to the art-museum, they displayed it in a handsome show-case, they wrote books about it, and they proclaimed it—or rather, its decoration—the most sublime work of Fine Art.

Well, days passed by. Years passed by. Still more years passed by. . . .

And then, one day, the handsome show-case had to be dusted. It was opened. It was emptied. And, behold, someone got the handle of the hammer in his hand—and **was he** surprisedly astonished because of the hammer's perfect balance and easiness to handle. He handled it. He hammered with it. And then, suddenly—he made an important discovery, bless his soul. He made the discovery that the applied décor was not the vital thing, but the shape and balance of the hammer itself. And he arrived at the conclusion that the hammer was not an object belonging to the realm of Fine Arts—as first believed—but to the realm of "functional" art.

Thus **"function"** entered into esthetic consciousness.

This story of the hammer is a true story. For, in fact, exactly such a thing happened—not literally to the hammer, but in a much broader scope.

So, here is the broader story:

In bygone days all the people needed shelter for various purposes, and they produced shelter for these various purposes—but nobody wrote books about the shelter having the **function** of shelter.

These same people needed this and that for their proper accommodation, and they made this and that for that purpose—but nobody wrote books about all these this-and-thats

having their respective **functions** to serve.

But although there were no books written about this matter, all the forms were originated in accord with strictly functional considerations—and **that's the strong point in our story.**

Meanwhile—as time passed and things became increasingly ripe—the originally functional form became covered with surface decoration, in much the same manner as the growing moss spreads its surface pattern along the trunk of the aging tree. And so, gradually—while still more time passed and thus caused over-ripening of things—later times adopted this surface decoration and used and overused it, supposedly as an exquisite product of Fine Art. Thus, as things have been already for a long period of time—and as we know ever so well—almost all of our buildings, both outside and inside, have become so thoroughly covered with the moss of decoration, that one is hardly able to get a glimpse of the functional thought—so solemnly and ornamentally buried beneath.

Yet somehow, someone must have gotten a hint of the hammer-story, for many eyes seem to have been opened to see the functional point. Since then, books and more books have been written about the indispensability of function in all design. And so it happens that we too—at this very writing moment—are writing about the same subject.

Now then, why has only our age discovered this functional bug, which was for so long pigeonholed in oblivion?

Well, there might be several reasons for the functional bug being at large, and undoubtedly one of these reasons lies in the fact that our time has become utterly tired of all that nonsensical decoration displayed everywhere. Naturally, this tiredness has caused a search for means whereby to escape unsound decoration—and, surely, the thought of function is one of these means.

But the real reason why particularly the present age has discovered the functional bug, is—as we see it—twofold:

In the first place, the development of science—of biology in particular—has increased man's knowledge of organic

life in nature, in which function is an all-permeating thought.

In the second place, the development of the machine has made man function-conscious. For the fundamental thought in the designing of machines is the proper functioning of these machines. Otherwise they are of no worth.

These are the two angles—Nature and Machine—from which we must examine the problems of function as they should be applied to human art.

Thus, first we have Nature.

1. Function in Art, as derived from Nature

In all of our attempts to discover fundamental laws in art, we have found them in nature. And if now—insofar as the laws of function are concerned—we would undertake a recapitulation of all that has been said heretofore on the matter, we could cite many a passage which all summed-up into a concise statement would read about as follows: "any cell in an organism, which has no reason for its existence, is bound to cease to exist—if the organism wishes to be healthy."

In plain English language this is much the same as to say: please, function—or else!

In plain art-language the same must hold.

Consequently:

Any color spot on the canvas must have its function—or else! Any accord in the musical composition must have its function—or else! Any detail in building design must have its function—or else!

And so on.

All of life is an organization of sundry problems which, properly interwoven, make life functional—no matter whether one considers the physical and practical phase of life, or the spiritually livable. Thus the problem of function —"form follows function"—is an intrinsic, necessary, and plainly self-explanatory phenomenon in life, art included. And, as indicated, there scarcely is any need of mentioning it.

Yet, it is mentioned.

Mentioned! ! !

Nay, this matter of function has been pushed around with vigor and exaltation—and it has spread itself like a forest-fire. In the fight between the outworn pre-nineteen-hundred form-concept and that of the post-nineteen-hundred, this matter of function has been made the very purging-center through which to clear form from its overlay of decorative "moss." And, surely, much of that unnecessary and nonsensical decoration has been made away with.

So far, so good.

But then we have the pendulum!

Really, the pendulum seems to be a hard thing to handle even in this case of function. The eagerness to wipe out non-functional features has often brought things out of logical balance. Non-functional unnecessities have been made away with, but other non-functional unnecessities have been brought in, instead. That is, stylistic decorations have been abandoned, but functional "decorations" have been invented to replace them.

That's the pendulum, for sure.

All this talk of function has caused much excitement in many quarters. To many—in these quarters—function is a **novelty, a new discovery, a "modern" thought.** And because in these days there is an ingrown habit of ranging things under a certain *nomen appellativum*, even the novelty of function is soon christened, "Functionalism."

This matter "functionalism" has often and again appeared in our discussions and, therefore, we have reason to assume that it has already been made explicitly plain. But, as our main topic at this writing moment is the very matter of "function" itself, we might add a few complementary remarks even about "functionalism."

The champions of "functionalism" do not seem to be aware that when function is raised to an "ism" its form-treatment is likely to become sophisticated and frequently used to express functions that do not exist. They do not seem to be aware that everything is formed functionally, with the exception of the imitative style—and of functionalism itself, precisely because it has been developed into

imitative style. For, being an imitative style, it is the demand of style which in functionalism commands the expression of function, and not the demands of function in itself. Thus the old habit of imitation begins to solve the problems of functionalism in accordance with pre-established functional style-standards—and often these are just the same, no matter what the function. In this respect it does not seem to make much difference whether the problem is a garden pavillion covered with roses, or a lighthouse on a lonely cliff.

And so the new "ism" of function is easily made an enemy of the idea it is so eager to promote. As an "ism," therefore, it is doomed to vanish, sooner or later.

But it has had its fruitful mission.

This is its story:

During a lasting drought everyone looks for the cloud that might bring the refreshing rain. Any of these clouds is a hope, or a herald. So was it with functionalism after a long drought of withering forms. It was a hope, or a herald. And it was met by expectations. It really brought many drops of fruitful rain that kept the crop alive. But others fell into barren sand—and helped the weed.

Yet, it was a herald.

Some day the real rain will come that makes the crop grow. And then any drop will be a functional drop that will turn form into its true function again.

So it must be, for **consciousness of function** has gradually and persistently grown strong. And this consciousness—as said—originates in the study of organic life in nature.

Partly.

Partly, again—as said—it originates with the machine.

2. Function in Art, as derived from the Machine

During the course of time—while the machine-idea was being born, while machines were being invented and, while an ever increasing number of machines were being constructed —a great multitude of these machines have been employed to produce cheap imitative reproductions of obsolete hand-made decoration. Thus, ornamental features of all the

ages have been machine-moulded, pressed, cast, and carved for the overflowing market of the poorest taste of all of human civilization.

In other words, the perfectly functioning machine has been put to work to produce utterly non-functional forms, and this fact has been highly instrumental in the lowering of taste for genuine things.

Surely, this is the machine's negative side.

Luckily, however, in the long run this negative side is going to effect a change to the reverse—to the positive.

Due to the long enduring circumstances of cheap, imitative, and machine-made ornamental saturation, our time has gradually become tired of decoration that has lost its meaning. Parallel with this, our time is beginning to understand the beauty of forms expressing contemporary functional demands. One learns to understand the beauty of a functionally designed airplane, a railroad car, an automobile, a motorship, et cetera. In others words, the non-functional form is doomed gradually to disappear, and the functional form will take its place.

This transition from non-functional to functional form-appreciation is a logical development for the better.

And we are willing to give the machine credit for this.

But even if the non-functional course of imitative decoration is abandoned, and the machine-inspired functional course is accepted, there still are two different ways to go. In the first place, there is the way leading toward the enthronement of the **spirit** of the machine. And in the second place, there is the way leading toward the enthronement of the **principle** of the machine.

These are the two ways which must be carefully watched in form-development, insofar as the influence of the machine is concerned.

To accept the spirit of the machine as the basis of form-development, is equivalent to mechanization of form. This means that form-expression grows directly from machine-facilities, and that the influence of human atmosphere—human aura—within and about our homes, is bound to be

affected by the spirit of these machine-facilities. Accepting such an attitude, man is forced to dwell in a coldly mechanized atmosphere. He will be surrounded by forms breathing the machine spirit, though they are machines neither by nature nor by function. Thus an art-form would come into existence which might be expressive of our mechanized age, but which might **not be expressive of the humanly cultural aspirations of this mechanized age.** Consequently, such a mechanized art-form cannot be truly genuine from a humanly acceptable point of view. It is affected. The spirit of the machine has been imposed upon form. The **functional principle** of the machine has been slighted.

The functional principle of the machine means that the solution of the machine problem must result in a functional organism of its own function—and of no other function. This means that the machine must be mechanical in its spirit because of the fact that its function is mechanical. This is the command of the functional principle of the machine. Accordingly, a chair must have the spirit of a chair, and not of a machine; a home must be a home as to both function and spirit; and the form-world of the whole field of human art must breathe the spirit of man's cultural aspirations.

Because the functional principle of the machine leads to functionally organic solutions, it is synonymous with the corresponding principle in nature. Here the machine and nature meet one another on a common ground of principles. Through the functional principle of the machine we approach the functional principle in nature. And by understanding and accepting the functional principle of the machine—as applied by man—the functional principle—as applied by nature—becomes clearer to us.

Such is the consequence of looking upon the machine as a mechanical organization for mechanical functioning only.

Having long been dealing with his art in terms of styles, man has forgotten the functional principle that governs art

of all time. But by building his machine he has been forced to meet the requirements of the functional principle of the machine. Through the machine, he now learns to know how to approach his art, insofar as function is concerned.

This, let's hope, is the greatest contribution that the machine ultimately, is going to render form.

* * *

XI. FORM AND COLOR

COLOR has as much functional reason for its existence as has form. Why not, for a colorless world were just as absurd a thing to imagine as were a formless world—and a formless world would mean no world at all. Now, as for this color-lessness, the farthest stretch of one's imagination in this respect is perhaps to say: "as gray as the grayest of all the grays"—which, of course, does not as yet cover our point, since even the grayest of all the grays is still color.

And—at that—the utterly gray world would be a pretty gloomy place in which to live.

On the other hand, whatever man discerns in terms of color depends entirely on the constitution of the human eye as to what kind of light-rays and wave-lengths it is able to register. As the human eye is constituted, it covers a certain chromatic range within which the eye is able to register, and, generally speaking, this range decides man's understanding of color. Now, if by chance this chromatic range were shifted toward, say, the ultraviolet group, the human eye could then register a richer and more brilliant scale, which, in compari-son with the most colorful of the tales of the "Arabian Nights," would make the latter look anemically pale. Or—to take another extreme example—if the human eye were so constituted as to register electric vibrations only, then—as Maeterlinck puts it—one could see through metal and other non-transparent substances, but not through the clearest glass. Whatever would happen to color in such circum-stances, we do not know, but certainly the human eye would reveal a strange world.

On the whole, though—since the human eye really does register chromatic vibration—man must be greatly grateful; for, insofar as color is concerned, this world of ours is a mighty pleasant place in which to spend our earthly days.

One speaks about "color of music," just as one speaks about "music of color." It is so, because in many respects there is similarity between color-tone in the realm of color and sound-tone in the realm of sound. They both communicate with one's sensibility—color through the eye, and sound through the ear. Furthermore, vibrations of both color and sound can be put into mathematical formulas for theoretical study. But as little as one can become musically talented through mere theoretical experience, just as little can one be made receptive of color by mere theoretical knowledge. **Receptiveness of color is entirely dependent on one's inner sensibility.** And one's inner sensibility is the only reliable and supreme counsel in the understanding and employment of color.

Inner sensibility, however, has countless grades.

Many are scarcely aware of the significance of color in their daily life. Notwithstanding this, everyone is impressed by color in one way or another according to his individual sensibility, whatever its grade. No doubt, everyone inclined to likes and emotions has his pet color, or colors. "I like color," people often say—perhaps with a slight touch of pride. Such a liking for color, in most cases, indicates a marked personal delight in strong and bright color. Now, if this delight concerns strong and bright color in general, without any ideas as to how these colors should be combined, where and in what degree they should be used, and what they are supposed to express, there is little reason for being proud of delight in color. To enjoy only noisy music is no sign of musical understanding. In order to be musical one must understand the whole scope of tunes, whether they come to the ear through the most colorful orchestration, or through the softest pianissimo.

Does not everyone like color? Everyone is impressed by the bright color display of the autumn landscape scenery. However bright these colors may be, they are always kept harmoniously together. They are expressive in their color-fulness and are therefore enjoyed by everyone regardless of personal inclination toward bright or soft. But the bright color display of the autumn landscape is only a specific phase

in nature's broad color register, for in it there exist all think-
able combinations of values and shades. The colors of a
cold wintry morning, when sunlight is pouring its sparing
golden glow through foggy atmosphere, are less bright but
thereby so much the more refined. The gray rainy day has
its own silvery charm. And the mellow tones of twilight
and nightfall raise strange emotions by their silent color-
melody. Aren't all these exhibitions of color very different
in their values? Yet, they are always in harmony with the
sentiments to be expressed. And they impress accordingly.

It may be that these color combinations are only isolated
effects which have no correlation to one another. Yet one
might discern here coherent chromatic compositions.

Such surely seems to be the case with seasonal color:

When sap is vital in the early spring, nature is dressed
in her virgin green. Slowly the verdure grows thick and full.
Buds unfold their blooms, and there evolves a bright radi-
ance of color, bringing joy and exaltation to man, to animals,
and to all that breathes life. But where color shines out
most intensely, inviting and enlivening, there—and just
there—music of delight, of health, and of action fills the air
with its multitudinous humming and song. Nature is in the
midst of her growth. Blossom turns into fruit. And when
the crop is ripe, all of nature gathers as if to a harvest fes-
tival: a festival of copious color-brilliance in the autumn
days.

Thus the seasons constitute a continuous color-sym-
phony—rich, animating, and with expressive color-move-
ments.

So, likewise, is the day with its events: a color-tone-
poem, where the silent depths of the night in a slow cres-
cendo dawn into a golden largo, where the glittering dia-
monds of the morning-dew perform the sparkling allegro,
where the sober daylight of shifting movements brings in
the theme of work, and where—when the work is over—the
spectacular show on the boreal sky enters in as a color-fan-
fare, a festivo: gradually sinking down into the calm diminu-
endo of a vesper-hymn—lucid—pale—distant—visionary—
and then—sombre. . . .

These changing plays and displays of color are dramatically expressive and impressive.

And eventful!

No doubt, nature, in the course of her constant evolution, introduces purposeful stimuli, through the influence of which impulses are born deliberately to bestow vitality and constructive potency upon just this very evolution. These stimuli are instituted by various means, of course. But as we are now interested particularly in color, we have intentionally confined ourselves to examples which have color as their predominant means of manifestation. And indeed, color is as important a means in these respects as are the other means—tune and movement, or music and dance, to mention some.

Now, just behold and learn:

Wherever one's eyes linger, they are met by color, beginning from the purest white of the sunlight and ending with the most impenetrable black of the night. Between these, all the gradations of color exist: from the pale to the brilliant; from the cold to the warm; from the mellow to the hard; from the quiet to the inflaming. But when we approach close to the innermost mystery of this multiphased domain of color—and to the reasons for this mystery—we make the amazing discovery that it is precisely where color is most potent that life is kept most alive; precisely there that fertilization brings new life into being, and maintains this new life. And one begins to understand that color expression is a language full of meaning.

Now, the spoken language is generally accepted as the most complete way of conveying ideas. This is true—and very much so—insofar as the settlement of affairs and schemes is concerned; and so it is also with chronicles and writings, facts and thoughts, and thousands of things of both public and private nature. The truth of this certainly cannot be denied. On the other hand, when we consider deeper human sensibility, it must be admitted that the spoken language is but the raw-material for the conveyance of thought and sentiment. The spoken language does not touch the

finest strings of human sensibility, unless the mental com-
munication is carried beyond the spoken language by
means of expressiveness and accentuation of sound and move-
ment—by indication, suggestion, and many other means not
directly belonging to the sphere of the spoken language.
The spoken language influences intellect, and through intel-
lect it influences inner sensitiveness. Those other means—
movement, sound, color, and such like—are directly com-
municative with inner sensibility. Therefore, the more the
spoken language is kept as the background in the conveyance
of inner sentiments, and the more the other means have the
chance to become primary means in this conveyance, the
more deeply the conveyance is likely to penetrate. Maeter-
linck develops this thought still further, insofar as the spoken
language is concerned, when he says that the most profound
mental intercommunication happens in silence, when words
are not exchanged—but felt. And were we to carry the
thought to its ultimate consequence—to the point where
even movement ceases and any vibrations of sound are
brought into silence, so that man is confronted solely with
the manifestations of color—then color alone speaks. Then,
color is the significant language. And its tongue is vibrant
whether it speaks through the nocturnal adagio of the soft
sentiment that inspired Corot or through the vivid pastorale
that Watteau expressed so humanly.

So much for the language of color in general terms.
But if now—on the basis of the aforesaid—we were to cham-
pion the thought that, even in human art, color has the
significance of a language, this might cause hesitation. For
it is considered—and rather generally, too—that color, as
such, does not have enough significative meaning to give rise
to an independent art-form without the aid of other means.
In other words; form, material, and subject-matter constitute
the dominant means, while color is the supporting element
only.
True enough, color must be considered together with
other means. But the same is equally true with regard to
other fields of expression. Dance, for example, appears in

connection with music—and because of this, one might maintain that rhythm of movement derives from rhythm of sound. Or, conversely, one might consider rhythm of sound —dance music—a derivative of rhythm of human movement. However this may be, dance and music are related to and influenced by one another. And frequently they appear together. Nevertheless, dance—plastic dance, for example— can be an independent art-form without the support of music. Music, on the other hand, has for a long time been dependent, not only on the characteristics of human movement, but perhaps more so on vocal rhythm—on poetry, in particular—and through this on the spoken language. The vocal tune—singing—was the predominant ingredient in the musical composition; the instrumental—the purely tonal —played the assisting role. Such a state of things lasted for a long time indeed. But when the time was ripe—and man with the time—to understand the world of sound as an independent means of art-expression, instrumental music then freed itself from the limitations that the vocal element imposed, and evolved ultimately into the most sublime form of music—the symphonic.

All this was a matter of evolution. Yet this evolution did not depend on the possibilities of sound, for sound always had its universal significance—although latently in symphonic understanding—until man in his cultural progress was able both to apprehend and to use it.

The world of color, surely, is not an exceptional one in this respect. It might be true enough that man, so far, has not been able to grasp the meaning of color as an independent phenomenon in art. This, however, does not prove that color can never be a means of art-expression. It rather indicates—just as in the case of sound—the present incapacity of man to unfold the potential secrets of color, to use color as independent means for his art purposes, and to understand the meaning of color.

Someday, though, things may change. In fact, already one begins to feel that something new is approaching. We cannot prophesy, but we cannot help wondering what the present nervousness among the painters really means. The

camera has invaded a field which the painter has for ages considered his own, and now he is forced to pioneer for new pastures in order to keep his art-form from withering. He surely is compelled to grope for something new—and, we assume, that's what he has already been doing for a long time. And—on our part—we are inclined to believe that the nervousness among painters is nothing but the beginning of a long—perhaps very long—and agonizing birth-throe which may herald the advent of the art of color—say, **the independent color-symphony.**

This may happen, or may not—after all, open-mindedness in this respect is a virtue.

In whatever degree color is going to liberate itself in its so far only anticipated progress toward an independent art-form, it always will remain connected with form and subordinated to it. Color, therefore, must accommodate itself to the demands of form. Analogically, for instance, the liberation of sound—as exemplified by the symphony—by no means freed it from the subordination of form. On the contrary, **the symphonic form** is a sublime accomplishment in the evolution of form.

Form is mainly constituted by its proportions, rhythm, volume, and scale. The colors used, therefore, should support and emphasize these form-properties, rather than bring disarray to them. Thus, the more neutral the general color scheme, the more form is apt to appear to its full value, **as form.** And the more color is regarded as the supporting, refining, and enlivening element, the more color is apt to bring variety and freshness to form. In nature, for instance —the tree, the forest, the mountain, the landscape, are in the main constant and stable form-manifestations, whereas their colors vary according to seasons, the direction of sunlight, and atmospheric changes. The city is the man-made landscape. Therefore, in analogy to conditions in nature, the city as to its form must be basically static, and the buildings, generally speaking, neutral in color. The verdant parks, the moving vehicles, and the people on the streets constitute the lively and changing color effect together with

light and shadow and atmospheric changes.

Thus in the city. So even in the confined circumstances of the room. The room comprises its walls and a number of miscellaneous objects such as furniture. These constitute the more or less static ensemble of the room, and naturally they must all be properly arranged into a co-ordinated system insofar as form is concerned. This must be true also insofar as color is concerned. Yet, one wishes to have diversity and freedom from too sterile a state of things, and for this reason one decorates the room with flower-groups, varying them in shape and color as the seasons change; one is dressed in various ways and in varying color in accordance with weather, mood, and occasion; one's visiting friends bring color combinations of their own; and so on. Naturally all this cannot be schemed beforehand in accordance with the prevailing color concept of the room, and thus occasional discordant colors are bound to be brought in. This, however, makes the picture that much more vivid. And because discord now and then—as we have found—is apt to emphasize accord, things then are proceeding on logical ground.

Suppose now that we have the following situation. Suppose that the room has been properly arranged according to the above description. Then, that in some part of this room there has been hung a picture; let's say, a rather conspicuous one as to its size, scale, treatment, and subject-matter—and above all, radiant in color. Obviously, this picture constitutes the paramount color-accent of its environment, and the environment must be rearranged accordingly. Also, if other paintings or objects of whatever kind are brought within the sphere of influence of this painting, their fitness must be decided according to the nature of this influence. Hardly any other procedure is possible if one's ambition is to build up a consistent color-harmony.

But how often are matters considered so consistently?

Well, it is only fair to admit that, during the present search for contemporary expression in all the fields of art, much change for the better has taken place in the above respect. But as the situation was yesterday—and still remains to a great extent today—there is yet much improve-

ment to be made. Look at what frequently happens, and in precisely those circles where things should be guarded with the greatest care in order to establish standards for others less concerned in art matters. Our age is the great age of exhibitions, museums, and private collections. Exhibitions are mostly market-places where color kills color. Crowded museums are the columbaria of form, color, and ideas. And art-collectors often so lard their rooms with thick and heavily over-decorated frames as to make the walls look craggy like alligator skin.

This is not as sharp a criticism as it perhaps sounds; much less is it addressed to those who have to arrange exhibitions and museums. They are surely in agreement with our point. But, being bridled by cold realities and age-long traditional ways of doing things, they are unable to escape the consequences. Yet facts are facts, and one should not hesitate to lay them open.

A food-market with glittering fish and bloody meat, with vegetables, fruit, and flowers, with men and women, boys and dogs, moving hither and thither, in sun and in shadow; all this makes a cheerful and picturesque color-display, artistic indeed for those able to see and to enjoy. A village fair with festoons and flags and country folk with shiny hair and red cheeks, an opera evening with thousands of tints in glimmering light; these are performances where the predominance of color makes the eyes sparkle. Each color-spot has its own meaning. All together constitute the collective impression. They can be enjoyed separately or collectively, just as is one's pleasure to enjoy them.

But a painting!

As a composition, a painting is a completely rounded integrity, from which nothing can be subtracted and to which nothing can be added. It is a picture, expressing something definite and distinctly limited. It must be viewed isolated from other paintings, and the more there is of a neutral zone about it, the more the mind of the observer can be concentrated to grasp its content. This kind of a setting, no doubt, has been the desire of the artist; and if he really has accomplished a good piece of art, he is right.

And the contemplation of the painting's content and the observer's reaction to its color must not be disturbed by the intrusion of other paintings into its sphere of influence. Otherwise it is as if Miss Smith were to play the Moonlight Sonata, while Jim Jones at the same time were to hum in one's ears, "Happy Days Are Here Again!"

At least, everyone should learn the significance of the analogy—just by learning to appreciate the right meaning of color.

Then—last but not least—there is still one thing to remember insofar as employment of color in art is concerned: **human art must be a humanly creative expression by means of color**—just as much as it must be by other means of expression. In other words—to speak in parallels —the human dance has its own rhythmic movement and does not imitate the movements of the gazelle or of the antelope. Nor does human music borrow its characteristics from the singing of the lark or the nightingale. In analogy with this, the human art of color must constitute a chromatic world of its own with the significant characteristics of man and of no other manifestations in nature.

When man came into being, all the colors of nature already existed. And as man's senses developed, the impressions he imbibed from surrounding color developed correspondingly. But his own expressions were primitive and colorless: his cave-paintings were executed simply in red, brown, and black. However, his early use of even these colors indicates that man had already begun to feel the meaning of color, and that he had the desire to express himself accordingly, although he was unable to do it to a greater extent.

Consequently, in the evolution of man's art, insofar as color is concerned we have two phases to note. First, we have **the desire for color expression**. And secondly, we have **the ability to produce color as means of expression**.

Yet, where desire was the spur, success was bound to come—gradually. So man tried. And he succeeded. He produced color from plants and from the soil. His chro-

matic expression became richer, step by step. The making of color was an important part of the creation of art in connection with the objects to be colored. Art became craft: things were lacquered, gilded, and ornamented. And learning about art was to a great extent synonymous with learning about color-ingredients, and dealt also with the preparing, grinding, and mixing of pigment.

Thus man lived with his color. He was close to the soil whence his colors originated. And it seems as though he must have been close also to the spiritual soil whence his art had its nourishment, and as if—through the weight of the mutual relationship—the respective chromatic scales of both the material execution of color and the spiritual contemplation of ideas had been made related to one another. More than that. It seems as if man's keen desire to produce certain color nuances—expressive particularly of his time, race, and creed—had aided him to overcome the difficulties of arriving at just these nuances, and as if the fervor of the striving and the joy of success in this striving had brought human flavor —a "humanly chromatic scale," so to speak—into his art.

Art and color thus were nurtured together in mutual struggle, in mutual growth, and in mutual elation.

But when the making of color lost its roots in the creation of art; when the matter of color technique became only a chemical procedure—of mercantile mass-production —then, all the colors of earth and heaven were brought to the market—and from the market onto the palette. Now, man has all the means of color-expression in his hand. He is free. But his freedom brings the humanly significative chromatic register into danger—because he is able **directly** and **correctly** to imitate all the chromatic worlds in their fullest scope.

We do not regret that science is able to produce color of unlimited nuances, and that it has brought forth a rich variety of material to handle. This, for sure, is a great scientific achievement. But we do regret that the art of painting did not sense the proper consequences of this scientific achievement. The art of painting has taken advantage of the facility offered by mercantile color, and because of

this the art of painting has become realistically imitative rather than experimentally creative.

However, we are not able to give advice as to what should be done and what not. This could only mean that we would put down theoretical systems of our own for the use of others—which would be against our thinking. The only thing we can stress—and with emphasis—is that color is not a mere matter of decorative enjoyment. It has a deeper meaning, and this deeper meaning everyone must individually learn to sense. Sound and movement—music and dance—are not for the sake of dinner-entertainment, as many seem to think. They are essential means for inner cultural growth.

So is color.

And so also must the art of color be.

* * *

XII. FORM AND DECORATION

WHILE analyzing what we have called "special provinces" of form, we have found that in several cases the subject to be discussed was mentioned already at the outset of this book. For one example, it was thus with "decoration." We mentioned then particularly the "superficially decorative form"—which, in fact, we decided to eliminate from our analysis.

In making this elimination we did not cherish the faintest illusion that the superficially decorative form could easily be made away with, and that it could be buried just like that —and then forgotten. On the contrary, we knew perfectly well that the superficially decorative form was going to follow ghost-like at our heels—all the time and along the whole path of this analysis. And we knew perfectly well that, whatever the topic of our discussion, the same superficially decorative form was going to be prompt with its intrusion— although it would be constantly playing a losing game.

That's exactly what has happened.

Thus, when we discussed the subject "truth," we had to discard the superficially decorative form for not being a true form. When we discussed the subject "logic," we said: "random decoration lacking in meaning has no more logical reason for its existence, than has a loud chuckle, when out of place." Again, when we discussed the subject "function," the superficially decorative form was fought because of its non-functional character. And in discussing the subject "color," it was maintained that "color is not a mere matter of decorative enjoyment, it has a deeper meaning." And in many other cases, all along the line, the superficially decorative form has popped up—to be turned down, again and again.

Well then—finally—in this chapter where the matter of

decoration is to be the main topic, we have a good chance to sift the grain from the chaff.

Now, it has already been made pretty evident—we think—that while the general concept of art during past centuries shifted from the creative to the imitative, this signified that the expressive quality of form gradually submerged, whereas the decorative quality arose correspondingly. Ultimately, the decorative viewpoint came to the fore to such an extent that during the closing decades of the past century the surface of an object of art scarcely could have been appealing to the average eye, unless it were covered with decoration. And the decoration was put there in order to make the piece look like a product of "art." **For "art" had become synonymous with "decoration."**

However, in such circumstances, it is easy to discern the importance of decoration. Decoration entered with a helping hand at a time when the creative impetus had become weak. Then decoration became the supporting friend of the designer who had lost his creative strength and was thus doomed to proceed nonchalantly along the broad avenue of decoration. But in the long run the broad avenue of decoration became deceptive. Without hesitation it can be said that when art became **purely** decorative, it ceased to be art.

Here, again, the advice of nature is clear and instructive. Nature is not decorative, she is functional. And when she produces decorative pattern—as happens constantly and everywhere—there is always functional thought and expressiveness behind it. Nature's case thus is fully obvious and convincing.

It is fundamental.

Things are different with man's conflicts between creative expressiveness and hollow decoration.

Please, go and make an experiment with an open, earnest, and critical mind. Go to those towns of olden times which have not as yet been damaged by later civilization. Walk along the streets; visit the buildings, the churches, taverns, inns, and homes. Go to the villages where people

still dwell in an indigenous atmosphere of their own; where they occupy themselves with folk-art for their own use— with dances, plays, and colorful festivals. Go to the remote primitive peoples where primitiveness of thought and customs of life still are genuine. Wherever you go, you will realize that there prevails a significant relationship between the people themselves and the ornamented objects they live with. You will find that their decorations—whether carved, painted, or woven—have grown from the spirit of their life, from their legends, meditations, struggles, and joys. These decorations are the true mirrors of the **best** of the people. These decorations are an essential part of the life of the people, a part without which their life would lose much of its depth and charm. You will detect that their decorations breathe the same love that gave them birth. And you will arrive at the conviction that these decorations are honest and sincere, however playful, rich, or fantastic.

Please, go to the Egyptians, the Greeks, and the Chinese. And you will find much the same situation. In all of these cases the respective ornamental concepts are the results of the experiences that these peoples have gone through in all phases of their spiritual lives. It does not matter whether or not you are familiar with the respective religions, thoughts, and lores that gave birth to these ornamental concepts; in either case you will find that these ornamental concepts radiate the silent tales of these religions, thoughts, and lores. And you will find that the silent tales are true and honest.

Please, go and experience still more:

Go to the crossroads of modern civilization, to the cities with their streets and centers, with their hotel-lobbies, restaurants, and theaters—and even their churches. Go to the homes. Go, and look, and observe. Everywhere do you meet decorations from the latter part of the nineteenth century—and a good many echoes of these decorations as carried up to the present time. Are these decorations honest? Are they sincere? No! It seems as if all the honest and sincere decorations that have been created by various peoples and various times, during thousands of years of

struggle, joy, and love, had been brought together to the mixing mill of our civilized confusion. These decorations are there, for sure—but the struggle, joy, and love that brought them forth are gone. They are like what is left of former virgins, now tossed about in the whirlpool of pleasure markets. Their complexion is not that of youthfulness and gaiety, but betrays the dead tint of cosmetics. They try to be gay, pleasing, and well-bred. But they are worn-out. And unworthy.

Alas, consider what has happened during already more than a hundred years—an ornamental orgy. And no wonder, for all the forces of promotion have been put into action to encourage this decorative nonsense. Even art-education has been carried on with the advice that ornament is but a decorative feature, and that it needs to be no more. On the first day of his studies, the poor student has become bitten by the malignant mosquito of decoration, and in the same spirit of decoration his education has been continued to its blessed end. Once out of school, the student has become the carrier of the bacteria of decoration—and so the ornamental disease has been spread. Thus acanthuses, astragals, cartouches, flower-, animal-, and what-not-garnishment have been let loose, distributed, and displayed in infinite variety. Ornament has overwhelmed countries and cities, buildings, and rooms. Countless textbooks spreading the miasma of decoration have been printed, and their contents have been injected into the minds of old and young. Libraries have been filled with these books, still more to spread this effluvium of decoration. Decorative "art associations" have been instituted to carry on with the big ornamental idea. And—worst of all—the ornamental ailment has acquired deep roots even in homes, under the illusive label "interior decoration."

Now, since the search for a new form has already been going on for a considerable length of time, undoubtedly a new era is dawning even insofar as "decoration" is concerned. This search for a new form has begun to show in the tendency toward simplicity. In some quarters ornament has

PLATE 13. THE GREEK FORM
View from the Parthenon toward
the Erechtheion

PLATE 14. THE MEDIEVAL FORM
Portal of church at Moissac, France

been entirely condemned, although in other quarters this is true only to a certain degree. In any case, there is a distinct trend toward simplification of form, and this we note as a positive step toward the better. We do so particularly because it is our conviction that the trend toward increasing simplicity ultimately will be on the winning side.

Whatever might or might not happen, the air is nevertheless still filled with the bacilli of decoration. Artists are not immune to it, and the general public seems to like ornate things. The ornament is pleasing to the eye, people say. It gives a cheerful touch to the background of one's life. It makes one's home more livable. It is a sign of refined taste. And of wealth! Ornament catches the eye—and for this reason it is good advertisement. And so, when a new form is born in truthful simplicity, it soon is made decorative, more or less.

There seems to be a sincere desire for simplicity, and a sensible endeavor to free oneself from that old alien ornament. But the habit of living amidst decoration is too deeply rooted to permit people to feel satisfied in wholly simplified environment. And so—instead of the old—there seems to grow a new set of decorations: that "modern style."

So it goes.

And yet—to get down to the roots of things—"ornament" is a phenomenon to be seriously reckoned with. Its concept lies deep in the soul of man—just as lies the trend to rhythmic pattern in the soul of the universe. Long before man became conscious of rhythm and cadence, he had an irresistible drift to express his emotions by means of rhythm and cadence in line and color. The origin of ornament springs from those same wells of human emotion that give rise to song, dance, joy, and love. Ornament, therefore, is comparable to folk-song and folk-dance. It develops in the same spirit of expressiveness as they do. It is as direct a stimulus to life as they are. It is as sensitive to meaningless and inordinate deviation as they are. Consequently, ornament must be kept with its roots in its own soil, just as folk-songs and folk-dances must be. Otherwise ornament is

doomed to decline to decorative imitation, to histrionic nonsense, to harmful triviality.

Ornament represents the spirit of man in an abstract form. It transposes the rhythmic characteristics of time into a significative pattern of line, form, and color. It evolves from the simple toward the rich, from directness toward symbol. In this evolution, ornament assimilates new ideas, new thoughts, and new patterns, until by and by it embodies decorative interpretations of floral and faunal forms and of all that man feels, observes, enjoys, and likes to live with. But no matter how ornament develops, it always is—or **should be**—a translation of emotions with inner meaning behind the forms; it always is—or **should be**—an emotional play of forms with sincerity at the bottom; it always is—or **should be**—a product of true art.

As the art-forms of the various means develop, ornament develops parallel with them; and the stronger the creative impetus of the time, the clearer is the status of the ornament. In this parallel development, ornament is the mediator between line and mass, color and material. Upon these, ornament bestows liveliness and variety, light and shadow. And it interblends them into a mellow rhythm.

In his decorative work the artist must have creative freedom in using his material without any restrictions from esthetic stipulation. But whatever the artist does in ornamental terms, and however he uses his freedom in this respect, his ornament must have the quality of **expressive language**. As such, the ornament must be understood. As such, it has reason for its existence. And only as such is it "art."

The present time is practical, hence there is no need for ornament—so it is oftentimes thought in "practical" circles. Such a thought, however, has little bearing, for it does not look the decorative problems straight in the eye. Isn't nature practical and functional? And yet she is, throughout, an organism of decorative tissue where ornament has its fundamental mission to serve. As long as there is ornamental pattern in the cell-tissue or elsewhere, nature is

healthy, and this ornamental pattern makes nature's forms expressive. In fact, there exists in all of creation—from the smallest particles of atomic life up to the most gigantic nebulae—a fundamental and imperative law of organic design. And "organic design" results in pattern which has ornamental qualifications—yet, basically, of functional significance.

Well, as long as it is so in nature, why should man take a coldly practical attitude when considering his own work. Shouldn't man, too, endeavor to bring into his work spiritual significance—as nature does. And shouldn't he keep his mind open in this respect, instead of pinning it down with "practical" requirements.

Practical requirements are nothing new and, surely, not significant particularly of our time. Practical requirements —as basically necessary prerequisites—have always been connected with man's activities—although perhaps differently understood and applied during different times. Therefore, to discard ornamental treatment of forms of today by reason of the "practical" disposition of the time, is no real reason. The real reason lies in the fact that the present time of transition does not, **as yet**, vibrate in decorative terms. The present time does not, **as yet**, sense the fundamental characteristics of its "ornament" to come. The present time is ready to throw overboard all that imitatively decorative stuff from yesterday, all right, but just because this very stuff— ornamentally noisy as it is—has been spread into every corner of our living spaces, the mind of today is too confounded to sense its own ornamental rhythm.

Nevertheless, much probing and trying is already going on in efforts to compose ornamental pattern of today. So far, however, the results reflect more the fashions of today than they do the sensing of fundamental characteristics of the age. They are experiments—although forwarding the search. Therefore it is safer to regard the products of these experiments as mere decorations of temporary nature, and not as having any connection with art that is expected to last.

The longer our age is able to remain simple, the more

regard does it have for its decorative language to come. And the more cautiousness there is in the search for this decorative language to come, the safer will be the ground on which to build the "ornament" of our age. The more downright the ornamental expressiveness and the fewer the means by which this expressiveness is attained, the stronger will be the ornamental "quality"—and the more its "quantity" can be reduced. History testifies that the lasting quality has always been attained through sparse decorative means. It testifies that simplicity is the stronghold of form.

The sparse ornament is the poetry of form.

For, as the virtue of poetry is **to touch the deepest strings with the shortest stanzas,** so likewise must be the virtue of decoration.

* * *

XIII. FORM AND SPACE

THE esthete is the professional analyst of art. He pigeon-holes the various art-forms in their proper places. Painting is the "art of color." Sculpture is the "art of form." And architecture is catalogued as the specific "art of space." It is perfectly understandable that when things have to be systematized with scientific correctness they must be ordered, numbered, named, recorded, and filed. It is just like the naming and enrolling of human beings: Jim Brown, Jack Green, and John Black. However, insofar as human values are concerned, the name means little; personality behind the name is the thing that counts.

So even in art.

Therefore, we are not so much interested in knowing into which particular class of appellation the art of building is catalogued, but merely what its significance in the large family of the "arts" really is. In spite of this we are going to put this epithet—"art of space"—under dissection. We do so, not because we are in a fighting mood, but simply and solely because we wish to clear up some misunderstandings —and grave ones, too—which this epithet has brought about.

In the great esthetic discrimination and grouping of the various art-forms, it probably was considered a good idea to name architecture the very "art of space." Skimming the surface, this sounds perfectly logical, for the enclosed room of protection is the prime idea of architecture. And room means space. Going deeper into the matter, however, one is met by obstacles of many kinds. For instance, how should the Monument of Lysicrates be classified? And what about the Triumphal Arches, the colonnades, the pyramids, and all the bridges of the world? The Parthenon itself—the eminent creation of architecture—with its unessential cham-

bers, gives much food for skeptical thought. Does the Parthenon really belong to the art of space? That is, is the Parthenon after all a product of architecture according to the esthetes' definition? Isn't there too much of elaborate form representing but two relatively modest chambers?

However, the difficulty seems easy to overcome. Space —some try to explain—means not only the inside space embraced by the structure, but that space embracing the structure as well. Namely, there can be imagined a certain "concavity" of space enclosing pyramids, towers, monuments, and what have you. With these two space conceptions— within and without—architecture must be understood, so it is said. Pretty transparent this, for it is fully obvious that the esthetic thought originally considered—and in prevailing quarters still considers—only the enclosed space, and that the esthete now, when the foundation begins to shake, is forced to broaden his understanding of space in order to save the situation. However all this may be, we are fully in accord with this broadened understanding of space.

And to accentuate our point: we are in accord **only with this broadened understanding of space.**

But what is the result of such reasoning? According to such reasoning, sculpture also belongs to the art of space, at least insofar as the embracing "concavity" of space is concerned. For there scarcely is any logical reason why sculptural forms should not be understood in terms of embracing "concavity" of space, if architectural forms are. As a matter of fact, they should be. Nay, they must! And the "art of color" is more than a flat surface covered by color—for nobody looks at a painting with his nose tight to the canvas, but always maintains a certain distance between the painting and his eyes. Thus, even the art of painting has its "concavity"—if you please—within which its influence vibrates. Massaccio's frescoes in the Brancacci Chapel, and Benozzo Gozzoli's murals in the Medici Palace, establish the aura of space more than do the really very simple architectural forms of these two rooms. And the vibrations of music do not stick to the strings of the violin, but fill the surrounding space with their melody.

Thus, form, whatever the means of expression, always must be understood in connection with space. And this so-called embracing "concavity"—and why not embraced "convexity" as well—is nothing else than the sphere of light, shadow, and atmospheric effects within which form must be conceived, and within which form exerts its influence.

This matter of space—to continue with the esthetes dilemma—has caused much bewilderment as to the spatial situation with the Greek Temple and the Gothic Cathedral, respectively. The former, the Greek Temple—as the rather unessential chambers of the Parthenon might indicate—brings the esthete's appellation into doubt; whereas the latter, the Gothic Cathedral, is an eminent example insofar as embraced space is concerned.

Yet we see here no contradictions whatsoever, provided the matter is viewed—not according to misleading esthetic stipulation—but on a basis where a proper understanding of reasons and results is taken into account.

These reasons and results we understand as follows:

The respective problems of the Greek Temple and of the Gothic Cathedral were unlike; naturally, then, the respective solutions of these problems were bound to be unlike. Now, in the case of the Temple, the people remained outside the structure during the ceremony; whereas in the case of the Cathedral they were gathered inside. Thus, the essential question concerns how the people were interrelated to their architectural environments in these two cases, the Temple and the Cathedral. And, as said, this interrelation was reversely different. It was just as reversely different as is the interrelation between seed and fruit in the strawberry and the fig—to employ a pomological parallel—where the strawberry is analogous to the Temple because of its outside seed, and the fig analogous to the Cathedral because of its inside seed. In spite of the reversely different situation, however, the leading thought was just the same in both of these cases—the Temple and the Cathedral—to wit, **the architectural "face" was turned toward the people.**

As to this architectural "face," look what happened.

In the case of the Temple, the outside architectural treatment—the architectural "face"—was made rich and exuberant by means of serene colonnades to direct minds to serene thought. Through abundant sunlight and because of the depth of the colonnades, there was created a play of light and shadow, of color and spatial brilliance, to achieve a sentiment of sanguine esthetic optimism. In now applying the same thought of sentiment-disposition to the Cathedral, the result was bound to be reversely different, because the aim was reversely different. In the case of the Cathedral, the inside space formation was made lofty and abundant so as to elevate minds accordingly. Through spare-light, the room was made spatially indistinct and thus appropriate for a sentiment of inner mystic contemplation.

This explanation of these two cases—the Greek and the Gothic—shows clearly, we think, how the respective times understood their spatial problems.

Let's continue with the Greeks and the Goths.

Arriving through the Propylaeum at the plateau of the Acropolis, on the right hand we would see the Parthenon, and on the left hand the Erechtheion. Neither of these structures was placed parallel with the main axis of the Propylaeum, nor were they parallel with one another. They were "irregularly" located—as the inveterate academic mind might put it. Yet they were located into the setting with the most exquisite sensitiveness so that those entering the plateau would get their impressions, not through a flat and two-dimensional aspect of the buildings, but rather through a three-dimensional spatial effect of the scenery as a whole, where the individual buildings were but details of a spatial composition, and where the atmospheric landscape—with the Penteliconian mountain azure as the background—constituted an inseparable effect.

What in this respect was true as regards the spatial composition of the Acropolis group, was true in any similar Greek case. The Greeks really did not conceive their buildings as isolated space-enclosures. Their buildings—and whatever features there might have been included—were

conceived in space. There is needed only a short study of the layouts of the Greeks—and of their form-relationships in general—to be convinced that the genuine Greek understanding of space was comprehensive.

Thus did the Greeks.

As for the Gothic era, the builder of that period did not erect his structure by just enclosing a certain amount of space independently of the environment, but—not possessing even the dimmest idea of esthetic space-consideration—he simply arranged the inner organism of the building to meet its practical requirements—and while he did so, the whole organism became fitted into its environment, automatically and harmoniously. Indeed, automatically and harmoniously, because the demands of the embracing space were to the Gothic builder just as essentially a part of the problem as were the demands of the embraced space: not by theoretical reasoning, but as a very natural thing where spatial sensitiveness acted as the unfailing guide.

So the erection of the Gothic town went on, step by step. Every new building was fitted into the urban organism like brick upon brick into an organic structure. Space became enclosed into streets, into street-openings, into plazas, into vistas, and into rambling ensembles of romantic groupings and perspective effects. And in these rambling ensembles, the Cathedral certainly evinced that its exterior space of "concavity" was just as important a spatial consideration in the forming of architectural effects, as was its interior space of "convexity."

Now, in comparing the spatial conceptions of these two discussed eras, the Greek and the Gothic, we shall find them contrasting indeed.

The Greek spatial concept was open and clear. It unfolded long vistas and atmospheric landscape effects. And because of the fact that such was the Greek inclination, even the forms of the buildings strove toward horizontality. The buildings were designed as if to spread themselves along the surface of the earth, along valleys and gently sloping mountains—and perhaps along those same mountains where even the gods had their semi-earthy abodes. That was the Greek

inclination. And were we to analyze every angle of Greek life, of action, art, and temperament, we would find that all these together formed a perfect accord within the characteristic spatial concept of the Greeks.

As was the Greek spatial concept "open," so was the Gothic spatial concept "closed." The Gothic town was a complexity of enclosed features, narrow and winding, thus still more to emphasize the nature of enclosure. From this narrowness of space the Gothic mind longed toward heaven where the Almighty dwelled and ruled. Upward went form-expression too, with towers, turrets, gables, and all kinds of features, as if seeking upward atmospheric space. And, as was the Gothic spatial concept closed and the spatial longing upward-bound, so was also the Gothic mentality: man lived in narrow darkness, and from this darkness he longed for heavenly light.

Notwithstanding the dissimilarity of the spatial concept of the Greek and Gothic eras, the basic principles that directed their "art of space" were similarly understood.

When Phidias located his Pallas Athene on the plateau of the Acropolis, he considered all the circumstances that could make for the statue a perfect setting. Interrelation of distances, combined effects of light and shadow, perspective views both open and closed, scale of buildings and display of masses—all these were vital points for Phidias to consider in locating his famous statue of the goddess. And surely any other feature on the plateau was subject to the same careful consideration.

Similarly did the Gothic era control its actions. The location of the fountain at the corner of the plaza was not an accidental or arbitrary action. It was as many-sided a spatial consideration as was the laying out of buildings and the disposition of the building masses of the Cathedral.

The above comparative analysis of Greek and Gothic understandings of space indicates that spatial psychology is very much a matter of time, of race, of environment, and of conditions of life. In fact, if we were to go more deeply into the subject, we could discover illuminating parallels in this

respect. And we would learn how many circumstances, physical and spiritual, influence the various concepts of space.

The Egyptians, confined to the narrow valley of the Nile river—bordered on both sides by deserts—no doubt imbibed much of their spatial impression from the geographical character of their environment. The spatial psychology of the nomadic Arabs is greatly due to the vastness of the desert, to the high-spanned sky, and to the far-away horizon. The Hungarian "pustas" and the great plains of Russia foster another spatial mentality than does the monumental plasticity of the Alps. And indeed in contrast to these, there is the Japanese miniature garden as an intimate Japanese concept of space—perhaps with a glimpse of that holy Fujiyama bringing in its distant and majestic accent. No doubt, all these various natural effects—together with racial inclinations and problems of life as well—mould man's spatial consciousness accordingly. And accordingly comes his art into expression—**in space.**

Let's then ask:

What are the present characteristics of spatial concept? What is the disposition of our time in this respect? And what is the trend toward the future?

Certainly our concept of space is not the mediaeval one with dark conditions and satisfaction of living in narrowness. Rather, closest to our disposition of living comes the Greek, because of the Greek desire for open and airy quarters. But even here a distinct difference can be noted. The Greek disposition was "static," so to speak, whereas ours is "dynamic": that is, the Greeks **lingered** in spatial complacence, whereas our inclination is to **move** in space.

The development of science, with all the new means of communication, surely has so stirred up consciousness of space as to make space utterly "spacious." This is the case insofar as the possibility of movement is concerned. But so is it the case in many other respects. For example, there is a distinct increase in spatial consciousness even in the quiet quarters of our homes. The growing demand for hygiene is the driving motive. Air and light are the goals to attain.

Increased openness, inside and outside of the living places, is the solution. All this is reflected in the mode of building design and in the use of color. Thus the windows are made ample. And the colors are preferably light.

The trend to openness is evident in all fields.

We do not paint anymore like Ribera and Rembrandt with light effects against the dark background of umbra. The painter's palette has become bright and light. The lonely Cézanne and the unhappy Van Gogh were the heralds of brightness and light. Even they had their shadows, of course. But their shadows were not those of somber umbra. Their shadows were translucent and vibrant. In this spirit of vibrant translucence has the art of color, generally speaking, developed since the days of Cézanne and Van Gogh.

Thus has evolved the sensing of space toward increased spaciousness.

Although the present time senses space differently than did previous times, those basic principles that govern form within this space must be just the same.

This same thought was mentioned a moment ago when we stated that, in spite of the dissimilarity between Greek and Gothic understandings of space, the principles that directed their respective actions were similarly understood.

We mentioned this thought then as a matter of **information.**

But as we are now going to elaborate on this same thought as applied to our time, we do it as a matter of **warning.** For things have not been carried on as they should have been.

Behold what has been going on in accordance with the esthetes' theory of space.

In a case similar to that of the informal interrelationship between the entrance gateway Propylaeum and the Parthenon, a designer of our academic time would have located these two structures along the same axis. Because of the highly formalistic educational system—and due to the long-enduring habit fostered by this system—one has been used to a sterile mode of planning, in which a rigid scheme

of axes governs the display of masses and spatial imagination has gradually become weak. Thus, for example, even the location of a sculptural monument has not been viewed—contrary to the procedure in Phidias' time—as a many-sided spatial problem, but the monument has been located—simply and easily—at the intersection of two axes, with the cold aid of the dividers. Moreover, the designer in our academic time has not been looking on his structure—as did the Gothic builder—as a part of a complex layout, but as a self-sufficient and independent feature. In other words, he has been looking on his structure as an "enclosure of space" —an isolated quantity of space within the structure. And even were it true that the structure, as such, might be of the most exquisite design, it would not matter, for the fact remains that it is a product of "art of space" in a limited understanding of the appellative.

Herein lies a substantial mistake.

As a matter of fact, the independent building—the enclosure of space—and the esthete's notion of this "enclosure," have been born and nurtured in the same spirit. Together and mutually they have brought both the idea of space and the results of this idea into an impasse. The building has been erected as a self-sufficient unit, and the esthete handles this self-sufficient unit as a matter of "space." "Isolated space," of course, for so must his reasoning be taken—and so it will be—in spite of his sophistic talk about broader understanding.

And here is the record:

Our towns and cities have become filled with these self-sufficient units—small, medium, and large—low, tall, and very tall; streets have become bordered and plazas framed by them in the most unbelievable variety. Much "space" has been enclosed, but much more has been left outside without any consideration whatsoever.

In order to overcome such a state of things, the right remedy must be found. To this end it is necessary to find the reason for the spatial disorder. And because we are convinced of the fact that the roots of this disorder lie in the misconception of the true nature of the art of building—the

253

so called "art of space"—We must ask: What is architecture?
Is it the mere building?

There is not the slightest doubt that the general opinion
would answer the question affirmatively, because according
to such an understanding has the matter been dealt with for
generations. And according to such an understanding, arch-
itecture has become the mere shell—the stylistic "façade"—
of that space within which the most intimate and important
architectural problems have been solved by someone else—
by the "interior decorator"—but not by the designer of the
shell itself. And outside of this shell, others—the "city
planners"—have been organizing problems which in fact
constitute the climax of architecture, but which often have
been solved by violating the most important principles of
this art-form.

Now then, repeating our question, What is architecture?
—the real answer must be found in the above.

And the real answer is that architecture is **the art of
space in space**—if your pleasure is to put it that way.

The building is organization of space in space. So is
the community. So is the city. In this space man lives and
works and moves. In this space he spends all of his life . . .
if the word "space" after all must be mentioned. For, finally,
it is just the very **atmosphere of art** which man must create
about himself, and in which he must dwell.

*** * ***

XIV. FORM AND THEORY

SOMEWHERE—while discussing fundamentals—we made the statement that "the world of number is an undercurrent of all that exists and that all things are consequently explicable in terms of mathematics." And because our task at this moment is to deal with theories, we wish to bring the above statement again into consideration. For, insofar as theories are concerned, the statement is indicative in several respects.

In the first place, it indicates that any act of art-creation must result in a mathematical formula of its own, representing this very act of art-creation.

In the second place, it indicates that this mathematical formula—if need be—can be defined as to its character, proportion, rhythm, and whatever tangible properties there might be, and that it can be analyzed together with related formulas so as to bring all these into a unified scientific system.

In the third place, it indicates that this process of theoretical definition is of purely scientific nature—of which intuition, instinct, imagination, and other phases of creative consequence must be kept entirely independent.

On the whole, this theoretical definition is of much the same nature as is the doctor's examination—by means of graphic diagrams or otherwise—of the beat of one's pulse and heart in order to be able to determine the efficiency of blood circulation and the status of the heart. Or, for that matter, this examination is of much the same nature as is the scientific study of such problems as sound, light, and vibration of all kinds, in order to learn about the fundamental nature of things.

Even in the field of art such a scientific—or let's say,

esthetic—definition takes place so that we may learn about things of fundamental nature in art. And so it must be.

Now, during the ages there has accumulated much art-material to examine. And, as esthetic thinking has grown increasingly eager to examine this art-material, the province of esthetics has become a significant factor in the cultural activities of the civilized world.

In this esthetic thinking we can note two different leanings, generally speaking.

First, we have what we may call "philosophy of esthetics," dealing with immaterial and intangible things. This leaning of esthetic thinking originated at least as far back as the time of Aristotle, and during the ages it has inspired much of the philosophical orientation toward art. We mention this phase of esthetics only in passing, for in our discussion on theories it is of little consequence.

Secondly we have what we may call "science of esthetics," dealing with material and tangible things. This leaning of esthetic thinking is of theoretical nature, and because its inclination is to establish—often in pseudo-scientific manner—fixed theories for artists to follow, we must include this phase of esthetics in our discussion.

Particularly during non-creative times of art-development—when the creative instinct is not alert enough to offer guidance—esthetic thinking is made to act as a substitute for instinct by stipulating all kinds of theoretical formulas whereby to produce art. These theoretical formulas, however, cannot in the long run be of much avail, because they are static by nature and therefore delusive in a dynamic process. And furthermore, because these theoretical formulas are often based on dogmatic reasoning which has nothing in common with indigenous art-creation, they are misleading already by the logic of this fact.

To impose upon indigenous art-creation a type of dogmatic reasoning that has nothing in common with that creation, *ipso facto* is a grave error from the viewpoint of art.

It is a grave error from the viewpoint of science, too. For while science considers the world of number an under-

current of all things, by all means it considers this solely in an **intrinsic** sense and not just a random picking up of numbers from somewhere else to represent something else. Otherwise all this talk about numbers would make no sense.

In order to have this talk about numbers make sense, any form-manifestation must be represented by a number-formula of its own, indigenous and non-transferable. In the chapter, "The Creative Instinct"—as may be remembered—our endeavor was to bring "scientific validity" into this thought. And to make our point still stronger, we cited Spengler as maintaining that each civilization has its own mathematical thought—"an expression of a specific world-feeling, representing the central essence of one and only one soul; that is, the soul of that particular Civilization."

Consequently, in cases where number-worlds of other civilizations are adopted for contemporary use, form is bound to be false. And how could it be otherwise—as long as form is established on alien characteristics and therefore cannot be expressive of our life, no matter what the theory.

It is perfectly true that the Greek proportions are refined and that they constitute enlightening material of study on theoretical basis. But it is also true that the proportions of their form—no matter whether of buildings, of sculptures, of vases, or of other products of Greek art—grew from the rhythmic characteristics of their life, and only from their life. And, once the key of these proportions was instinctively formed, their theoretical formulas were fixed in order to get rational advice—but **never to create.** Consequently, in the Greek case, **art did not grow through formulas, but formulas grew through art.**

Such was the case also with the Goths.

With regard to these matters, let's cite Spengler again, as follows: "The idea of the Euclidean geometry was actualized in the earliest forms of Classical ornament, and that of the infinitesimal calculus in the earliest forms of Gothic architecture, centuries before the first learned mathematicians of these respective cultures were born." In other

words, the mathematical form-language was instinctively sensed, before intellect could conceive its characteristics, much less establish its formulas.

Isn't this clear enough!

And yet we have been adopting alien formulas and "composing" art through them. We have been doing so because we have overlooked the basic fact that these formulas are only ancient theoretical explanations of how instinct—previous to formulas—transposed the vibrations of that particular time into the vibrations of art.

We must learn to know what is right or wrong in this respect, and we must draw our conclusions from this knowledge. Our life vibrates just now with rhythms of its own. It is up to us to transpose these into form. And once the characteristics of our form are established during a long evolutionary process, future esthetes then can fix all the theories, formulas, and what-nots—if that be their pleasure.

But the language of mathematics does not deal only with the great civilizations of man. It goes down to man's everyday life, to man himself.

Earlier while discussing the problems of man himself—in terms of aura—we maintained that an individual, during the whole orbit of his development—whether he creates, understands, or appreciates art—is subconsciously impelled to do it in a close relationship with the particular rhythm-expression he represents. We maintained, likewise, that his mode of creation, of understanding, and of appreciation of art, grows from just this rhythm-expreession. And furthermore we maintained that "were it possible to discover all the mysteries of mathematics, one could reconstruct a scientific formula a 'module,' if you will—according to which an individual exists, develops, and acts, in all his comprehensiveness, no matter how personal or impersonal."

This only shows that the world of vibration—of "number"—in human art, is **inherent in man**. It shows, in other words, that there is within man something inexplicable which comes individually into expression, and in which—when genuine—as we have put it, "the creative instinct is the sensitive seismograph that records vibrations of life and

transposes them into corresponding vibrations of art."

Why, then, play with theories! Why not instead try to sharpen one's creative instinct to discern principles!

The difference between a principle and a theory is fundamental. A principle is universal and from time immemorial, constant and unchangeable. A theory is local and limited.

For example, when it is said that material must be used according to its fitness, it is a principle. And this principle is valid in any circumstance. It was valid thousands of years ago. It is valid today just as much as it will be valid thousands of years hence. And it is valid in art of nature and art of man as well. But when it is said that concrete, steel, glass, and whatever it may be, are the proper building materials of today—as frequently is said—it is a theory. And the theory holds only as long as fitness has been taken into account—that is, as long as theory is in accord with principle.

Again, when it is said that a piece of art has a good dynamic balance in the disposition of its subject-matter, it is so because the originator of this piece of art sensed the principle of organic order **in which dynamic balance is inherent.** But when someone superimposes upon this same piece of art his more or less arbitrary diagrams of so-called "dynamic symmetry"—whatever it means—in order to drag out from the piece of art the artist's mode of reasoning, it surely results in a more or less unreliable theory.

And, furthermore, when it is said that a piece of painting has an expressive color composition, it is so because of the fact that the painter was sensitive to the principle of organic order **in which both expressiveness and correlation of color are inherent.** But when a non-creative mind—as most frequently is the case—organizes color into a so-called "color theory" for the use of those who by heavenly gift have been endowed with an indigenous color-sensitiveness of their own, he is talking about matters that nobody should listen to. Such a "color theory"—rigidly systematized as it is—would only bring one's indigenous color-

sensitiveness into confusion—if one should fall into the trap. But this must not happen, for indigenous color-sensitiveness is just as important for those inclined to use color, as the eyes are important for those wishing to see.

Now then, as we see, principles constitute the firm foundation on which to develop art. Theories, on the other hand, are the by-products of this development. These theories might be helpful in certain cases, if used with discrimination. In other cases they might be harmless—**particularly if ignored.** But in the hands of those who do not know how, where, and when to use them, they are deceptive.

Yet in many quarters these theories are considered imperative for everyone, big or small. Here is an example:

Some conservative musicians told Beethoven that he had no right to violate established theories.

"You perhaps have not the right to do so," he retorted, "but I have."

Just because Beethoven made himself free from restricting theories, he became—through his genius—the great master. And it is just because so many lean upon restricting theories, that there is so much stereotyped music. For freedom from restricting theories gives freedom to mind, and this offers the possibility of progressive growth. Whereas a constant leaning upon theories is much the same as trying to drink from a dried well.

It is a proper thing to examine the realm of tune and time in order to prepare the soil for the art of music. Such an examination, however, is not necessarily synonymous with the preparation of theoretical formulas for dictatorial purposes. Rather, it is the provision of explanatory analyses of the material of music expression. Such analyses—"theories," let's say—presuppose constant change and adjustment to conform the development of music to both the composer's creative ego and the trend of the time. As for the composer's creative ego, these analyses must leave a free hand to those who are able to develop their art in freedom, whereas they might restrict the weak ones whose work is

not vital enough to grow freely. Again, as to the trend of
the time, the said analyses must result in living rules that
evolve parallel with the evolution of time. Consequently,
those rules that are going to direct musical composition of
a distant future are not the rules of today.

Speaking about art in general, it is—parallel with
music—a proper thing to examine the material of art-
expression in order to prepare the soil for genuine creation.
However, this examination of the material of art-expression
has little to do with creation of art. As for creation of art,
the artist must be as free from theoretical stipulations as
the composer. The artist must lean upon his instinct by
sensing the underlying principles which make him free—
not upon theories which might at first help him, but which,
in the long run, will surely restrict his freedom and hinder
his growth. Therefore, in the creation of art, freedom is
dependent on the strength of the creative instinct in sensing
underlying principles. To lean upon theoretical formulas,
on the other hand, is a sign of weakness that produces
weak art.

When theoretical formulas conduct art creation, the
creative instinct is strangled and made mute. Yet—occa-
sionally—such formulas may have been instituted by crea-
tive artists themselves for certain personal purposes of their
own. With regard to this, we know of many artists—and
outstanding ones, too—who have a fancy for playing with
theoretical formulas. These artists try to analyze their own
work through theoretical control so as to check its merits
and faults. And yet they produce strong art.

Now, is their art strong, thanks to their theories?

Certainly not! Through these theories—instituted ac-
cording to the personal inclinations of the artist—the artist
may control his work, but **his instinct controls his theories.**
That is to say: after all, the artist's instinct is the deciding
tribunal. And because the theories are personal, and there-
fore representative merely of the individual artist's instinct,
they are as non-transferable as instinct, and cannot become
commanding theories for others. However, in certain cases
these theories may provide good advice for others. But

they do so only as long as they are based on the ever-changing fundamental form which—note!—**make these theories, too, change.** They can be of good advice only if it is presupposed that those who lean upon them sense the right relationship between the theories and the fundamental form—that is, when their advice is superfluous. So there we are, again.

But when esthetic theories are instituted regardless of the fundamental form, art is bound to stagnate and lose its creative quality. For how can art be created if it does not spring from the inner being of the artist, but is prescribed by someone else somewhere else, who does not know what the work really will be, what it is going to signify, who will be the artist, and when, where, and why it will be materialized? Isn't such an idea on the face of it an absurdity?

Surely, if theories are not based on the characteristics of the time and the fundamental form, but instead on the experiences of some distant past, they inevitably become dangerous toys in the hands of those who use them seriously. Theories of this kind should never be taken seriously, for—seriously speaking—they belong to the domain of bridge and poker, or to any other leisure time divertissement.

So, then!

Theories of this kind become dangerous indeed when used as educational material, for it is the surest way to make education fruitless—**from the point of view of creative art.** More than many promising talents have been and are being turned away from the right path of indigenous creation to the easy road where cleverness of execution—according to rules—is considered more important than the inner meaning of form. And countless numbers of art products have been spreading this shallow understanding of art.

Why, then, institute these theories and keep them artificially in command beyond their time of fitness? Is it really so difficult to understand that each of these theories is a drop of deadly poison slipped into a refreshing drink?

* * *

XV. FORM AND TRADITION

"HONOR thy father and thy mother: that thy days may be long upon the land which the Lord thy God giveth thee."
Herein lies the quintessence of "tradition."

In its broadest understanding the above means that we must honor our forebears; and to honor them, we and our children alike must have ambition to progress in behavior and work in the same candid tenor of tradition as did they— thus to establish a continuous and unified orbit of cultural evolution for the benefit of community, nation, and humanity.
We know this. And we fully accept it.

And yet, considering the fact that almost page by page in this analysis we have been rather harsh about the doings of our forefathers, and that we have denounced much of their work insofar as art is concerned, we might easily have created the impression that we have forgotten the fourth commandment.
It is far from true, however.

It must be understood that "to honor someone," in fact means honoring the "best" of someone. But as for the "rest," it is perfectly proper to employ constructive criticism, we think. In other words, in the fourth commandment—no matter whether applied in narrow or broad sense—a logical discrimination can and must be used.
And this we have done.

However, there is no point now in lamenting about matters, or in again digging up all the facts about form-decline. Our problem now must be to make it clear how

and in what sense the true nature of tradition can be made constructive in the search for form.

The true nature of tradition is analogous to the erection of a structure: stone upon stone, brick upon brick. Yet, in the structure, any piece of stone or brick is of substantially the same grain, whereas in the structure of tradition, any new achievement is a new substance of mental order. This new substance of mental order, however, is not rhapsodically independent of the general progress, but sequentially coherent and the result of a continuous "transmission"—"tradere"—"tradition"—from one achievement to the following. The progress of tradition, therefore, is a continuous process that runs parallel and together with the progress of form-evolution.

Consequently, as life progresses from day to day, so progresses tradition.

The achievements up to yesterday constitute the traditions on which the achievements of today must be built. The state of things of yesterday is the tradition of today. And the progress made today—already inherently comprising previous progresses—is the tradition of tomorrow. This is an evolutionary process where each achievement is a revolution in itself. But the more regularly things proceed along a normal course, the more the individual revolutions are blended into one another to form an evenly running process of evolution. In case this does not happen, and the process of evolution deviates from its normal course—or stagnates—then necessary corrections must take place through more or less deeply effective revolutions—and something seemingly strange enters into the evolutionary process. However, this is not necessarily as strange as it may seem: it may be only a natural drift properly belonging to the general course of things, which now—having deviated or stagnated—resumes its logical position in the general course of things. It may be overdone—and most likely it will be—due to the revolutionary effect and because of man's inability to control things he has not as yet experienced. Yet, overdoings correct themselves—or they must be corrected. And on the basis of

the new, the new progress must be built: not on the old that drifted astray.

But whatever happens and however it happens, "tradition" must always be at hand as the intrinsic drift. This tradition—when real—is the light of yesterday that brightens the road of today, thus bringing enlightenment into the process.

This enlightenment, however, does not depend only on the work done yesterday, or on its traditions. Primarily it depends on the qualitative results of today and of tomorrow. The eyes always must be looking forward, and not toward the past. For the past, after all, follows along—inherent in the achievement of the present.

So, likewise, does man do his life-work.

To look forward is the vitality of youth. To work for the needs, thoughts, and aims of today and of tomorrow is the strength of manhood. But to bend one's mind toward the past, is a sure sign of senility. And during all of life there are no "traditions" to go by except those inherited through birth, gained by development of mind, and every-day experiences.

As for inheritance through birth, it is not a privilege to boast about, but rather an obligation on which further to build. The inheritance may be a noble one with a long traditional line of great achievements for generations; it does not change the situation insofar as tradition is concerned, for in all circumstances the inheritor should look forward by doing his work with the same ambition as did his an-cestors. "Noblesse oblige" does not mean—as seems to be the easy thought in some "noble" quarters—to linger in constant complacence and vainglory without any obligations of one's own. Rather, it means—and must mean—that one's nobility obligates one to do his work well. Only by doing so can one keep his tradition in honor. As soon as one begins to lean upon his "noble traditions," and fails to have ambition to do his work in accordance with the best of his abilities, he goes downhill, he degenerates, and he dishonors his traditions. And his "noble tradition" becomes a dan-gerous tradition.

Civilizations have the same obligation as individuals. They must have the same ambition. And, surely, they have the same danger **if they are inclined to lean upon the "noble traditions" of other civilizations.**

In every walk of life, the erection of a cultural structure goes on. And in everyone of these cases, the spirit of tradition enters as an intrinsic drift.

The workers in the field of science erect their scientific structure, discovery upon discovery, invention upon invention. In this manner they erect their monument of human deeds, which grows higher and spreads wider with every event of scientific progress. There are no antiquated "traditions" to hinder this course of things. The astronomer of today does not consider old geocentric ideas. Those ideas have been found erroneous, and a new theory of the construction of the universe has been developed, where each new discovery brings enlightenment and perhaps necessary changes in this new theory. The electrician of today does not consider Galvani and his early exploits in the field of electricity. He is far beyond these exploits, for his tradition is up-to-date electricity—including Galvani's contribution. Forward looks the philosopher of today, discovering ever new fields of thought based on up-to-date knowledge of things. So does the composer. So does the painter. So does the sculptor. In every field of cultural activities a gradual and up-to-date growth, a gradual and up-to-date understanding of things, is significant. Tradition *eo ipso* is subconsciously alive as an indigenous drift. But it is—and must be—consciously unconsidered. This is true in every field, except in the field of architecture—and in "religions" —for here "traditional traditions" still have a hard grip— although the urge for freedom, here too, grows increasingly strong.

There used to be freedom in architecture, till man invented an easy system according to which he could borrow forms from earlier times. This made matters convenient, because from then on there was no necessity for direct creation. Through this kind of system, architecture was made

into a sort of stock-market where "styles" and "revivals"—
the products of the work of others—are from time to time
rendered fashionable and offered for use, and where values
are established by the golden standards of "tradition"—or
rather, "traditions"—for they are many. And often these
"styles" and "revivals" are identified by the most ambitious
titles, including a long nomenclature of kings and queens.
It is a splendid collection of famous traditions, an abundance
of perfected forms and of seasoned styles. So many think.

But the reaction is bound to come. As a matter of
fact, a strong reaction has already existed for a long time.

In our analysis of the post-nineteen-hundred search for
form, we elaborated on this reaction, and it was then learned
that all other phases of cultural activities were developed
more or less parallel with the development of life; only the
all-embracing mother art was involved in dogmatic tradi-
tions and became stagnant in its course. In due time, how-
ever, men realized the deplorable situation and there de-
veloped a sincere fight for freedom from the shackles of these
traditions. And—as things stand now—much has already
been gained; so far the fight has been most successful, and
it still goes on.

On the other hand, in some conservative circles there
are still many who harbor the happy thought that this fight
for freedom from the shackles of traditions is but a passing
adventure. It is—some seem to believe—just an adventure
of youthful harbingers, over-ambitious to lean upon their
own powers and to think with their own brains. In all this
—some seem to hope—there is an echo of that old story
about the prodigal son who left his father's house, but who
soon—when exhausted and tired of his free-lancing adven-
ture—returned to his father's house—to the shadows of his
"fatherly traditions."

Perhaps this is the old story in a new form.

And so, to these prodigal harbingers the warning echoes
again and again: "You forgot your traditions!"

But they do not listen:

because they know, that **tradition does not mean to push into the background one's ambition to produce creative art;**

because they know, that **through the creative work of today, the tradition of tomorrow is built;**

because they know, that **only through sincere creation can the creative traditions of the past be kept in honor; and**

because they know, that **to create is their "noble tradition."**

Yet they should know, as well, that individual creation must not be an independent action, but merely a brick in the creative structure of culture in the making, where the spirit of tradition—evolving parallel with the general evolution—constitutes the cleaving mortar.

Certainly, tradition is not an accumulation of ready-baked forms which can be taken at random just as one takes a book from the library shelf. Yet the book can be read, its contents digested, and the digested thoughts from time to time adopted, when appropriate. Similarly, the forms of the past can be so studied as to learn from them. But they must not be used, unless they are first passed through the double-procedure of both the selective and creative process in order to bring them onto the firm ground of the fundamental form of the present. This is to conduct things in a proper manner according to the spirit of tradition.

In this process, time distance—no matter how short—does not justify exceptions.

The time of Louis XIV did not establish traditions for the time of Louis XVI to go by. It brought forth the direct tradition of the time of Louis XV. And yet, even then, "tradition" did not mean that forms could be directly copied and used as such. The transmission had to go through the metamorphosing process of the creative instinct. Tradition—even in those days—meant continuity of evolution from one time to another by a creative approach to the problem. And so it was, in spite of the momentous imita-

tive adventure and its pernicious results. Accordingly, in those days there was no such idea as to take "period" forms from another period, no matter how closely connected.

Our time does not seem to grasp the significance of this point. We certainly have been taking "period" furniture from the periods of these and all other august sovereigns just as readily and easily as one picks apples from a tree. And we are lounging in imitative reproductions of their chairs, proud of our "traditions." Which are, for sure, nothing of the sort, for there are no traditions whatsoever involved in such a procedure. Only stagnation. And this stagnation has nothing to do with the chairs or one's sitting capacities, but with the end of one's body where the mind is housed.

So things must be understood when dealing with a small period of time. They must be understood so much more so when considering times at large.

The Western branch of human civilization has produced many epochs, widely different, and with long time intervals. It should be self-evident that none of these could provide direct traditions to be used for form-development of today. This is true particularly because our time has become uprooted from the soil of earlier creative epochs as a result of many intervening imitative adventures. Continuity of creative evolution thus has been broken and genuine form-tradition lost. In spite of this, our homes, buildings, towns, and cities have been made the very "world's fairs" of historic and histrionic forms. We have been proud of our traditional form-abundance, and disdainful toward those who have tried to evolve an expressive form of our time by employing forms of their own. And all this has happened, notwithstanding the fact that one of the ten commandments forbids one to take things belonging to others.

However, we are beginning to have our eyes opened to distinguish the proper spirit of tradition. And gradually— as indicated—we are trying to free ourselves from our long-lasted imprisonment in the realm of borrowed "traditions." On the other hand, we seem to be too close to the happenings all about us to be able to get a clear view of things at large.

Therefore, in our efforts to discern the indigenous characteristics of our time, we often stumble hither and thither, not knowing where to go and how to act. And during all this we frequently bring forth strange and tricky products of all kinds, products that have but little—if anything—to do with the natural course of things. Really, one often wonders where we are heading.

Now it seems to be easier to find the mote in our neighbor's eye than in our own. It might therefore be a happy thought to look upon things from a greater distance, and for that reason we are going to investigate matters on the Chinese front.

The Chinese cultural evolution exhibits a long orbit of thousands of years of unbroken continuity of traditional adherence, relatively speaking. Far down in the dim past the Chinese traditional significances were founded through direct and simple means of expression. It really is astounding to learn how "modern"—in terms of today—the early Chinese form really was. Their form of construction was mechanically clean and functional, straightforward and inventive—just like the machine tool of today or the vertebral construction of the mastodon. And their first attempts to form pewter, for example, were just as clear-cut as is the Swedish pewter of today—yet as Chinese in conception as the Swedish. It was so, because the Chinese went down into the most fundamental characteristics of their racial soul.

Such was the start of the Chinese form. And in the same perceptive spirit it began slowly but surely to develop, gathering impressions along the way, growing in volume of forms and in abundance of means of expression. And during its long and eventful history, the Chinese form evolved toward a precious treasure of human art. It evolved from simplicity to richness, from functional to decorative, from creative to—imitative. "Imitative," we repeat—for even the Chinese could not escape the bane of imitation. True enough, the Chinese cultural ramification did not degenerate to imitative ventures in such a manner and to such an extent as did the Western world. And yet, the Chinese could not

always resist the temptation to imitate, when skill and cleverness of execution offered encouragement. And so, finally, the Chinese brought his imitative ability to a perfection similar to that of Madame de Pompadour in her pet factory at Sèvres, where she produced naturalistic porcelain flowers to please that not always faithful king, "le bien-aimé." Notwithstanding these imitative extravagances, the Chinese form always remained Chinese with its Tartarian blend. Yet it fertilized itself again and again, and in the long run it was bound to become self-imitative by using the same forms over and over again. And following this process of self-imitation the Chinese form stands now ripe and rich. It is overmature. It has been overmature for already a long period of time.

Really, the Chinese form is so saturated with traditional symbols, emblems, tokens, and all sorts of things that there is hardly any further for it to go. Yet Chinese life goes on, things must be done, and the development of form must follow the same course. But what kind of a course, may we ask? Should the Chinese stick to their traditional forms by repeating and again repeating them, thus becoming increasingly involved in their symbols, emblems, tokens, and so on? Or should the Chinese go back to their very origin and start all over again? Neither of these, we should say. Constant repetition of ever the same forms—no matter how traditional—cannot be creation. On the other hand, to go down to the wells of the past, where once upon a time the Chinese form originated, would mean to attempt to be expressive in terms of remote history. Such a procedure could not result in true art. For certainly the Chinese fundamental form has shifted considerably during its long course of thousands of years.

Well, to get an answer, let's put it thus:

While a family has been living in the same dwelling for a long time, the attics, cellars and storerooms have become filled with all kinds of miscellaneous stuff, mostly of no more use. No doubt, every piece of the heaped material —at one time or another, in one way or another—has served its purpose during the days and years of the family's past.

271

Consequently, every piece has, more or less, some sort of a traditional connection with the history of the place. Some day, however, one might begin to wonder what to do with all this accumulated stuff.

Now, should the family continue to keep that accumulated stuff, because of its "traditional" nature, and extend its storerooms for ever growing accumulation—perhaps ad infinitum? Scarcely. Isn't it clear common sense to get rid of all such antiquated material which has become totally useless and obsolete because of changed conditions, changed aims, and changed taste? Certainly. And in this general clearance as to what should be kept and what should be gotten rid of, the family's present cultural status and sentiment of mind must be its guide as to "traditional values."

As for these "traditional values," there is no vital difference whether the clearance happens within the narrow circumstances of the Jones household, or in the vast lands of Eastern Asia. No doubt, the Chinese form-attics and cellars are filled with stuff that previously had its useful significance, but not any more. Why not, then, reduce all this stuff into its simplest quintessence? By letting the overmatured Chinese form-world pass through the selective purgatory of up-to-date considerations, **the quintessence of this form-world would become distilled into a clear elixir of tradition. And this tradition would be that of today.**

However, this purge would not result in a "Renaissance" of Chinese art. For, there never was, and never could be, a re-naissance—"rebirth" or "revival"—of old forms, except in an imitative sense. But it could become the "birth" of a youthful Chinese art.

This short excursion into the Chinese world was undertaken mainly for two reasons:

First, because we thought it wise to have a longer perspective from which to look upon the problems of tradition.

And secondly, because the Chinese cultural evolution exhibits a long orbit of thousands of years of a rather unbroken continuity of traditional adherence.

This latter point in particular is essential in our case.

For, if a truly traditional form—as, to be sure, the Chinese is—must be purged from much of that dead-weight of **genuine** traditional forms heaped under a long way of development, so much the more then must as long and heterogenous an accumulation of **adopted** forms as the Western "traditional" situation exhibits go through a selective purgatory in order to be reduced into the essence of truly Western traditions.

This purging, however, is by no means a sign of disrespect for our forebears and their achievements.

Surely, a son does not show respect for his father by aping his actions. He does so by approaching his work in the same sincere spirit as did his father. In this way the constructive spirit of tradition goes from father to son, from generation to generation.

And only in such a spirit can we look upon "tradition" with high veneration.

* * *

XVI. FORM AND BEAUTY

THE word "beauty" is a stranger in our analysis.

True enough, we used the word—and lavishly too—when nature was our topic, and beauty was emphasized in all nature's manifestations. Beauty was furthermore mentioned in connection with "Fine Arts," in which beauty is supposed to bestow that eminent quality of "fine" upon "Art of Beauty." As for the rest of our analysis, we have avoided the word—or have mentioned it only now and then in passing.

We have avoided the word "beauty," purposely.

First, because the word seems to slip all too easily from many people's lips, and is thus overused timely and untimely, and mostly without meaning. Secondly, because—being overused timely and untimely—the word "beauty" is disliked by many people as meaning something sweet and effeminate. And thirdly, because we feel that this word—when rightly valued—is too precious to be misused.

Hence our cautiousness.

Of course, in connection with nature we did not hesitate to speak about beauty simply because everyone is naturally captivated by nature's beauty. Everyone is enchanted by the beauty of a flower, by the beauty of a landscape, by the beauty of a sunset. And everyone connects—consciously or subconsciously—this enchantment of beauty with that enigmatic **expressiveness of life**, inherent in all of nature's manifestations. This conscious or subconscious connecting of beauty with expressiveness of life is present in the sensing of beauty in the human face, the human body, and the characteristic rhythm of human movement. So it is with our conception of beauty in faunal life. So even in floral life. So even in mineral life, for, as said, the ages-old granite pattern still expresses today the glowing life which

brought this pattern about. All these manifestations are expressive of life, and, because of this expressiveness, they radiate that intangible quality we call "beauty."

In other words, whenever we sense beauty in nature, we do not sense beauty, as such. We sense this beauty in connection with that enigmatic expression of life that nature radiates.

So in nature.

It is then a logical assumption that this same definition of beauty must also hold in human art. Consequently, when we speak about the beauty of, say, a building or a painting, we do not speak about beauty, as such. We speak —or rather, **should** speak—about that intangible essence that radiates life-qualities through the forms of the building or of the painting.

So it must be . . . and yet, just here we find ourselves in the midst of a clash of ideas.

Often, and really in the most eminent cases of esthetic evaluation, a building might be considered most beautiful . . . but, from the point of view of expressiveness of life-qualities, it might be not only dead and sterile but also an utter fake.

Conflicting—what!

Now then: since we are dealing mainly with art matters; since we are convinced of the fact that beauty is inseparably connected with form-expression in art; and since there seems to exist a serious conflict of ideas in this respect; we must at least **try** to tackle this intangible matter of beauty in those of its points where enlightenment is possible.

To analyze beauty is a delicate thing, for no man knows nor ever will know why that intangible something we call beauty brings well-being and enjoyment to the human mind. And why should one know? For surely, if one should someday learn all the facts about beauty, what good would it do. In all probability such an erudite venture would cause the loss of much of one's instinctive sensibility to beauty. And one's instinctive sensibility to beauty is a precious gift which must be guarded to the utmost.

Obviously, beauty is some sort of an intangible essence radiating from mind into form at the moment of inception of form, and from form into mind at the moment of sensing this essence. This—we should say—is just as natural a thing as when someone sings of gaiety and makes others gay through his song. But when we go close to the roots of this matter, all this talk about beauty is quite puzzling and beyond human logic. Of course, one can speculate about these things as to how and why, and one can institute esthetic rules to go by, and often it is done—and too often, too. But almost equally often such rules lead into theoretic hair-splitting.

Frequently ornament is summoned, wherewith to beautify form. This, by the very nature of the process, is a hopeless mode of approach; for, although form can be made rich, lively, and impressive by means of ornamental features, it cannot be made beautiful merely by the means that are applied for these purposes. Form must breathe beauty through its inner merits, whether rich or simple: outer efforts rather disturb than help. It must be borne in mind that beauty is not a specific means by itself. Nor is it an end. Beauty must grow directly from and together with the creation of art. And it must be unintentionally innate in the end. For, in all circumstances, beauty is—or **should** be—an all-penetrating quintessence of life as well. So, for instance, when we learn from the Scriptures that love is the highest attribute of all, it is true only insofar as beauty permeates love. Otherwise, love is bound to decline to mere sensualistic passion.

Another question is this: Where is the source of beauty to be found—in the quality of the object that is perceived, or in the potency of the perceiving mind? In other words: is there such a property in itself as "beauty"? or is the enjoyment of beauty only a sentiment that the receptive mind feels when discerning certain manifestations which in themselves are not necessarily beautiful, but which, for some inexplicable reason, affect those so disposed but not others?

This question is frequently asked. The answer depends

on how one is inclined to look upon things. For example:

A piece of stone is not heavy in itself; one only understands it to be so, because the physical law of attraction affects the piece of stone accordingly. However, just as the physical law of attraction keeps substances in physical order, so is form kept in orderly coherence by another law—the principle of organic order—that, too, being a force of attraction. And, just as the physical law of attraction infuses into substance the physical quality we call "gravity," so does the principle of organic order infuse into form the spiritual quality we call "beauty." The appearance in each of these two cases is different. The effect is similar. As gravity has its gradation of force according to the nature of substance, so has beauty its gradation of effect according to the quality of manifestation. And as gravity is differently felt in accordance with the physical potency of the counter-action, so is beauty differently felt in accordance with the sensibility of the influenced mind.

Manifestation of beauty, thus, presupposes two poles in co-operation: **"quality of beauty"** and **"sensibility to beauty."**

Analogous is the case with love. For example:

When a young man meets a young woman, and his heart begins to burn with passionate love, obviously then the young woman must possess qualities that cause the feeling of love in the young man, and the young man must possess potentialities that can be influenced by those qualities of the young woman. Well, what's the difference between love and beauty? For after all, love—when elevated—originates in the sensing of **inner and outer beauty-values** in the beloved person. Really, it is all the same co-operation between the two mentioned poles: "quality of beauty" and "sensibility to beauty." It only remains to see to what extent these two poles, respectively, prevail in the universe.

Now, as for "quality of beauty," we have maintained that it is the all-penetrating quintessence in all of nature constituted by the universal principle of organic order. This then means that beauty is of universal significance. Again, as to what extent "sensibility to beauty" exists in the

universe, opinions seem to vary very much. Some go so far as to consider the sensing of beauty a mere product of human culture. This might be true insofar as conscious sensing is concerned, but it cannot hold in the case of subconscious sensing. Otherwise the case of beauty would constitute the greatest paradox that ever existed, considering the fact that beauty, as we have said, is a universal phenomenon embracing all times and all spaces, while human culture, in comparison, is but a hyper-microscopic affair as to both time and space. The simplest logic calls immediately for a sensible relationship between the general existence of beauty and a general, although perhaps subconscious, sensing of its existence. Therefore, leaning upon the authority of logic, we must accept the fact that the subconscious sensing of beauty must be as universal a phenomenon as is beauty itself. Again, when the question is asked as to how, to what degree, and by what means the subconscious sensing of beauty is conveyed in all the universe, the answer is beyond man's understanding.

However, we are mainly interested in the problems of man's art. And because beauty is—or **should** be—the all-penetrating quintessence of man's art, we are readily inclined to accept the opinion that conscious apprehension of beauty is a product of inner sensibility in the progress of art of man—or **a product of inner "cultural sensibility,"** to put it another way.

Beauty is apprehended differently at different times. This holds true insofar as the various eras, races, and ramifications are concerned—for each era, race, and ramification exhibits its own characteristic conception of beauty. But this holds true equally as concerns an individual during the various stages of his development. A piece of art, which earlier was found beautiful, may now have lost its power of attraction. And a piece of art which now may be enjoyed as having the most outstanding esthetic values, some years hence might lose its esthetic enchantment.

Now, does this mean that the values of beauty, as such, are changeable, or does understanding of beauty change?

Considering that beauty is known only through its reaction upon the human mind, we might venture an answer to this question by investigating corresponding reactions between man and man.

Supposing you meet a person who from the first moment captivates you. You like his or her appearance, manners, and so on. If both of you are lacking in intellectual interests and are generally ignorant, you will probably get along fairly well in an empty social way. But suppose you are intellectually curious and the other is not at all; you are then soon through with him or her. In the reverse case —you being the ignorant one and the other intellectually interested—you cannot understand him or her unless you become interested in deeper things yourself. Through this stimulus you will grow mentally and a new world of thought will be opened for you. Gradually, then, you begin to grasp the simple logic even in deeper things. And you may soon learn that the smallest and often the most commonplace subjects become spiritually captivating when they pass through a spiritually keen mind.

But in case you begin to observe that the other is a mere living encyclopedia, one who uses his or her knowledge as a dry recording of facts without any mental digestion or personal fertilization of these facts, and for the sole purpose of accumulating immense knowledge, you will soon meet that person's talk with coolness at best.

Again, as soon as he or she begins to be affected in the attempt to impress you with semblance of a deeper intellectual life than there really is, you will gradually withdraw from his or her company.

Affectation of manners is befitting at dramatic moments when emotions run high and ideas meet. They are the moments of symposium in the hours of night when thoughts sparkle like stars on the sky. And nectar inspires. These moments are not lasting. They come and they go. They will come again in a new form, always refreshing. But they are not decisive insofar as enduring relationship is concerned.

And finally: dishonesty is a death blow.

Let's now transpose all these various moments of re-
ciprocal influences between man and man to corresponding
relations between man and form, and we shall find much
similarity.

Only an empty mind can be satisfied with shallow
beauty. A culturally developed mind dislikes it. A recep-
tive mind grows through beauty; for his understanding of
it grows and he does not grope for beauty any more for its
outer appearance, but for its inner meaning. He begins
to understand that beauty is one with life while radiating
from this life. A sensitive mind can discover beauty even in
its simplest manifestation. He is able to enjoy the beauty of
a line, of a shadow, of a movement. Even in an abstract
indication of form he can sense beauty, for subconsciously
he senses life in its rhythm and movement.

A dry academic form of much knowledge and skill in
handling the presentation, but lacking in the creative quality
needed to make it breathe, is boring to the sensitive mind.

Occasional festivals of form and color are like symposia.
They sparkle, but they do not last. They are effects of the
moment: necessary events in the breaking of monotony.
But they are not decisive insofar as the understanding of
lasting values of beauty are concerned.

And finally: dishonesty of form is the antithesis of
beauty.

In comparing beauty values with human values, many
a confused question can be answered.

Here is one:

A lady once told me that she had visited a terrible ex-
hibition of the works of Degas. When I informed her that
Degas was one of my favorite painters, she hastily said,
"What, don't you think art must be beautiful?" Well, I had
it on the tip of my tongue to answer that Socrates is to my
liking in spite of his not too pretty face. But why bother!
Those things cannot be explained, they must be experienced.

Another confused question of similar nature is when
—as frequently happens—someone says: "I like this, you
like that, and Jones agrees with neither of us. Who, then,

is right? And when even the so called highest art-experts do not agree among themselves, where do we find the standards by which to judge beauty?" Such confused questions originate in a lack of experience in art matters.

As to human conditions, the situation is less confused, being more experienced:

Many people like a sweet "flapper." Others dislike such a type, preferring a less sweet but more sincere girl. The reasons for the difference in likings are self-explanatory, and nobody asks: "What, shouldn't a girl be sweet?" And it is an everyday experience that you, Jones, and myself may have our individual likings for various persons, and this is considered the most natural thing. We find similar disagreements among persons of the highest cultural development: people simply are different in their inclinations, that's all.

This does not mean, however, that a general tribunal in the evolution of human standards does not exist. On the contrary, it is all too well known that there are certain generally accepted qualities which are characteristic of the best in man. Everyone should arrive at the experience that there are corresponding qualities which are characteristic of the best of man's art as well—and, through these, of the standards of beauty. These standards of beauty are the **"objective criteria"**—the commandments of beauty, so to speak—on which everyone's **"subjective inclinations"** in beauty matters must rest. It should be everyone's ambition to grow to understand the commandments of beauty. For through such understanding the true beauty values of human art become one with one's being. Through such understanding the gradation of beauty values becomes clear. And through such understanding it becomes evident how little beauty value the superficial, correct, clever, and sweet picture-making—so commonly admired—really has. It is the pretty emptiness which beclouds many an eye.

As regards beauty, the following point must be emphasized:

Beauty cannot be achieved through a "beautiful" form

alone, but rather through an expressive form.

This means that two forms, seemingly alike, are not necessarily of equal beauty value. One form might be a surface lacking in meaning. The other might be expressive of the meaning behind the surface. And even if these two forms should seem to express their respective meanings equally well, there still might be an essential difference. One form might have come into being according to the spirit of its time. The other might be an imitation stolen from bygone times.

For example:

The Parthenon in Athens is considered one of the most beautiful buildings ever built. It is now in ruins, but a complete picture of its former beauty can be reconstructed —in one's mind, at least—through the still remaining fragments. Now, the forms of the Parthenon must not be considered beautiful in themselves, but in terms of Greek life; representing Greek religion, Greek art, Greek culture, and Greek psychological attitude in general. Although the original Greek life has already expired long ago, this life still vibrates through the fragments of the Parthenon—and just this gives these fragments their spiritual value.

The "Parthenon" in Tennessee is a replica of that in Athens. If form is to be considered beautiful in itself, surely, the Tennessee replica then would be as beautiful as the original Parthenon. It is far from so, however—for, in fact, the Tennessee "Parthenon" gives one an impression of complete nonsense.

Why?

Simply, because the Tennessee "Parthenon" vibrates the very spirit that originated it.

There is one more point concerning beauty which must be discussed in connection with the Parthenon in Athens.

It has been said that the Parthenon owes much of its beauty to its well-balanced and restful "symmetry." This means, in other words, that symmetry is considered an essential criterion of beauty. And because almost every Greek Temple was conceived in symmetrical terms, Vitruvius—

the supreme architectural analyst of the Classical era—issued the following statement: "No building can possess the attributes of composition in which symmetry and proportions are disregarded."

Insofar as "symmetry" is concerned, this Vitruvius' statement has been in many respects momentous. Not because symmetry might not have its place in certain circumstances —as, for example, in the Greek Temple—but because to make of this symmetry a categorical rule certainly was a short-sighted action of that old man Vitruvius.

However, this Vitruvius' statement had no momentous effects on the Greeks, for the Greeks lived and acted prior to Vitruvius; they used symmetry when appropriate, they did not use symmetry when not appropriate, and they never used symmetry in their planning layouts. These planning layouts—as we have learned—were conceived in space, and not in rigid symmetrical terms.

Nor had Vitruvius' statement any momentous effects on the Middle Ages. The people of the Middle Ages did not know about Vitruvius' thinking—or perhaps they did not care to know, for they had their own noses to sense with, and they acted accordingly.

But as soon as Vitruvius' thinking was revived by Vignola—during the days of the Late Renaissance—"symmetry" was put on a pedestal and "beauty of symmetry" became the guiding star of all building design. From then on, all the schools, schoolbooks, and building practices have engaged in carrying on with this grand idea of symmetry.

Ultimately, however, this idea of symmetry was not limited to building design only. In the course of time, books and more books were written about the beauty of symmetry. Thus "dynamic symmetry"—under the auspices of beauty of symmetry—has been pushed into the important position of providing basic thought in all design. At least, such has been the holy effort.

This has caused perplexity in many respects.

For there is no such thing as "beauty of symmetry," with the exception of those cases where—because of the nature of the problem and its logical solution—the **"balance" line**

of design happens to coincide with the middle-line of sym-
metry. Only in such cases is symmetry logical, and thus
beautiful. For in such cases "balance" becomes one with
"symmetry," and "beauty of balance" becomes transferred
onto symmetry. In all other cases symmetry is artificial—
and therefore not necessarily beautiful.

"Beauty of balance" is the fundamental thought in all
design, for the principle of balance has a universal signifi-
cance. This is true in nature as well as in human art.

In nature, always when one sees a symmetrical form
there is a logical and functional reason for having "beauty
of balance" coincide with "beauty of symmetry." So is the
case with most of the animals. So is the case with most of
the flowers. And so is the case in countless ramifications of
nature's form-world.

Man himself—to take the nearest example—is a sym-
metrical creature. Man's nose indicates the middle axis of
his symmetrical body, and on both sides of this middle axis
man's outer body is equally divided. This symmetrical
human body has been the subject-matter for all artists of all
the ages. Millions and more millions of images of this
human body have been produced. But behold, **never as
yet—not even in a single case—has there been produced a
human image in symmetrical position;** but instead, **all of
these images—without even a single exception—have been
produced in balanced position.** Indeed, these facts show
clearly that all the artists of all the ages have considered the
beauty of balance in the human body the significant thing,
while they have probably considered the symmetrical shape
of this body from the viewpoint of its practical functioning.
As a matter of fact, since the symmetrical shape of the
human body is fully logical from the viewpoint of its prac-
tical functioning, then by virtue of this logic, the **function-
ing symmetry** of the human body has its quality of beauty.

In other words, the human body **has not its symmetrical
design because the law of beauty requires such a design. It
has its symmetrical design merely for functional demands.**
And because these functional demands have been satisfied in
the designing of the human body, this body, then, has the

requisites of beauty. For the law of beauty requires good functioning as the basis of good design.

A horse is of symmetrical design, too, with its middle axis drawn from nose to tail. But no one looks along the nose-to-tail line in order to enjoy the horse's beauty—yet everyone enjoys this beauty, either by looking from the side or by observing the gracefully balanced forward movement. And instinctively one feels that, in this gracefully balanced forward movement, it is essential that the horse's balance line should coincide with its nose-to-tail line. In other words, it is essential that the horse should be symmetrically built for a proper balancing of its movement.

The same is true with the fish in the water and the bird in the air. Both of these creatures must be symmetrically built in order to balance their respective movements. For the same reason, the boat in the water and the airplane in the air must be symmetrically built.

Now then, as we see, "balance" is the primary idea, "symmetry" being its by-product—yet **only in those circumstances in which symmetry is essential for balance.** Naturally then, when we speak about beauty in this connection, we must speak about "beauty of balance" rather than about "beauty of symmetry."

"Beauty of symmetry," if you please!—is the insistent answer to this. For such has been the centuries-long teaching. This teaching, however, has caused much misconception, inasmuch as it has sustained the understanding that "symmetry" is an all-embracing law of beauty. Consequently, symmetry has even been imposed upon conditions that have nothing in common with this beloved symmetry. So, for example, some go so far as to say that there cannot be "design" without "symmetry."

Of course, this is a stupid theoretical imposition.

A building might have symmetry, or it might not have symmetry; it does not matter, for in either case the building can be most beautiful or it can be ugly to the utmost. In other words, symmetry or no symmetry is by no means decisive.

But no building lacking in balance can be beautiful.

If the building is lacking in balance, it is lacking in that most essential property which might make it beautiful. The Parthenon has both symmetry and balance. That exquisite Erechtheion has a perfect balance, whereas symmetry would have deprived it of much of its intimate charm. And surely, symmetry would have meant a complete destruction of beauty in the case of Mont Saint Michel with its superbly-balanced building masses.

Now then, what about Vitruvius with his imperative omnipotence of symmetry?

Well:

Let's not blame Vitruvius too much. After all, how do we know what significance Vitruvius put into that word "symmetry." He might have meant "balance"; or perhaps "rhythm" or "eurhythmy"; or perhaps he meant what we call "organic order." Surely, in the long run, many words of the spoken language are apt to change their meaning.

But whatever Vitruvius meant, the cold fact remains that, because of his influence, symmetry has dominated architectural design for centuries; symmetry has been regarded as the indispensable criterion of beauty in all design—building design or otherwise; symmetry has been implanted in the minds of generation after generation of students of architecture as something to follow if their aim is to achieve architecture of distinction. And so, during the long course of many centuries, this advice has been followed almost literally. It has been followed, not only insofar as individual buildings are concerned, but even in large town-planning layouts.

And no wonder!

Symmetry is really easy to achieve. **One takes a middle axis and puts some stuff on one side of this middle axis, then reverses the same stuff on the other side of the middle axis —and there it is: "beauty of sterility."**

On the other hand, to be sensitive to balance is to be sensitive to the living quality of beauty—**which is not quite as easy.**

It is just this living quality which must by all means be

preserved, no matter whether it concerns beauty in general or art in general.

Symmetry is not always in agreement with this thought.

Therefore, although we have dealt quite lengthily with symmetry, we have not done so because symmetry, as such, deserves all this attention. We have done so, primarily, because symmetry—when it is by theoretical command imposed upon form—is apt to sterilize the living quality of form, and consequently of beauty as well. And because the influence of symmetry has prevailed for so long a period of time and has become so widely spread, the understanding of beauty has suffered correspondingly. Naturally, this has caused decline of the concept of beauty as to its living quality. And so, as said, even the fake form is often considered beautiful.

Symmetry alone is not to be blamed for the decline in the understanding of beauty. There are theoretical formulas, dogmas, and doctrines of many kinds, which with all their concerted efforts are obstructive in the progress of creative and living art.

On the other hand, there are new winds blowing, and they already have blown down that adored symmetry from its formerly so dominant pedestal. There are new fronts opened in the development of form, and many of these fronts herald a restored understanding of the living qualities of beauty.

The field of art has been broadened.

Art no longer includes only a few phases of life. It embraces all of life when life is at its best.

So, for example, we speak about "art of living," about "art of thinking," about "art of eating," about "art of drinking," and so on. Couldn't we then just as well speak about **"art of everything,"** meaning that all of life should be art, and radiate beauty. For, as was said, "beauty is—or should be—the all-penetrating essence of life."

So beauty must be understood.

Beauty really should be restored to its rightful position through a proper understanding of its significance in all of

life. Indeed, the sense of beauty is an elevated feeling, pro-
vided it is made free from its aureole of vulgarity where
superficial exclamations becloud its real value; exclamations
such as "nice," "pretty," "isn't it charming," and many others
that some warm-hearted enthusiast is always eager to ejacu-
late.

* * *

PLATE 15. THE VITAL EARLY RENAISSANCE FORM
"Saint Peter Baptizing the Neophytes":
Fresco painting by Masaccio, Brancacci
Chapel, Santa Maria del Carmine, Florence

PLATE 16. THE MATURE HIGH RENAISSANCE FORM
"Entombment," painting by Michelangelo

XVII. FORM AND TASTE

TO DEBATE beauty is a delicate task. But to analyze taste is to walk on a slippery road. There hardly are two persons who fully agree on taste matters. The late Julius Meier-Graefe—the noted German critic—once related that while he was discussing art problems with two other critics one of them remarked: "Now, at least we three can agree that Greco, Cézanne, and Rubens are superior masters." Whereupon another member of the party—most likely Meier-Graefe himself, as I knew him—answered bluntly: "Yes, Greco and Cézanne; but Rubens—phuui!"

This already gives us reason for hesitation. But when so eminent an art writer as Hippolyte Taine is likened by his friend Turgenieff to a hunting-dog—most perfect in every respect, but entirely lacking in scent—the safest thing is to withdraw from the making of comments on taste, unless one can find some leading thought to follow.

It is obvious that beauty and taste cannot be separated, one from the other. Beauty is inherent in a piece of art which has been created and which must be understood and appreciated. Taste, on the other hand, is the controlling agency in the creation, understanding, and appreciation of this piece of art. In fact, in our foregoing discussion about beauty, taste was automatically there as the inevitable yet unnoticed censor as to what is what in the realm of beauty. Therefore, no phase of beauty could have been analyzed in this discussion without a simultaneous, although silently present, analysis of the corresponding phase of taste. And because of this fact, many a question on taste has already been indirectly answered in our discussion about beauty.

For example:

In this discussion it was mentioned that beauty is

sensed differently during different times, and that this holds true concerning the various eras and ramifications of civilization as well as individuals and their various stages of development. Taste is subject to corresponding shiftings. And these shiftings must be understood and judged from the same point of view as we understood and judged beauty—namely, from the point of view of both "objective criteria" and "subjective inclinations."

Now, in the case of beauty, the objective criteria must constitute the foundation of the general concept of beauty; whereas the subjective inclinations are the individual modifications of this general concept. Consequently, also in the case of taste, the same relationship between the objective criteria and the individual inclinations must exist.

For instance—to choose a rather material parallel—someone might fill his stomach with cakes and cookies, whereas I might prefer beefsteak. This, though, does not necessarily mean that I am inclined to regard beefsteak as the better of the two foods, generally speaking. No, I must have standards of judgment to go by other than personal preferences. And these standards must be based on a broad analysis of food in general.

The same holds true in art.

Renoir—to take an example at random—frequently offends my taste because of his—as I see it—sweet and bodiless brush-treatment of small pink and pistache spots, scarcely corresponding to his often so broad and bold conception of the subject-matter. This disagreement I will write down merely on account of my subjective inclination as to "pink and pistache" in certain circumstances. Otherwise I am ready—and very much so, too—to accept Renoir as an outstanding painter as judged by the standards of the present era. Perhaps—and undoubtedly—he will be so accepted also as judged by the standards of the future. In this respect it must be borne in mind that, the longer the time distance, the more clearly is one able to evaluate the bearing and non-bearing qualities of Renoir's painting. Thus, time will finally decide the real value of Renoir's contribution in the general progress of art.

Taste of history, consequently, is the supreme areopagus, comparatively speaking. Therefore, the present discriminative sharpness of taste—general and individual—must be measured according to the degree of agreement it will have with future historic discrimination. That is, the more sharply one discerns the **lasting values** of current art-development, the stronger bearing has one's taste in art judgment in general.

The lasting values of art, however, can be discerned along two different lines. First, they can be discerned on the basis of such art-products as have already passed the purgatorial judgment of history; namely, along pre-established objective standards. Second, the lasting values of art can be discerned—besides along these objective standards—through genuine instinctive sensitiveness to art in general.

Consequently, the matter of taste can be divided, generally speaking, into two main categories: **"scholastic taste,"** and **"instinctive taste."**

As for the former—"scholastic taste"—it may be said that the person capable of distinguishing the very best of historic art material is considered a person of exquisite taste. His taste has been nurtured in the world of art and art-criticism, through books and esthetic theorization; and through all this his taste—inborn or ingrafted—has been cultivated so that it can discriminate between generally accepted good art and generally considered poor art. In other words, he is a "student of art"—and thus, of taste. And he has acquired his high subjective standard of judgment in art—perhaps mainly—through generally and historically accepted objective standards of judgment.

Now, if he really is this type of student of art—one who has become accustomed to lean **mainly** upon generally and historically accepted objective standards of judgment, without any particular instinctive sensitiveness of his own—it then quite often easily happens that his very exquisite taste may become uncertain when it finds itself on the deep waters of new art concepts not yet objectively evaluated. He may be in much the same predicament as the stylist-architect who has become accustomed to lean upon mere historic styles and

then, suddenly, finds himself in a situation where these styles are no longer good. It is like someone pulling one's chair away, isn't it.

Well, we are afraid that our good "student of art" is often, and often again, in the same embarrassing predicament.

"Instinctive taste," on the other hand, must lean upon its own inner eye and discriminative judgment. Of course, instinctive taste likewise has the large material of established standards to lean upon. But, insofar as new art-movements are concerned, judgment of taste must be kept free and unbiased if one is to discern, among the steadily growing volume of contemporary art material, those values that really possess potential lastingness. Surely, in this kind of situation, taste must be based on the firm foundation of **indigenous gift.**

Continuing our analysis of taste, we must refer again to the previous discussion about beauty.

In this discussion, there were parallels drawn between man and man in order to bring to light various differences in the relationships between people of different character. These parallels were drawn—as will be remembered—so as to stress corresponding differences in the relationships between people themselves and their concepts of beauty.

As to these differences of people's character we said, "this does not mean, however, that a general tribunal in the evaluation of human standards could not exist." By no means, for we said further, "there are certain generally accepted qualities which are characteristic of the best in man."

What these qualities are, we did not mention, then.

We did not mention them, then, because our topic was beauty—and beauty is an inherent quality **in art.** Our topic now, on the other hand, is taste—and taste is an inherent quality **in man.** Here then, we think, is the proper place to take this matter under discussion.

The highest human qualities are not found in the colorless person who is indifferent, superficial, and unreliable, or

in the person who is boasting and arrogant. The highest human qualities are to be found in the person who is intelligent, sincere, sensitive, discriminative, honest, modest, and "human" in the best understanding of the word.

Analogically, the highest qualities of human art are to be found in that art into which the creative instinct has infused such qualities as correspond to the above mentioned human qualities. And, conclusively, the highest qualifications of judgment of art—taste—are to be found where the said qualities in art are accepted as the foundation of this judgment.

According to this understanding, **human culture** is made the highest tribunal in art matters. And taste becomes **cultural taste.**

As for this cultured taste, it is important to draw a distinct line between "culture" and "civilization." This means that good taste does not grow parallel with the growth of civilization, but is rooted in the finest qualities of inner cultural sensitiveness. Thus, it happens frequently—and horrifyingly frequently, at that—that a person who has reached the highest peaks of civilization—with its conveniences and glamour, wealth and power—has mentally and esthetically departed from such presuppositions as are indispensable for good taste; whereas, to go to the other extreme, it is a common experience—and very common too, for that matter—to discover that the primitive man exhibited good taste in his art and art-appreciation, in spite of the fact that taste was to him an unknown thing.

Thus, in the dial of taste the grade of culture can be read, where good taste indicates cultural strength. Poor taste, on the other hand, finds its most fertile soil in the spiritual slums of civilization, **no matter what one's social status.**

All this is clear.

And yet a few additional comments might make the matter additionally clear. So here is another story:

A lady whose prospective residence we were discussing made the remark that her husband was fond of modern

interiors, whereas she herself preferred Empire style. "You see," she added, proudly smiling, "I have better taste."

Well, it is not immediately possible from this statement to determine whether she or he had the better taste. But inasmuch as she thus put two things one against the other— contemporary design and "period" styles—and already from this drew her conclusions as to taste, her comment furnishes an excellent starting point from which to discuss taste on the basis of fundamentals. Her comment introduces two opposite modes of procedure—one mode using indigenous and creative forms for living accommodations, the other mode imposing imitative and alien forms upon these accommodations.

Thus, the old story in a new form: creation versus imitation—"taste" being now the point of verdict.

And there are many examples to cite.

The most prominent and most oft reiterated incident in this respect occurred when the Late Renaissance became dressed in Greek garments. This indicates—so one might think—that, because the Late Renaissance adopted the Greek form, seemingly these two times had the same taste. But only seemingly. For there is a broad gap of differences —and decisive ones, too—between these two tastes, in which the Greek taste represents **genuine creation**, and the Late Renaissance taste represents **unscrupulous imitation**. There cannot be the slightest doubt which of these two tastes is superior to the other.

So then, we arrive at this maxim: "taste does not mean only what we like, but also how we use what we like."

Now, I might admire a lady's dress—and if this dress really is beautiful, obviously my taste is good. But suppose I should begin to wear that beautiful dress myself, what then about my taste? Of course, this is a rather extreme case and, if really carried out, could be a comical one, too—for it just doesn't happen that men wear ladies dresses. But there are plenty of equally extreme cases—and comical ones, too—yet, curiously enough, mostly they are accepted as sheer matters-of-fact. Take, for example, a rugged "nouveau riche" surrounding himself with a cheap imitation of that

sumptuous splendor of bygone royalty. This splendor—originally and genuinely—might have exemplified excellent taste. If so, it is fully appropriate that our good "nouveau riche" should admire it—if that be his taste. But as soon as he surrounds himself with a cheap imitation of this splendor, his taste is gone, and he is a good subject for Gilbert and Sullivan.

However, it is not necessary to drag extreme cases into light in order to prove our point that the liking of something and the using of this same something are quite different insofar as taste is concerned. There are enough less extreme cases in which taste is short in the above respect, and there are more than enough similar cases where shortness of taste has instituted lasting tasteless conditions. And, surely, these lasting tasteless conditions are apt to weaken even the surest taste.

And so, we arrive at this maxim: "taste is weakened through lasting tasteless conditions."

As everyone knows, people very commonly furnish their homes with objects from strange periods. In mentioning this, we do not mean objects which are genuine and which have been inherited generation after generation within the same family. These objects constitute the family's tradition. As such, they must be understood and respected. But we do mean all those cheap imitations that are mass-manufactured and spread inappropriately into almost every home in town and in country.

To furnish homes with this kind of cheap imitation is —strangely indeed—considered good taste, in spite of the contemporary clothes people wear.

Now, may we ask, how could it be considered good taste to have two entirely different form-worlds arbitrarily mingled together? Isn't this apt to create disturbing dissonance? Surely, it is. Due to the fact, however, that people have been born and bred in this dissonance, their sense for good taste has become immunized against feeling this dissonance. Herein lies the danger.

To get rid of the dissonance, there are two ways to go: either to refurnish the home in a contemporary manner to

fit contemporary clothes—and contemporary life as well; or to wear old-fashioned clothes to fit the old-fashioned forms of the home. The first alternative is fully logical for fully obvious reasons. The second alternative—to wear old fashioned clothing—is a horrible thought, for sure. By all means, one must be dressed according to the "latest" fashion! To wear old time fashions would suggest a masquerade!

Certainly.

But why are people afraid of masquerade effects in dress, while the whole home is nothing but a masquerade. The home really is a masquerade. Yet this pageantry has gone on for so long a time that—as said—the sense for good taste has become blindfolded.

Future critics will not be blindfolded.

There will be books and books written about the decline of taste in our days. And lots of fun will be made about the copying of the various periods, the Elizabethan, the Jacobean, the Victorian, and all the Louis'; about the kings from here and the queens from there; about the royal decorations that have surrounded the simplicity of modern thought, and the latest fashions from Paris. And lots of fun will be made about the craving for that aristocratic magnitude that our beloved democracy so often brings with it.

And books and books will be written about the efforts of those who tried to restore common sense. For in its spirit —although not always in its methods and forms—the contemporary movement is a matter of clear common sense.

Well, some might say, the contemporary form is too hard, too clumsy, too unrefined. Does not good taste mean appreciation of refinement of form? Yes, indeed!—but refinement on the basis of indigenous values. Refinement of taste and refinement of mind go hand in hand. Refinement of mind is a mental process coming from within. Refinement of taste is, and must be, a similar indigenous process.

The Greek column—at its beginning—was hard, clumsy, and unrefined. But in its construction, in its logic, and in its truthfulness lay hidden its potentialities of refinement. Before the Greek column could be refined, it had to undergo

the process of evolution. Through a similar process of evolution the road is paved for the refinement of our form, too.

It is good taste—we think—**to understand and to appreciate this point.**

<p style="text-align:center">* * *</p>

XVIII. FORM AND IMAGINATION

ON THE oceanic spaces, myriads of waves appear and disappear in endless motion, and—as Lafcadio Hearn fancies—they begin to wonder about the purpose of their constant birth and extinction. They go to the Mother-ocean for information. But she replies: "Do not ask; there is no answer."

We are waves ourselves. Even we appear and disappear. And even we are wondering.

But since there is no answer, the perception of things becomes a matter of hypothetical speculation in the realm of that mysterious unknown. And because our instinct is not sharp enough to penetrate the secrets of the mystery, we are forced to picture things in our own way. Yet every nuance of life is in incessant touch with unknown things. Then so much the more does this foster our imagination. And so, eventually, we begin to use our imagination even with things we are able to discern and understand, but about which we like to speculate in an imaginative manner.

So imagination was born.

It was born ages and ages ago when the seed of wondering was put into man's mind. Since then, during the long progress of mankind, imagination has become one with man, permeating man's life and making it rich in wonders, in dreams, in hopes, in aims—and in achievements.

Thus, imagination has been one with man from his earliest existence. And this holds true, no matter whether one considers humanity as a whole or individual members of humanity.

What kind of sentiments the new-born cherishes when he first eyes his environment, nobody can determine—but undoubtedly the seed of imagination already is there. For soon, when the first fairly-tale about goblins and princesses

is told, the child's imagination is in full swing. He sees pictures of distant realms of his fancy. He begins to tell about experiences of his own, among imaginary beings. And when he plays with dolls and toys, surely they—he imagines —are living beings and real things.

And so, as life begins with imagination, so does it continue—when life is lived at its best.

Speaking about imagination, it might be in place to recall what has been previously said about the matter.

While man's apprehensive faculties were being discussed—in the chapter "Introductory Analysis"—we mentioned particularly those faculties which are most essential in the search for form; namely, the triumvirate, "intuition-instinct-imagination." Furthermore, it was mentioned that the mission of **intuition** is to establish immediate contacts with primary facts and truths; that the mission of **instinct** is to record vibrations of life and to transmute these vibrations into corresponding form; and that the mission of **imagination is to produce such mental ideas and pictures as have no relationship to previous concepts, knowledge, or experience.**

Now, these three nuances of man's apprehension—intuition, instinct, and imagination—are pretty much interwoven into one another. For this reason there cannot be drawn distinct borderlines between the three constituents of the triumvirate. But these three constituents can be distinguished through the character of their respective functions in the integral process of art-creation. And were we to venture a definition of the part played by imagination in this integral process of art-creation, we would be inclined to put it thus: **imagination is the "pioneering speculation" in and about the process of art-creation which acts to bring enlivening impulses and animation into this process.**

This "pioneering speculation"—whether consciously or subconsciously active in the creation of art—constitutes the very point at issue in our analysis of imagination. This means that—to use a concise definition—**imagination is the**

searchlight in the search for form.

Such a concise definition of imagination, however, is only indicative as to the nature of imagination, and by no means inclusive as to the broad field that imagination embraces. Really, a broad field, for—generally speaking—every human being has his share of imagination, although very unevenly distributed—in fact, frequently just a trifle.

"He has no imagination," is often said about someone, meaning that "someone" has a mere matter-of-fact mind or something close to that. The word "imagination," in such cases, does not necessarily need to signify more than some sort of an elastic attitude of mind—for "home use," if we may say so. Between this "home-use" imagination and such imagination as spans important issues of mankind, there are a great multitude of grades and ramifications as to importance, concept, inclination, character, and nuance. The spoken language already reveals this multitude of grades and ramifications, for there are a number of words that are expressive of many aspects of mental leaning that distinctly belong to the domain of imagination. Besides words such as "imagination," "imaginative," and "imaginary," we might mention words such as "fantasy," "fantastic," and "fanciful," or words such as "vision," "visionary," and "dreamy," or such as "fiction," "romance," and "humor." Et cetera.

We mention these words, not because we intend to go more deeply into individual analyses, but because we wish to emphasize the rich modulation of human tendencies insofar as imagination is concerned.

While some people—particularly those void of imagination—are eager to advocate the thought that imagination is but dealing with unrealities that have no positive application in the creation of new values, we are not in accord with such a thought. Rather, we consider such a thought a flat bit of reasoning that has no support of personal experience and which is thus of no value.

Let it so be that imagination, fundamentally speaking, is not the real instrument of creation, and let it so be that the creative instinct—as has been strictly maintained

throughout our whole analysis—is the real instrument in this respect; nevertheless, imagination is the leading star— the "searchlight"—in the pioneering for new thoughts and ideas in the process of creation. As such, imagination is of essential creative avail.

And as such, imagination is essential in any walk of life. Surely, the proprietor of even the smallest business enterprise must rub his knuckles of imagination in order to create success for his business enterprise. In the same sense, any human activity is in need of imagination to infuse creative spirit into this activity. The progress of science is led by the star of imagination—and because of this, innumerable discoveries have been made. Thanks to imagination, even the boldest speculations have been surpassed—and so, many of Jules Verne's fantastic adventures are now far behind actual progress in the field of science.

If the creative avail of imagination is thus accepted in the realm of science, so much the more then must it count in the realm of art.

It is a well-known fact that when one member of an organism is withering the whole organism is bound to suffer. So then, if in the integral triumvirate, intuition-instinct-imagination, the faculty of imagination is on the decline, this is bound to affect instinct so as to weaken its sensitiveness to vibration of life. Even so, it is bound to affect intuition so as to sever its immediate communication with fundamentals. And vice versa: if the intuitive faculty is on the decline, this is bound to affect the sensibility of instinct. And when this is so, naturally then, imagination is left alone: it is detached from its proper soil, it is doomed to become a free wanderer —a "Wandering Jew," groping for something utterly lost, or perhaps blindly craving for that arbitrarily fantastic—say, Don Quixote!

All this shows that imagination is indispensable in the creation of art. **But it is indispensable only in case it functions in harmony with the creative instinct and sucks its nourishment through intuitive channels.** If this is not the case, imagination has no creative significance. It is only a dramatic gesture; an arbitrary fancy.

Speaking still about the creative avail of imagination, it is important to bear in mind that imagination—just like intuition and instinct—originates in the deepest corners of the human soul, where nature has sown an indefinable and irresistible longing. How and when imagination originates within man, however, is beyond man himself. Perhaps the secret of this lies in those billions of not yet explored cells of the human brain, or perhaps these cells constitute only the receiving and broadcasting centers of messages from an unknown somewhere: who knows!

Anyhow, there is much room for speculation.

This speculation, to be sure, is often carried on via unimaginative short-cuts. So, for example, when it is said, "Let's sleep on this and decide tomorrow," it is believed that the freshness of the morning mind makes it a dependable adviser. Things are not as simple as that, though. For the freshness of the morning mind has less to do with the prudent conclusions that may be reached than has the silent nocturnal sensitiveness. It is the silent nocturnal sensitiveness which—unperceived by intellect—is solving the problems while intellect is not awake to disturb this sensitiveness.

In this connection it must be understood that, originally, man was a creature of intense subconscious sensitiveness, while his intellect still was in its inception. But the more man's intellect sharpened, the more his subconscious sensitiveness became subdued. Yet his subconscious sensitiveness still is there. And it is still alert enough to take its chance at any moment when intellect ceases to function—as, for example, during the hours of sleep. In other words, **those problems that are consciously deliberated during the hours of work are subconsciously digested during the hours of sleep.** And the more one is blessed with the gift of imagination, the more this kind of action and reaction between work and rest becomes true.

This kind of action and reaction between work and rest is true not only insofar as imagination is concerned. It is a general phenomenon in man's mental development. In exercising on the violin, for example, one does not grow in skill during the practice time only, but definitely also dur-

ing the leisure time between periods of diligent study. For during this leisure time the results of the diligent study become subconsciously digested.

On the physical side the same situation exists:

One does not gain in physical strength while eating the meal. One gains it afterwards while blowing cigar smoke in the air.

Although it is beyond man to know how and when imagination originates within him, nevertheless he is able to employ his imagination to suit his wishes and ambitions.

It has been said—by Schopenhauer, if our recollection holds—that there are three kinds of authors. First, there are those authors who pursue fame: they produce a book for every Christmas. Second, there are those authors who pursue money: their concern is quantitative production. And third, there are those authors who have a message to bring to humanity: they write because of an inner fire burning within them.

The same is true in any action of art-production.

In every such action, imagination is needed. And this imagination is used in accordance with the aim that causes the action. Thus, in case fame is the governing aim, the artist is easily tempted to turn his imagination into tricky things—abstruse or decorative—in order to obtain his desired fame. And in case material profit is pushed to the front—and the selling quality is of more importance than the artistic—imagination frequently indeed becomes involved in popular trivialities and blatant trumperies.

However, fame and money do not belong to our subject. Therefore, we shall simply mention that in art one should strive for neither fame nor money, but for that which is artistically best. And if one does so—both fame and money may be close at hand.

Again, as to the sincere endeavor in which imagination is to serve the best in art, there is no need of our advice. It is up to each one individually to ponder over his own problems. It is much the same as in buying a horse. One has to assure himself whether or not the animal is in proper form.

As outsiders, it is none of our business. Yet if by chance we happen to know the horse's untamable qualities, we might whisper—just casually—"Be careful with that animal, it may get wild."

As for imagination, we happen to know that the lively Pegasus most frequently gets tempestuous indeed.

So then—!

No matter how essential imagination may be in the creation of art, equally essential it is to subdue its exaggerations. In times like ours, when all the gates of form-freedom have been opened and the search for forms to come goes on everywhere, it is so much the more important to make the significance of "freedom" clear insofar as imagination is concerned. For indeed, imagination has not always been properly balanced. Often it looks as if even serious minds had lost their sense of discrimination.

It is an easy task to let one's imagination run wild and to produce such forms as never before existed. But it is a difficult thing—and one which calls for much concern—to find just those forms that are expressive of the problem at hand. Accordingly, the value of art does not depend on one's rich imagination. The value of art depends on how one's rich imagination is mastered. "In der Beschränkung zeigt sich erst der Meister," says Goethe. Freely translated, we might put it thus: "To be a master means to master one's imagination."

Imagination is not a free play of ideas, thoughts, and forms—yet it must have freedom of movement along its own course. It must be made free from rules and doctrines, except from those which constitute fundamental principles. Fundamental principles, however, fetter imagination only when the artist's creative ego is not in agreement with these fundamental principles. In case such an agreement exists, then through the strength of this agreement the artist must have the right freely to wander through the territory of his art, looking for new forms, for new modes of expression, and for new ideas in the development and enrichment of his art.

In such conditions, imagination must be flexible for any modulation of expression.

As for "moduation of expression," the spoken language can offer explanatory parallels.

When explaining a philosophical, scientific, or technical idea, the accent of interest must be put on the subject itself, and the language must be simple, direct, and logical. In a sermon, the language must be serene and elevated—not pathetically affected, as it much too often is. In a political speech the language usually is loudly oratorical. In describing an idyllic bit of scenery or a romantic episode, the language must be poetic and dramatic. And in a humoresque the language must be playful and witty. Thus expressiveness is brought into the language. And the content of the subject governs imagination, while imagination directs language into expression.

So also in art.

The problem itself is the deciding factor, and form must be modulated so as to bring the nature of the problem into expression.

Consequently—no matter how imagination is mastered —every problem has its own key which must come into expression through the solution of the problem itself. But since the problems are many and different, so must the solutions of these problems be many and different: sometimes simple and modest, sometimes vivid and playful, sometimes serene and elevated.

Andante. Vivace. Festivo.

It is up to imagination to master the modulation.

1. IMAGINATION AND HUMOR

Just as imagination is essential in the creation of art, so is it essential in the course of everyone's everyday life. For when we go more closely into the matter, we soon will discover the benediction that imagination brings to man. Those who are able to keep the sparkle of their imagination alive, fresh, and alert, make their existences fruitful and their minds

young. Young; for—psychologically speaking—man should not recognize other ages than those of mind.

As to mind, man might be born either young or old.

One frequently meets children who act like aged people. And often one meets aged people with the sparkling mind of youthfulness. The "aged child" has no interest beyond prosaic realities. He is tardy in playing, because the child-like playing is the playing of imagination—of just the very faculty he does not possess. And the "youthfully aged" looks upon life with the spectacles of imagination—and of **humor: the reconciling elixir of youthfulness.**

Sense of humor—just like imagination—is an inner eye which visualizes things in a certain mood. If humor is pure this "certain mood" then contains both humor and seriousness in balanced proportion. As such, humor is a healthy disposition of mind. And only as such shall we consider humor in our discussion—and surely not as the making of jokes or the telling of stories.

Humor is related to imagination. It is the gentle sister of imagination, acting as the expiatory fairy in the hardships of life. Humor is the recreating spice that gives life its flavor of unselfishness, helpfulness, and gladness. Humor is the levelling agency that brings immoderation of ambition into balanced humanness. Humor is a free wanderer, and as such it can deal with the loftiest beliefs and the most depraved thoughts—without hurting the former, yet helping the latter. And it concentrates its efforts to make of a man a better man, by exposing his faults and weaknesses in a humanly lenient, yet effective, manner.

Humor is the inner sunshine of mankind.

It were a mistake to deny humor its place in the creation of art. Otherwise art would not have its origin from the best of human imagination, where humor—the invigorating disposition of mind—constitutes the essence of youth.

However, opinions vary in this respect. Many seem to believe that the Greek art-form, for example, was free from humor; for—as they say—the Greek art-form in all its vari-

ous fields reached so high a level of perfection that there was no place for the degrading play of humor. We see the point. And we are willing to bargain to some extent, understanding that everything should be judged from the angle of relativity where even misjudgment frequently has its free play. Misjudgment, we say; for how could one draw his conclusions from the ultimate refinement of an art-form which had become petrified into perfection during the long period of several centuries! Shouldn't one rather draw his conclusions from the creatively impulsive conditions of an earlier date when the basic characteristics of the Greek form were shaped? As regards this, we have said somewhere that the Greek creative vitality was not at its strongest when the Greek form neared its final perfection, but rather when the Greek soul first emerged from its barbaric state and discovered the values of beauty. No doubt, this discovery caused a creative elation which served to bring the best of the time to the altars of art. And, no doubt, much of this "best" had the flavor of enlivening humor—or perhaps a refining flavor of gladness. So it must have been, for undoubtedly the Greek art-form had its origin from the same wells of spirited disposition as produced the Dionysian pageantries and the comedies of Aristophanes.

But the more the Greek art-form developed toward a definite style, the more there passed away, not only the animating flavor of humor, but likewise the flexibility of imagination. And so, finally, the Greek art-form in its further development was bound to become a constant repetition toward the perfection of previous achievements. Yet a constant repetition toward perfection was a distinct sign of the end.

Nevertheless, just at this point there is frequently committed an error of judgment as to the significance of the Greek art-form. Only the ultimate perfection of its gradual shaping is accepted, and because of this perfection the Greek art-form is called "Classical." But its expressively alive stage during the long evolution—when the Greek art-form still was young, vital, and imaginative, with its blend of humor

—is forgotten. And the conclusions are drawn accordingly. Isn't it plain?

By continuous repetition, even the best of jokes becomes old and its point of humor wears out. And finally it causes but a dry smile of politeness—and boredom.

When the Late Renaissance adopted the obsolete forms of the Classical era, the result could not possibly become otherwise than void of humor. The adopted form tried to be pleasant, of course, but its smile waned into a stereotyped simper of affected dignity.

It goes without saying that the art-forms of both the Romanesque and Gothic times had a genuine disposition of humor—often rather burlesque. As a reflection of this mediaeval disposition of humor, the Early Renaissance had a tempermental mood of its own. The Baroque moulded its forms amiably, with cornices, columns, cartouches, and putti swaying in gay rhythm. And the Rococo, with its flexual lines, swung in a gallant minuetto—just as did the gentle-people themselves.

For sure, there was good humor in all these art-forms.

Even the Neo-Romantic period tried to follow the trend. It picked up all the outworn wits of the world and used them clumsily out of time. It forgot that humor loses its point when out of tune with the situation.

And then, finally, we have the super-perfection of "Fine Arts."

Well, one almost is tempted to say that, in the ivory tower of the Fine Arts, humor in art is considered something profane—a sacrilege—by Jove, something terrible!

Today we wend our way between the old wells of exhausted witticism and the arid reasoning of the machine spirit. The old wells will gradually be drained, and new wells will be found from which can arise a humanly expressive disposition of the time. These new wells are the wells of fertilizing imagination. And from these same wells sparkles forth also enlivening humor.

Let's hope so.

For why should the form of our age necessarily be mean-

inglessly reproductive or mechanically dry? Why can't it be humanly expressive, as has been and must be form of all time?

2. IMAGINATION AND ROMANCE

The trails of imagination have many nooks, all of which cannot be scrutinized. Our short investigation of the subject, therefore, is bound to produce more or less of a generalization. Occasionally, however, imagination may take a certain specific disposition, which—being significant enough —should not be passed without notice.

By this we mean the romantic bent of imagination.

Whatever "romance," with its varied inflections, actually signifies, is a matter of personal opinion. This much, however, can be commonly agreed upon—romance is an emotional deviation from reality. Whether this deviation—considering romance in art—is of positive or negative propensity, is an open question. Yet, because we are engaged in sifting grain from chaff, there must be found an answer.

No doubt, romance, in a moderate degree, is apt to add positive richness to art. In an immoderate degree, on the other hand, the curve may easily turn to the negative. At just what point things become so exaggerated as to be considered negative, is a matter to be determined by taste. To be able to discuss the subject on a common platform, however, it is essential, first of all, to have a precise definition of the word "romance"—as it appears in art.

Now, if by romance we mean—as indicated—emotional deviation from reality, romance in art means such emotional form-expression as has not grown from real conditions of life. And since art acts on the human mood in accordance with its nature—real or unreal—we consequently arrive at the following definition: **"Romance in art means the creation of unreal mood through unreal form."**

According to this definition we are going to continue.

In this age of mechanization, romance in art has become aureoled with much discredit. And as the effort to escape

this much discredited romance is widespread, in many respects things have drifted into all kinds of inconsistencies. Many are eager to discover romantic tendencies in anything that strays from strict rationality. Even rationality itself is often considered romantic when it deviates from another rational point of view. Thus, even the most rational reasoners frequently and mutually blame one another for romanticism. And only a few seem able to escape the dreaded epithet.

Much of this kind of talk about romance is caused by the fact that logic is understood as a purely intellectual matter. Because of this understanding things often seem to be illogically—that is, romantically—carried out. Now, logic—as we have learned—does not function one-sidedly. Even the most rational mind is subordinated to his emotions. His actions, therefore, are bound often to diverge from his rational reasoning—and promptly these actions are stamped romantic. But as soon as logic is understood as a twofold manifestation of both rational and emotional leanings—properly balanced, of course—much of this chatter about romance is seen to be just chatter.

On the other hand, as soon as logic is out of balance, things are bound to be overdone in one way or another. The tendency to produce something unusual—for the mere sake of being "unusual"—easily turns things into romantic digressions. So, for example, much that is done in our mechanical age is really some kind of romance, in spite of the fact that clear reasoning seems to be the governing aim and that romantic leanings are carefully avoided. In order to avoid these leanings, forms are made simple, logical, and functional, without any emotional sentiment whatsoever. But romance does not mean unreasonable forms only. It also means dimensions that are unreasonable. Therefore, when dimensions are exaggerated beyond reasonable purpose, the so-called clear reasoning is pretty much emotional romance. The passion to erect tall and big buildings—the "tallest and the biggest in the world"—the mania for unreasonable speed, et cetera, are purely romantic manifestations: "romance of mechanization."

So then, even in the midst of this clear, practical, and mechanical age of ours—when everything seems to be weighed by a strictly thinking brain, and romance is considered unfitting sentimentalism—there still is much romance. So it goes. Man's emotions must always find an outlet.

People are different, though. Romance is not always considered an unfitting disposition—not even in our day. Nay, romance is often very much yearned for. Many seem eager to dwell in an unreal atmosphere and they try all kinds of means and methods to obtain the desired effect. Thus, any sentimental—or perhaps vainglorious—endeavor to establish an environment in a certain spirit or style which has no connection with one's life conditions or the existing time is a romantic inconsistence. For example: modern-Gothic-Cathedrals, new-old-English homes, American-French-chateaux, et cetera. Certainly, these are splendid romantic manipulations with unreal means.

Speaking about unreal means, however, it must be understood that there can be a fundamental difference between "unreal" and "unreal." The difference depends on whether the unreal means represents **emotional honesty,** or **emotional fallacy.**

It is fully obvious that an honest form, however emotionally exaggerated, is and remains honest; and, as long as this holds true, its romantic disposition is and remains on the positive side. So, for example, the tallest of the skyscrapers, if honest, is just as positive a manifestation as is the pyramid of Cheops—though they are both prominent examples of romantic megalomania. On the other hand, any romantic aim established by fallacious means—such as the above-mentioned cases of the copying of alien forms from bygone times—must be considered negative.

It is essential that a clear distinction shall be observed between honest and fallacious romance.

Let's draw a parallel!

The coldly calculating business man of today, dwelling in his pompous "Richardsonian pseudo-romanesque castle"

—with its towers and turrets and imitative trinkets—might consider himself free from romance and other sissy things; whereas his picture of the living conditions of those people who really originated the genuine Romanesque form, might be highly romantic. If these people, on their part—cold and hard warriors as they were—perchance could have been permitted to get a peep at our "man in the castle," surely they would have had a hearty laugh.

There seems to be a prevailing idea that the Romanesque time was the most romantic period in the history of man. Well, true enough, romantic castles were then built on romantic sites; the lady of the castle sat by her tower-window, spinning and dreaming with tears in her eyes and melancholy in her heart; far beneath, the troubadour sang his fiery ballads full of passion and love. The air was saturated with romance—so one would think.

But it is a complete misconception to believe that the castle was built on the "romantic" site merely in order to make the charming lady unattainable, or to keep her lover out. No, someone else had to be kept out. The time was hard. Indeed, there was not much thought of sentimental romance in the scheming and the erection of the castle. Let's grant the castle its inaccessible location, its towers and crenellations, its drawbridge and all the things that according to our conception go to make a perfect romantic setting. But the enemy, trying to force the castle—often in vain— did not think it much of a romance. He knew that every entrance, every window opening, every tower with its crenellations or whatever treatment it might have had, was placed at just the right spot to keep him out and enable the defenders to kill him if possible. No doubt, he considered the castle a perfect machine that had called for much brain work when it was schemed. Really, the castle was as functional in its design as the most functional product of today. It was utterly real as to both conception and construction. It was far from being based on sentimental romance.

Yes, the castle was real on the very site wherefrom its functional organism sprang. As an imitative product, ar-

bitrarily erected somewhere else, it would lose its true quality. As such it would represent, not only a romantic fallacy, but likewise a grave paralogism.

In spite of the obviousness of the paralogism of such and similar cases, it is amazing to note that even outstanding members of the neo-romantic era—and particularly of the post-neo-romantic one—were altogether undiscriminating in the commitment of blunders of this kind. And what is still more puzzling is that the notions of even the present practical age are quite foggy in this respect. Many people are proud of their "castles," and remain not at all conscious of the childishly naïve yet deceptive romance that they are involved in—just like our aforementioned coldly calculating businessman.

Due to emotional leanings toward romance, many are inclined to discover similar leanings in nature. A certain type of landscape is considered romantic. Nature, however, is always real and therefore cannot be romantic—if we stick to our definition of romance as the creation of "unreal mood through unreal form." One may be put into a romantic mood because a landscape is mountainous, rocky, and wild —at variance with that placid character to which one is accustomed. Therefore one considers the landscape itself "romantic." To the mountaineer, however, who is used to living with it, it is as real as it could be.

Thus, romance is a point of view.

This point of view can be applied to individuals as well as to general trends. So, for example, during the neo-romantic days, nature's romance played an essential role. A landscape—no matter how vigorous its growth and topographic variety—was not, if cultivated, regarded as fit to inspire man. It lacked in poetry. In order to be "poetic," the landscape had to be wild, cliffy, and useless for cultivation. In such a world of poetry, man should feel, think, and create. When Johann Ludwig Tieck, the great German admirer and translator of Shakespeare, left for England to see with his own eyes the wild landscape scenery that had inspired the great master, he was certainly disappointed be-

cause of the mildness of the terrain. He could not see how it was possible for Shakespeare to accomplish such great things in so unpoetic an environment—which actually was abundant with natural beauty.

This was significant of the neo-romantic concept of life.

The neo-romantic concept of life strove for unrealities, and therefore the whole movement became unreal with exaggerations. It was a rootless "romantic plant."

The neo-romantic movement was akin to its prototype, mediaeval romanticism. Both of these movements were born through a desire to dwell in an imaginary world. The difference between these two, however, is that the former— the neo-romantic movement—came into being as a counterbalance to the "Age of Reason," whereas the latter—mediaeval romanticism—emerged as a direct expression of mediaeval psychology. As such, mediaeval romanticism was inherently real, and therefore of positive birth. It came into being as hero-worship, appealing to imagination and stimulating minds to positive deeds. Mediaeval romanticism dealt with unrealities, it is true, but it conceived these unrealities as inspiring idols which could elevate minds from prosaic realities to noble thought. As such, mediaeval romanticism had its cultural mission to fulfil. And if we, after all, are going to accept romance as a positive trend in art, it must be in this elevating spirit.

Therefore, let us try another definition of romance, now in this elevating spirit, thus: **romance is the humanly emotional imagination that inspires to constructive deeds.**

When two young people are engaged—someday to be married—their combined sentiments and thoughts may have as extremes two opposite directions in which to go: either they may consider the marriage a matter of cold and practical reality; or they may exaggerate it into complete romantic unreality. Yet they have still a middle-way to go: they may dream about their coming united life as a lasting and reciprocal encouragement toward constructive action for the benefit of home, children, society, and mankind. This dream, so far, might be their romance of imagination. But

once the dream becomes fulfilled into life-long action, their dream-romance is then their real romance.

Yet, what is the difference between those two and all of the rest of us?

Haven't we too—everyone individually and all together —the opportunity of following either of two extreme and opposite roads: we may either regard life as cold materialistic reality, or we may run into exaggerated romantic unreality. For certain, we have also the opportunity to select the golden middle-way: to devote thought and action to the best for society, culture, and humanity. And if more of us were to join in a reciprocal encouragement to constructive action, so much the more would our life reflect the humanly healthy atmosphere of common spirit and collective action.

We may call it: "romance" of society—of nation—of time.

Looking through the spectacles of time upon the Egyptian era—with struggles forgotten, and art remaining—the era appears like a gigantic romance of devotion to the spirits of art. The Greek temple and the cathedral of the Goths tell their romantic tales of art in the service of man and God.

And—for that matter—the whole history of man's mythology is a long and comprehensive tale of the great romantic drama of mankind.

It is the great drama of human imagination.

3. IMAGINATION AND HUMANITY

Indeed, the history of man's mythology is a great drama where man's fears, hopes, passions, and struggles have kept imagination alert in the search for the secrets of all things.

It is a great drama—and it is prevalent:

From Greek mythological imagination—as sung by Homer—has come to us a long song of hero-worship, with heroes, demigods, and gods engaged in gallant deeds, expeditionary seafare, warfare, and romantic love-affairs. The Indian mythological imagination—as sung in the Mahabharata, Ramayana, and other epics—has given us a fantastic tale of oriental occultism about all kinds of spirits incarnated

3 1 5

into human beings and into animals, hidden in the depths of rivers and deep waters, dwelling in trees and in woods, in the soil and in the sun, and in almost everything between soil and sun. The Teutonic mythological imagination—as sung in the songs of the Niebelungen—has recorded a struggle of human passion in all of its thinkable phases. So also with the Nordic mythological imagination—as sung in the Icelandic songs of the Edda. The Finnish mythological imagination—as sung in the songs of the Kalevala—tells much of a successful fight with the weapons of art, as in the irresistible songs of Wäinämöinen and the magic craftsmanship of Ilmarinen.

And many other mythical epics, sagas, tales, legends, and ballads have been sung and told by all the peoples and all the races and all the ages.

Thus, during all the times of man's existence, man's imagination has been in constant alertness in the search for the secrets of all things. Constantly it has been in constant movement like the waves of the ocean with their constant birth and extinction—and **constant wondering.**

Because of this constant wondering, religion has been born **in the search for truth.** Because of this constant wondering, philosophy has been born **in the search for explanation.** Because of this constant wondering, science has been born **in the search for facts.** And because of this constant wondering, art has been born **in the search for form.**

It is a constant wondering, and a constant search for the secrets of all things.

And the search for these secrets goes on till it cannot go further, and must not. Because, as was said, "these secrets—insofar as man is concerned—will always belong to the realm of 'unknown.' And so they must! **For as long as they remain secret, they will remain sacred.**"

So there is nothing more to search for.

And so, consequently, even our search for form has now come to an

 E N D.

* * *

EPILOGUE

EPILOGUE

IT IS a precarious undertaking to try to forecast the nature of form-development in a time when old idols have been found irrational and new ones are in the making. Naturally, in such circumstances, viewpoints are apt to clash, and therefore a unanimous support of one's ideas cannot be had.

And, really, why should it be had!

Haven't we been disposed, during the course of our analysis, to assume that even the most logical reasoning in the drawing of conclusions has its emotional digressions and that, when so, this must hold true in the writer's case as well as in the reader's. No doubt, then, when the writer's conclusions and the reader's opinions meet one another, the reactions are bound to diverge in various ways. Those inclined toward conservatism are eager to read radical leanings in a forward way of thinking. Those carried along the wave of mechanization will stamp less mechanized propensities as old-fashioned musings. And the practical reasoner, when reading about matters beyond his matter-of-fact horizon, is ready to detect idealistic tendencies.

Yet, an analysis is an analysis. Its intent must be to discover governing laws and to render intelligible their meaning and far reaching significance. Therefore, an analysis must avoid deviations toward conservatism, radicalism, idealism, or whatever the -ism may be. And no compromises in one direction or another can be allowed. Compromises may first enter in when actual problems must be solved—on the basis of governing laws—and when possibilities are confronted with impossibilities. The proper solution, then, must be carried as far as possible. And the impossible is the compromise.

Again, as to the possibilities of carrying out ideas, it is not a novelty that one's aim must be fixed beyond the at-

tainable rather than below it, for the further one aims, the further one will go. To be sure, this is not idealism. It is just the opposite. For, idealism—in most cases—is the lulling of oneself into the complacent concept that things are running wonderfully—with the aid of some divine guidance, perhaps—so that there is no need of one's personal worry. We are advocating just the opposite thought—a realistic one, rather—that each one personally has his duty to fulfil. It is up to each one, individually, to accept this challenge. Really, to arrive at such a state of mind is already in itself an achievement. Complacent indifference, on the other hand, is an obstructing brake. Hence, each one in his turn is responsible for the course our form-development is going to take.

Having realized our obligation in this respect, we have tried to bring our share into the stack. And so we have confronted ourselves with the following question: **"What are the basic reasons for a strong or weak form?"** In order to find a valid answer to this question, we undertook this just now completed investigation. And although we have dealt at some length with manifestations in nature, our purpose has not been to analyze form-appearance beyond human art. We have referred to nature as merely a trustworthy adviser with regard to those universal principles which are imperative in any art, natural as well as human.

Because our analysis, thus, is predominantly an investigation of fundamental principles, its strength or weakness must be judged accordingly. Also, if divergences of opinion arise, they must arise primarily from the point of view of these principles. In this respect, as said, it is not, and must not be, the main idea that one's opinions should be accepted by others, but that these opinions, on their part, might contribute to the general search for form.

1. MAN, THE STAGE-MANAGER

We have advocated that **the answer to all the problems of human art must be found in man himself: man is the stage-manager.** Accordingly, during the progress of our analytical

performance, while form was acting on the stage, man himself was managing the play behind the scenes. However, in any performance, when the play has come to an end it is a proper thing to call in also the manager.

So even now.

Therefore—as our "form-play" has come to an end—it remains to express our approval or disapproval of man's part in this play. In other words, it remains to examine man's attitude toward the fundamental principles of form: **as to how he has learned to understand these fundamental principles, how he has learned to obey them, and how he has educated others to understand and to appreciate them.**

a. The Dogmatic Mind

Due to the creative nature of art, it is self-evident that we could not arrive at a common platform with the inveterate stylist who tries to maintain form-development on a basis of adopted alien doctrines. It would have been like abandoning a sincere search for form. To have accepted such a **dogmatic** point of view would have meant throwing overboard our conviction of the necessity of a creative progress in art—a progress which is the significant sign of vitality in all other walks of life. To have accepted such a **stylistic** point of view would have meant continuing along the easy road of imitation of existing forms, instead of creating new ones. To have accepted such a **stagnant** point of view, indeed, would have put us into the position of the Italian plaster-caster who keeps selling, again and again, reproduced casts of ever the same "putti," "bambini," and such like. And if we should have turned our investigation to defend such a position, we would have been much the same—in attitude and action—as the lawyer to whom law is superior to right, and who—due to such a dogmatic attitude—is disposed to accept something obviously unethical rather than to advocate the changing of antiquated stipulations to meet ethical demands. In other words, to defend such a position would have made our analysis fundamentally untenable, and our investigation of no value.

As regards these style-bound tendencies, however, by no means has it been our purpose to fight them. We have used them merely as the warning background in order to explain how things must be done henceforth. We are certain that these styles are obsolete forms from yesterday. And although in many quarters they still linger as the very thing, to be sure, they are but like **the dwindling sound of a swansong.**

Again, as to such styles, "isms," and fads, as frequently grow from the midst of contemporary trends, our attitude has been much the same as it has been toward styles in general. These styles—"fashions" is a word more to the point—do not come into being through direct creation. For the most part, they are the products of intentional and artificial pursuit of style where reciprocal admiration plays the major role. Naturally, one could not have arrived at an agreement with such an "ismic" attitude of mind, particularly in an analytic deliberation wherein the creative point has been so thoroughly emphasized as one of the cornerstones of art.

Creative style cannot be intentionally and artificially produced. Creative style—as we have said—"evolves on the basis of the fundamental form in a direction that nobody knows, but that everyone is compelled to follow." Only thus does style become genuinely expressive. Only thus does style have cultural significance. And **only thus have we accepted style-manifestation in our analysis.**

b. The Mechanized Mind

Just as we found it impossible to arrive at a common understanding with the inveterate stylist, so do we find it impossible to come to an agreement with his antithesis—the machine maniac.

Certainly, we are not against machines and machine-made products in themselves—**by no means.** But we are not in agreement when the machine so affects the weak spots of someone as to make him a machine-maniac—just as we are not in agreement when people **go crazy** about stamp-

collecting and bridge playing, notwithstanding that we have nothing against stamps and cards in themselves.

Of course, we are aware that the machine belongs to our time, and that the present and following generations will be mentally mechanized—to a great extent, at least. Yet we do not regret this, for we know that thanks to such a trend the present dogmatic disposition of mind will pass through a wholesome purging process, and a new disposition of mind will be born. And should it happen that the new disposition of mind may be mechanized, this will not be a lasting state of things; for undoubtedly, mechanization of mind will turn—when the time is ripe—into humanization of the mechanized mind. Form is bound to follow the same metamorphosis. And then, let us hope, the experiences of the machine age—having purged form of its previous dogmatically stylistic state—will be helpful in the development of the creative form of the humanized post-machine age—with a multitude of machines, but less of machine-mania. Therefore, in the search for form, this search must be directed with a humanized quality of form as the goal. In the meantime, however, the present trend to mechanization must be accepted—provided, of course, it is balanced. But as soon as the trend may incline toward exaggeration, man's mind will be brought from its logical course. Or—who knows—such an exaggeration might be only a casual agitation that is relatively easy to cure. Or—perhaps—it will pass off of its own accord as its own reaction against its own exaltation. So really there is no reason for worry.

The source of machine-enthusiasm is to be found in the great achievements of our age, where the production of machines and machine made things has a truly prominent place. All this has the background of science and human intellect, and thus it is a cultural achievement, for sure. It is creation. But it is creation only insofar as invention and materialization of invention are concerned. And this invention is concentrated only in those minds and brains which have invented and materialized the machines. From then on, however, the machine is put into mechanical motion—and man becomes a mere tool wherewith to control

the monotonous running of the machine.

Now, what is the effect of all this on the human mind?

Well, the machine-enthusiast reasons thus: the machine must do the work—the more the better—so that man can have that much more leisure-time for his cultural development. This sounds good and valid. And we wish it were true. But it is not. The machine-enthusiast forgets that the proper use of leisure-time is a difficult art—one that only relatively few are able to practice. And even those few have learned its practice primarily by maintaining a creative spirit in their work during the hours of non-leisure. That is, **only when man is using his brain, his mind, and his interest in his work—thus infusing individuality, initiative, and creative spirit into this work is he able to use his brain, his mind, and his interest during the time of leisure—thus infusing individuality, initiative, and creative spirit into it.** The monotonous running of the machine, on the other hand, introduces non-creative indifference. Consequently, it is apt to turn man's mind toward non-creative functioning. And for this very reason, man's leisure time is spent, rather commonly, in shallow divertisement—which is not only the killing of time, but even the **killing of mind.**

c. The Creative Mind

The pre-machine man—of whatever vocation in which brain had to initiate any action of hand—was compelled to create, in one way or another. And once the spirit of creation was infused into action, this same spirit of creation prevailed even beyond the actual work to be done. Thus—metaphorically speaking—during the hours of relaxation, when the pipe was lit and smoke curled slowly toward the ceiling, thought followed this curling, and ideas were born. There was philosophy in the air. And if it did not always ponder over the deepest depths of all things, at any rate it was founded on the deepest secret of all philosophical thinking —common sense. Those who have experienced this—or something similar—know that there was produced thus more initial thought than is frequently the case in circles

where work is considered debasingly unfashionable, and where time is spent in platitude and unfertile entertainment.

Thus, creation during the time of work is the key to creative growth of mind. And abstraction from creative work is mental sterilization. As long as man is compelled to find his own ways, his mind is bound to become inventive. So the seed of creation is planted. And through work the seed grows.

But as soon as man is able to get along through the inventiveness of others, his mind is bound to become unfertile. So the seed of imitation—the leaning upon the work of others—is planted. And due to such easy living the seed of imitation grows.

Here is to be found the secret in the fact that folk-art always is—or rather, was—creative. Really, folk-art did not grow from the work for daily livelihood, but—because of the creative nature of this work—from the longing for creation even during the time of leisure. It grew from inner drift for inner satisfaction.

As long as this was the case, folk-art was creatively strong.

Again, as soon as folk-art ceased to be an expression of inner drift for inner satisfaction, and became instead mercantile production of toys and souvenirs, it lost its creative strength and became worthless imitation. When this happened, folk-art did not grow any longer out of a desire for creation and for an art-form to live with. It became a source of material profit. And the "art-form" we live with is now imported from the centers of manufacturing toys and souvenirs, and consists—alas!—to a large extent of the most tasteless stuff that man and machine—in cooperative imitation—are able to produce.

This was the downfall of folk-art.

The formerly so exquisite Western Indian art has now become worthless imitation offered for sale at the crossroads of pleasure travel. In the same manner, worthless imitation has spread to almost every place where folk-art was once creatively strong.

Primarily, all this was a change in mind.

But this change in mind—**from appreciation of creative art into acceptance of imitative art**—was not confined to folk-art only. In all fields of art, man's mind shifted steadily but decidedly along the same downbound course. The first blow came through the dogmatic sterilization of form. The second blow came through the industrialization of this dogmatically sterilized form.

It was a general degeneration of mind in the appreciation of creative art. It was a general degeneration of taste, as well.

True enough, during the post-nineteen-hundred era, there has been a sincere trend to regeneration of mind toward better appreciation of creative art—and thus toward sounder taste as well. Much has been gained in this respect. For sure, much more will be gained, as time goes on. But in the long course of things, **some of the finest threads within man have been broken.**

These threads are those that tend to keep man close **to the creative values of life.** And indeed, **to renew these threads will involve a long and slow process of mental readjustment.**

2. ART EDUCATION

To keep man close to **the creative values of life,** does not seem to be currently held in high esteem. Our modern civilization is too often eager to break the creative relationship between man and life, almost in the cradle. Indeed, though we are trying to make man the best of men, often we do not seem to know what the "best" is. In one way or another we have become purblind so that we cannot discern the finest human values—quite likely because some of the finest human values have been lost in ourselves.

This is very widely true in the field of education.

In education, the sense of creation and the eagerness to create—so genuinely alive in the child's mind—are confronted with a rigid system of preconceived educational ideas which restrict individual development. Surely, this

is a fundamental disadvantage to the child. Therefore— although education is outside our main subject, and we do not consider ourselves experts in educational cookery—we shall dip our finger into the soup, just a little. To begin with, we wish to intimate that there are not—**and must not be**—essential differences between general education and art-education, insofar as creative trends versus routine aping is concerned. Yet this is an important point, according to which any educational method must be accepted, criticized —**or rejected.**

Frequently indeed, education seems to be more concerned with smart brains than with good characters. In other words, education tries to further scholarly knowledge rather than living wisdom of mind. It consists of the teaching of facts, and of the periodic examination of those to whom these facts have been taught. That is to say, the pupil is like an empty sack, to be filled during the school year with all kinds of stuff. And then, at the end of the school year, the sack is to be opened to find whether or not that stuff is still there. If it be there—no more, no less—the pupil is recorded as excellent. And he will be sent to college for further stuffing.

Well, that's what it is, or—has been.

And it happens from the very start.

When the child is first brought to the children's school, he has freedom to ask things, to do things, and to make use of his vivid curiosity. He really does ask this and that. He really does all kinds of things with excitement and interest. He really uses his childlike imagination with creative vigor. He really has that "little spark of genius."

The child's actions are individually characteristic and direct, and he is considered childishly naïve. Yet, this childish naïvete is considered a passing stage, in the conviction that when he becomes more mature the child will do things more correctly and express himself more exactly. And so the child's education begins in the direction of generally accepted correctness and exactness, to be acquired by means and methods of outworn school-books and other trite things. Each child must be moulded just the same as must be

moulded the others. And he must memorize the same facts as must memorize the others.

Poor little soul! Why not nurture that "little spark of genius" by continuing the child's education during the whole school period in the same individually selective spirit that the child himself so clearly indicates? Why treat everyone just the same, regardless of inclination and interest? Why make school work a matter of mass-production, year after year, in which the main concern is the happy pride of passed examination—and college entry—instead of education toward inner mental growth? Education must not mean the amassing of stereotyped book-knowledge, but rather the guiding of mind toward living wisdom, so that the pupil will not only imbibe knowledge with eagerness but also digest this knowledge and make it fertile. As regards this, the reciprocal training of both mind and hand—concept and creation, thought and action—is not only the best method but even the only one. For, as said, "creation during the time of work is the key to creative growth of mind." Thus, by educating minds to find their own ways, we educate minds toward constructive growth.

Contrary to this, the usual pumping-in of always the same facts, and the encumbering with standardized rules, commonplace directives, and what not (everything must be done just the same as everyone does it everywhere, and so on) is the safest way to kill the sense of creation—that "little spark of genius."

This, surely, is not education. It is just routine teaching.

After this mild side-blow at the routine teacher, let us now return to our own field—to art—in order to learn how educational matters have been managed there.

To begin with, let us bear in mind that the approach to art education must be examined from two different points of view: first, to educate the layman in the understanding and appreciation of art, and second, to educate the artist in the creation of art. The former constitutes the demand. The latter must take care of the supply. Naturally, in nor-

mal conditions, these two sides must be adequately balanced so that vital demand keeps production alert. In this balancing, the mission of art education is to raise both demand and production toward **"quality."**

Well, at this very point of "quality" we face two contrasting ways of looking upon things.

As ever so often stressed, art is considered, on the one hand, a direct expression of life embracing all the fields of human activity; whereas, on the other hand, art is considered something for its own sake and restricted to a few fields only. In the former case, art grows with its roots in life. In the latter case, art must feed upon its own excellence—having no roots in life through which to suck vitality.

Self-evidently, then, art education—considering both the layman and the artist—must be differently instituted in these two cases. And they must be separately investigated as to both methods and results.

a. *Creative Learning*

It is easy to realize that in the case of genuine creation, where art grows with its roots in life, understanding and appreciation of art is a rather simple thing to achieve.

There really is nothing to do about it:

Art grows from the conditions of life that the people themselves have brought about. Art expresses the needs of the people, their aims and longings—just those very thoughts and feelings without which their lives would hardly be worth living. Consequently, it would not do much good to send all the art-teachers and lecturers of the world to the Hungarian village in order to make its people understand and appreciate their own folk-art. It would be much the same as to persuade, impel, and urge the thirsty to have a drink. For surely, once a genuine demand is there, the action is also there—and so is even the understanding and appreciation of the action.

In the mediaeval case, for example, everyone—without any art-school certificate whatsoever—felt that any object, however simple, belonged to the same form-family as did the

elaborate cathedral of the town. Everyone felt that whatever was needed for the proper running of life—material as well as spiritual—was made both because of the need and in accordance with the prevailing form-language of the time. And everyone felt that this was just as natural a thing as to speak one's mother tongue in the family circle. Everyone felt this, simply because form development was logical. And the commonly felt logic which joined life and its interpretation into art prepared the soil for form to grow further. Thus, form grew with deep roots in the soil. Form grew, expressing the demands of life, all along the scale from the tiniest commonplace object up to the highest peaks of the highest ambitions. Form grew with all its phases expressed in the same tongue—just as the honest melody of the cradle-song contains the fundamental characteristics and sentiments of the loftiest symphony of the time. So form grew. And there was no need for artificial form-nurseries, educational factories, appreciation lecturers, or any things of that sort whatsoever.

Demand for art brought forth the artist. Demand instituted the studios, workshops, and the many sided activities about the large building sites themselves. In these studios and workshops, art was developed in almost all of its fields. In these studios and workshops, the master-artists were active with their commissions. And here, young men, eager to learn and to work under good leadership, were gathered as apprentices. Here they ground color, they forged iron, they carved stone and wood. And during these pursuits they observed the work of the master. In this manner they absorbed knowledge of technical processes, of material treatment, and of construction methods. They imbibed the spirit of form-expression of the age. And they grew in sensitiveness to form and in skill of execution.

In these circumstances there were no sterile dogmas to hamper the freedom of direct creation. Nor was there "teaching"—for **art cannot be taught, it must be learned.** So they felt, and they acted accordingly. Style-form in the making—in the midst of which they lived, and the atmosphere of which they breathed—was the inspirer and instruc-

tor in their work. **Art itself was the great educator in the understanding, in the appreciation, and in the creation of indigenous and true art.**

So was art education constituted during the Middle Ages.

But this mode of art education was not confined to the Middle Ages alone. The same mode was employed by the Egyptians, the Greeks, the Romans, and indeed generally **by all times and under all circumstances where art development has resulted in genuine and creative form.**

In fact, this mode of art education must be considered the **fundamental** mode of art education.

It is the mode of art education, **where a subsequent transference of creative impetus and technical ingenuity takes place from one generation to the following generation; where education is carried through the execution and demonstration of actual work in all the fields of art; and where, through the progress of this mode of art education, the style-form of the time gradually comes into being.**

It is the mode of art education which might be best called **"creative learning."**

b. *Dogmatic Teaching*

If we compare now this "creative learning" with that mode of art education which has come down to us through previous generations, we will find fundamental differences between them. The most conspicuous of these differences lies in the fact that, whereas "creative learning" is based on an indigenous and creative quality of art, the prevailing mode of art education is based—regrettably enough—on an inherited reproductive concept of art from foregone centuries. And because this inherited reproductive concept—imitative of something else, as it is—has but weak roots in the soil of existing life, the prevailing mode of art education must to a great extent be dogmatic teaching based on doctrines and formulas derived from the said reproductive concept itself. In other words, the prevailing mode of art education is far

331

from "creative learning." It is bound to be—as we may call it—dogmatic teaching.

From the point of view of this "dogmatic teaching," we must now ransack the prevailing mode of art education.

But before we can do so, we must first examine the inherited reproductive concept itself, as to its fitness for educational material. Such an examination may serve well as the background against which to project "dogmatic teaching."

1. Background of Dogmatic Teaching

When we were discussing the Late Renaissance imitative adventure, we mentioned something to the effect that "the gnawing worms of imitation gradually brought the roots of form to wither—when the time was ripe during the nineteenth century." In other words, the relationship between life and art was doomed to become increasingly vague.

It is true enough that during a rather long stretch of time there were considerable efforts to match the adopted form with contemporary life—which only shows that there was still a distinct purpose to bring art close to life. Later on, however, an ambitious effort to elevate art onto a higher plane—apart from life—caused an unfortunate break in this respect.

By this we mean the Fine Arts.

There is no reason now, however, for dragging this episode of the Fine Arts again into our discussion—though we might mention in passing that the said episode was a violation of the fundamental meaning of art, **which calls for an equal qualitative consideration throughout the whole world of forms.** "Nature herself," we said, "acts in this spirit, for she does not let only the big species become 'fine' examples of her art, but even the most minute cell-pattern in the most obscure of these species is made 'fine.'"

Man must act accordingly and, therefore, every piece of his art must be handled with the same care, no matter how inconspicuous. And if anything in this comprehensive world of forms should be "fine," it should by all means be

just those little everyday objects closest to man's life.

In the realm of art there must be no "little things"—just as there are no little things in general which may be overlooked. The tree cannot grow into a fine specimen unless its little seed has the same quality. And the composer cannot accomplish his masterpieces unless the fine vibrations of the simplest accord put his sentiveness into vibration. Art of man may rise to its highest heights—inconceivable perhaps to the common mind—but it is not yet art of man in a true sense unless it has its roots in the inmost core of humanity—conceivable to all. This core may be "fine." But above all it must be "true."

So one would think.

But the Fine Arts reasoning did not run that way. Hence the unhappy consequences.

Well, even the Fine Arts themselves had to swallow their share of the unhappy consequences.

Because of the exclusive attitude of the Fine Arts, of being for their "own sake," their products are demanded by only a few. Whereas art in olden times was accepted as every man's daily enjoyment—displayed as it was in public buildings, at public squares, and everywhere reachable by the common man—the rather general thought of today seems to be that only the rich man can afford to live with art—with **painting**, if you please.

In spite of such an awry attitude toward art—toward **painting**, if you please—there has developed a tremendous educational machinery for teaching to paint and to paint, and there has developed a tremendous production of painting and of painting. And all this, notwithstanding the well-known fact that there remains but an echo of demand.

There is not the slightest doubt that much of this work of the brush is sincere, honest, and excellent art. This is a fact, and so can be noted with satisfaction. Another fact remains, however—that overproduction on one hand and the lack of adequate demand on the other have tended to create an unfortunate competitive spirit, which has encouraged the introduction of insincere means—in some circles of course. Thus, in order to attract attention at the art-

market, to get publicity through the critic, and to tickle the dealer's pocketbook, artists have frequently lost honest directness in their work. And many are nervously groping for novel ways to go, often tricky and absurd.

All this is apt to make the breach between art and public so much the more broad.

However, in order to restore proper equilibrium between production and demand, the art-lecturer is summoned to do his best. It is up to him to educate the public in the understanding and appreciation of art. He does it with eagerness—and with thorough knowledge of his field, perhaps—and often the matter is pushed with such vigor upon the "ignorant" public that many are ashamed of not having enough pictures hanging around.

Now, let's ask: does this lecturing do much good?

How could it, **unless there is worth behind the words.**

The gardener cannot palm off artificial flowers as real ones by merely hawking them as living plants. His living plants, on the other hand, are bought without much talking —provided the demand is there.

Well, in the gardener's case it is easy to discern what is what. At the art-market, however, the matter might be tangled. And since there are more than plenty of artificial art-flowers, one cannot always blame the public for lack of understanding and appreciation. For sure, things have developed far from that earlier happy relationship between art and life, where art, because of its genuineness and logic, was understood and appreciated by all. For sure, there has developed a break between art and life.

It is to be regretted that there has developed a break between art and life. It is to be regretted so much the more because—as said—the public cannot be primarily blamed for the situation, but rather the artists themselves, due to their disposition toward both art and public. Oftentimes the artists are not speaking to the public in direct, clear, and honest terms. Oftentimes they are putting over upon the public something that has perhaps been put over upon themselves from some outside sources.

These outside sources may be of manifold nature. But, no doubt, the most influential has been and is the prevailing mode of art education—or rather, **dogmatic teaching**—which to a large extent has induced art production along channels such as could not prevent—but would rather encourage—an affluence of artificial "art-flowers."

This mode of dogmatic teaching, therefore, must be scrutinized as to its drawbacks.

2. Drawbacks of Dogmatic Teaching

As regards dogmatic teaching, the following three points must be borne in mind:

First, it must be borne in mind that the reproductive trend in art-development increasingly gained ground until ultimately the trend was so generally accepted as to make skilful reproduction the supreme virtue in art. Naturally, **this trend became the leading thought in art education as well.**

Secondly, it must be borne in mind that the introduction of reproductive methods in art-development caused a need for dogmatic guidance, and that in the course of time this need resulted in an abundant literature of esthetic rationalization. This abundant literature not only became the dogmatic guidance in art production in general: **it even became an essential and very decisive part of art education.**

And thirdly, it must be borne in mind that the abundant literature of esthetic rationalization brought about the **"non-creative-school-book-learned-art-teacher" to conduct art education.**

It is essential that these three points be borne in mind if one is to understand the reasons and results of dogmatic teaching.

As to the first point—the reproductive mode of art education—this must be said:

It is obvious, of course, that when reproduction—that is, imitation—is introduced into art education, one's wings of creative enthusiasm are cut short. It is much the same

as to deaden that "little spark of genius" in the children's school.

Take, for example, the case of a young mind who already in his earliest years—because of vivid imagination and inherent urge to do things—is eager to get proper guidance in art training. Yet as soon as the doors of art education are opened, he is told that nothing can be done in terms of imagination until he can draw correctly—that is to say, before he can reproduce correctly whatever he sees with his physical eye. Consequently, his imagination must for the time being be shelved until he is through the long process of training in correctness—and most likely until his aspiring imagination, because of the lack of practice in its use, has run dry.

We do not mean that a thorough training would be of no value to the art student. On the contrary, we do mean, and very decidedly so, that the artist—whether student or matured—never can be **too** familiar with his means of expression, just as we mean that a violin player can never be **too** familiar with his violin. But the training—whatever the means of expression—must be directed toward creative expressiveness rather than toward slavish reproduction. Surely, creative expressiveness must be the aim from the very start; and slavish reproduction must be avoided—that, too, from the very start.

It is true, of course, that by painstaking practice, with the model to follow, the eye becomes sharpened to see and the hand trained to do. But while both eye and hand are disciplined in this way to concentrate themselves to the correctness of the camera, one's mind has but a slight chance to penetrate beneath the physical surface. Perhaps it is assumed that one's mind can have its chance later on, once the technical skill has been perfected. But things do not work that way. Certainly, one cannot afford to let the child develop into manhood by merely giving him food and physical training, with the assumption that, once he is grown up, his mind can easily be moulded. Wouldn't this result in making him only into a wrestler with muscles of a giant and mind of a dwarf!

Architectural education has been a prominent misleader of the exact "model-to-go-by" education.

In the year 1536, Buontalenti founded the first academy of architecture, in Florence. Since then, during the long course of more than four hundred years—just think of it!—every student of architecture, from the first day of his studies, has been taught that the Greek orders are **"the"** architecture par excellence. "Learn them, their formulas, and their exact measurements, by heart," has been the quintessence of the teaching. "Take them, and use them," has been the centuries-long echo of this inducement. Thus, the first "wisdom" planted into unnumbered seeking souls has been the advice that in art it is perfectly correct to usurp things belonging to others, and that this is good ethics. Why not then—that's the moral—usurp the Greek orders. For, anything that deviates from these orders could scarcely be recommendable architecture. So it is said.

Self-evidently, such a perverse mode of education could not bear proper fruit.

No wonder, then, that past generations did not exhibit creative vitality, or that prevailing architecture has been dry imitation in millions of variations of always the same overused theme. No wonder, then, that prevailing architecture has been an imitative surface with no expressive meaning. No wonder, then, that prevailing architecture has ceased to be "creative" art, and has become only "fine" art—**thanks to the Greeks.**

Well, it might be said, every age cannot manifest creative vitality. Things go in waves, and waves have their tops and bottoms.

We grant this. But the tops can be broken by a breakwater.

To be sure, during the past four centuries, many a young architectural genius has been born with independent creative strength. But, because the insistent breakwater training has subdued his rise beyond the sanctioned stylistic concept, and because the general attitude of mind—thanks to the long-lasting stylistic concept—has prohibited such a rise, his creative strength has been turned down to play at

jig-saw puzzles by "putting together" the elements of the sanctioned stylistic concept in every conceivable way—till the last drop of meaning has been squeezed out of this style concept, originally so full of meaning.

As to the second point—dogmatic guidance—this must be said:

Buontalenti could not possibly have instituted his academy of architecture—in such a reproductive spirit as he did—unless he had dogmatic educational material to lean upon. Or, let us put it the other way: because there was dogmatic educational material at hand, Buontalenti's academy of architecture sprang into being.

And, for sure, such educational material was increasingly at hand.

The first revised Italian edition of Vitruvius' original "De Architectura" was published in Rome in the year 1486. Before that time, Alberti had already published his "De re aedificatoria." But when Vignola—in his "Regola delli cinque ordini d'architettura," of the year 1563—finally pinned down his rules of the five Greek orders, and did it so rigidly that there was hardly any escape from direct copying—and, moreover, when all architectural education became equally rigidly pinned down by these same rules—then indeed, dogmatic teaching became the sole method of architectural training—for long, long times to come.

This dogmatic teaching in architecture has since then radiated its reproductive spirit so that it has gradually permeated the mode of education in all fields of visual art. Through this mode of education, the idea has been ingrafted into growing generations that the essential thing in art is the skilful reproduction of something already existing, directly discernible to the naked eye. But since that "something already existing" was constituted according to certain governing laws, these governing laws—so was the thinking —had to be put into doctrines, formulas, and theories, by means of which to conduct art education. Thus, in the course of time there appeared an abundant literature of esthetic rationalization.

And what has happened here, in this respect.

The classical orders have been put into rigid formulas according to which to proceed. The problems of proportion and rhythm have been settled by the establishment of golden rules for everyone to follow. The matter of color has been put into scientific theories which have made instinctive sensing superfluous, if not rebelliously disturbing. The display of form and color, of light and shadow, and of heaven knows what has been regulated into diagrams of static and dynamic symmetry by which to advise and control design. The greater part of this stuff—and much more of the same sort—has been accomplished by the theorizing brain of esthetic rationalization, and not by the sensibility of the creative instinct. That is, to a large extent this dogmatic material has been developed by those who have lacked creative instinct, to rule over those who have the instinct to discern and to create. A rather backward course of things, for sure. Just **as though to have the snail dictate rules for birds to fly.**

The greatest part of this esthetic rationalization has been constituted on the basis of examples from bygone times, a procedure that entirely overlooks the fundamental fact that things are not static, but constantly changing and alive. Furthermore, all this inappropriate material has been printed and distributed in endless textbooks, for the teacher to teach and for the student to have his creative freedom cramped and be led astray. And so, the mode of art education—of dogmatic teaching, rather—has been developed from top to bottom into an immense educational institution which, generation after generation, has been driving the budding creative instinct of the young along the barren road of dogmatic reproduction.

As to the third point—the case of the "non-creative-school-book-learned-art-teacher"—this must be said:

Indeed, **the quality of leadership is the decisive point when we are scrutinizing the modes of art education.** For, suppose that the leader of art-education were not that "non-creative-school-book-learned-art-teacher," but that he was in-

stead a creative artist—**active in his field, and inspiring:**
this fact in itself would bring an entirely different atmos-
phere into art education. In such a case the creative artist
would turn the spirit of art education into art creation, and
consequently our first point—that of reproduction—would
evaporate of its own accord. Moreover, in such a case the
creative artist would turn the spirit of art education toward
living principles and away from dogmatic what-nots, and
consequently our second point—that of doctrines, formulas,
and theories—would disappear automatically. And finally,
in such a case the creative artist would turn the spirit of art
education toward personal creative experience, and conse-
quently our third point—that of the "non-creative-school-
book-learned-art-teacher"—would soon become a thing of
the past.

In other words, when the leader of art education is a
creative artist—**active in his field, and inspiring**—art educa-
tion becomes that mode of art education **where transference
of creative impetus and technical ingenuity takes place from
the leader to the student, and where education is carried on
through the execution and demonstration of actual work in
the field of art.** In fact, art education becomes close to that
mode which was general during mediaeval times as well as
during the times of all the great Civilizations.

This is the mode of art education which we previously
have considered the **fundamental** mode of art education.

And when it is so, naturally then, the position of
the "non-creative-school-book-learned-art-teacher" is **funda-
mentally** wrong.

Sooner or later this fact must be recognized.

Now, in order to arrive at a concise conclusion as to
the aforesaid, we have two definite statements to make:

First, it is important that **the prevailing mode of art
education be put under a thorough examination, so as to
discover a new and more appropriate mode through which
to offer the latent creative potentialities of growing youth
a better chance.**

And secondly, it is important that **the leadership of art**

education be put into the hands of the artist profession.

This latter point is imperative.

And—for that matter—this latter point offers the artist profession the opportunity of being in close contact with the growing youth and with all the aspiring possibilities which lie concealed beneath that veil of "something to come." We consider this fact of great importance to the artist profession, for to look toward "something to come"—particularly toward something to come from the best of human youthfulness—is apt to keep one's mind young and one's creative impulse alert.

Granted that the artist's mission is not only to produce art, but also to influence his time to better understanding and appreciation of art; it is then fully logical that the artist should turn his attention toward promising youth. For indeed, here, minds are much in the making, and therefore minds are here most receptive of the true objectives of art. For this very reason—we are sure—it would be a happy turn of events if the artist profession, more than heretofore, should become engaged in the leadership of growing youth. It would be a happy turn of events for the growing wouth. It would be so for art education in general. And, not least, it would be so for the artists themselves.

We know, of course, that much has already been accomplished in this direction, and we assume that this fact constitutes a sound indication as to the course of things. On the other hand, we know equally well that there is still a long way to go, **for eventually the artist profession must be recognized as the only qualified leadership in art education.**

Indeed, such was the situation during the great Civilization, and it was so **without exception.**

Furthermore, we know perfectly well that, generally speaking, much progress has been made in the field of art education. Therefore, while we have, in the foregoing, been rather sharp in our criticism of the dogmatic mode of art education, this does not mean that the said system is, in our estimation, going to be long-lived—particularly insofar as dogmas derived from imported styles are concerned.

On the contrary.

A moment ago, when we were referring to imported styles, it was maintained that these styles are doomed to disappear and that—as we put it—"they are but like the dwindling sound of a swan-song." The same, let us hope, is going to be the destiny also of "dogmatic teaching" in general; in fact, in many respects the said mode of art education has already given way to new modes—"progressive," or otherwise.

In the last analysis, however, it is not the **mode** of art education which counts. The important factor is the **spirit** in which art education is conducted.

And this spirit must be **creative.**

c. *Objectives of Art Education*

At the outset of our discussion about education in general, we said this: "To begin with we wish to intimate the fact that there are not—**and must not be**—essential differences between general education and art education, insofar as creative leaning versus routine aping is concerned." On the whole, then, no matter whether one considers general education or art education, the objectives are much the same.

Now then, first: what are the objectives of general education?

Whatever the schools and teachers of general education are aiming at as they go on cramming thousands of facts into the brains of the poor boys and girls, is one thing. But —fundamentally speaking—the objectives of general education must be the development of good individuals with good characters. However, good individuals with good characters, as such, are not satisfactory unless at the same time they incline to bring about good human relations—in homes, among neighbors, in communities, and throughout the nation—whereby to achieve good social order.

In other words, the objectives of general education must be: **good individuals, good human relations,** and **good social order.**

In art education we have a corresponding situation.

Whatever the schools and art-teachers are aiming at as

they pump all kinds of dogmatic wisdom into the heads of the poor students, is one thing. But—fundamentally speaking—the objectives of art education must be the development of genuine art—and the understanding and appreciation of it. However, genuine art, as such, is not satisfactory unless at the same time it is of such quality as is apt to constitute good form-relations—in homes, in neighborhoods, in communities, and throughout the nation—whereby to achieve good form-order.

In other words, the objectives of art education must be: **genuine art, good form-relations,** and **good form-order.**

As we see, in both cases—in general education as well as in art education—the objectives must be of both individual and interrelative nature. This is perfectly in accord with our "trilogy" of fundamental principles: where the principle of "expression" represents, respectively, good individuals and genuine art; where the principle of "correlation" represents, respectively, good human relations and good form-relations; and where the principle of "organic order" represents, respectively, good social order and good form-order.

In this spirit must the objectives of both general education and art education be conceived.

A few pages back we found it important "that the prevailing mode of art education be put under a thorough examination, so as to discover a new and more appropriate mode," and furthermore, we found it likewise important "that the leadership of art education be put into the hands of the artist profession.

And now comes this matter of "objectives." Evidently, something must be done.

But how?

It is far from being our ambition to issue conclusive statements as to how to solve the problems of art education. Besides, neither is this the proper place, nor do we have sufficient space.

However, our aim is—as it has been throughout this analysis—to imprint the significance of fundamental prin-

ciples, which are imperative in any circumstance. We have done so, often and again. And for this very reason we have emphasized this also in the case of art education and its objectives. We might just as well emphasize this same fact once more—now applying these principles to the psychology of the child.

To this end, let us take a rather familiar picture from the realm of children's fancy: a group of children playing together—with sand, with stones, with blocks of wood, or with whatever there happens to be at hand—the idea being to plan and to build something of their own. Just as real people do.

Indeed, this is not a mere play. It is a matter of vivid imagination—where, no doubt, the dreaming of future deeds enters in as an inspiring spur.

Now, by psychoanalyzing, individually, the partakers of this enterprise, we might arrive at about the following: some of the children might have in their veins a sense of organizational scheming—the future planners; others might be sensitive to proportion, rhythm, form, and color—the future artists and craftsmen; some might be inventive, pro motive, or practically minded—the future scientists, engineers, manufacturers, business men, et cetera; and finally, some of the children might be ordinarily indifferent, yet acting at the moment in full swing, stirred up by the general interest. They represent average people, short of marked inclinations.

Thus, the children's play represents a miniature picture of adult activities in general.

It is sheer common sense—as well as psychologically correct—to see that in the case of these children the spirit of art education—once things have come to that stage—should be directed first to sharpen the children's respective instincts in accordance with their natural inclinations, and secondly to strengthen the cooperative tendency latent in each one of these children, by making mutual action a matter of particular interest.

To simplify the problem, let's assume that these children—as a team—should carry on with their art studies

throughout the whole school period, say, during five years or more. In addition, let's assume the following: first, that the basic idea of **elementary** art education is to offer everyone—**talented or not talented**—the opportunity to develop his or her particular leanings; second, that the individual characteristics of the children themselves make up the mental material to be considered, and that such influences as textbooks and other directives should be **strictly** kept away; and third, that the selected problems have direct connection with the children's conditions of life so as to bring into the art work a spirit of reality.

Now, as to these selected problems, it has been said repeatedly that the "room" is the most essential form-feature in civilized conditions. And it is a comprehensive form-feature, too. Here are the problems of proportion and color, of construction and material selection. And here is the problem of designing and bringing into a workable ensemble the various objects of the room, such as furniture, textiles, paintings, sculptures, ceramics, pottery, and many other things, depending on the nature of the room. In other words, in the room there lie the opportunities for many different inclinations—artistic as well as practical—to plan and to organize, to create and to correlate.

Suppose that the children's first problem were to design their own future rooms.

Indeed, such a selection would make of the educational mode a personal affair of future importance, for sooner or later everyone has to face the problem of arranging his or her place in which to live. Therefore, the problem, by its very nature, would be likely to create interest—and besides, by means of **proper psychological guidance** from the leader's side, the problem could be made so much the more appealing to the child.

However, the room is only the beginning of the big game. A group of rooms makes a home, and groups of homes make a community. In all of these problems, in a growing scale, the same approach should be applied as in the case of the room.

All this would require a long time of study, for sure.

But on the other hand, many years would pass before the final graduation. It would be a long way to go, but it would be traveled on a real road toward the realities of life. It is true, of course, that just a few years of experience could not accomplish a manifest result, for the development toward good design and taste takes place only by a slow process of mind. But the seed would have been put into the young soil for further growth. No doubt, then, after the school experiences were over, the bulk of this youthful group would be able to tell where things have gone astray, and why. They could tell why much of the decorative stuff pasted here and there is just utter nonsense; why the usual accumulation of things, arranged without discernment as to how and where, is poor taste; why pictures are so often ineptly hung, disturbing their environments and the pictures themselves; why cities are planned and built with such disorder, inviting early decay; and so forth, and so on.

So far we have considered merely the original group.

But, suppose that the above approach to **elementary** art education were to be put into function in every school and for the benefit of every child. Then, in a few more years, there would come into being a new generation of youth, grown up in the spirit of this cooperative art-educational experiment. And then, still a few more years, and this same well-trained generation of youth—now grown up —would take the running of things into its hands. Every member of every family—**relatively speaking**—would have learned in early years that there can be no good results— in rooms, in homes or in communities—unless things are logically formed, suitably correlated, and put into workable order. Morever, every citizen in every community—again, **relatively speaking**—would have become already convinced in childhood that communities cannot be successfully developed unless every citizen gives his positive support.

So much for this cooperative art-experiment with children.

Now would all this work?

Well, everyone can take this matter as relatively as it suits his fancy—but in any case, much of this relativity comes

from **the quality of leadership.** The stronger the leadership, and the more inspired it is by the problem, and the more it is able to convey this inspiration to those to be led, the better will be the result.

Indeed, **quality of leadership is the sole key to success.**

To make it plain, the foregoing discussion does not mean that we advocate a new mode of art education—at least, not in that sense in which the matter is commonly understood. Much less is it our idea to impose a specific mode of procedure upon any circumstance. In fact, we have been dealing only with the general concept of fundamentals as they could—and as we think they **should**—be implanted in young minds. In other words, we have been considering **merely the soil** which could produce strong roots, and not the plant itself which is supposed to grow from these strong roots. We consider this point the nucleus of all the educational problems in the field of art. For what is the use of putting the seed into the soil, unless the soil is made fertile for the seed to grow? Analogically, what is the use of having the young study art, unless this study— **first of all**—is made to be fertile soil in which the young-art-seed may grow roots?

And finally:

What is the use of searching for form, unless this search aims at finding a general form-feeling of the time, **which grows from a fertile soil, and through strong roots.**

3. FINALE

A few words more.

Our whole analysis is founded on this leading thought:

"Art form of man is something which is within man, which is strong when man is strong, and which declines when man declines."

Now, the sceptic might deny the validity of this, maintaining that historic facts do not support such a thought. He might insist that already at a barbaric stage—and very

much just then—art was most direct, creative, and true; whereas at a higher cultural stage—and very much just then—art became imitative. And furthermore he might insist that when art was most vital—as during the Dark Ages, when the Romanesque and Gothic forms came into being—conditions of life were very much depraved. Murders, crimes and vices of all kinds were on the daily program, and life was thoroughly demoralized even among the members of the Church—which was supposed to be the great inspirer of art in both spirit and subject-matter. Surely—so the sceptic might say—this makes it evident that creative art and its constructive influence did not have much in common with the cultural level of the times. In other words, artistically creative strength seems to be an independent happening—a high wave—which does not necessarily run parallel with the crests and hollows of general life. In this respect there is no difference between epochs and individuals —the sceptic might continue. For many of even the greatest geniuses in the field of art were morally unbalanced themselves. How, then, could human ethics and strong art be interdependent?

As to the last remark, it is far from our intention to preach that the artist should be a moralist and produce program-art of morally touching tendencies. Such a leaning is absolutely foreign to the nature of art, for the constructive value of art must be of intrinsic quality which would only be disturbed by artificial efforts. On the other hand, we are ready to admit that some of the great artists really did have the reputation of moral depravity. Well, even if they were veritable rascals, one thing is certain: **it was through their positive properties that their art was born, not through their negative ones.** And the influence of their art was, always has been, and still is, constructive—their vices gone and forgotten. Surely everyone—even the most disgustingly "perfect" person—is Janus-faced, with both good and bad.

Again as to history, the sceptic should not overlook the fact that history does not always penetrate the secrets of the human soul. With due respect to the historian, his profession is to record the facts and to draw his conclusions ac-

cordingly, but he is scarcely the detector of individually pulsing hearts. And with due respect to the reader of history, often he is apt to be only the skimmer of the surface—and indeed, the cream does not always look too good. History—looking at it through average spectacles—appears much of a gigantic performance of rulers, tyrants, statesmen, and diplomats. It is the great fireworks of wars and warriors, of tractates and secret treaties, where intrigues and speculation have frequently played a deciding role. It is a continuous drama where religions and patriotism were frequently dragged in to serve other and opposite purposes than those they really represented; where chauvinism, egotism, and human passions of every imaginable brand were brought to the stage; and where only a few conducted the play, but millions had to dance by command, whether they liked it or not. How, then, can such a play mirror the inner aims that dwelt at the bottom of the individual, of the people, of the time?

When the trumpets heralded this latest war, nations arose against nations, millions and again millions were brought to the battlefield to perform slaughter and destruction. Does this indicate that mankind was bewitched by the demons of death, eager to kill and to be cruel? Indeed not! No one wished to do harm to the other. But once brought to the battlefield, the situation was rapidly changed. One was compelled to kill and to be cruel—for the defence of one's home and country. The bravest and the best were in the firing-line and died at their posts. But the cowards and the speculators were hiding themselves, and lurking for profit.

Thus this war, having its origin in unintelligent political gambling, became the scene of tear and fear, of hate and love, of bravery and great deeds. It became the scene where man and wife, father and son, brother and sister, were separated—perhaps forever; where homes were demolished, and countries and cities wasted—**in spite of the peaceful attitude that had, a few moments previously, been the attitude of every thinking mind.**

Alas, there was much of cruelty! And the cruelties have been carefully recorded. Yet there was much of charity and revelation of the best in man. But most of this lies hidden in the depths of millions of suffering hearts, and but little of it will ever be written on the pages of history. So it was in this war. So it has been in all times. Vices have been brought into light. But most of the virtues have remained in the shadows of oblivion.

Was primitive man a mere barbarian. Certainly not! Kropotkin and many others found, in the back-yards of Asia, that primitive man was far from being so. In fact, murder and crime, lie and falsehood were unknown things to primitive man. And the Western Indians did not create their exquisite art through warfare or by collecting scalps, but through their peaceful and intimate contact with the powers of heaven who bestowed sunshine, refreshing rain, and good harvests upon the tribe.

During the whole course of the history of man—whether we happen to be considering the climax of civilization or the primitive life in the wilderness—we observe that the destructive powers acted on the stage, but that the constructive powers gathered themselves behind the scenes to preserve the human race, the cultural seed, and the potencies from which human art sucks its vitality. **The history of these potencies is written in form and color on the pages of that history which cannot lie: i.e., the great history of human art.** Here, the aims of the times and the strength of the races come into evidence. Here the sceptic may read the answer. And, if he but have eyes to see and senses to feel, indeed, his scepticism will vanish.

The sceptic may read still more.

As the cell-structure in the organism has its various stages of vitality; as the passing year has its spring, summer, and autumn; as man has his youth, manhood and old age; so also have the historic epochs their grades of growth, strength, and decay.

Therefore, the cultural strength of the times should not

be measured by the attained cultural level, but by the vitality of the development in its early course. The Greek culture was most vital when the Doric order was in the making, and not when it was ready. And the Greek vitality was on the decline with the highest accomplishments of the Corinthian form.

Form is always most vital when the search for form is youthfully intense.

Accordingly, the true search for form is a sign of youthfulness. Youth always is close to the future, for in the future it discerns its actions to come. Youth is apt to live in forward-looking spirit and to imbibe inspiration from the vital ideas it will meet along the way. Therefore, it is through the young that the coming form is to be found. And therefore, it is primarily to the young that we address our analysis of the search for form.

Again; he who fancies himself old, is old just because of this fancy. By going to the wells of youth, and by accepting its aims, its hopes, and its readiness to take progressive action in the search for forms to come, he will remain young.

For the question is not necessarily youthfulness of years; but primarily, positively, and decidedly, youthfulness of **spirit**.

* * *

SOURCES OF ILLUSTRATIONS

A CATALOG OF SELECTED
DOVER BOOKS
IN ALL FIELDS OF INTEREST

A CATALOG OF SELECTED DOVER
BOOKS IN ALL FIELDS OF INTEREST

CONCERNING THE SPIRITUAL IN ART, Wassily Kandinsky. Pioneering work by father of abstract art. Thoughts on color theory, nature of art. Analysis of earlier masters. 12 illustrations. 80pp. of text. 5⅜ × 8½.　　23411-8 Pa. $3.95

ANIMALS: 1,419 Copyright-Free Illustrations of Mammals, Birds, Fish, Insects, etc., Jim Harter (ed.). Clear wood engravings present, in extremely lifelike poses, over 1,000 species of animals. One of the most extensive pictorial sourcebooks of its kind. Captions. Index. 284pp. 9 × 12.　　23766-4 Pa. $11.95

CELTIC ART: The Methods of Construction, George Bain. Simple geometric techniques for making Celtic interlacements, spirals, Kells-type initials, animals, humans, etc. Over 500 illustrations. 160pp. 9 × 12. (USO)　　22923-8 Pa. $9.95

AN ATLAS OF ANATOMY FOR ARTISTS, Fritz Schider. Most thorough reference work on art anatomy in the world. Hundreds of illustrations, including selections from works by Vesalius, Leonardo, Goya, Ingres, Michelangelo, others. 593 illustrations. 192pp. 7⅛ × 10¼.　　20241-0 Pa. $8.95

CELTIC HAND STROKE-BY-STROKE (Irish Half-Uncial from "The Book of Kells"): An Arthur Baker Calligraphy Manual, Arthur Baker. Complete guide to creating each letter of the alphabet in distinctive Celtic manner. Covers hand position, strokes, pens, inks, paper, more. Illustrated. 48pp. 8¼ × 11.
　　24336-2 Pa. $3.95

EASY ORIGAMI, John Montroll. Charming collection of 32 projects (hat, cup, pelican, piano, swan, many more) specially designed for the novice origami hobbyist. Clearly illustrated easy-to-follow instructions insure that even beginning papercrafters will achieve successful results. 48pp. 8¼ × 11.　　27298-2 Pa. $2.95

THE COMPLETE BOOK OF BIRDHOUSE CONSTRUCTION FOR WOOD-WORKERS, Scott D. Campbell. Detailed instructions, illustrations, tables. Also data on bird habitat and instinct patterns. Bibliography. 3 tables. 63 illustrations in 15 figures. 48pp. 5¼ × 8½.　　24407-5 Pa. $1.95

BLOOMINGDALE'S ILLUSTRATED 1886 CATALOG: Fashions, Dry Goods and Housewares, Bloomingdale Brothers. Famed merchants' extremely rare catalog depicting about 1,700 products: clothing, housewares, firearms, dry goods, jewelry, more. Invaluable for dating, identifying vintage items. Also, copyright-free graphics for artists, designers. Co-published with Henry Ford Museum & Green-field Village. 160pp. 8¼ × 11.　　25780-0 Pa. $9.95

HISTORIC COSTUME IN PICTURES, Braun & Schneider. Over 1,450 costumed figures in clearly detailed engravings—from dawn of civilization to end of 19th century. Captions. Many folk costumes. 256pp. 8⅜ × 11¾.　　23150-X Pa. $11.95

STICKLEY CRAFTSMAN FURNITURE CATALOGS, Gustav Stickley and L. & J. G. Stickley. Beautiful, functional furniture in two authentic catalogs from 1910. 594 illustrations, including 277 photos, show settles, rockers, armchairs, reclining chairs, bookcases, desks, tables. 183pp. 6½ × 9¼. 23838-5 Pa. $8.95

AMERICAN LOCOMOTIVES IN HISTORIC PHOTOGRAPHS: 1858 to 1949, Ron Ziel (ed.). A rare collection of 126 meticulously detailed official photographs, called "builder portraits," of American locomotives that majestically chronicle the rise of steam locomotive power in America. Introduction. Detailed captions. xi + 129pp. 9 × 12. 27393-8 Pa. $12.95

AMERICA'S LIGHTHOUSES: An Illustrated History, Francis Ross Holland, Jr. Delightfully written, profusely illustrated fact-filled survey of over 200 American lighthouses since 1716. History, anecdotes, technological advances, more. 240pp. 8 × 10¾. 25576-X Pa. $11.95

TOWARDS A NEW ARCHITECTURE, Le Corbusier. Pioneering manifesto by founder of "International School." Technical and aesthetic theories, views of industry, economics, relation of form to function, "mass-production split" and much more. Profusely illustrated. 320pp. 6⅛ × 9¼. (USO) 25023-7 Pa. $8.95

HOW THE OTHER HALF LIVES, Jacob Riis. Famous journalistic record, exposing poverty and degradation of New York slums around 1900, by major social reformer. 100 striking and influential photographs. 233pp. 10 × 7⅞.
22012-5 Pa $10.95

FRUIT KEY AND TWIG KEY TO TREES AND SHRUBS, William M. Harlow. One of the handiest and most widely used identification aids. Fruit key covers 120 deciduous and evergreen species; twig key 160 deciduous species. Easily used. Over 300 photographs. 126pp. 5⅜ × 8½. 20511-8 Pa. $3.95

COMMON BIRD SONGS, Dr. Donald J. Borror. Songs of 60 most common U.S. birds: robins, sparrows, cardinals, bluejays, finches, more—arranged in order of increasing complexity. Up to 9 variations of songs of each species.
Cassette and manual 99911-4 $8.95

ORCHIDS AS HOUSE PLANTS, Rebecca Tyson Northen. Grow cattleyas and many other kinds of orchids—in a window, in a case, or under artificial light. 63 illustrations. 148pp. 5⅜ × 8½. 23261-1 Pa. $3.95

MONSTER MAZES, Dave Phillips. Masterful mazes at four levels of difficulty. Avoid deadly perils and evil creatures to find magical treasures. Solutions for all 32 exciting illustrated puzzles. 48pp. 8¼ × 11. 26005-4 Pa. $2.95

MOZART'S DON GIOVANNI (DOVER OPERA LIBRETTO SERIES), Wolfgang Amadeus Mozart. Introduced and translated by Ellen H. Bleiler. Standard Italian libretto, with complete English translation. Convenient and thoroughly portable—an ideal companion for reading along with a recording or the performance itself. Introduction. List of characters. Plot summary. 121pp. 5¼ × 8½.
24944-1 Pa. $2.95

TECHNICAL MANUAL AND DICTIONARY OF CLASSICAL BALLET, Gail Grant. Defines, explains, comments on steps, movements, poses and concepts. 15-page pictorial section. Basic book for student, viewer. 127pp. 5⅜ × 8½.
21843-0 Pa. $3.95

BRASS INSTRUMENTS: Their History and Development, Anthony Baines. Authoritative, updated survey of the evolution of trumpets, trombones, bugles, cornets, French horns, tubas and other brass wind instruments. Over 140 illustrations and 48 music examples. Corrected and updated by author. New preface. Bibliography. 320pp. 5⅜ × 8½. 27574-4 Pa. $9.95

HOLLYWOOD GLAMOR PORTRAITS, John Kobal (ed.). 145 photos from 1926–49. Harlow, Gable, Bogart, Bacall; 94 stars in all. Full background on photographers, technical aspects. 160pp. 8⅜ × 11¼. 23352-9 Pa. $11.95

MAX AND MORITZ, Wilhelm Busch. Great humor classic in both German and English. Also 10 other works: "Cat and Mouse," "Plisch and Plumm," etc. 216pp. 5⅜ × 8½. 20181-3 Pa. $5.95

THE RAVEN AND OTHER FAVORITE POEMS, Edgar Allan Poe. Over 40 of the author's most memorable poems: "The Bells," "Ulalume," "Israfel," "To Helen," "The Conqueror Worm," "Eldorado," "Annabel Lee," many more. Alphabetic lists of titles and first lines. 64pp. 5³⁄₁₆ × 8¼. 26685-0 Pa. $1.00

SEVEN SCIENCE FICTION NOVELS, H. G. Wells. The standard collection of the great novels. Complete, unabridged. First Men in the Moon, Island of Dr. Moreau, War of the Worlds, Food of the Gods, Invisible Man, Time Machine, In the Days of the Comet. Total of 1,015pp. 5⅜ × 8½. (USO) 20264-X Clothbd. $29.95

AMULETS AND SUPERSTITIONS, E. A. Wallis Budge. Comprehensive discourse on origin, powers of amulets in many ancient cultures: Arab, Persian, Babylonian, Assyrian, Egyptian, Gnostic, Hebrew, Phoenician, Syriac, etc. Covers cross, swastika, crucifix, seals, rings, stones, etc. 584pp. 5⅜ × 8½. 23573-4 Pa. $12.95

RUSSIAN STORIES/PYCCKNE PACCKA3bl: A Dual-Language Book, edited by Gleb Struve. Twelve tales by such masters as Chekhov, Tolstoy, Dostoevsky, Pushkin, others. Excellent word-for-word English translations on facing pages, plus teaching and study aids, Russian/English vocabulary, biographical/critical introductions, more. 416pp. 5⅜ × 8½. 26244-8 Pa. $8.95

PHILADELPHIA THEN AND NOW: 60 Sites Photographed in the Past and Present, Kenneth Finkel and Susan Oyama. Rare photographs of City Hall, Logan Square, Independence Hall, Betsy Ross House, other landmarks juxtaposed with contemporary views. Captures changing face of historic city. Introduction. Captions. 128pp. 8¼ × 11. 25790-8 Pa. $9.95

AIA ARCHITECTURAL GUIDE TO NASSAU AND SUFFOLK COUNTIES, LONG ISLAND, The American Institute of Architects, Long Island Chapter, and the Society for the Preservation of Long Island Antiquities. Comprehensive, well-researched and generously illustrated volume brings to life over three centuries of Long Island's great architectural heritage. More than 240 photographs with authoritative, extensively detailed captions. 176pp. 8¼ × 11. 26946-9 Pa. $14.95

NORTH AMERICAN INDIAN LIFE: Customs and Traditions of 23 Tribes, Elsie Clews Parsons (ed.). 27 fictionalized essays by noted anthropologists examine religion, customs, government, additional facets of life among the Winnebago, Crow, Zuni, Eskimo, other tribes. 480pp. 6⅛ × 9¼. 27377-6 Pa. $10.95

FRANK LLOYD WRIGHT'S HOLLYHOCK HOUSE, Donald Hoffmann. Lavishly illustrated, carefully documented study of one of Wright's most controversial residential designs. Over 120 photographs, floor plans, elevations, etc. Detailed perceptive text by noted Wright scholar. Index. 128pp. 9¼ × 10¾.
27133-1 Pa. $11.95

THE MALE AND FEMALE FIGURE IN MOTION: 60 Classic Photographic Sequences, Eadweard Muybridge. 60 true-action photographs of men and women walking, running, climbing, bending, turning, etc., reproduced from rare 19th-century masterpiece. vi + 121pp. 9 × 12.
24745-7 Pa. $10.95

1001 QUESTIONS ANSWERED ABOUT THE SEASHORE, N. J. Berrill and Jacquelyn Berrill. Queries answered about dolphins, sea snails, sponges, starfish, fishes, shore birds, many others. Covers appearance, breeding, growth, feeding, much more. 305pp. 5¼ × 8¼.
23366-9 Pa. $7.95

GUIDE TO OWL WATCHING IN NORTH AMERICA, Donald S. Heintzelman. Superb guide offers complete data and descriptions of 19 species: barn owl, screech owl, snowy owl, many more. Expert coverage of owl-watching equipment, conservation, migrations and invasions, etc. Guide to observing sites. 84 illustrations. xiii + 193pp. 5⅜ × 8½.
27344-X Pa. $7.95

MEDICINAL AND OTHER USES OF NORTH AMERICAN PLANTS: A Historical Survey with Special Reference to the Eastern Indian Tribes, Charlotte Erichsen-Brown. Chronological historical citations document 500 years of usage of plants, trees, shrubs native to eastern Canada, northeastern U.S. Also complete identifying information. 343 illustrations. 544pp. 6½ × 9¼.
25951-X Pa. $12.95

STORYBOOK MAZES, Dave Phillips. 23 stories and mazes on two-page spreads: Wizard of Oz, Treasure Island, Robin Hood, etc. Solutions. 64pp. 8¼ × 11.
23628-5 Pa. $2.95

NEGRO FOLK MUSIC, U.S.A., Harold Courlander. Noted folklorist's scholarly yet readable analysis of rich and varied musical tradition. Includes authentic versions of over 40 folk songs. Valuable bibliography and discography. xi + 324pp. 5⅜ × 8½.
27350-4 Pa. $7.95

MOVIE-STAR PORTRAITS OF THE FORTIES, John Kobal (ed.). 163 glamor, studio photos of 106 stars of the 1940s: Rita Hayworth, Ava Gardner, Marlon Brando, Clark Gable, many more. 176pp. 8⅜ × 11¼.
23546-7 Pa. $10.95

BENCHLEY LOST AND FOUND, Robert Benchley. Finest humor from early 30s, about pet peeves, child psychologists, post office and others. Mostly unavailable elsewhere. 73 illustrations by Peter Arno and others. 183pp. 5⅜ × 8½.
22410-4 Pa. $5.95

YEKL and THE IMPORTED BRIDEGROOM AND OTHER STORIES OF YIDDISH NEW YORK, Abraham Cahan. Film Hester Street based on Yekl (1896). Novel, other stories among first about Jewish immigrants on N.Y.'s East Side. 240pp. 5⅜ × 8½.
22427-9 Pa. $6.95

SELECTED POEMS, Walt Whitman. Generous sampling from *Leaves of Grass*. Twenty-four poems include "I Hear America Singing," "Song of the Open Road," "I Sing the Body Electric," "When Lilacs Last in the Dooryard Bloom'd," "O Captain! My Captain!"—all reprinted from an authoritative edition. Lists of titles and first lines. 128pp. 5³⁄₁₆ × 8¼.
26878-0 Pa. $1.00

THE BEST TALES OF HOFFMANN, E. T. A. Hoffmann. 10 of Hoffmann's most important stories: "Nutcracker and the King of Mice," "The Golden Flowerpot," etc. 458pp. 5⅜ × 8½. 21793-0 Pa. $8.95

FROM FETISH TO GOD IN ANCIENT EGYPT, E. A. Wallis Budge. Rich detailed survey of Egyptian conception of "God" and gods, magic, cult of animals, Osiris, more. Also, superb English translations of hymns and legends. 240 illustrations. 545pp. 5⅜ × 8½. 25803-3 Pa. $11.95

FRENCH STORIES/CONTES FRANÇAIS: A Dual-Language Book, Wallace Fowlie. Ten stories by French masters, Voltaire to Camus: "Micromegas" by Voltaire; "The Atheist's Mass" by Balzac; "Minuet" by de Maupassant; "The Guest" by Camus, six more. Excellent English translations on facing pages. Also French-English vocabulary list, exercises, more. 352pp. 5⅜ × 8½. 26443-2 Pa. $8.95

CHICAGO AT THE TURN OF THE CENTURY IN PHOTOGRAPHS: 122 Historic Views from the Collections of the Chicago Historical Society, Larry A. Viskochil. Rare large-format prints offer detailed views of City Hall, State Street, the Loop, Hull House, Union Station, many other landmarks, circa 1904–1913. Introduction. Captions. Maps. 144pp. 9⅜ × 12¼. 24656-6 Pa. $12.95

OLD BROOKLYN IN EARLY PHOTOGRAPHS, 1865–1929, William Lee Younger. Luna Park, Gravesend race track, construction of Grand Army Plaza, moving of Hotel Brighton, etc. 157 previously unpublished photographs. 165pp. 8⅜ × 11¼. 23587-4 Pa. $13.95

THE MYTHS OF THE NORTH AMERICAN INDIANS, Lewis Spence. Rich anthology of the myths and legends of the Algonquins, Iroquois, Pawnees and Sioux, prefaced by an extensive historical and ethnological commentary. 36 illustrations. 480pp. 5⅜ × 8½. 25967-6 Pa. $8.95

AN ENCYCLOPEDIA OF BATTLES: Accounts of Over 1,560 Battles from 1479 B.C. to the Present, David Eggenberger. Essential details of every major battle in recorded history from the first battle of Megiddo in 1479 B.C. to Grenada in 1984. List of Battle Maps. New Appendix covering the years 1967–1984. Index. 99 illustrations. 544pp. 6½ × 9¼. 24913-1 Pa. $14.95

SAILING ALONE AROUND THE WORLD, Captain Joshua Slocum. First man to sail around the world, alone, in small boat. One of great feats of seamanship told in delightful manner. 67 illustrations. 294pp. 5⅜ × 8½. 20326-3 Pa. $5.95

ANARCHISM AND OTHER ESSAYS, Emma Goldman. Powerful, penetrating, prophetic essays on direct action, role of minorities, prison reform, puritan hypocrisy, violence, etc. 271pp. 5⅜ × 8½. 22484-8 Pa. $5.95

MYTHS OF THE HINDUS AND BUDDHISTS, Ananda K. Coomaraswamy and Sister Nivedita. Great stories of the epics; deeds of Krishna, Shiva, taken from puranas, Vedas, folk tales; etc. 32 illustrations. 400pp. 5⅜ × 8½. 21759-0 Pa. $9.95

BEYOND PSYCHOLOGY, Otto Rank. Fear of death, desire of immortality, nature of sexuality, social organization, creativity, according to Rankian system. 291pp. 5⅜ × 8½. 20485-5 Pa. $7.95

A THEOLOGICO-POLITICAL TREATISE, Benedict Spinoza. Also contains unfinished Political Treatise. Great classic on religious liberty, theory of government on common consent. R. Elwes translation. Total of 421pp. 5⅜ × 8½. 20249-6 Pa. $8.95

MY BONDAGE AND MY FREEDOM, Frederick Douglass. Born a slave, Douglass became outspoken force in antislavery movement. The best of Douglass' autobiographies. Graphic description of slave life. 464pp. 5⅜ × 8½. 22457-0 Pa. $8.95

FOLLOWING THE EQUATOR: A Journey Around the World, Mark Twain. Fascinating humorous account of 1897 voyage to Hawaii, Australia, India, New Zealand, etc. Ironic, bemused reports on peoples, customs, climate, flora and fauna, politics, much more. 197 illustrations. 720pp. 5⅜ × 8½. 26113-1 Pa. $15.95

THE PEOPLE CALLED SHAKERS, Edward D. Andrews. Definitive study of Shakers: origins, beliefs, practices, dances, social organization, furniture and crafts, etc. 33 illustrations. 351pp. 5⅜ × 8½. 21081-2 Pa. $8.95

THE MYTHS OF GREECE AND ROME, H. A. Guerber. A classic of mythology, generously illustrated, long prized for its simple, graphic, accurate retelling of the principal myths of Greece and Rome, and for its commentary on their origins and significance. With 64 illustrations by Michelangelo, Raphael, Titian, Rubens, Canova, Bernini and others. 480pp. 5⅜ × 8½. 27584-1 Pa. $9.95

PSYCHOLOGY OF MUSIC, Carl E. Seashore. Classic work discusses music as a medium from psychological viewpoint. Clear treatment of physical acoustics, auditory apparatus, sound perception, development of musical skills, nature of musical feeling, host of other topics. 88 figures. 408pp. 5⅜ × 8½. 21851-1 Pa. $9.95

THE PHILOSOPHY OF HISTORY, Georg W. Hegel. Great classic of Western thought develops concept that history is not chance but rational process, the evolution of freedom. 457pp. 5⅜ × 8½. 20112-0 Pa. $9.95

THE BOOK OF TEA, Kakuzo Okakura. Minor classic of the Orient: entertaining, charming explanation, interpretation of traditional Japanese culture in terms of tea ceremony. 94pp. 5⅜ × 8½. 20070-1 Pa. $2.95

LIFE IN ANCIENT EGYPT, Adolf Erman. Fullest, most thorough, detailed older account with much not in more recent books, domestic life, religion, magic, medicine, commerce, much more. Many illustrations reproduce tomb paintings, carvings, hieroglyphs, etc. 597pp. 5⅜ × 8½. 22632-8 Pa. $10.95

SUNDIALS, Their Theory and Construction, Albert Waugh. Far and away the best, most thorough coverage of ideas, mathematics concerned, types, construction, adjusting anywhere. Simple, nontechnical treatment allows even children to build several of these dials. Over 100 illustrations. 230pp. 5⅜ × 8½. 22947-5 Pa. $7.95

DYNAMICS OF FLUIDS IN POROUS MEDIA, Jacob Bear. For advanced students of ground water hydrology, soil mechanics and physics, drainage and irrigation engineering, and more. 335 illustrations. Exercises, with answers. 784pp. 6⅛ × 9¼. 65675-6 Pa. $19.95

SONGS OF EXPERIENCE: Facsimile Reproduction with 26 Plates in Full Color, William Blake. 26 full-color plates from a rare 1826 edition. Includes "The Tyger," "London," "Holy Thursday," and other poems. Printed text of poems. 48pp. 5¼ × 7.
24636-1 Pa. $4.95

OLD-TIME VIGNETTES IN FULL COLOR, Carol Belanger Grafton (ed.). Over 390 charming, often sentimental illustrations, selected from archives of Victorian graphics—pretty women posing, children playing, food, flowers, kittens and puppies, smiling cherubs, birds and butterflies, much more. All copyright-free. 48pp. 9¼ × 12¼. 27269-9 Pa. $5.95

PERSPECTIVE FOR ARTISTS, Rex Vicat Cole. Depth, perspective of sky and sea, shadows, much more, not usually covered. 391 diagrams, 81 reproductions of drawings and paintings. 279pp. 5⅝ × 8½. 22487-2 Pa. $6.95

DRAWING THE LIVING FIGURE, Joseph Sheppard. Innovative approach to artistic anatomy focuses on specifics of surface anatomy, rather than muscles and bones. Over 170 drawings of live models in front, back and side views, and in widely varying poses. Accompanying diagrams. 177 illustrations. Introduction. Index. 144pp. 8⅜ × 11¼. 26723-7 Pa. $7.95

GOTHIC AND OLD ENGLISH ALPHABETS: 100 Complete Fonts, Dan X. Solo. Add power, elegance to posters, signs, other graphics with 100 stunning copyright-free alphabets: Blackstone, Dolbey, Germania, 97 more—including many lower-case, numerals, punctuation marks. 104pp. 8⅛ × 11. 24695-7 Pa. $7.95

HOW TO DO BEADWORK, Mary White. Fundamental book on craft from simple projects to five-bead chains and woven works. 106 illustrations. 142pp. 5⅝ × 8. 20697-1 Pa. $4.95

THE BOOK OF WOOD CARVING, Charles Marshall Sayers. Finest book for beginners discusses fundamentals and offers 34 designs. "Absolutely first rate . . . well thought out and well executed."—E. J. Tangerman. 118pp. 7¾ × 10⅜. 23654-4 Pa. $5.95

ILLUSTRATED CATALOG OF CIVIL WAR MILITARY GOODS: Union Army Weapons, Insignia, Uniform Accessories, and Other Equipment, Schuyler, Hartley, and Graham. Rare, profusely illustrated 1846 catalog includes Union Army uniform and dress regulations, arms and ammunition, coats, insignia, flags, swords, rifles, etc. 226 illustrations. 160pp. 9 × 12. 24939-5 Pa. $10.95

WOMEN'S FASHIONS OF THE EARLY 1900s: An Unabridged Republication of "New York Fashions, 1909," National Cloak & Suit Co. Rare catalog of mail-order fashions documents women's and children's clothing styles shortly after the turn of the century. Captions offer full descriptions, prices. Invaluable resource for fashion, costume historians. Approximately 725 illustrations. 128pp. 8⅜ × 11¼. 27276-1 Pa. $11.95

THE 1912 AND 1915 GUSTAV STICKLEY FURNITURE CATALOGS, Gustav Stickley. With over 200 detailed illustrations and descriptions, these two catalogs are essential reading and reference materials and identification guides for Stickley furniture. Captions cite materials, dimensions and prices. 112pp. 6½ × 9¼. 26676-1 Pa. $9.95

EARLY AMERICAN LOCOMOTIVES, John H. White, Jr. Finest locomotive engravings from early 19th century: historical (1804–74), main-line (after 1870), special, foreign, etc. 147 plates. 142pp. 11⅜ × 8¼. 22772-3 Pa. $8.95

THE TALL SHIPS OF TODAY IN PHOTOGRAPHS, Frank O. Braynard. Lavishly illustrated tribute to nearly 100 majestic contemporary sailing vessels: Amerigo Vespucci, Clearwater, Constitution, Eagle, Mayflower, Sea Cloud, Victory, many more. Authoritative captions provide statistics, background on each ship. 190 black-and-white photographs and illustrations. Introduction. 128pp. 8⅜ × 11¼. 27163-3 Pa. $13.95

EARLY NINETEENTH-CENTURY CRAFTS AND TRADES, Peter Stockham (ed.). Extremely rare 1807 volume describes to youngsters the crafts and trades of the day: brickmaker, weaver, dressmaker, bookbinder, ropemaker, saddler, many more. Quaint prose, charming illustrations for each craft. 20 black-and-white line illustrations. 192pp. 4⅝ × 6. 27293-1 Pa. $4.95

VICTORIAN FASHIONS AND COSTUMES FROM HARPER'S BAZAR, 1867–1898, Stella Blum (ed.). Day costumes, evening wear, sports clothes, shoes, hats, other accessories in over 1,000 detailed engravings. 320pp. 9⅜ × 12¼.
22990-4 Pa. $13.95

GUSTAV STICKLEY, THE CRAFTSMAN, Mary Ann Smith. Superb study surveys broad scope of Stickley's achievement, especially in architecture. Design philosophy, rise and fall of the Craftsman empire, descriptions and floor plans for many Craftsman houses, more. 86 black-and-white halftones. 31 line illustrations. Introduction. 208pp. 6½ × 9¼. 27210-9 Pa. $9.95

THE LONG ISLAND RAIL ROAD IN EARLY PHOTOGRAPHS, Ron Ziel. Over 220 rare photos, informative text document origin (1844) and development of rail service on Long Island. Vintage views of early trains, locomotives, stations, passengers, crews, much more. Captions. 8⅜ × 11¾. 26301-0 Pa. $13.95

THE BOOK OF OLD SHIPS: From Egyptian Galleys to Clipper Ships, Henry B. Culver. Superb, authoritative history of sailing vessels, with 80 magnificent line illustrations. Galley, bark, caravel, longship, whaler, many more. Detailed, informative text on each vessel by noted naval historian. Introduction. 256pp. 5⅜ × 8½. 27332-6 Pa. $6.95

TEN BOOKS ON ARCHITECTURE, Vitruvius. The most important book ever written on architecture. Early Roman aesthetics, technology, classical orders, site selection, all other aspects. Morgan translation. 331pp. 5⅜ × 8½. 20645-9 Pa. $8.95

THE HUMAN FIGURE IN MOTION, Eadweard Muybridge. More than 4,500 stopped-action photos, in action series, showing undraped men, women, children jumping, lying down, throwing, sitting, wrestling, carrying, etc. 390pp. 7⅞ × 10⅝.
20204-6 Clothbd. $24.95

TREES OF THE EASTERN AND CENTRAL UNITED STATES AND CANADA, William M. Harlow. Best one-volume guide to 140 trees. Full descriptions, woodlore, range, etc. Over 600 illustrations. Handy size. 288pp. 4½ × 6⅜.
20395-6 Pa. $5.95

SONGS OF WESTERN BIRDS, Dr. Donald J. Borror. Complete song and call repertoire of 60 western species, including flycatchers, juncoes, cactus wrens, many more—includes fully illustrated booklet. Cassette and manual 99913-0 $8.95

GROWING AND USING HERBS AND SPICES, Milo Miloradovich. Versatile handbook provides all the information needed for cultivation and use of all the herbs and spices available in North America. 4 illustrations. Index. Glossary. 236pp. 5⅜ × 8½. 25058-X Pa. $5.95

BIG BOOK OF MAZES AND LABYRINTHS, Walter Shepherd. 50 mazes and labyrinths in all—classical, solid, ripple, and more—in one great volume. Perfect inexpensive puzzler for clever youngsters. Full solutions. 112pp. 8⅛ × 11.
22951-3 Pa. $3.95

PIANO TUNING, J. Cree Fischer. Clearest, best book for beginner, amateur. Simple repairs, raising dropped notes, tuning by easy method of flattened fifths. No previous skills needed. 4 illustrations. 201pp. 5⅜ × 8½. 23267-0 Pa. $5.95

A SOURCE BOOK IN THEATRICAL HISTORY, A. M. Nagler. Contemporary observers on acting, directing, make-up, costuming, stage props, machinery, scene design, from Ancient Greece to Chekhov. 611pp. 5⅜ × 8½. 20515-0 Pa. $11.95

THE COMPLETE NONSENSE OF EDWARD LEAR, Edward Lear. All nonsense limericks, zany alphabets, Owl and Pussycat, songs, nonsense botany, etc., illustrated by Lear. Total of 320pp. 5⅜ × 8½. (USO) 20167-8 Pa. $6.95

VICTORIAN PARLOUR POETRY: An Annotated Anthology, Michael R. Turner. 117 gems by Longfellow, Tennyson, Browning, many lesser-known poets. "The Village Blacksmith," "Curfew Must Not Ring Tonight," "Only a Baby Small," dozens more, often difficult to find elsewhere. Index of poets, titles, first lines. xxiii + 325pp. 5⅜ × 8¼. 27044-0 Pa. $8.95

DUBLINERS, James Joyce. Fifteen stories offer vivid, tightly focused observations of the lives of Dublin's poorer classes. At least one, "The Dead," is considered a masterpiece. Reprinted complete and unabridged from standard edition. 160pp. 5³⁄₁₆ × 8¼. 26870-5 Pa. $1.00

THE HAUNTED MONASTERY and THE CHINESE MAZE MURDERS, Robert van Gulik. Two full novels by van Gulik, set in 7th-century China, continue adventures of Judge Dee and his companions. An evil Taoist monastery, seemingly supernatural events; overgrown topiary maze hides strange crimes. 27 illustrations. 328pp. 5⅜ × 8½. 23502-5 Pa. $7.95

THE BOOK OF THE SACRED MAGIC OF ABRAMELIN THE MAGE, translated by S. MacGregor Mathers. Medieval manuscript of ceremonial magic. Basic document in Aleister Crowley, Golden Dawn groups. 268pp. 5⅜ × 8½.
23211-5 Pa. $8.95

NEW RUSSIAN-ENGLISH AND ENGLISH-RUSSIAN DICTIONARY, M. A. O'Brien. This is a remarkably handy Russian dictionary, containing a surprising amount of information, including over 70,000 entries. 366pp. 4½ × 6⅛.
20208-9 Pa. $9.95

HISTORIC HOMES OF THE AMERICAN PRESIDENTS, Second, Revised Edition, Irvin Haas. A traveler's guide to American Presidential homes, most open to the public, depicting and describing homes occupied by every American President from George Washington to George Bush. With visiting hours, admission charges, travel routes. 175 photographs. Index. 160pp. 8¼ × 11. 26751-2 Pa. $10.95

NEW YORK IN THE FORTIES, Andreas Feininger. 162 brilliant photographs by the well-known photographer, formerly with *Life* magazine. Commuters, shoppers, Times Square at night, much else from city at its peak. Captions by John von Hartz. 181pp. 9¼ × 10¾. 23585-8 Pa. $12.95

INDIAN SIGN LANGUAGE, William Tomkins. Over 525 signs developed by Sioux and other tribes. Written instructions and diagrams. Also 290 pictographs. 111pp. 6⅛ × 9¼. 22029-X Pa. $3.50

ANATOMY: A Complete Guide for Artists, Joseph Sheppard. A master of figure drawing shows artists how to render human anatomy convincingly. Over 460 illustrations. 224pp. 8⅜ × 11¼. 27279-6 Pa. $9.95

MEDIEVAL CALLIGRAPHY: Its History and Technique, Marc Drogin. Spirited history, comprehensive instruction manual covers 13 styles (ca. 4th century thru 15th). Excellent photographs; directions for duplicating medieval techniques with modern tools. 224pp. 8⅜ × 11¼. 26142-5 Pa. $11.95

DRIED FLOWERS: How to Prepare Them, Sarah Whitlock and Martha Rankin. Complete instructions on how to use silica gel, meal and borax, perlite aggregate, sand and borax, glycerine and water to create attractive permanent flower arrangements. 12 illustrations. 32pp. 5⅜ × 8½. 21802-3 Pa. $1.00

EASY-TO-MAKE BIRD FEEDERS FOR WOODWORKERS, Scott D. Campbell. Detailed, simple-to-use guide for designing, constructing, caring for and using feeders. Text, illustrations for 12 classic and contemporary designs. 96pp. 5⅜ × 8¼. 25847-5 Pa. $2.95

OLD-TIME CRAFTS AND TRADES, Peter Stockham. An 1807 book created to teach children about crafts and trades open to them as future careers. It describes in detailed, nontechnical terms 24 different occupations, among them coachmaker, gardener, hairdresser, lacemaker, shoemaker, wheelwright, copper-plate printer, milliner, trunkmaker, merchant and brewer. Finely detailed engravings illustrate each occupation. 192pp. 4⅝ × 6. 27398-9 Pa. $4.95

THE HISTORY OF UNDERCLOTHES, C. Willett Cunnington and Phyllis Cunnington. Fascinating, well-documented survey covering six centuries of English undergarments, enhanced with over 100 illustrations: 12th-century laced-up bodice, footed long drawers (1795), 19th-century bustles, 19th-century corsets for men, Victorian "bust improvers," much more. 272pp. 5⅜ × 8¼. 27124-2 Pa. $9.95

ARTS AND CRAFTS FURNITURE: The Complete Brooks Catalog of 1912, Brooks Manufacturing Co. Photos and detailed descriptions of more than 150 now very collectible furniture designs from the Arts and Crafts movement depict davenports, settees, buffets, desks, tables, chairs, bedsteads, dressers and more, all built of solid, quarter-sawed oak. Invaluable for students and enthusiasts of antiques, Americana and the decorative arts. 80pp. 6½ × 9¼. 27471-3 Pa. $7.95

HOW WE INVENTED THE AIRPLANE: An Illustrated History, Orville Wright. Fascinating firsthand account covers early experiments, construction of planes and motors, first flights, much more. Introduction and commentary by Fred C. Kelly. 76 photographs. 96pp. 8¼ × 11. 25662-6 Pa. $8.95

THE ARTS OF THE SAILOR: Knotting, Splicing and Ropework, Hervey Garrett Smith. Indispensable shipboard reference covers tools, basic knots and useful hitches; handsewing and canvas work, more. Over 100 illustrations. Delightful reading for sea lovers. 256pp. 5⅜ × 8½. 26440-8 Pa. $7.95

FRANK LLOYD WRIGHT'S FALLINGWATER: The House and Its History, Second, Revised Edition, Donald Hoffmann. A total revision—both in text and illustrations—of the standard document on Fallingwater, the boldest, most personal architectural statement of Wright's mature years, updated with valuable new material from the recently opened Frank Lloyd Wright Archives. "Fascinating"—*The New York Times.* 116 illustrations. 128pp. 9¼ × 10¾. 27430-6 Pa. $10.95

PHOTOGRAPHIC SKETCHBOOK OF THE CIVIL WAR, Alexander Gardner. 100 photos taken on field during the Civil War. Famous shots of Manassas, Harper's Ferry, Lincoln, Richmond, slave pens, etc. 244pp. 10⅝ × 8¼.
22731-6 Pa. $9.95

FIVE ACRES AND INDEPENDENCE, Maurice G. Kains. Great back-to-the-land classic explains basics of self-sufficient farming. The one book to get. 95 illustrations. 397pp. 5⅜ × 8½.
20974-1 Pa. $7.95

SONGS OF EASTERN BIRDS, Dr. Donald J. Borror. Songs and calls of 60 species most common to eastern U.S.: warblers, woodpeckers, flycatchers, thrushes, larks, many more in high-quality recording.
Cassette and manual 99912-2 $8.95

A MODERN HERBAL, Margaret Grieve. Much the fullest, most exact, most useful compilation of herbal material. Gigantic alphabetical encyclopedia, from aconite to zedoary, gives botanical information, medical properties, folklore, economic uses, much else. Indispensable to serious reader. 161 illustrations. 888pp. 6½ × 9¼. 2-vol. set. (USO)
Vol. I: 22798-7 Pa. $9.95
Vol. II: 22799-5 Pa. $9.95

HIDDEN TREASURE MAZE BOOK, Dave Phillips. Solve 34 challenging mazes accompanied by heroic tales of adventure. Evil dragons, people-eating plants, bloodthirsty giants, many more dangerous adversaries lurk at every twist and turn. 34 mazes, stories, solutions. 48pp. 8¼ × 11.
24566-7 Pa. $2.95

LETTERS OF W. A. MOZART, Wolfgang A. Mozart. Remarkable letters show bawdy wit, humor, imagination, musical insights, contemporary musical world; includes some letters from Leopold Mozart. 276pp. 5⅜ × 8½.
22859-2 Pa. $6.95

BASIC PRINCIPLES OF CLASSICAL BALLET, Agrippina Vaganova. Great Russian theoretician, teacher explains methods for teaching classical ballet. 118 illustrations. 175pp. 5⅜ × 8½.
22036-2 Pa. $4.95

THE JUMPING FROG, Mark Twain. Revenge edition. The original story of The Celebrated Jumping Frog of Calaveras County, a hapless French translation, and Twain's hilarious "retranslation" from the French. 12 illustrations. 66pp. 5⅜ × 8½.
22686-7 Pa. $3.95

BEST REMEMBERED POEMS, Martin Gardner (ed.). The 126 poems in this superb collection of 19th- and 20th-century British and American verse range from Shelley's "To a Skylark" to the impassioned "Renascence" of Edna St. Vincent Millay and to Edward Lear's whimsical "The Owl and the Pussycat." 224pp. 5⅜ × 8½.
27165-X Pa. $4.95

COMPLETE SONNETS, William Shakespeare. Over 150 exquisite poems deal with love, friendship, the tyranny of time, beauty's evanescence, death and other themes in language of remarkable power, precision and beauty. Glossary of archaic terms. 80pp. 5³⁄₁₆ × 8¼.
26686-9 Pa. $1.00

BODIES IN A BOOKSHOP, R. T. Campbell. Challenging mystery of blackmail and murder with ingenious plot and superbly drawn characters. In the best tradition of British suspense fiction. 192pp. 5⅜ × 8½.
24720-1 Pa. $5.95

THE WIT AND HUMOR OF OSCAR WILDE, Alvin Redman (ed.). More
1,000 ripostes, paradoxes, wisecracks: Work is the curse of the drinking classes; I c
resist everything except temptation; etc. 258pp. 5⅜ × 8½. 20602-5 Pa. $5.9

SHAKESPEARE LEXICON AND QUOTATION DICTIONARY, Alexander
Schmidt. Full definitions, locations, shades of meaning in every word in plays and
poems. More than 50,000 exact quotations. 1,485pp. 6½ × 9¼. 2-vol. set.
Vol. 1: 22726-X Pa. $15.95
Vol. 2: 22727-8 Pa. $15.95

SELECTED POEMS, Emily Dickinson. Over 100 best-known, best-loved poems by
one of America's foremost poets, reprinted from authoritative early editions. No
comparable edition at this price. Index of first lines. 64pp. 5³⁄₁₆ × 8¼.
26466-1 Pa. $1.00

CELEBRATED CASES OF JUDGE DEE (DEE GOONG AN), translated by
Robert van Gulik. Authentic 18th-century Chinese detective novel; Dee and
associates solve three interlocked cases. Led to van Gulik's own stories with same
characters. Extensive introduction. 9 illustrations. 237pp. 5⅜ × 8½.
23337-5 Pa. $6.95

THE MALLEUS MALEFICARUM OF KRAMER AND SPRENGER, translated
by Montague Summers. Full text of most important witchhunter's "bible," used by
both Catholics and Protestants. 278pp. 6⅛ × 10. 22802-9 Pa. $10.95

SPANISH STORIES/CUENTOS ESPAÑOLES: A Dual-Language Book, Angel
Flores (ed.). Unique format offers 13 great stories in Spanish by Cervantes, Borges,
others. Faithful English translations on facing pages. 352pp. 5⅜ × 8½.
25399-6 Pa. $8.95

THE CHICAGO WORLD'S FAIR OF 1893: A Photographic Record, Stanley
Appelbaum (ed.). 128 rare photos show 200 buildings, Beaux-Arts architecture,
Midway, original Ferris Wheel, Edison's kinetoscope, more. Architectural empha-
sis; full text. 116pp. 8¼ × 11. 23990-X Pa. $9.95

OLD QUEENS, N.Y., IN EARLY PHOTOGRAPHS, Vincent F. Seyfried and
William Asadorian. Over 160 rare photographs of Maspeth, Jamaica, Jackson
Heights, and other areas. Vintage views of DeWitt Clinton mansion, 1939 World's
Fair and more. Captions. 192pp. 8⅞ × 11. 26358-4 Pa. $12.95

CAPTURED BY THE INDIANS: 15 Firsthand Accounts, 1750–1870, Frederick
Drimmer. Astounding true historical accounts of grisly torture, bloody conflicts,
relentless pursuits, miraculous escapes and more, by people who lived to tell the
tale. 384pp. 5⅜ × 8½. 24901-8 Pa. $8.95

THE WORLD'S GREAT SPEECHES, Lewis Copeland and Lawrence W. Lamm
(eds.). Vast collection of 278 speeches of Greeks to 1970. Powerful and effective
models; unique look at history. 842pp. 5⅜ × 8½. 20468-5 Pa. $13.95

THE BOOK OF THE SWORD, Sir Richard F. Burton. Great Victorian scholar/ad-
venturer's eloquent, erudite history of the "queen of weapons"—from prehistory to
early Roman Empire. Evolution and development of early swords, variations (sabre,
broadsword, cutlass, scimitar, etc.), much more. 336pp. 6⅛ × 9¼. 25434-8 Pa. $8.95

tory of My Experiments with Truth, Mohandas K.
ies, purification, the growth of the Satyagraha
. Critical, inspiring work of the man responsible for
., 5⅜ × 8½. (USO) 24593-4 Pa. $7.95

.ND LEGENDS, T. W. Rolleston. Masterful retelling of Irish
.ies and tales. Cuchulain, King Arthur, Deirdre, the Grail, many
. paperback edition. 58 full-page illustrations. 512pp. 5⅜ × 8½.
 26507-2 Pa. $9.95

THE PRINCIPLES OF PSYCHOLOGY, William James. Famous long course
complete, unabridged. Stream of thought, time perception, memory, experimental
methods; great work decades ahead of its time. 94 figures. 1,391pp. 5⅜ × 8½. 2-vol. set.
 Vol. I: 20381-6 Pa. $12.95
 Vol. II: 20382-4 Pa. $12.95

THE WORLD AS WILL AND REPRESENTATION, Arthur Schopenhauer.
Definitive English translation of Schopenhauer's life work, correcting more than
1,000 errors, omissions in earlier translations. Translated by E. F. J. Payne. Total of
1,269pp. 5⅜ × 8½. 2-vol. set. Vol. 1: 21761-2 Pa. $11.95
 Vol. 2: 21762-0 Pa. $11.95

MAGIC AND MYSTERY IN TIBET, Madame Alexandra David-Neel. Experiences
among lamas, magicians, sages, sorcerers, Bonpa wizards. A true psychic discovery.
32 illustrations. 321pp. 5⅜ × 8½. (USO) 22682-4 Pa. $8.95

THE EGYPTIAN BOOK OF THE DEAD, E. A. Wallis Budge. Complete
reproduction of Ani's papyrus, finest ever found. Full hieroglyphic text, interlinear
transliteration, word-for-word translation, smooth translation. 533pp. 6½ × 9¼.
 21866-X Pa. $9.95

MATHEMATICS FOR THE NONMATHEMATICIAN, Morris Kline. Detailed,
college-level treatment of mathematics in cultural and historical context, with
numerous exercises. Recommended Reading Lists. Tables. Numerous figures.
641pp. 5⅜ × 8½. 24823-2 Pa. $11.95

THEORY OF WING SECTIONS: Including a Summary of Airfoil Data, Ira H.
Abbott and A. E. von Doenhoff. Concise compilation of subsonic aerodynamic
characteristics of NACA wing sections, plus description of theory. 350pp. of tables.
693pp. 5⅜ × 8½. 60586-8 Pa. $13.95

THE RIME OF THE ANCIENT MARINER, Gustave Doré, S. T. Coleridge.
Doré's finest work; 34 plates capture moods, subtleties of poem. Flawless full-size
reproductions printed on facing pages with authoritative text of poem. "Beautiful.
Simply beautiful."—Publisher's Weekly. 77pp. 9¼ × 12. 22305-1 Pa. $5.95

NORTH AMERICAN INDIAN DESIGNS FOR ARTISTS AND CRAFTS-
PEOPLE, Eva Wilson. Over 360 authentic copyright-free designs adapted from
Navajo blankets, Hopi pottery, Sioux buffalo hides, more. Geometrics, symbolic
figures, plant and animal motifs, etc. 128pp. 8⅜ × 11. (EUK) 25341-4 Pa. $7.95

SCULPTURE: Principles and Practice, Louis Slobodkin. Step-by-step approach
to clay, plaster, metals, stone; classical and modern. 253 drawings, photos. 255pp.
8¼ × 11. 22960-2 Pa. $10.95